INDIA
IN MY EYES

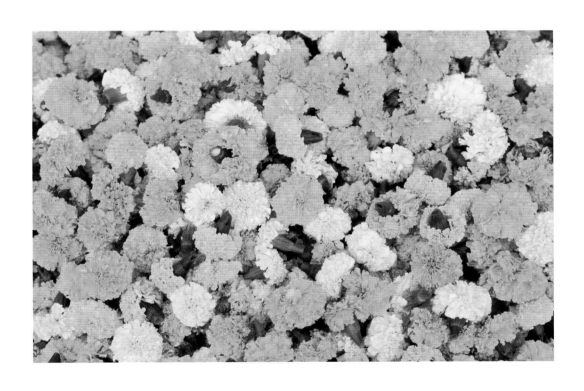

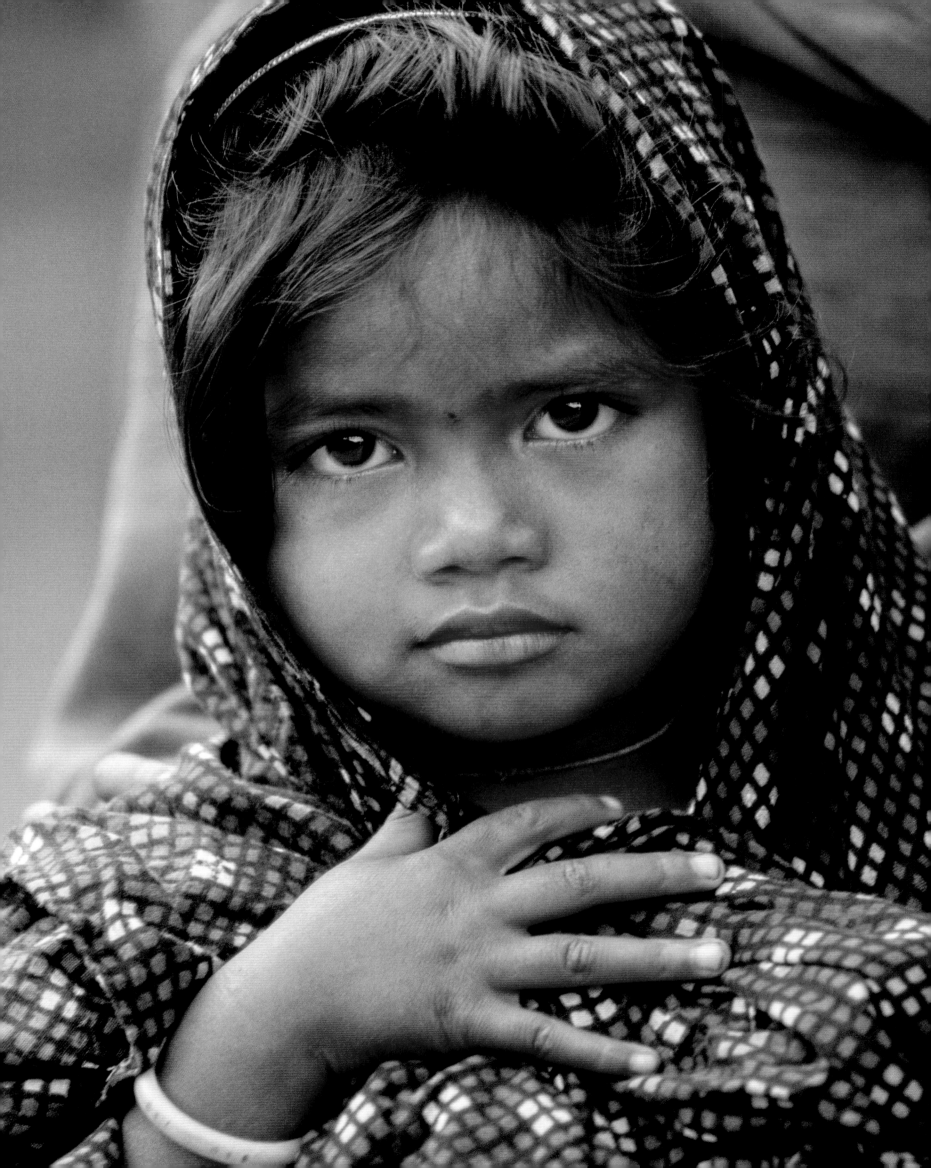

INDIA
IN MY EYES

BARBARA
MACKLOWE

Foreword by Pritish Nandy

Texts by
Philippe Garner
Eleanor Heartney

I dedicate this book to my children, Benjamin and Amanda,
both of whom share my love and passion for life.

All quotations of poetry are from *Stray Birds* by Rabindranath Tagore (1918–1941).

First published in Great Britain in 2012 by Papadakis Publisher
An imprint of New Architecture Group Limited

 PAPADAKIS

Kimber Studio, Winterbourne, Berkshire, RG20 8AN, UK

Tel. +44 (0) 1635 24 88 33
Fax. +44 (0) 1635 24 85 95
info@papadakis.net
www.papadakis.net

Publishing Director: Alexandra Papadakis
Design Director: Aldo Sampieri
Editor: Sheila de Vallée
Post Production: Sofie Barfoed

ISBN 978 1 906506 29 2

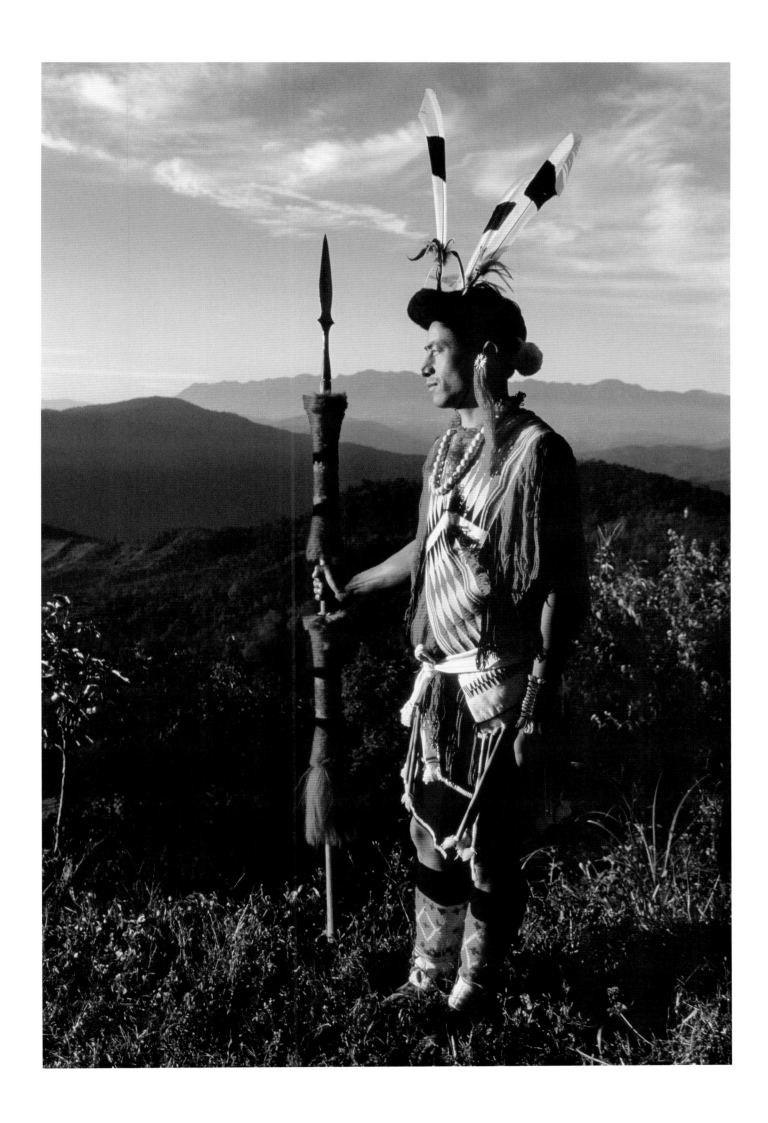

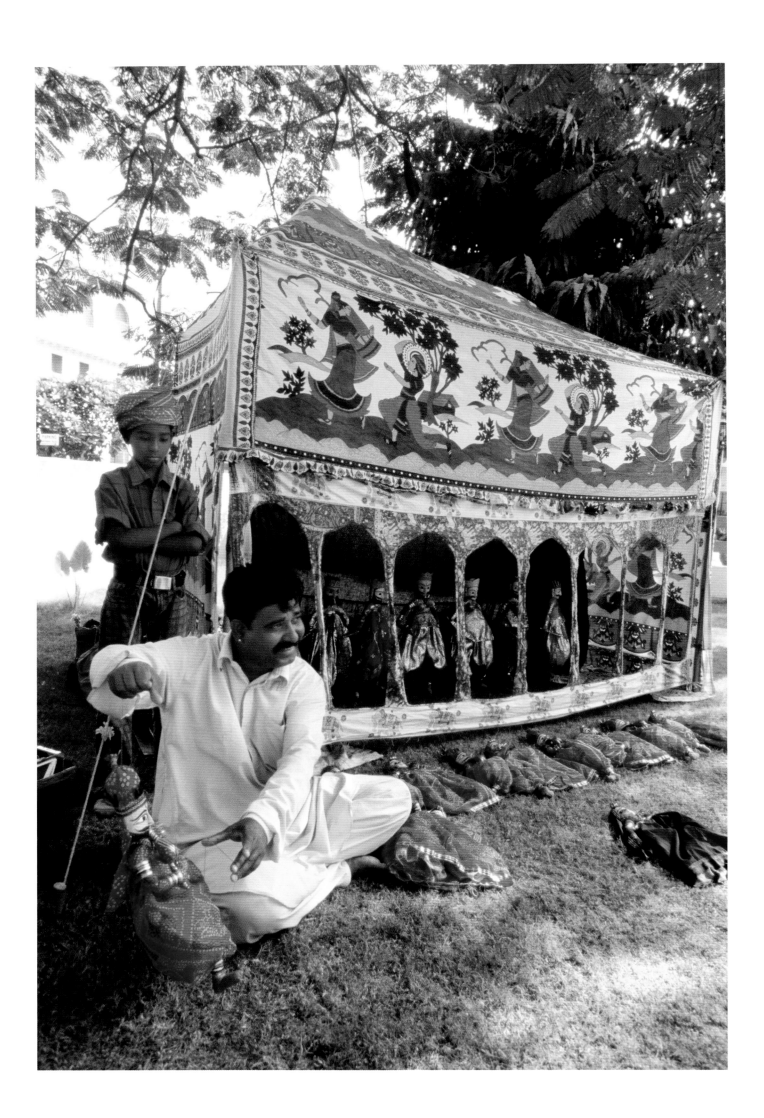

Foreword
Pritish Nandy

India is not a country, nor a nation. It is an entire continent in its reach, its diversity, and its spirit.

I come from one end of India, Calcutta. It's now called Kolkata. During the British Raj it was the capital of India. Its imposing buildings, its intellectual fervor, its literary and artistic genius, and its spirit of compassion best represented by Agnes Gonxha Bojaxhiu, known to the world as Mother Teresa, an Albanian nun who made it her home and worked among the poorest of the poor. It is only when she won the Nobel Peace Prize that people around the world recognized the incredible work she had done in the normal course of her day. Calcutta has been home to some of the greatest artists, film makers, writers, musicians who ever lived on this planet. Interestingly, many of them lived during the past 100 years and yet Calcutta is not one of the richest nor more successful cities of modern India. People say it lives in its past. Part of that past and its present as well have produced some of the greatest craftsmen of the English language. As Malcolm Muggeridge once said, the last Englishman standing would be a Bengali. Why did I leave Calcutta? I couldn't find a job that would allow me to change India.

I left Calcutta to come to bustling Bombay, the City of Gold, thirty years ago. It's now called Mumbai. But whatever you may call the city, it is never adequate to describe its amazing work ethic. Even Mark Webber would have been astonished to see such a display of the Protestant Ethic. People work round the clock here to build modern India's dreams of becoming an economic powerhouse. But the city is not only about industry and enterprise. It is also about celebration. It is the heart of the Indian entertainment industry, the world's biggest by far. Often referred to as Bollywood, it offers a showcase to thousands of people who can act, sing, dance, or do anything special that people may find amusing. Talent migrates to Mumbai from all over India. People often live in the most despairing conditions, hoping to one day become a huge star. Many fall by the way; many make it, and they make it really huge. Sometimes these stars become politicians and chief ministers. Sometimes they go to Parliament.

Politics has a great appeal in India. Like me, everyone wants to change the world and everyone has a political perspective on everything. That is why democracy works so wonderfully in India and Governments change so quickly. Everyone's view matters. It was no surprise therefore that I spent six years sharing my time between Mumbai and New Delhi, where Parliament sits. Delhi is India's centre of power and this is where the news business, modern India's most powerful weapon of change, the free press, is actually centred. I lived in a beautiful Lutyens bungalow on Ashoka Road, full of flowering trees and an exquisite lawn during my stint in Parliament and it seemed almost impossible to believe that this was a city that ruled over the lives of 1.22 billion people, 60 per cent of whom lived below the poverty line as proud citizens of a great nation that they hope will one day give their children a better future than they have. That is the magic of Delhi. It symbolizes hope for millions of people who live lives that are otherwise distressed. But their dreams do not abandon them.

I have lived in only three cities of India and travelled through a hundred more. Cities. Towns. Villages. It is an impossible task to capture its spirit, its magic, its beauty. But Barbara Macklowe has got as close as it is possible. Her images reach out and speak to every one of us, whether we live in India or, like her, traveled through it, trying to discover its indomitable mystique. This book is a tribute to her search, her perseverance, her genius. Flip through its pages. Hold on to a few images. Read her words. And, trust me, you will experience India. The experience may be incomplete, as experiences of all great and diverse nations are. But you will gain insight into what makes India, India.

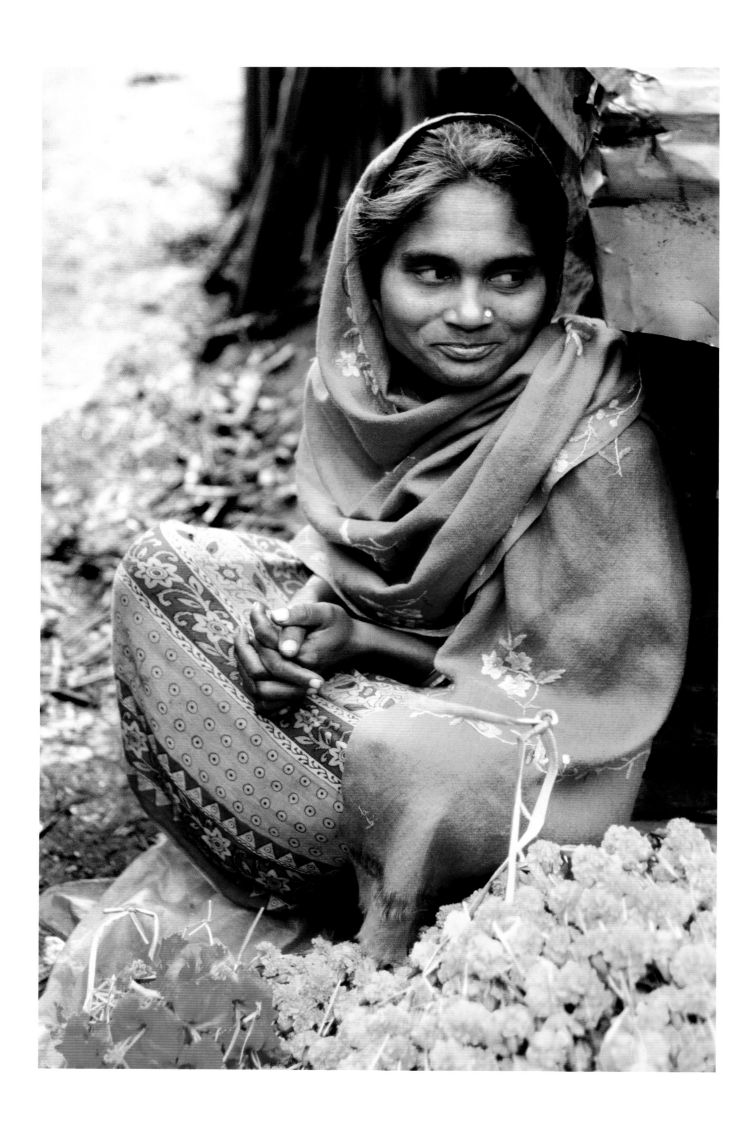

A Culture Revealed

Philippe Garner

Barbara and I go back forty years. Our professional lives have run in parallel, both of us devoted enthusiasts sharing a deep love of Art Nouveau, Barbara as a prominent New York gallerist, myself as an auctioneer. Our passion for the sensuous lines of French Art Nouveau furniture or graphics, or for the rich, jewel-like colors and effects of the glass created around 1900 by Louis Comfort Tiffany in the United States or Emile Gallé in France brought us together and gave us much to discuss over the years.

Barbara knew that my other area of professional and personal interest was the history of photography, but, although on more than one occasion she told me of her own delight in taking pictures, we never discussed that side of our lives in any detail. What a delightful surprise it was, therefore, to discover the full story of her intensive pursuit of this self-initiated project to capture in photographs the spirit of India and of the Indian people; and what a pleasure to have this opportunity to write a few words about Barbara's venture.

The Indian sub-continent has been a subject of fascination for photographers since the mid-nineteenth century, when expatriate British practitioners, many of them military officers or colonial civil servants, were seduced by the wonders before them and motivated to record the landscape, architectural splendors, people and customs of this magical territory – dubbed by Prime Minister Benjamin Disraeli 'The Jewel in the Crown' of the British Empire.

Despite the dramatic changes that have transformed our world since that time and despite the accelerating homogenization of so many aspects of our global culture, the authenticity of so much that distinguishes Indian tradition has survived. The peoples of India, their way of life, their philosophy and the vibrant visual symbols of caste, profession and ritual continue to fascinate. While the pioneer photographers of the 1850s and 1860s were limited to the somewhat static rendering of their subjects and to the warm cream-brown monochrome of the albumen print process, modern color photo-technology allows for a more fluid and comprehensive translation of the glories of India, a freedom that Barbara has appreciated and exploited to the full.

I can validate the back-story that so effectively informs her picture-making, the years of long and careful looking at works of art, the opening of her eye and heart to myriad forms of artistic expression. I can confirm specifically, through her connoisseurship in the areas of jewelry and of art glass, that Barbara clearly understands the wonder of light itself as it allows materials to come alive – and what is great photography but the ability to capture those telling moments when light reveals subjects as the most expressive confluences of form and color. The gifted photographer seizes such moments to make richly engaging images such as those we can enjoy in the present volume, images that convey what Barbara describes simply as 'the warmth, beauty and humanity of the Indian people'.

Western travelers to India have long been overwhelmed by the subcontinent's human, natural and historical diversity. Writers like George Bernard Shaw, Rudyard Kipling, Mark Twain and E.M. Forster, scientists like Albert Einstein and Werner Heisenberg, artists ranging from Orientalists Jean-Léon Gérôme and Eugène Delacroix to contemporary figures like Francesco Clemente and Bill Viola have all been inspired by this ancient land's heady mix of tradition and modernity, sublimity and chaos, nature and civilization.

There are as many Indias as there are observers: there is Colonial India, with its complicated intermingling of European and native customs, architecture and art. There is Spiritual India, where traditions as varied as Hinduism, Islam, Buddhism, Christianity, Sikhism, and Jainism co-exist. There is Modern India, with its sprawling cities and burgeoning high tech industry. There is Traditional India, where tribal people live in ways that seem nearly untouched by modernity. There is Mythic India, with its proliferating gods, voluminous epics and multiple worlds.

As the seventh largest and second most populous country in the world, India can never be contained within a single vision. But while this multiplicity may be daunting, it also opens creative possibilities to the sympathetic observer. India reveals herself in myriad ways to those who are willing to take the time to understand her.

The images in this book are a reflection of one photographer's experience of this most challenging land. Barbara Macklowe came to India first in 2004 with an open mind and a receptive eye. As an antique dealer experienced in the nuances of Art Nouveau and Art Deco decorative arts, furniture and antique jewelry, she was immediately struck by the visual cacophony that is India. Her photographs reflect the vivid colors, the clashing patterns, and the visual complexity that she found as she traveled the length and breadth of the country. She has captured the symphony of green, red, orange and purple fabrics that swathe pilgrims dipping into the holy waters of the Ganges. She brings out the rhyme between facial tattoos and silver earrings worn by women of the Kutia Kondh tribe. She shows the red turbans of the elite Sikh regiment lined up like a row of red flowers before the India Gate in New Delhi.

But these photographs also peer beneath the surface of this teeming land to reveal its human dimension – we are stopped short by the direct gaze of a young girl in a red shawl, by the fond gaze between a mother and child, by the patient resignation in the faces of sadhus lining the steps in the holy city of Varanasi. Such images reveal Macklowe's uncanny ability to connect with her subjects across a vast cultural divide.

Barbara Macklowe's India

Eleanor Heartney

While she spent some time in the big cities of India, Macklowe was more drawn to the rural areas where past and present meet and ancient rituals, costumes and practices are still a part of daily life. By seeking out less traveled places, Macklowe is able to suggest the amazing ethnic diversity of India, which ranges from the Naga tribes whose Asiatic faces reveal their kinship to the neighboring Burmese, to the isolated Bonda people of southwestern Orissa who are among the oldest and most primitive peoples in India, and the nomadic gypsies of Pushkar. The photographs also chronicle many of the gatherings and meeting places that are part of Indian life. These include the Hornbill Festival, a weeklong celebration of Naga cuisine, handicrafts, music and dance, the annual livestock fair in Rajasthan, the wholesale flower market of Kolkata, and the religious observances in the pilgrimage city of Varanasi. Macklowe takes us deep into the mountains, across the deserts, into remote villages, and inside the agricultural communities where people toil in fields exactly as their ancestors did.

India is a land of contradiction and through this very personal visual journey, Macklowe reveals how she made sense of it. Her India is a land of beauty, hardship, joy and fantasy. It breathes with life and surges with energy. In 1897 Mark Twain made a similar journey and concluded that India is "the one sole country under the sun that is endowed with an imperishable interest for alien prince and alien peasant, for lettered and ignorant, wise and fool, rich and poor, bond and free, the one land that all men desire to see, and having seen once, by even a glimpse, would not give that glimpse for the shows of all the rest of the world combined."

Macklowe reveals how true those words still are.

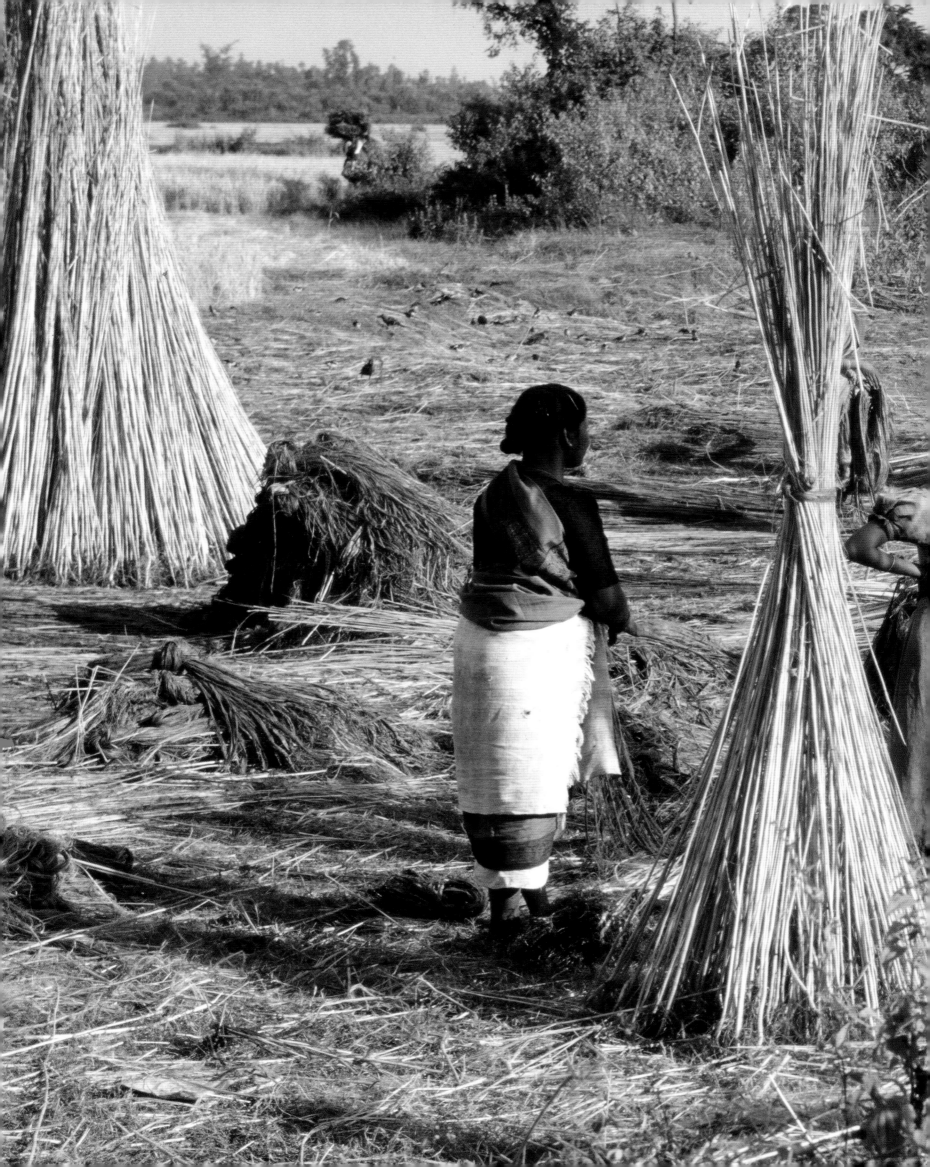

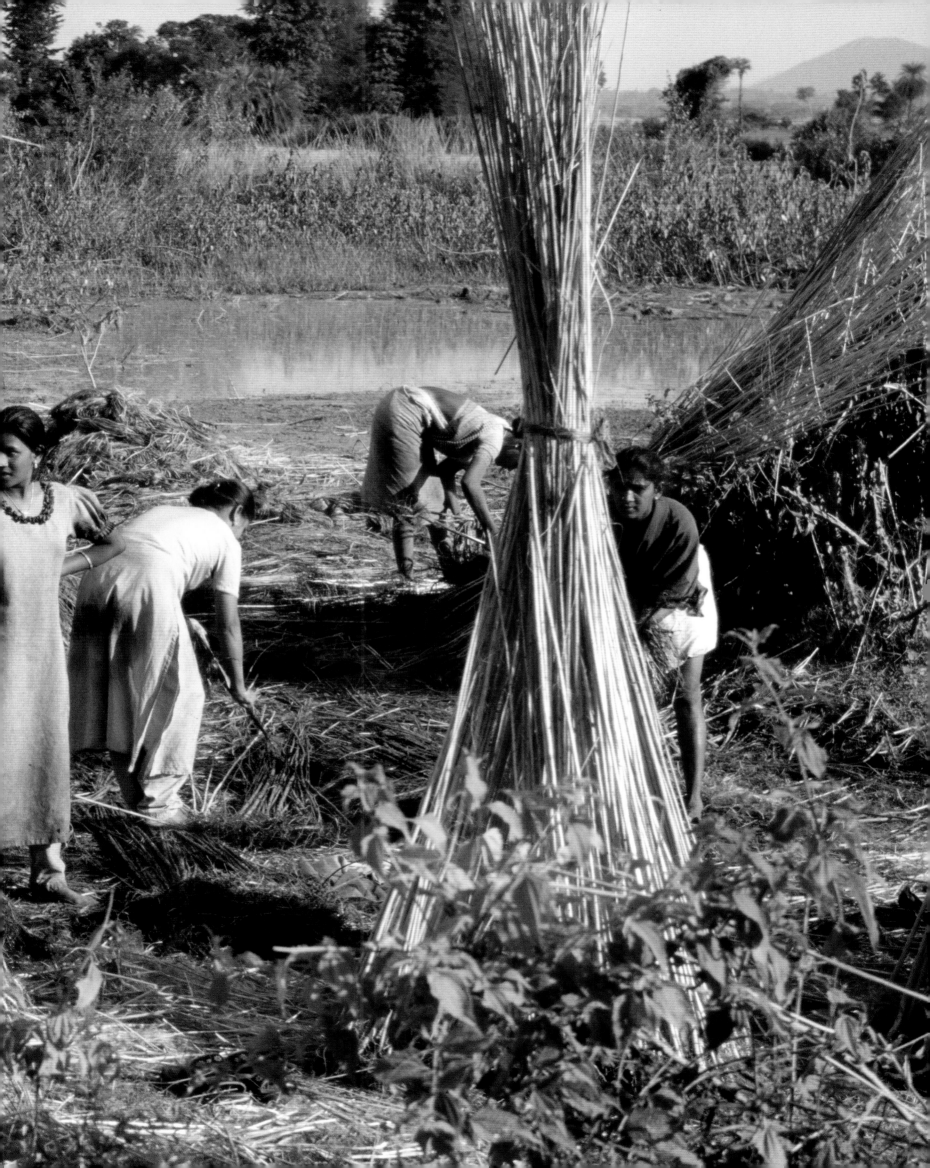

My book is filled with the warmth, beauty and humanity of the Indian people. Most of those whom I photographed did not speak English, yet we spoke through our eyes and our smiles. My images are of children, women and men of all ages. There is no sign of anger or despair evident in their manner or body language. I was truly moved by their acceptance of life as it is.

Sometimes when I meet people I feel as if I am looking through their eyes and into their souls. I often experience a physical sensation like an electric charge. I hear a sound. The sound can be somewhat like music, but more intense, insistent, and personal, that happens without warning or premonition. I am most often drawn to these particular people by first seeing them as color and light, then form, and then subject. They magnetically spring forth and as a photographer I rush to capture these feelings in an image. These images often turn out best when the subject and I have eye contact. My easy smile and the genuine love and warmth I feel towards my subject encourages the humanity in others to rise to the surface which then, if I am lucky, transfers into my pictures. It's like a gift being given to me each time that it does.

My approach to scenes and landscape is different and more of a whole. The "painting" of the image spreads out in front of me: its geometry, light and form beckoning first, with color and subject following. The knowledge and feelings are immediate and spontaneous. In order to capture the action of movement and the light, which is never the same from moment to moment, I must be vigilant, always watching and waiting for just the right time to seize the image.

When I first arrived in India it was night in Mumbai. As a native New Yorker I am accustomed to a city that never sleeps. But in Mumbai night was like day without the sunshine. Myriad people were in the streets, mostly walking and carrying bundles of some sort on their heads. Everybody was going in every direction, as were the assortment of vehicles carrying goods and people. Confusion seemed to reign and I was acutely aware that I was now someplace different from any place I had ever been. I have since learned that Indians get along very well this way and they do not seem to find it confusing at all. This was the first of my many unexpected, wonderful and contradictory experiences in India.

When I was in the states of Orissa in the east, Gujarat and Rajasthan in the west, and Nagaland in the far northeastern corner of the country, I saw tribal peoples who live as their ancestors have for centuries. I hope that through my book you will experience the tribes as I did and feel their strong spirit and connection to the land and the natural world. I found that most of them exhibited a willingness and curiosity towards me, checking out my camera and tripod and allowing me into their world if only for a short time. Outsiders are rarely seen in these areas and I think that as a Westerner I was as much of a curiosity for them as they were for me.

VISITS TO TRIBAL VILLAGES

In the state of Orissa, in the eastern part of India, I found that few of the inhabitants had ever seen a Westerner, or a camera, for that matter. They are a proud people who live off the land. Many of them are illiterate. The headman is the leader of the tribe but group tribunals are formed when more serious problems arise that affect the group as a whole.

Introduction

Barbara Macklowe

These communities of people live in the land of their ancestors where there is generally no electricity or running water. I watched women and children walk a mile or more to access water for washing and return home with pails on their head carrying drinking and cooking water for the day. Some of the boys and girls do have the opportunity to go to a government built school. The girls work the fields, take care of younger siblings and help keep the home.

I was captivated by the tattoos and scarification practiced by the women. The Kutia Kondh tribal women have facial tattoos that resemble tiger whiskers. Their belief is that it adds to their beauty and will give them the ability to recognize each other in the spirit world. The women and girls in many tribes are adorned with jewelry. I treasure a brass ring and bracelet I bought from a Kondh woman and wear them at times as a talisman and also to honor the woman from whom they were purchased.

I remember waiting anxiously by the side of the road hoping to encounter the Bonda tribal people. Would our timing be right to find them making their weekly journey to the Sunday market? The Bondas have aggressively guarded their traditional culture and I knew that it wasn't possible to visit their tribal villages and that this was my best chance to photograph them.

The women appeared on the road. They were wearing colorful beaded caps, silver tubular necklaces and large decorative earrings. Long strands of colored beads covered their chests disguising the fact that they are semi-clothed. The young Bonda woman headed to market, carrying a bundle of leaves on her head, is one of my more arresting images. I have included other dramatic photos I made that day. The market was a hive of activity and a great subject for my camera.

Later that week, I traveled to Gujarat where I was invited to visit Gujarati tribal villages and to meet with community leaders. Conversation was fluid and it was here that I discovered that the Indian people speak with their eyes. Color, color, color was everywhere. The women all wear jewelry and the fabrics of their clothing are extraordinarily beautiful. The baby girl in my photograph, who is adorned with bracelets and has tassels in her earlobes, looks very loved and very pampered.

I was attracted to the beauty of the people who were friendly, welcoming, and eager to sell things made in their village. Their surroundings are a world dominated by ornamentation, color and design. The textiles are gorgeous. The jewelry they produce is mainly of silver, some set with stones and some intricately worked.

On a trip to Nagaland in the Himalayas, the nights were freezing, the vistas breathtaking and the sunrise was in colors I had seen only in my dreams. There are sixteen tribes in Nagaland, each with its own language. They are of Indo-Mongoloid origin and live primarily in the mountains. The tribes are openly hostile towards each other, stemming from a history of warring and head hunting, which was at one time considered essential for entry into manhood. Even today each warrior, when in traditional dress, wears animal teeth on a neckpiece signifying the number of men he has hunted.

In the mid-nineteenth century, Baptist missionaries came to this isolated area. The missionaries came to convert the Naga people to Christianity and because they had no written language, taught them to read and write in English so that they could read the Bible.

My trip was planned to coincide with the government-sponsored Hornbill Festival. For days the Naga tribes prepare and then come together to perform traditional tribal dances. They forego their mainly western-style clothing to wear the coverings of their forefathers, which include loincloths, woven blankets and feathered headdresses.

OTHER PLACES AND OTHER CITIES

My book covers my visits to the holy city of Varanasi where for as long as memory has it, the Hindu pilgrims have come to worship at and in the waters of the Ganges River. I've seen mendicants, often entire families, who are there for prayer, ritual bathing and to cremate and bury their dead. The sight of floating flowers and candles in the night river and the sounds of the priests making offerings and prayers is hypnotic and unforgettable.

My night and pre-sunrise images in Varanasi were taken from either a car or a small boat on the river that rendered them in soft focus, emphasizing a sense of movement, mirage and miracle. The ghost-like images of the city float in and above the mist, which with the addition of smoke from the pyres, rises up from the river. People appear and then quickly disappear depending upon the light. My image *Woman ascending the Ghats* is an example of this. It felt as if I were working with an enchanted camera.

I had a momentary view of wrestlers jogging past the worshippers who had risen before the sun. While walking on the ghats, on the banks of the river, I encountered religious sadhus who had come to pray and ask for donations in order to continue their life of dedication and prayer. Many of them had slept on the steps during the night wearing their colorful shawls and headscarves. They were slowly waking as I passed by.

A shaved head is a sign of mourning and barbers are there on the steps, plying their trade and serving the public. All manner of things are for sale by street vendors. Two separate women vendors proudly introduced me to their children who were returning from school. When I look at my images I can still experience the unique spiritual energy I felt in Varanasi.

The annual livestock fair in Rajasthan, held in the ancient town of Pushkar, presents itself in open fields and covers a territory for as far as the eye can see. It features the traders who come to appraise, purchase and sell camels, horses, bullocks and other greatly prized animals. A festive air is all about. There are fortune-tellers, musicians, singers and dancers who will entertain you for a sum. There are food and drink vendors, catering to the families who come to work there and the visitors who come to experience the spectacle. There is also a great spiritual presence in Pushkar, which at other times is a peaceful town of lakes and over 400 temples that attract religious pilgrims. The little singer in gold and yellow belted out a song in Bengali to raise money for her family. Her father stood by her side. Another musician played a stringed instrument while his wife sat beside him. There were camels everywhere and a lot of action and a lot of dust.

While in Pushkar two gypsy women invited us to their camp for the following day where we would attend a private dance and music performance. I became a part of these gorgeous, sensuous and talented people through my lens, and was caught up in their magnetic dance movement and infectious music. I learned that the gypsies originated in India and that gypsy dance greatly informed Spanish Flamenco dance. This incredible experience was one of the high points of my life.

In Kolkata it was the bustle and sophistication of the city life that called out to me. My images of the wholesale flower market early in the day are similar to those I have taken in other cities, the greatest difference here being that families live in tents around and near the market.

The former British presence is evident everywhere in Kolkata, from the street names and architecture, such as the Victoria Monument, to the beautiful parks where families meet, stroll, picnic and play. Yet when I walked among the people and shopped in the sidewalk stalls in the neighborhood where spices and sweets are sold, all life was decidedly Indian. There were children playing in the streets. People, both rich and poor, were walking home from the market and others were riding in all manner of vehicles. I experienced the highly charged atmosphere of the city and of "business as usual."

I observed the once beautiful buildings that were now in an advanced state of decay with hopeful sounding "For Sale" signs suggesting urban renewal projects. Trees were sprouting from windows and rooftops. Two teenage boys decided to protect and guide me through the unfamiliar area keeping the beggars and hawkers away, making it possible for me to soak up the life of the neighborhood with my camera and not be jostled. The only language the boys and I shared was a lot of hand waving and our smiles.

In Jaipur I found a welcoming city, cosmopolitan, beautiful, buzzing and seemingly thriving. The store displays were filled with Rajasthani wares. I enjoyed poring through a world-class selection of exquisite textiles and shawls. There were decorative objects made of *pietra dura*, in which white marble is set with inlays of colored stone. I visited stores which displayed fine gold and precious gemstone jewelry. Jaipur has had a history of fine jewelry-making for centuries. Its family artisans have ensured its renown throughout the world.

Parts of the "Pink City" were as surprising to me as the snake charmers in the street, the decorated elephants on the road, and the roosting storks in the ancient ramparts. I stood for hours on a sidewalk facing a crazy busy road leading past the Maharaja's palace in the "old city". The palace is hidden behind beautifully colored arched and gated entrances just meters beyond the Hawa Mahal, which is a 300-year old pink building also known as the Palace of the Winds. The story told to me by my guide about this confection of a building was that it is only one room deep. He said that the ornate façade was erected for the palace concubines. The women gathered there to look out from the windows when the prince rode by. This gave him the opportunity to choose from among them. The façade is ornamented with tiered open balconies and screened windows that were simply empty when I first saw them. Nevertheless, at the end of the day when I was being driven out of Jaipur, and my camera was unreachable, we passed the five-story structure again and virtually every window was now filled with the body of a monkey. I could almost hear the laughter of the eighteenth-century women of the palace.

To be immersed in the temples of Khajuraho is to be transported back to the ninth and tenth centuries of Central India. Many theories abound regarding these carved stone masterpieces that are considered the pinnacle of North Indian temple art and architecture. There are hundreds of erotic sculptures covering the walls depicting maidens, animals, and gods and goddesses.

I was in a park in the Indian capital city of Delhi when I was drawn to the sea of red turbans of the elite Sikh Regiment. They stood and marched before the India Gate and the elegant Canopy designed by Sir Edwin Lutyens.

In Agra, I waited in the dark to be among the first people to see the magnificent Taj Mahal at sunrise. I was unprepared for its majesty. I have chosen an image showing the Taj from across the river so that we can observe it, along with the other buildings in its complex, as both structure and reflection.

The Taj Mahal was built in the seventeenth century as a gift of love from emperor Shah Jahan for his favorite wife, Mumtaz, who had died and was buried in its tomb. It has since become a great gift to the world.

My book, *India in my Eyes* is a love poem to India and is my gift to you.

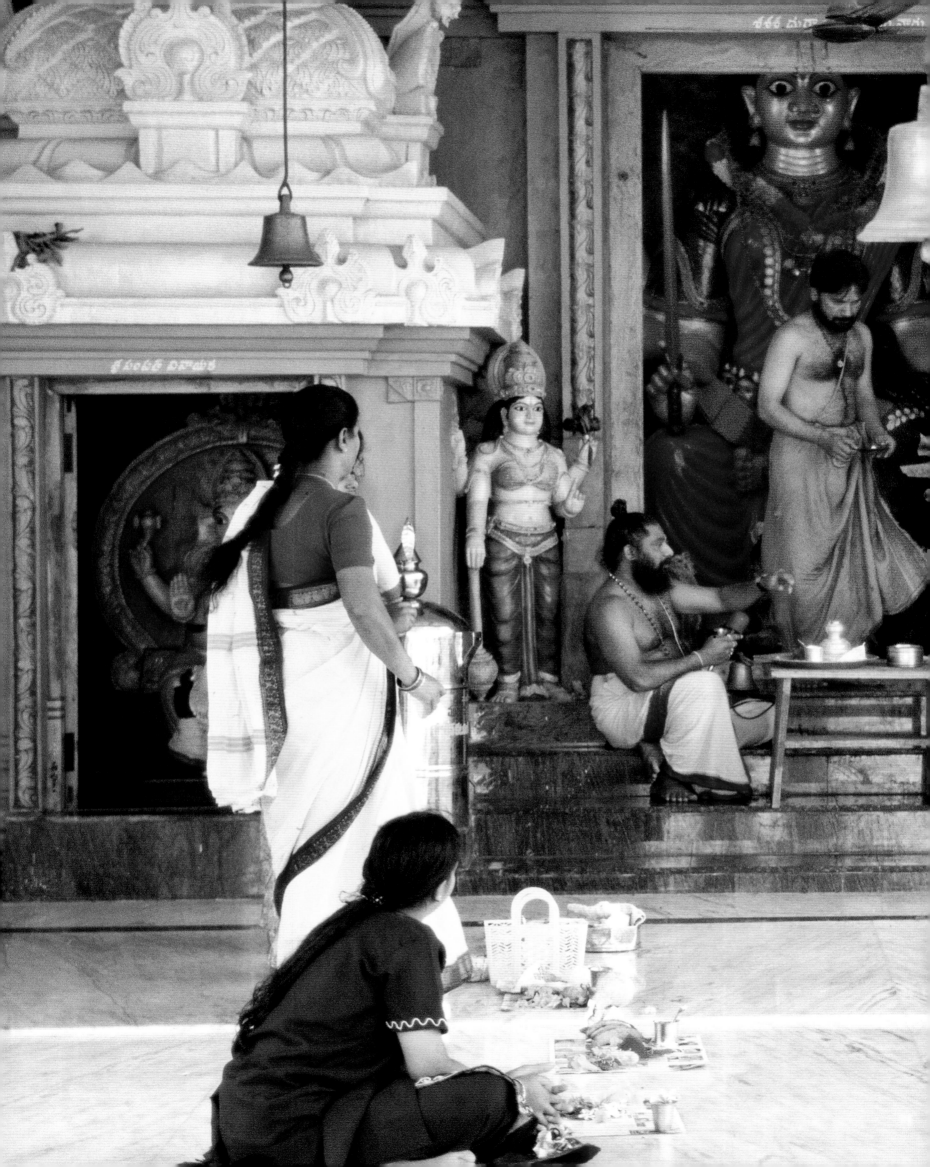

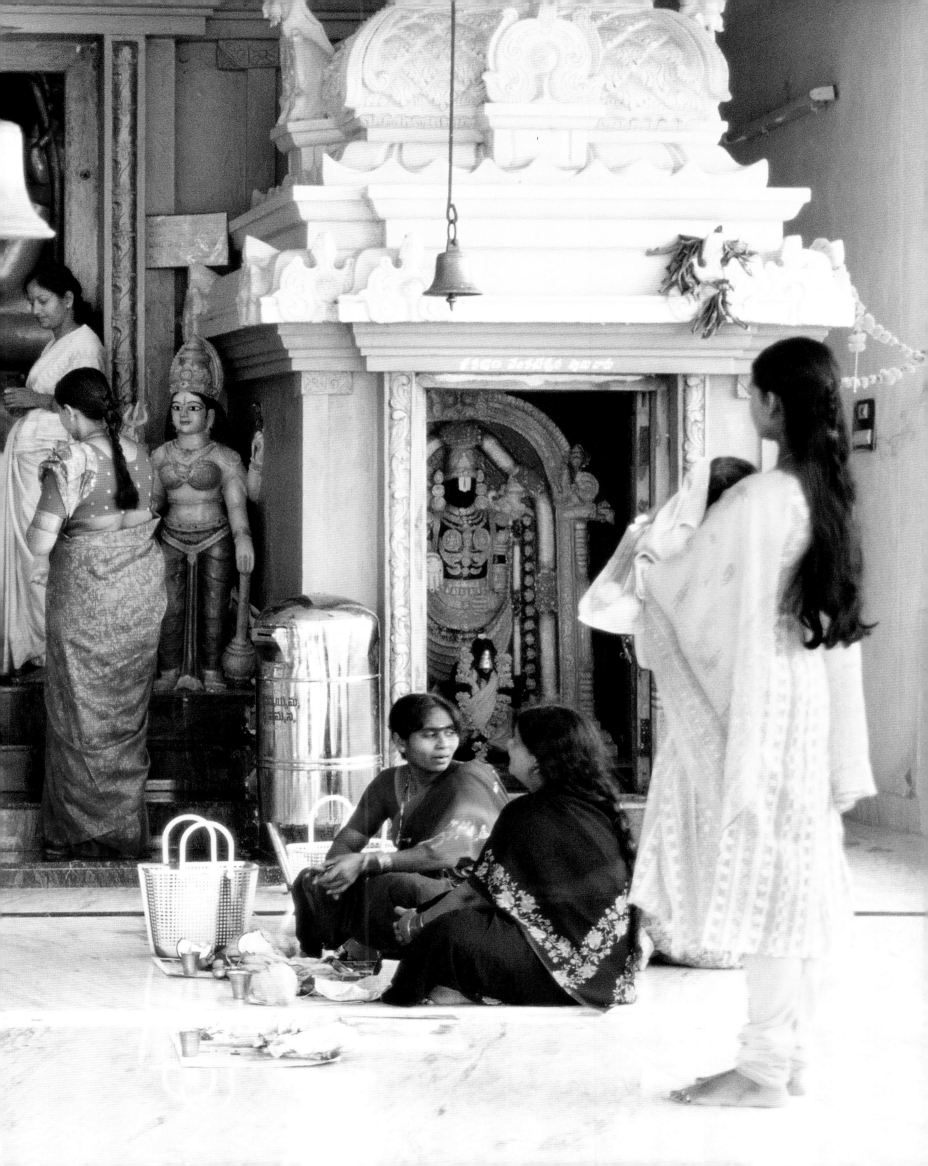

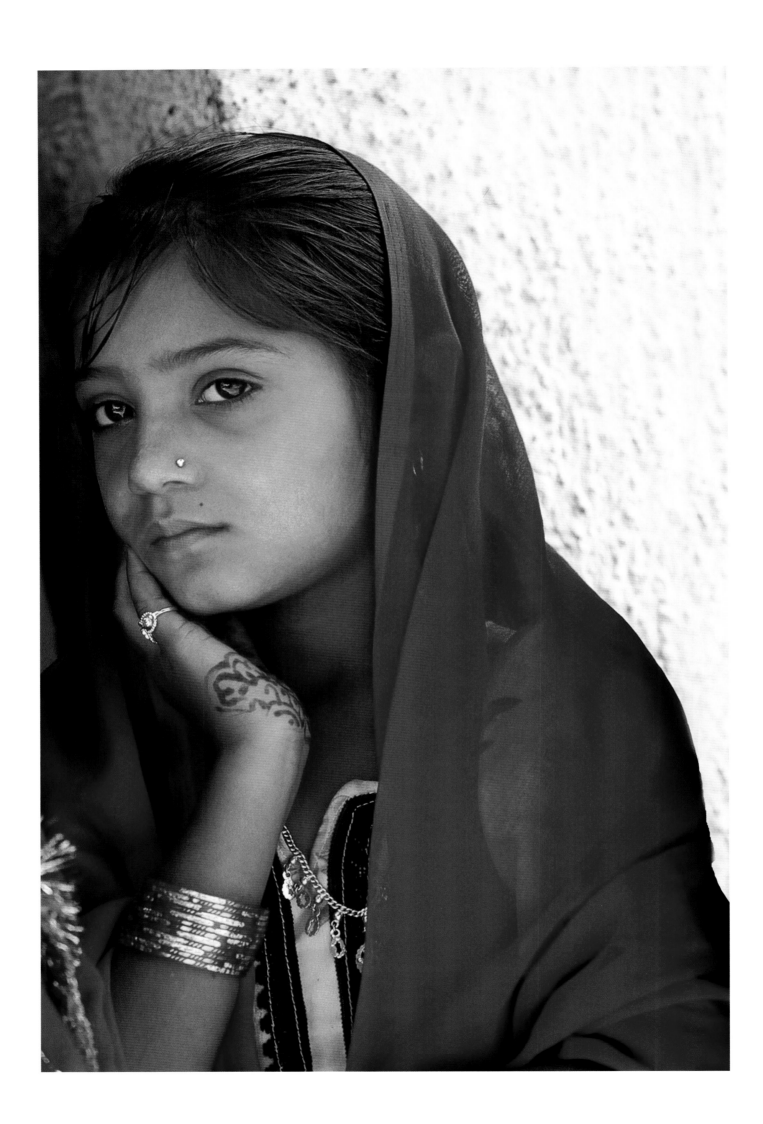

"They light their own lamps and sing their own words in their temples. But the birds sing Thy name in Thine own morning light, for thy name is joy."

Pages 18–19: A Hindu ceremony for women and children with offerings of fruit and flowers at a roadside temple, Mumbai.

Pages 20–28: Festive dress and *Mehendi*, henna designs on the girls and women, welcomed us in a small village in Gujarat.

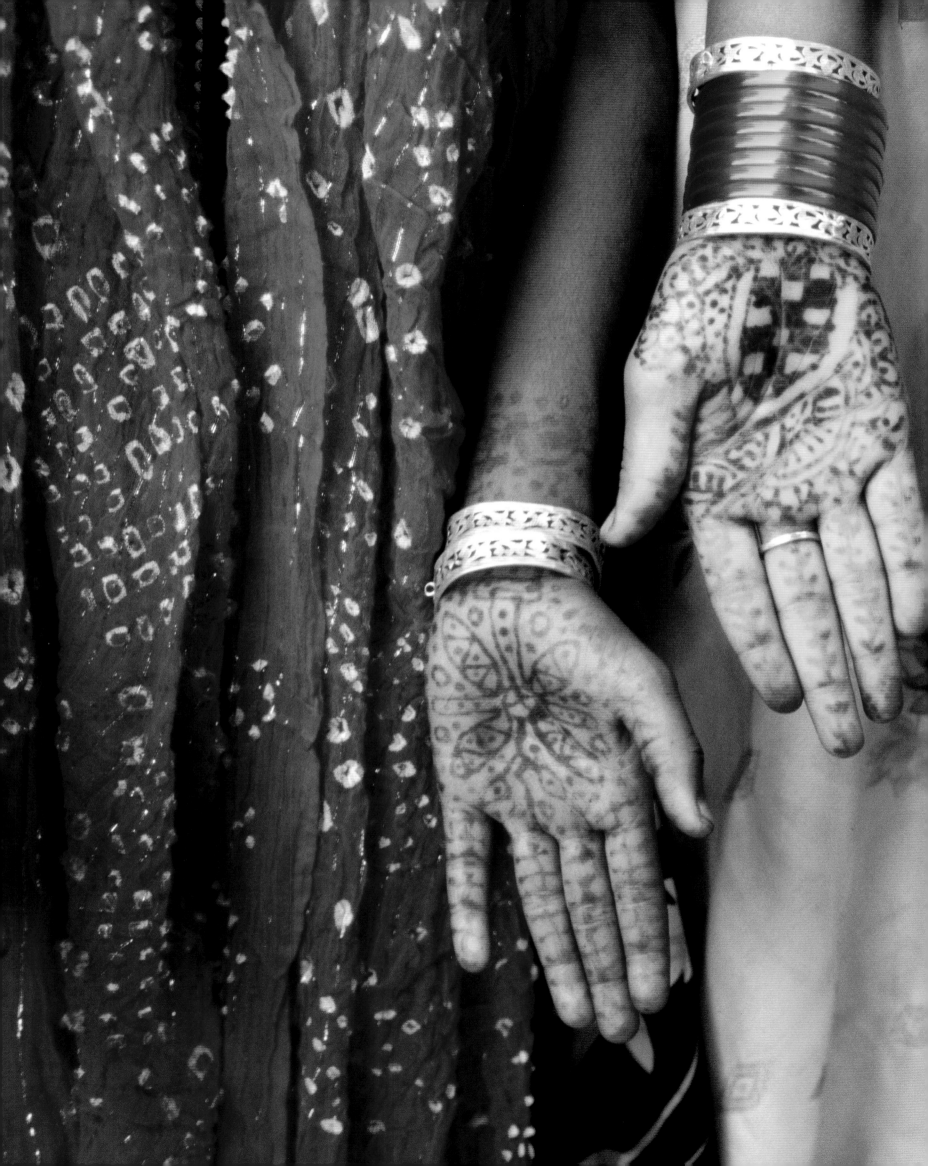

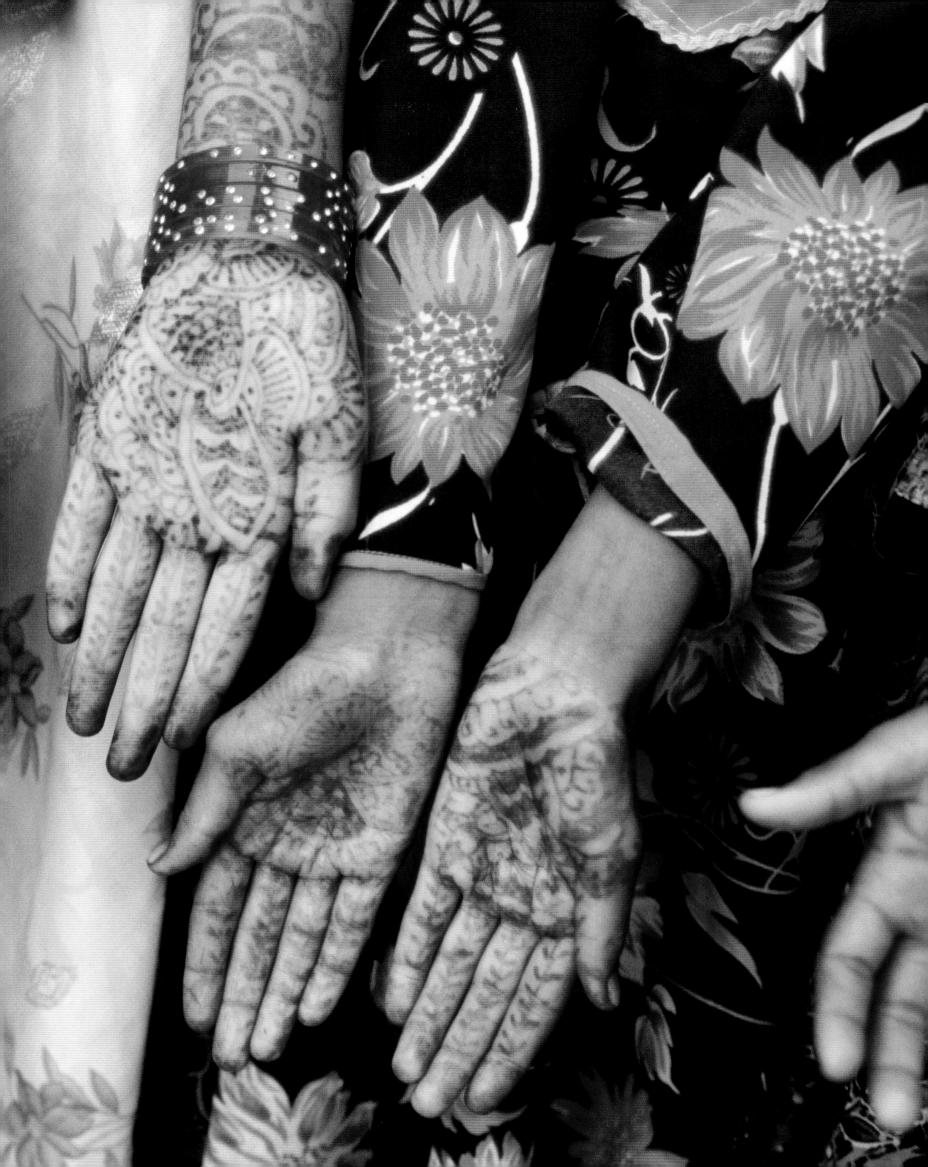

"Maiden, your simplicity,
like the blueness of the lake,
reveals your depth of truth."

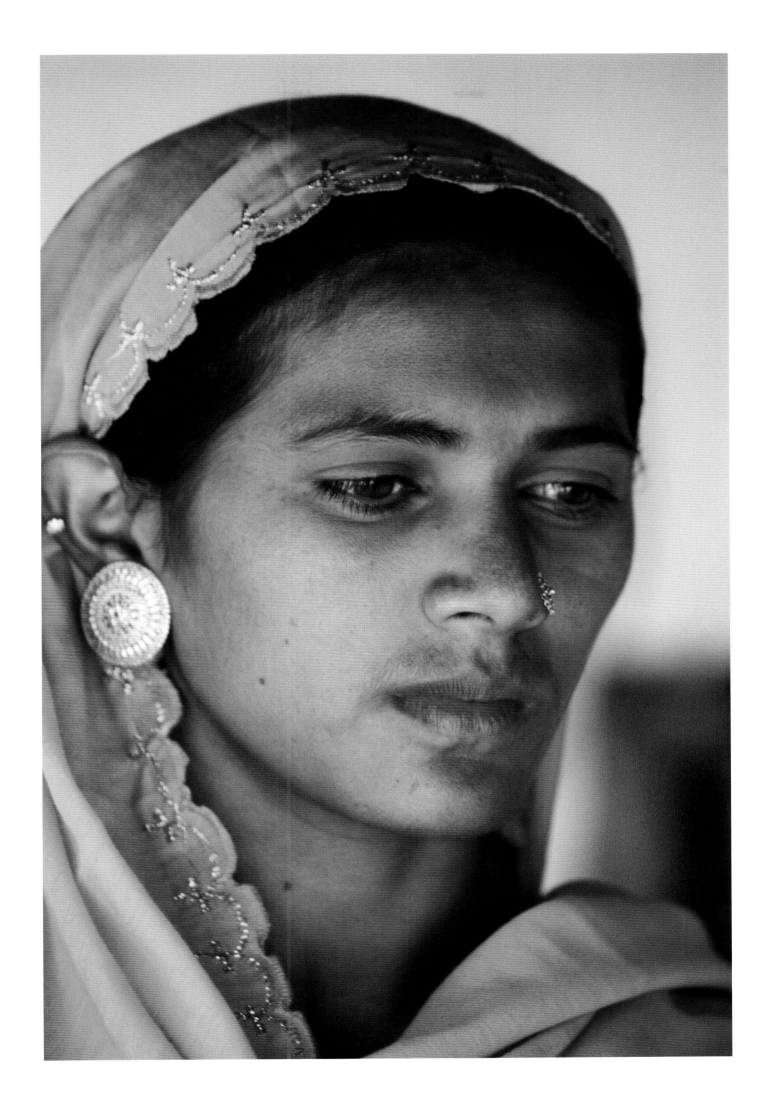

"How far are you from me, O Fruit?"
"I am hidden in your heart, O Flower."

Right: A welcoming open door with shoes.

Pages 27–43: Meghwar village in Gujarat, which specializes in the crafts
of textile design, beading, embroidery and silver jewelry making.

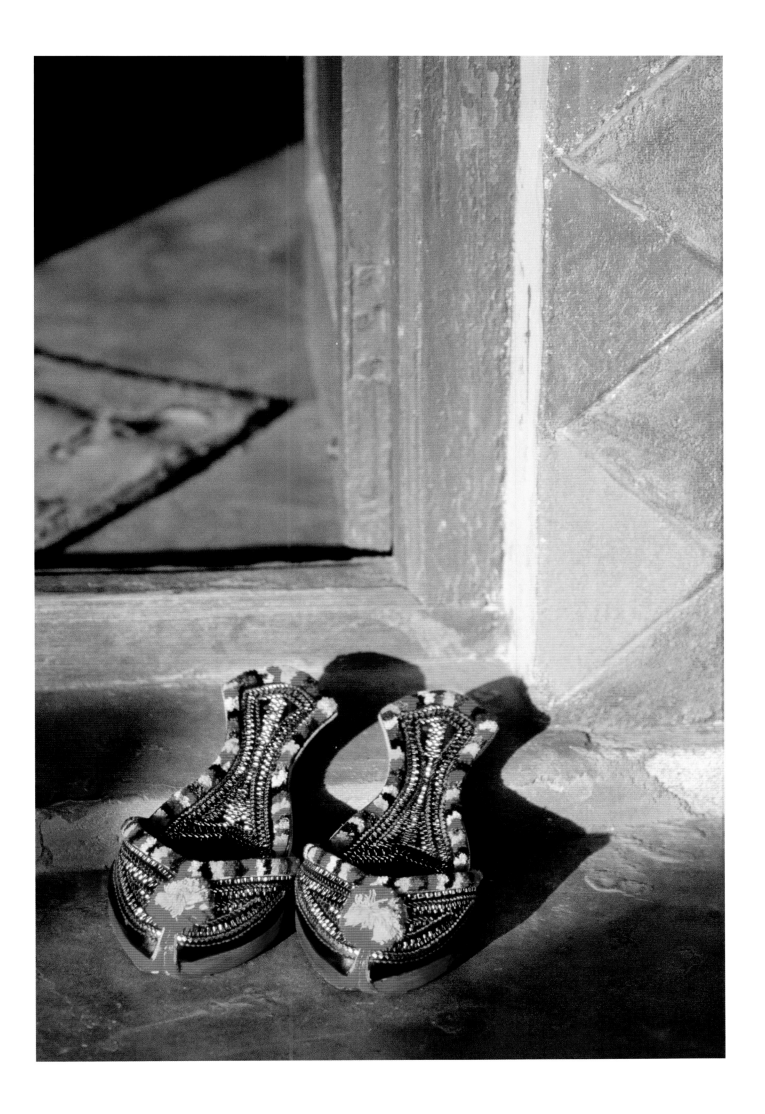

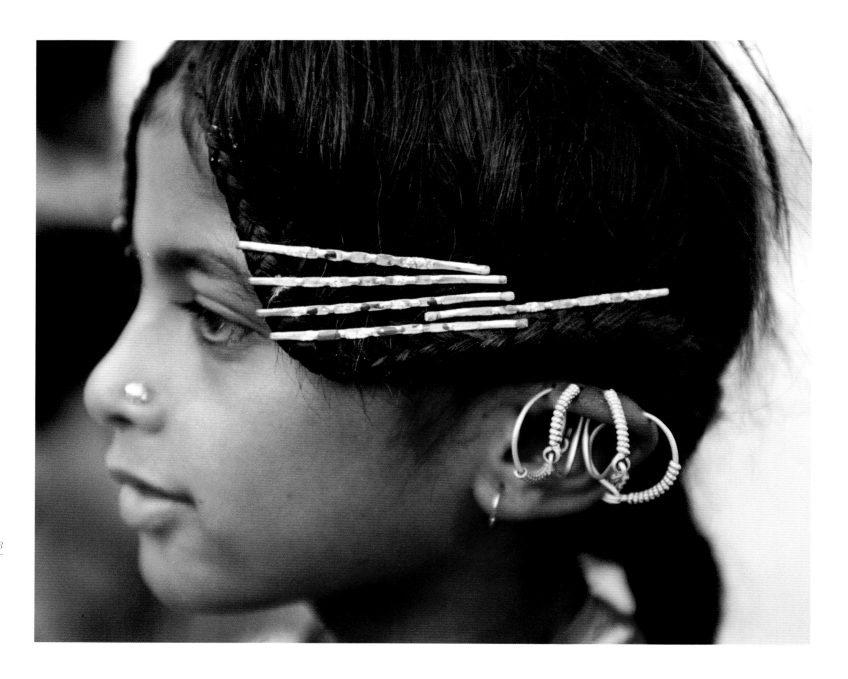

My camera loves the accoutrements: clothing, hair ornaments and jewelry,
and alternates between them and the faces of the wearers.
These two sisters are in festive dress for visitors.

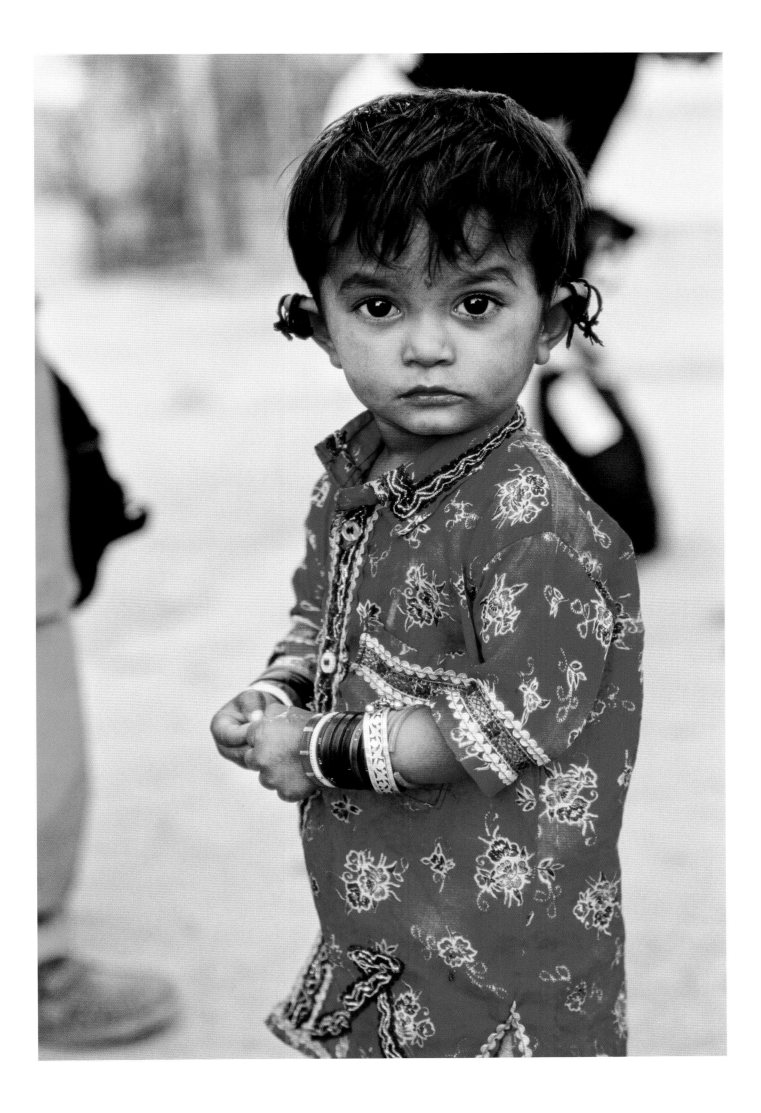

"By plucking her petals, you do not gather the beauty of the flower."

A beautiful young woman in traditional festive dress strikes a demure pose
using her head scarf in a typical Indian manner to at once conceal and reveal her face.

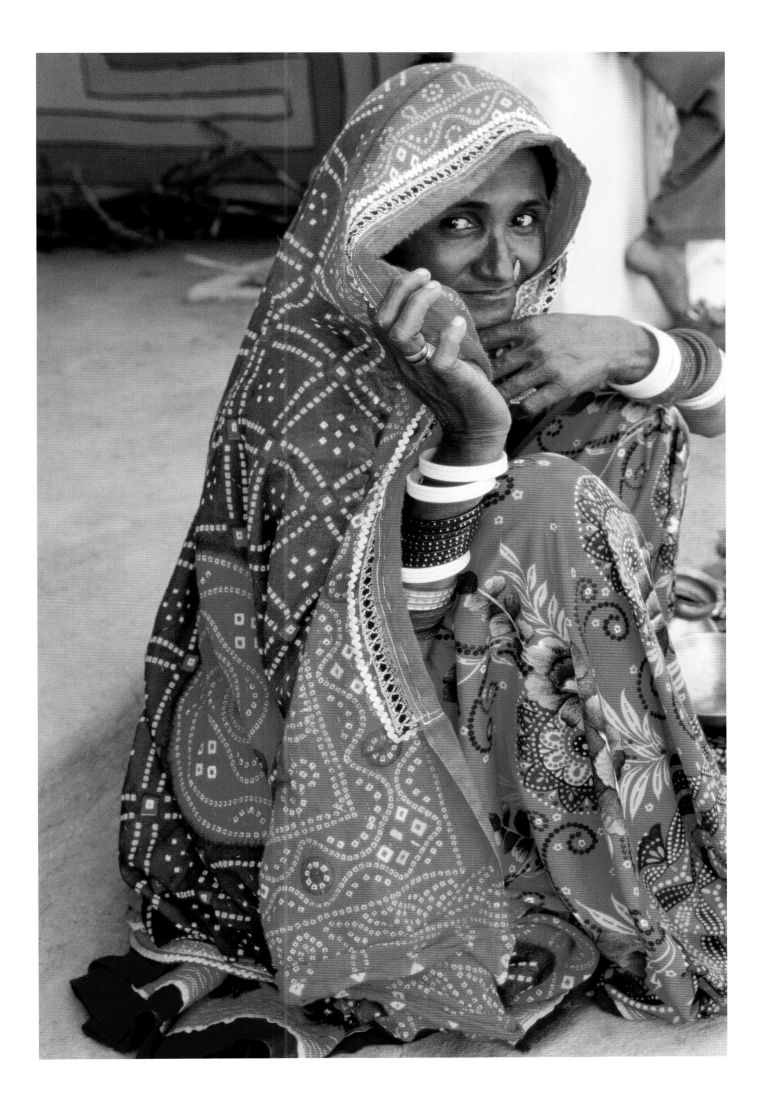

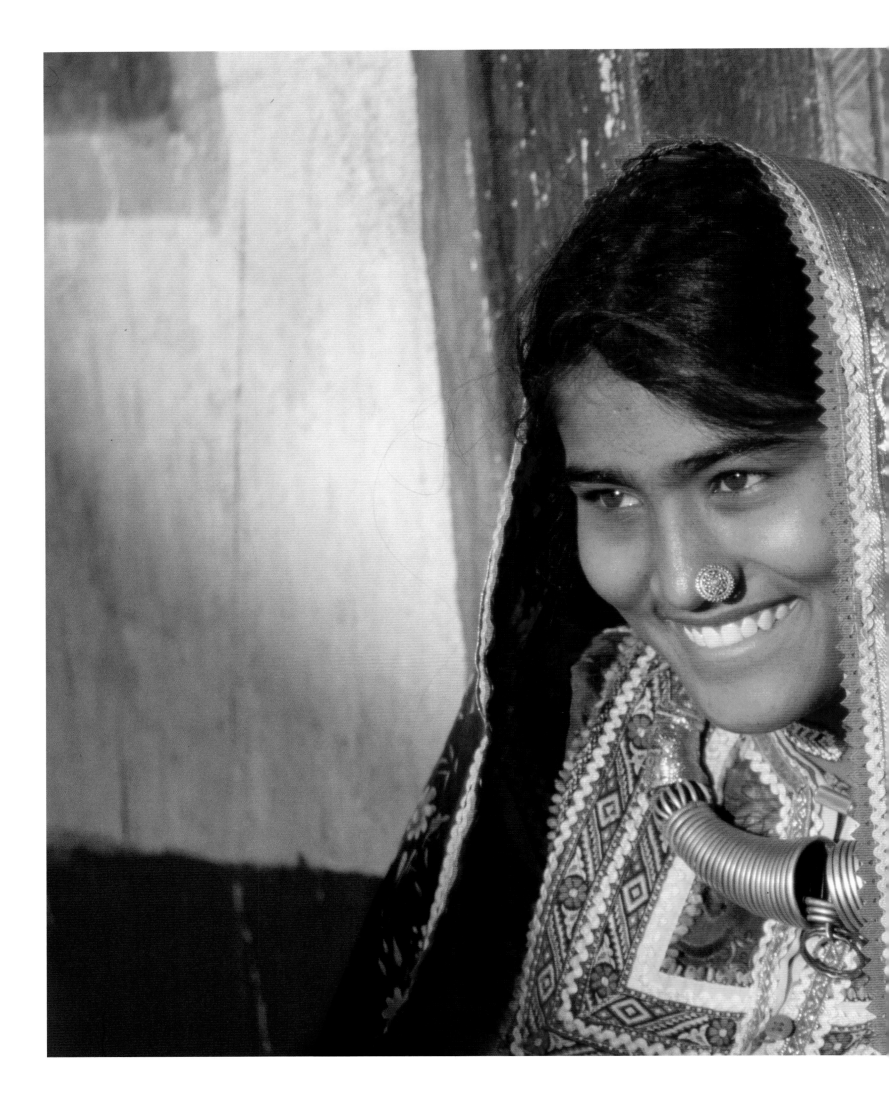

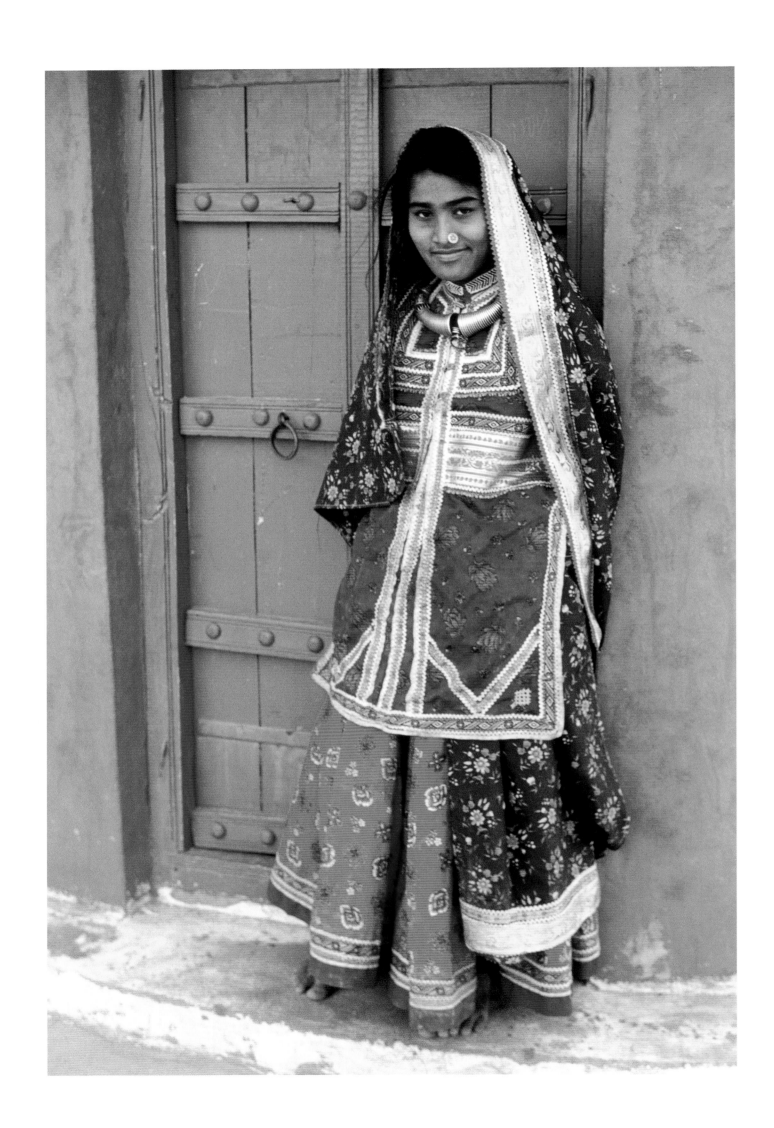

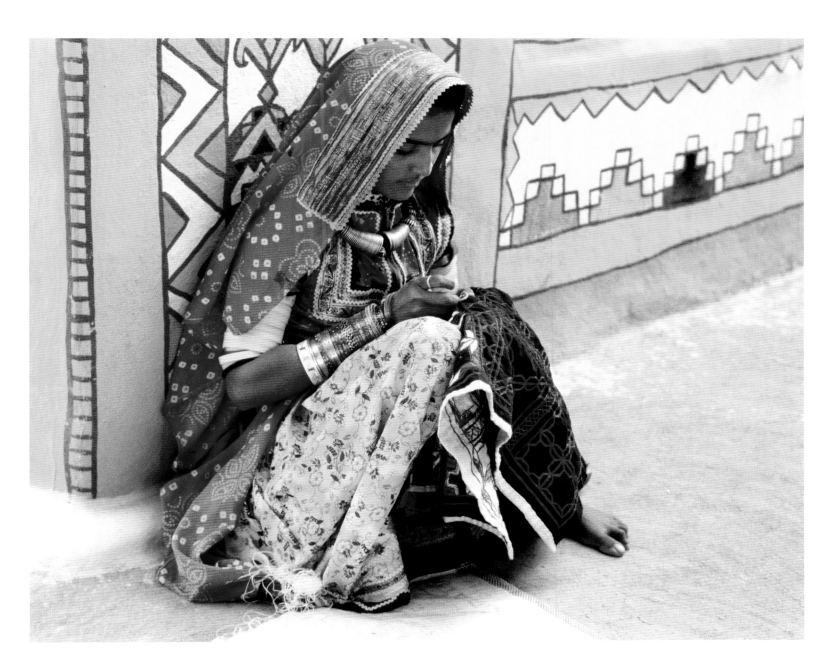

"*God grows weary of great kingdoms, but never of little flowers.*"

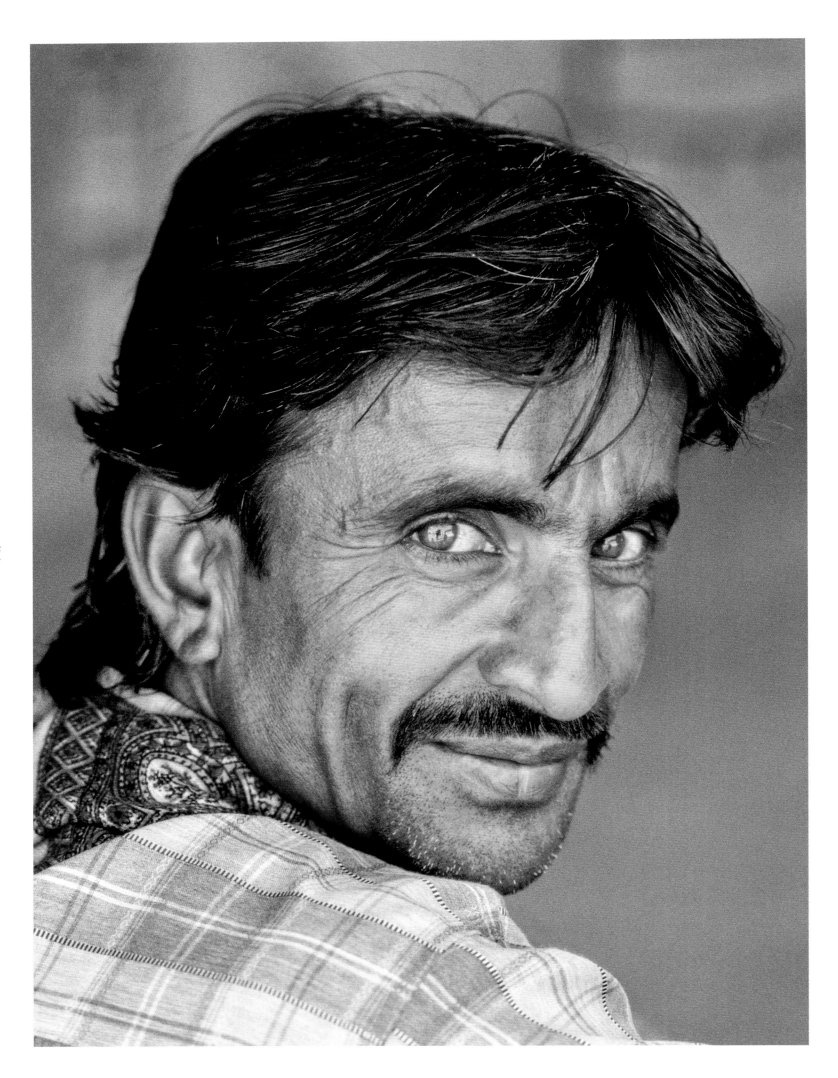

"Life finds its wealth by the
claims of the world, and its
worth by the claims of love."

With his wares spread out in front of him, the amused yet piercing eyes of a
Gujarati fabric merchant speak a language all their own.

"I think of other ages that floated upon the stream of life and love and death and are forgotten, and I feel the freedom of passing away."

An old woman with a handmade doll sent to comfort her and keep her company.

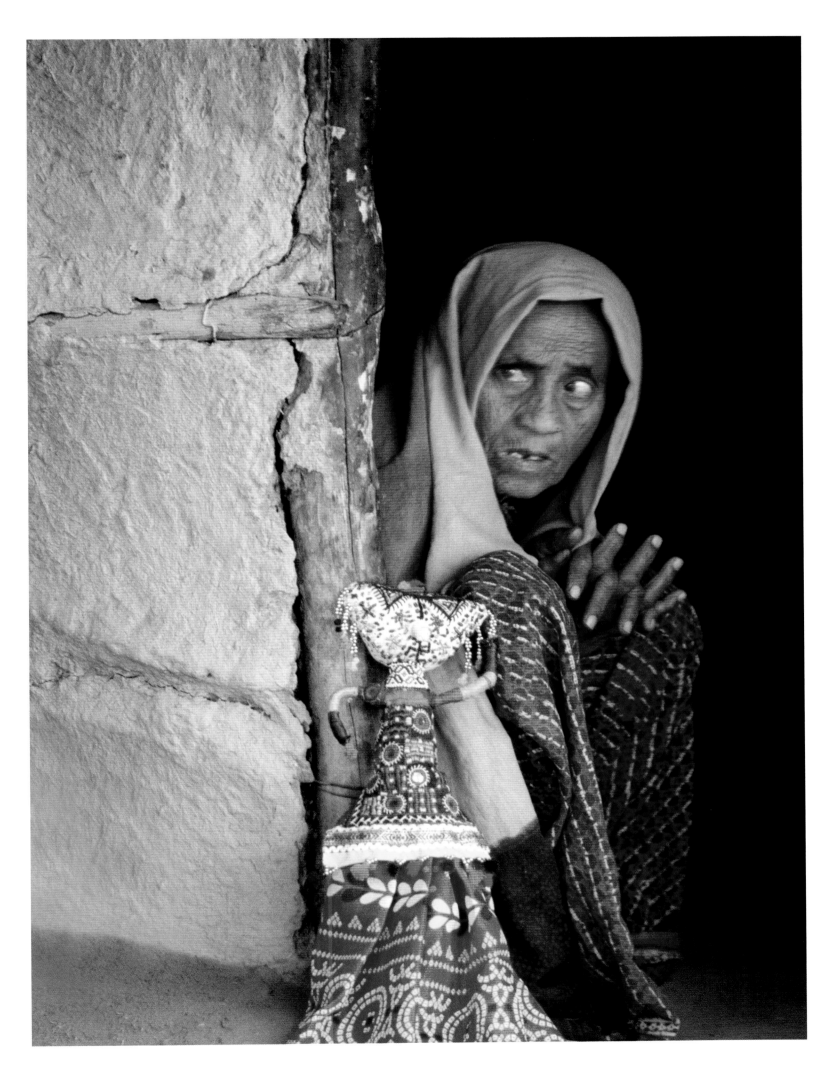

" Tiny grass, your steps are small, but you possess the earth under your tread."

A happy baby girl wearing the ankle, arm and ear jewelry
favored by this prosperous tribe.

"Woman, in your laughter you have the music of the fountain of life."

Pages 44–56 and 64–65: Images of members of a Kutia Kondh tribe in Orissa.

Left: Note the tribal facial tattoos which resemble tiger whiskers on the women. The tattoos are worn for beautification and to ensure that they will be recognized by other members of their tribe in the spirit world after death.

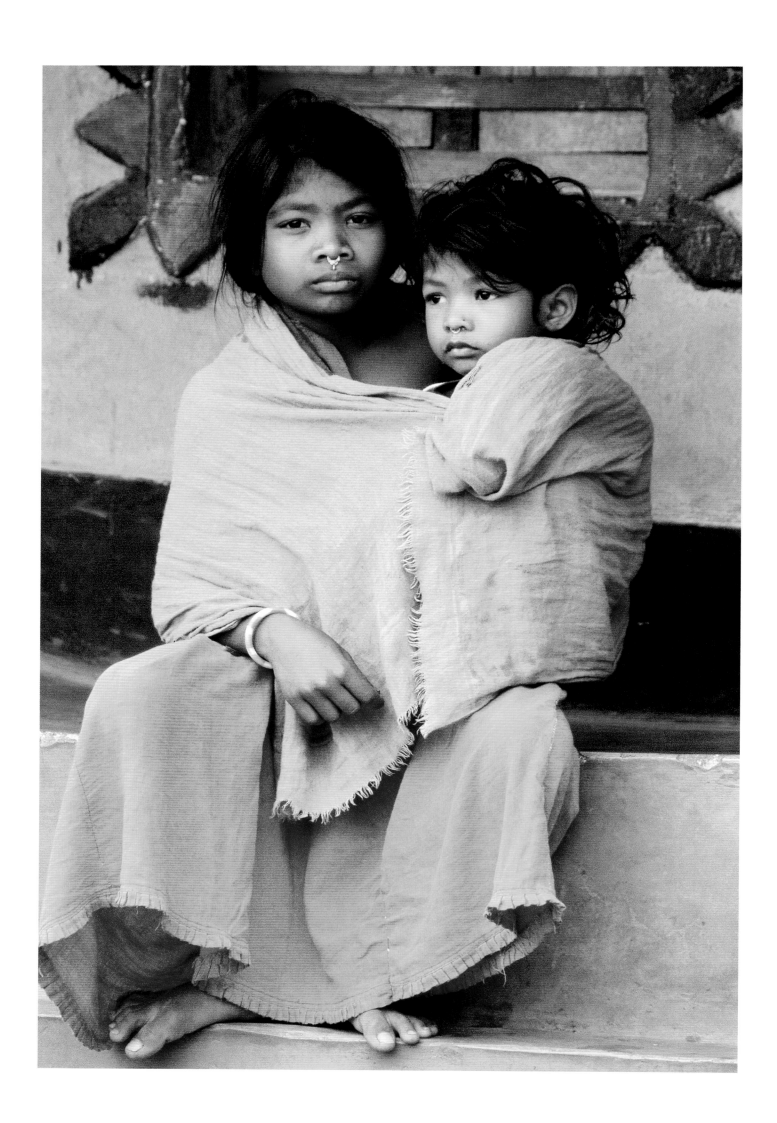

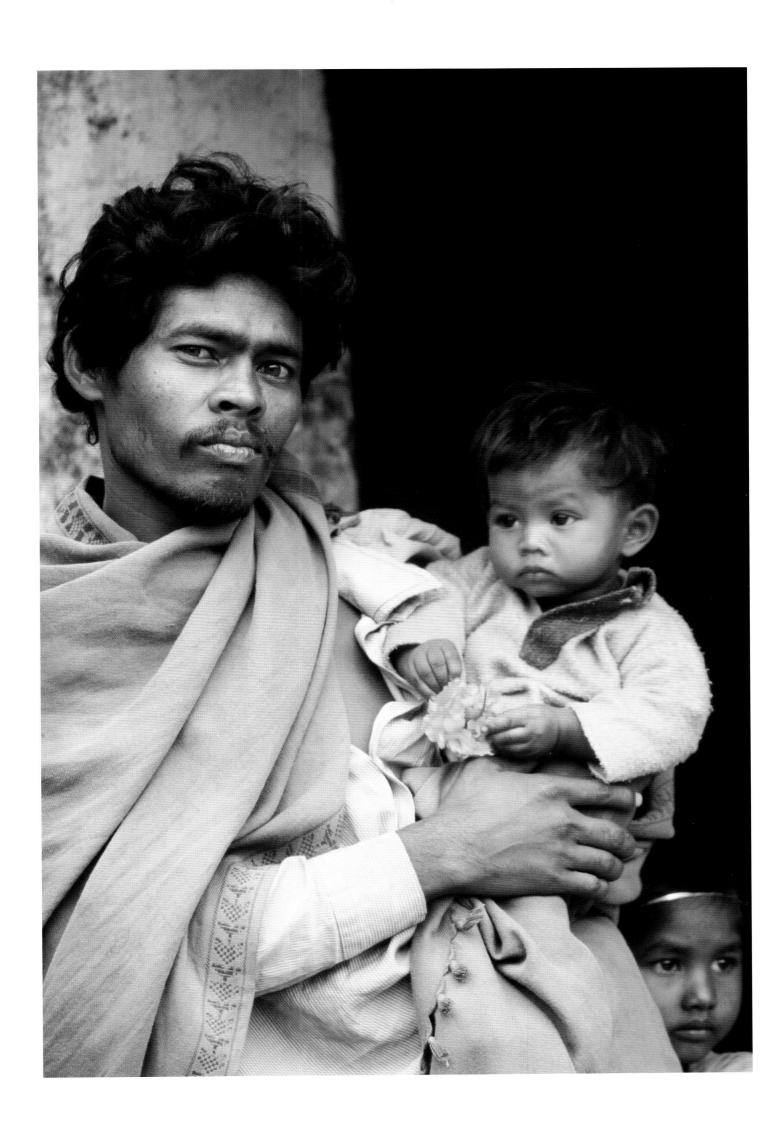

"The infant flower opens
its bud and cries,
Dear World, please do not fade."

Page 46: Two sisters, the older one caring for her younger sister, a sight not uncommon in India.

Right: A very shy girl. Many Indians shave the head of their little girls in the belief that this will encourage thicker, more beautiful hair to grow.

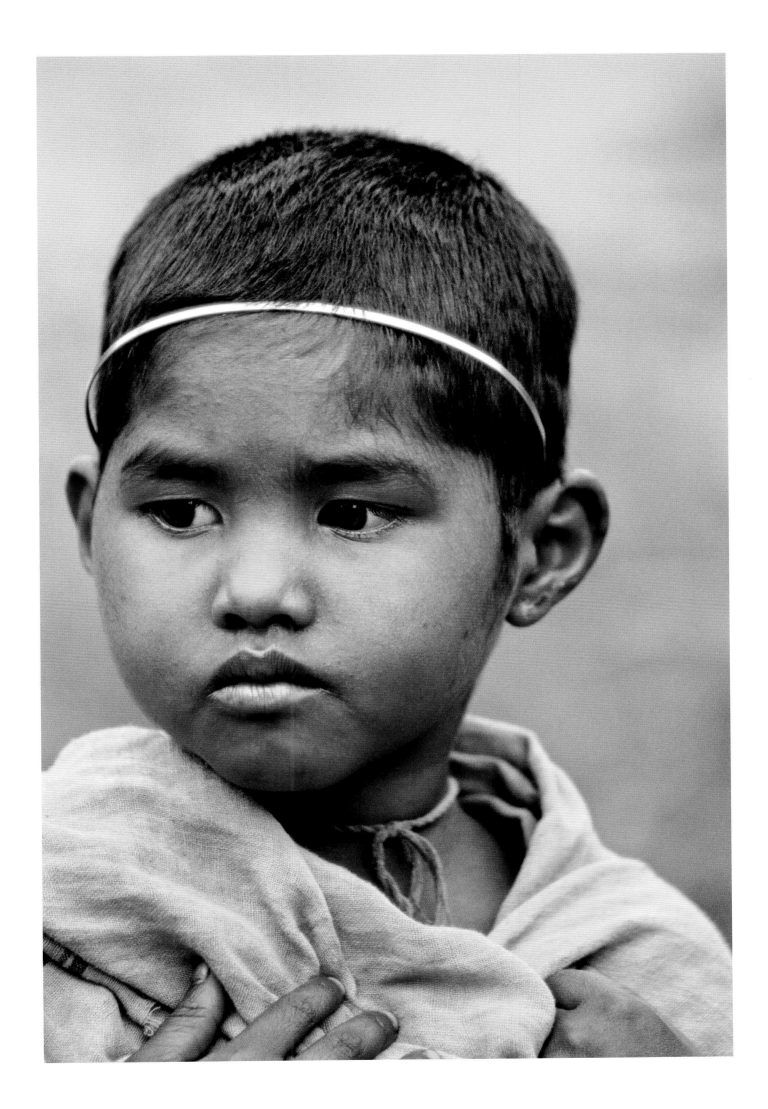

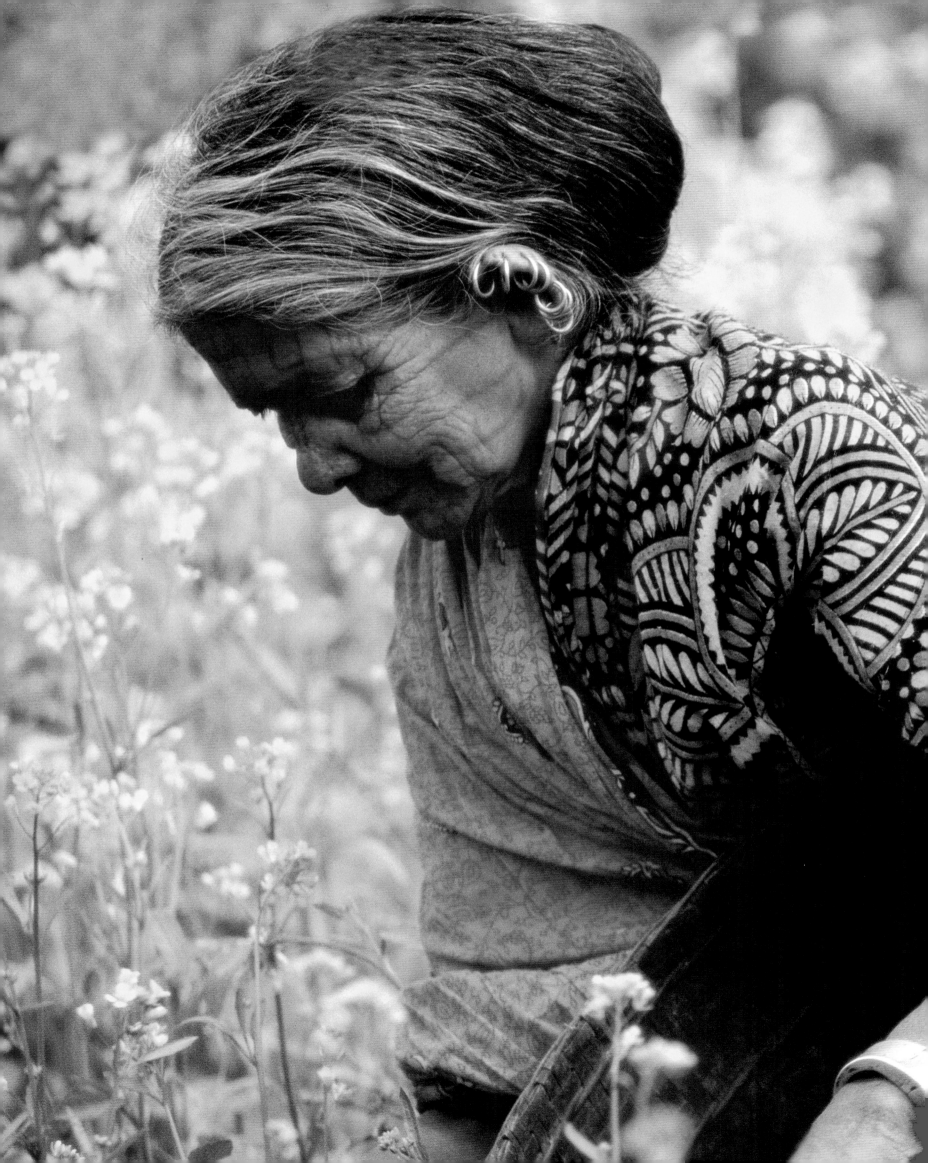

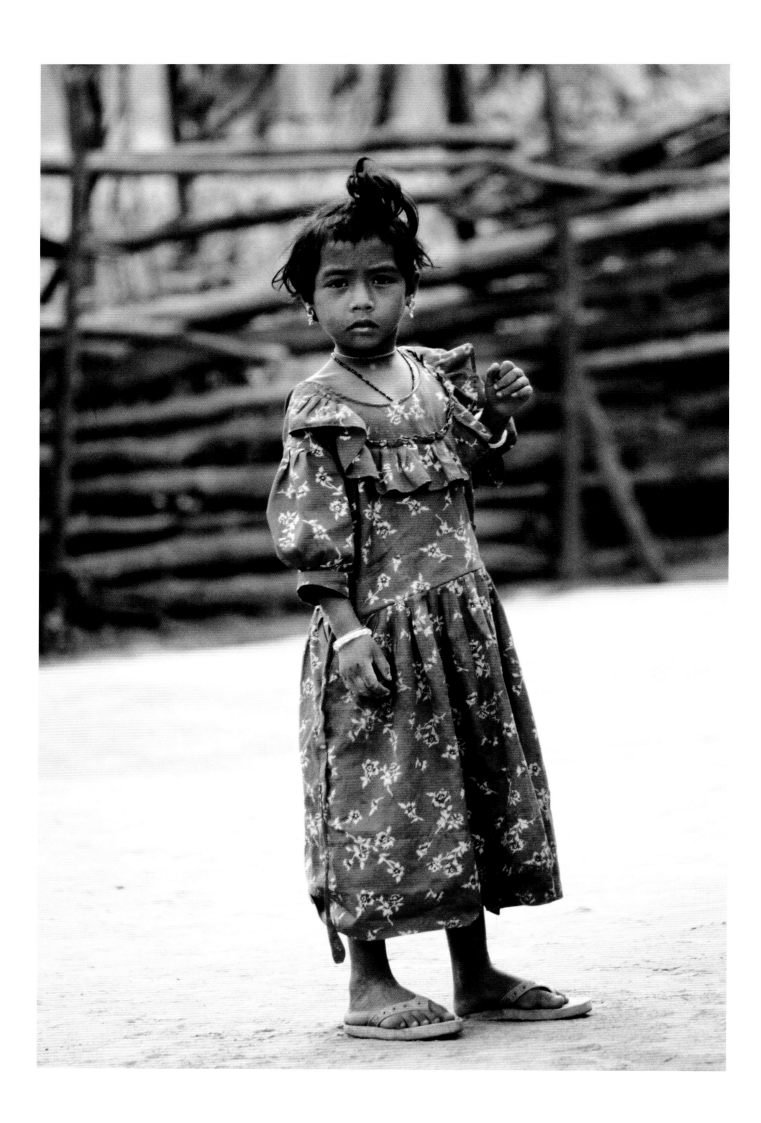

*"We, the rustling leaves, have a
voice that answers the storms,
but who are you so silent?"
"I am a mere flower."*

"Some unseen fingers,
like idle breeze are playing upon
my heart the music of the ripples."

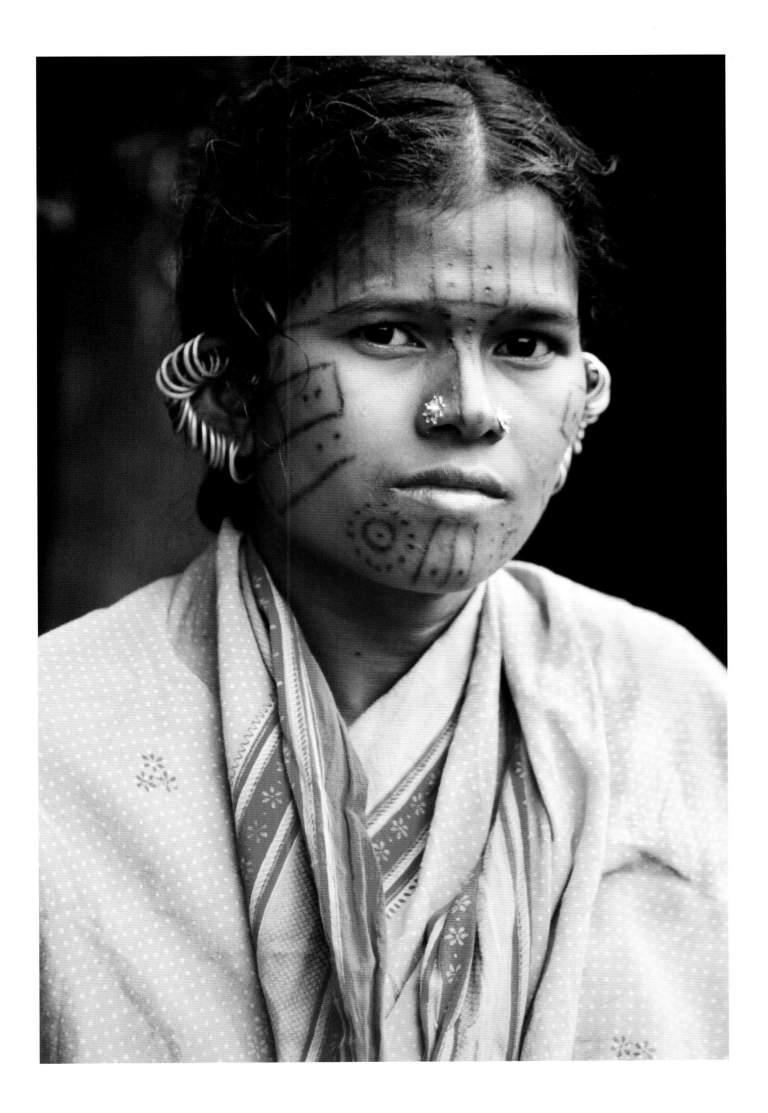

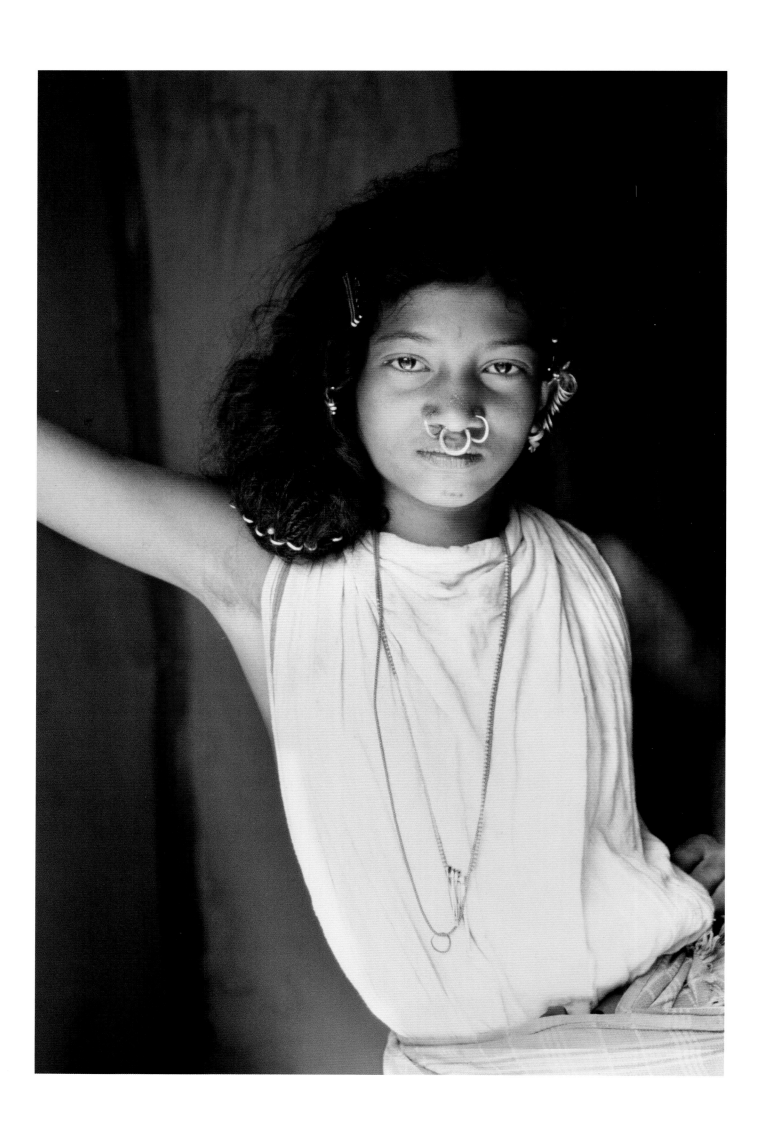

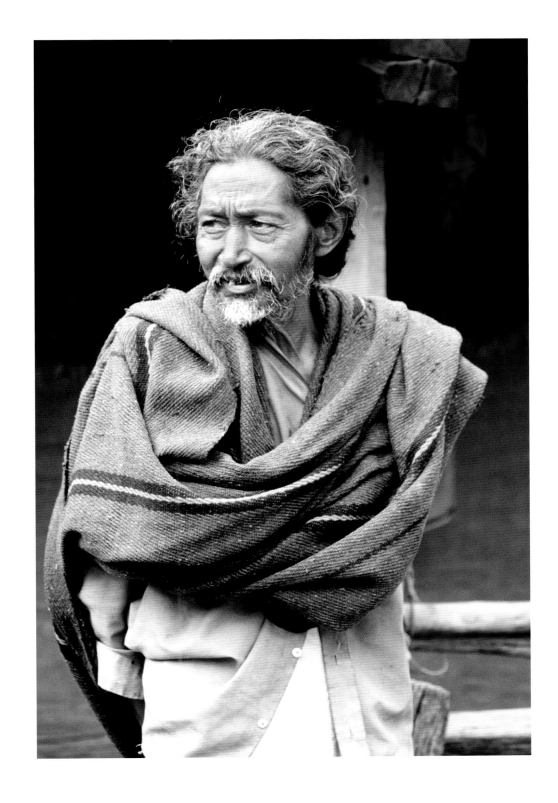

Pages 57–63: People of the Paroja, Gadaba, and Kondh tribes in the Koraput District of Orissa.

"If you shed tears when you miss the sun, you also miss the stars."

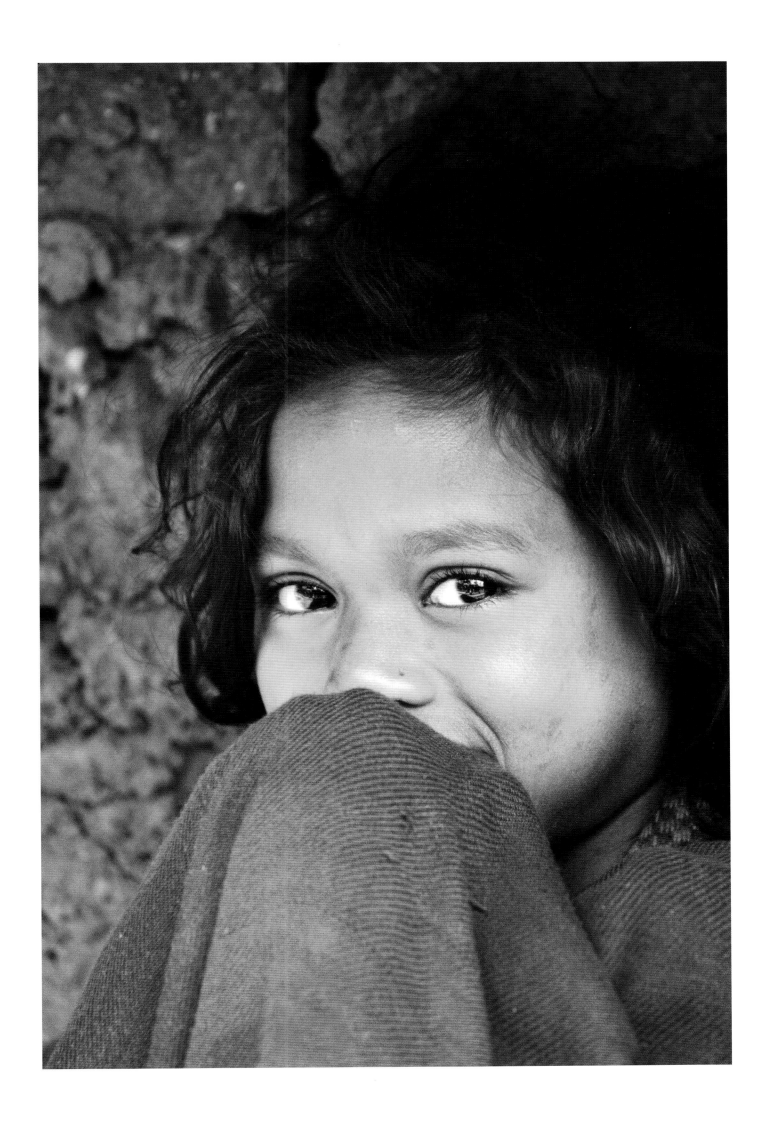

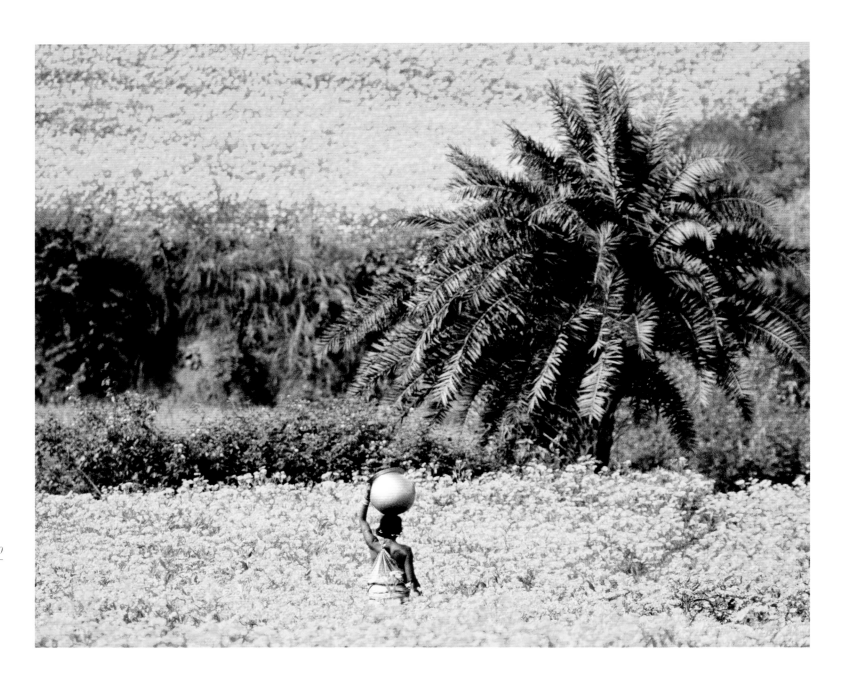

With elegance and swaying grace, women walk to the water source each morning
with *gagars*, metal jars to hold the water, on their head.

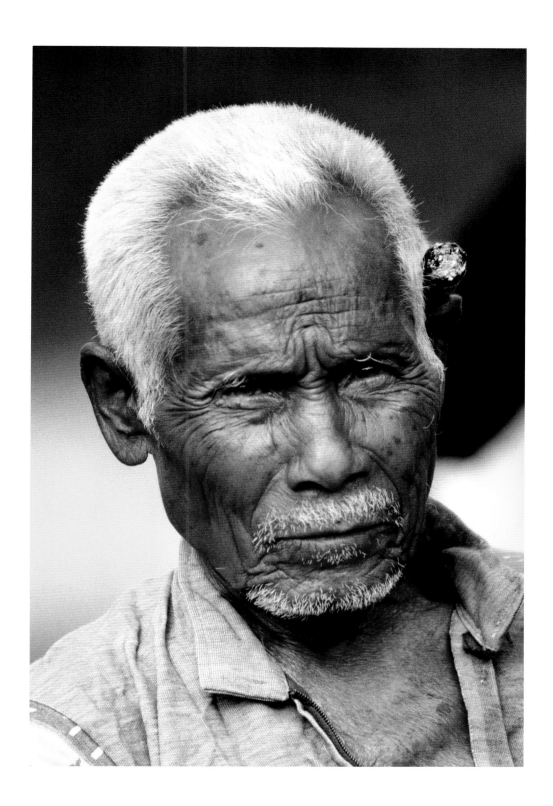

An elderly man with a self-rolled cigar behind his ear, holds the
hand of his tiny granddaughter while looking me in the eye.

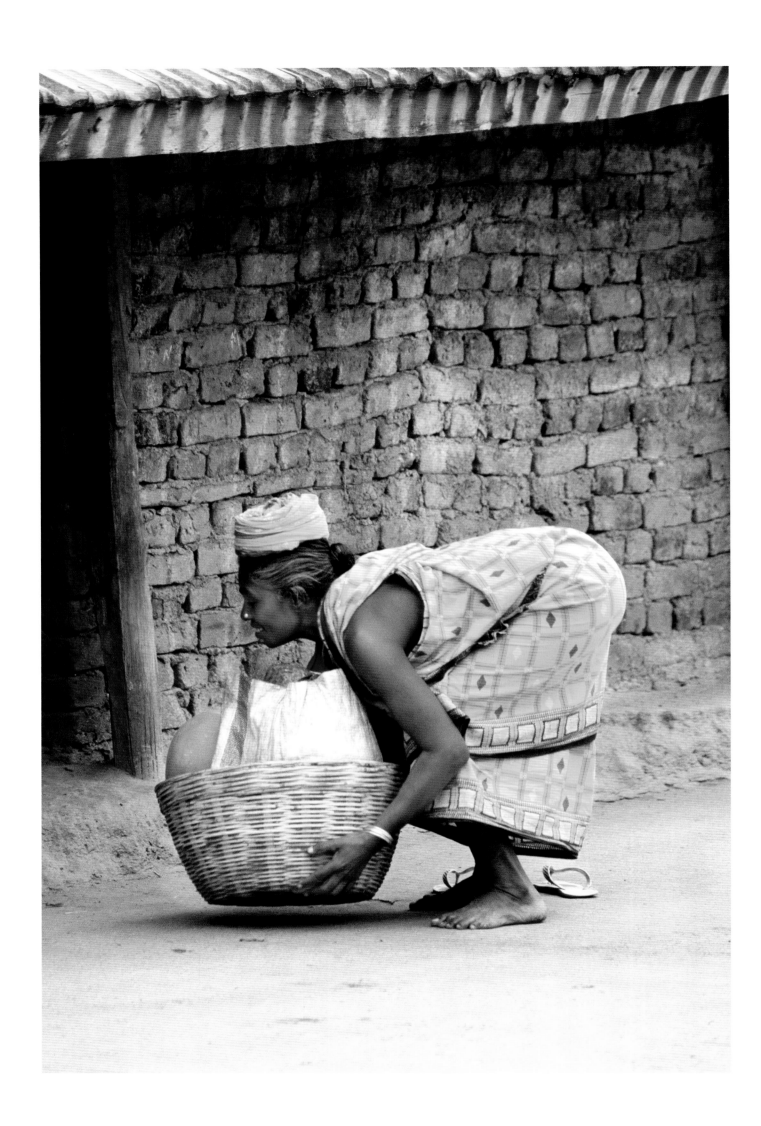

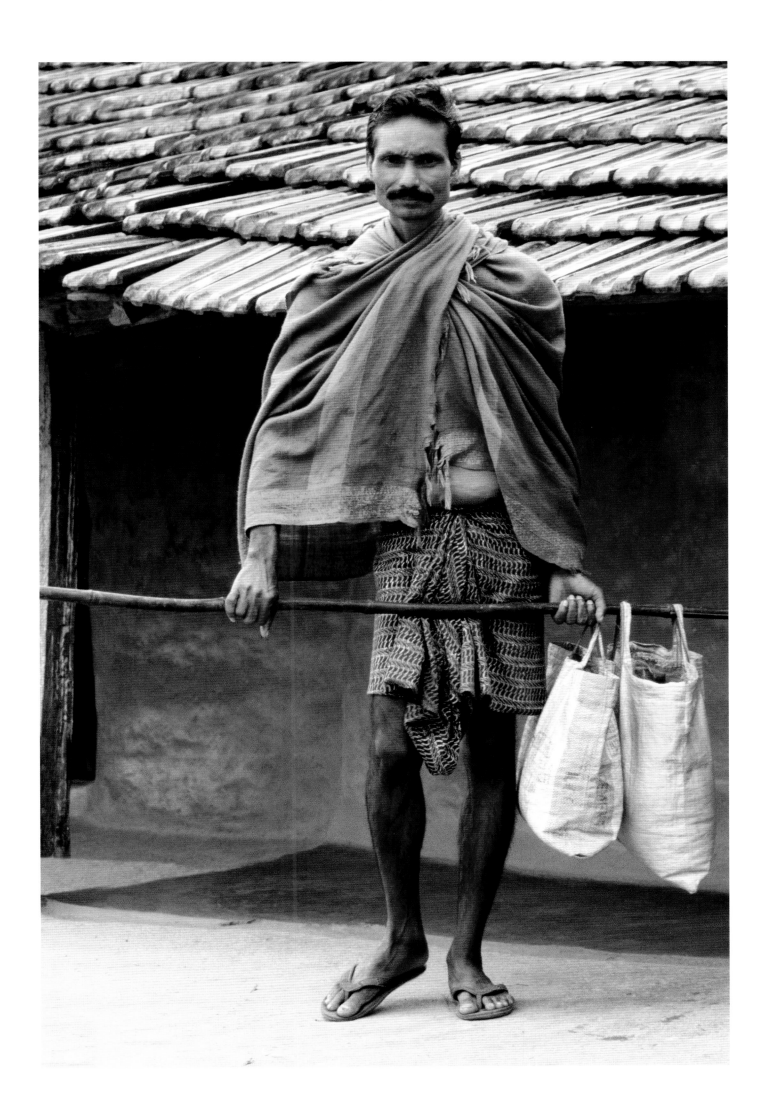

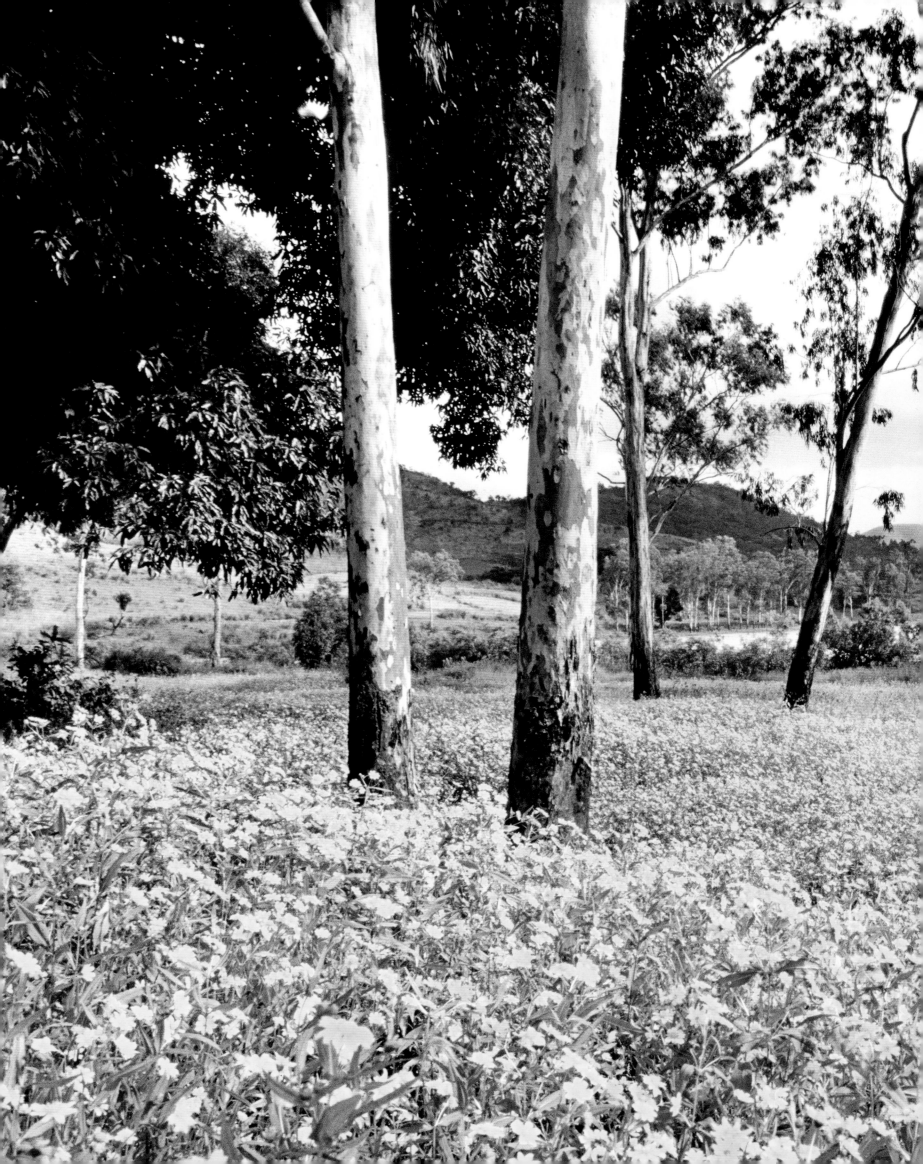

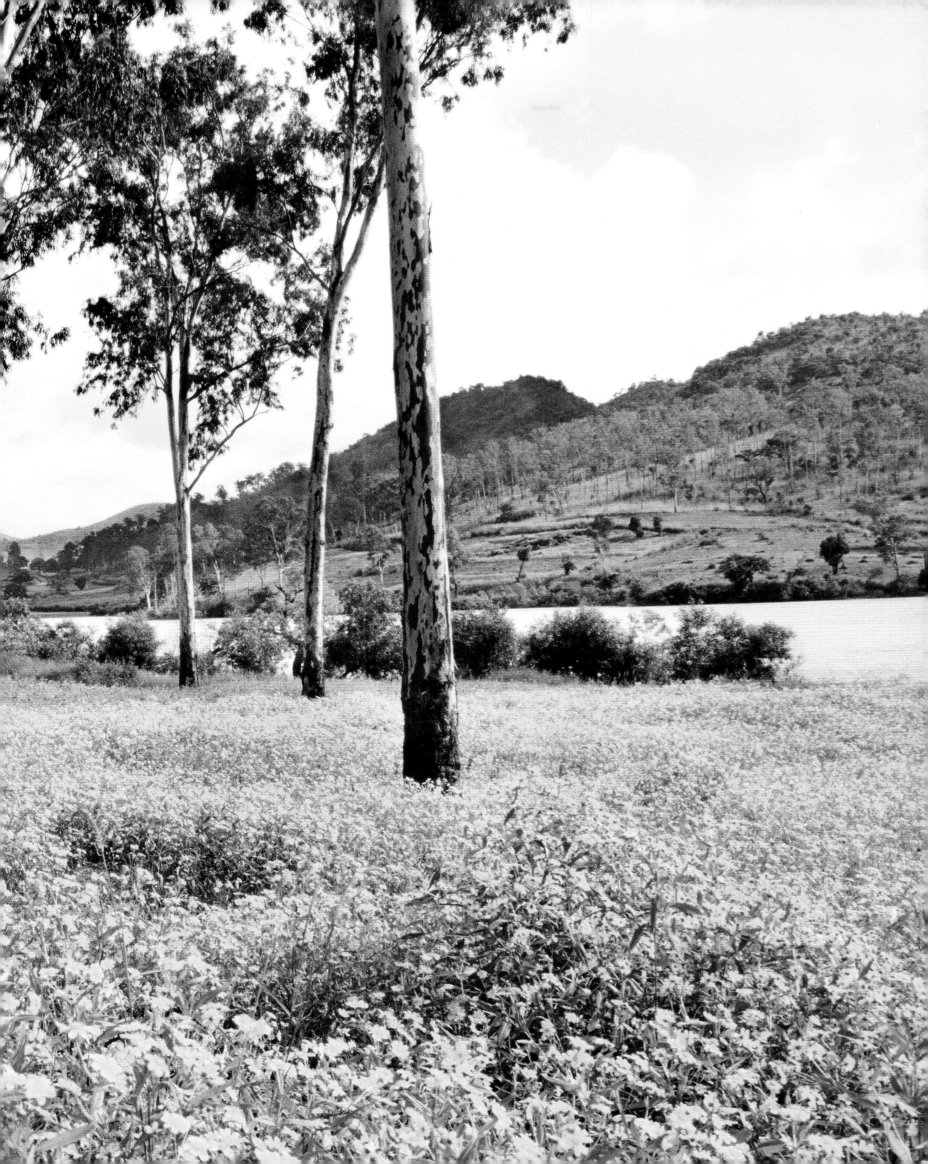

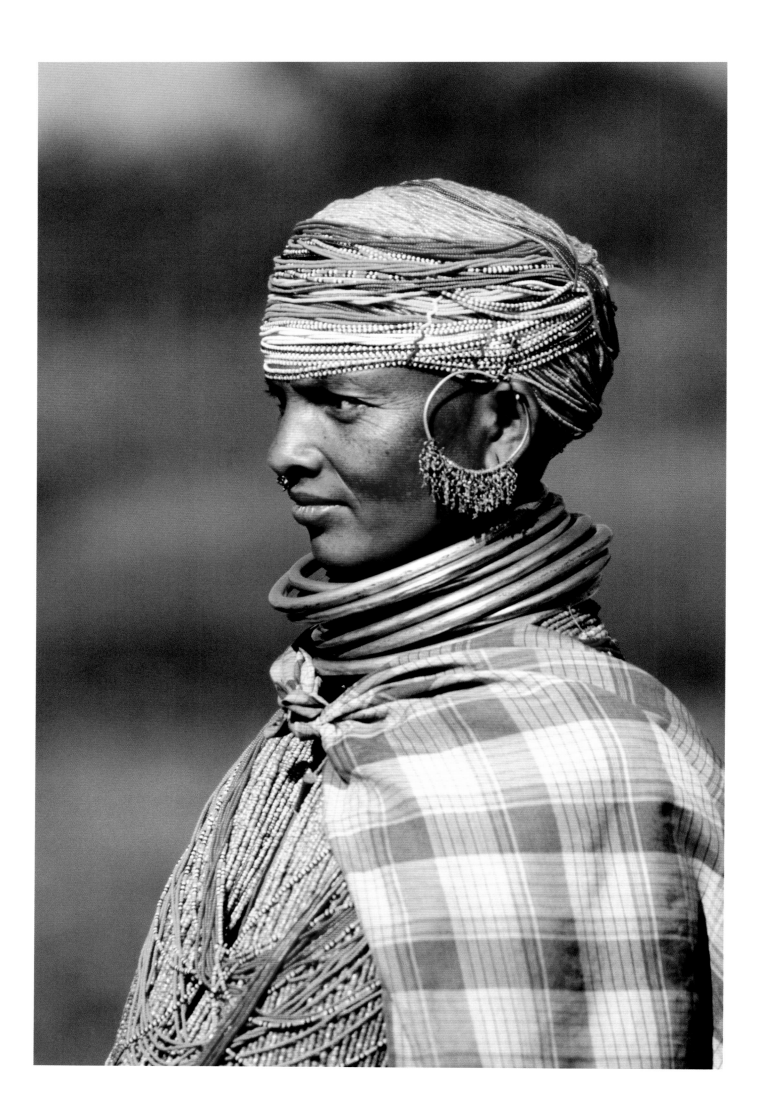

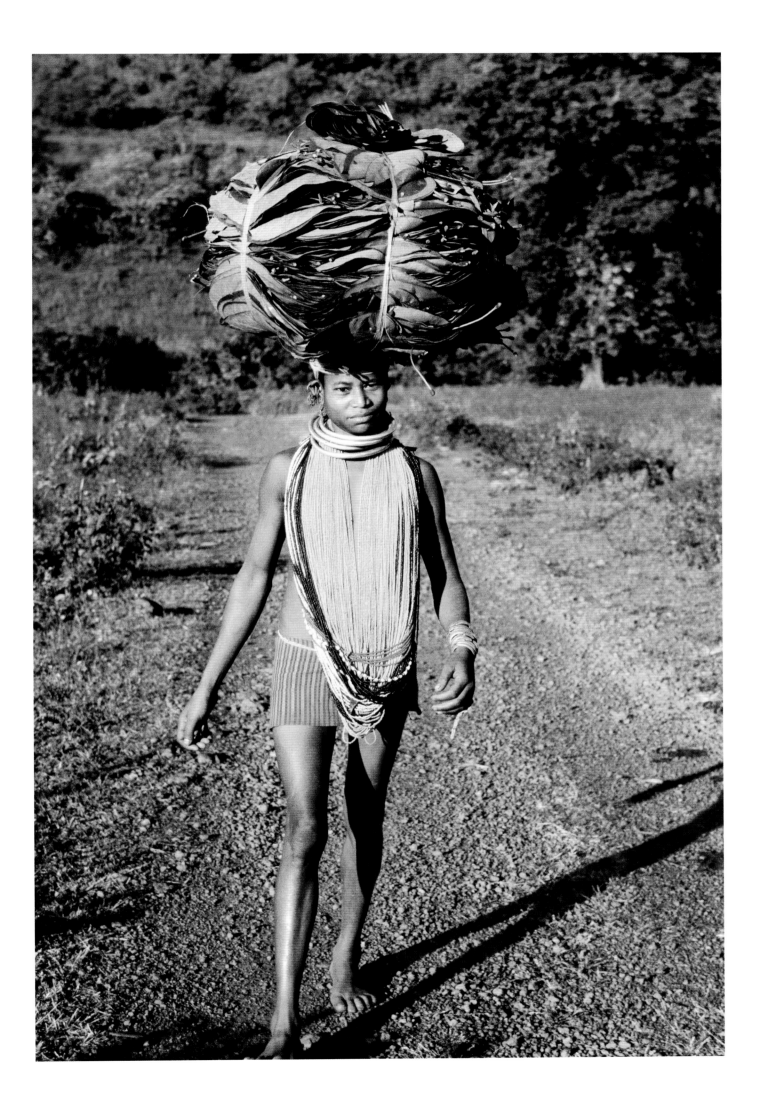

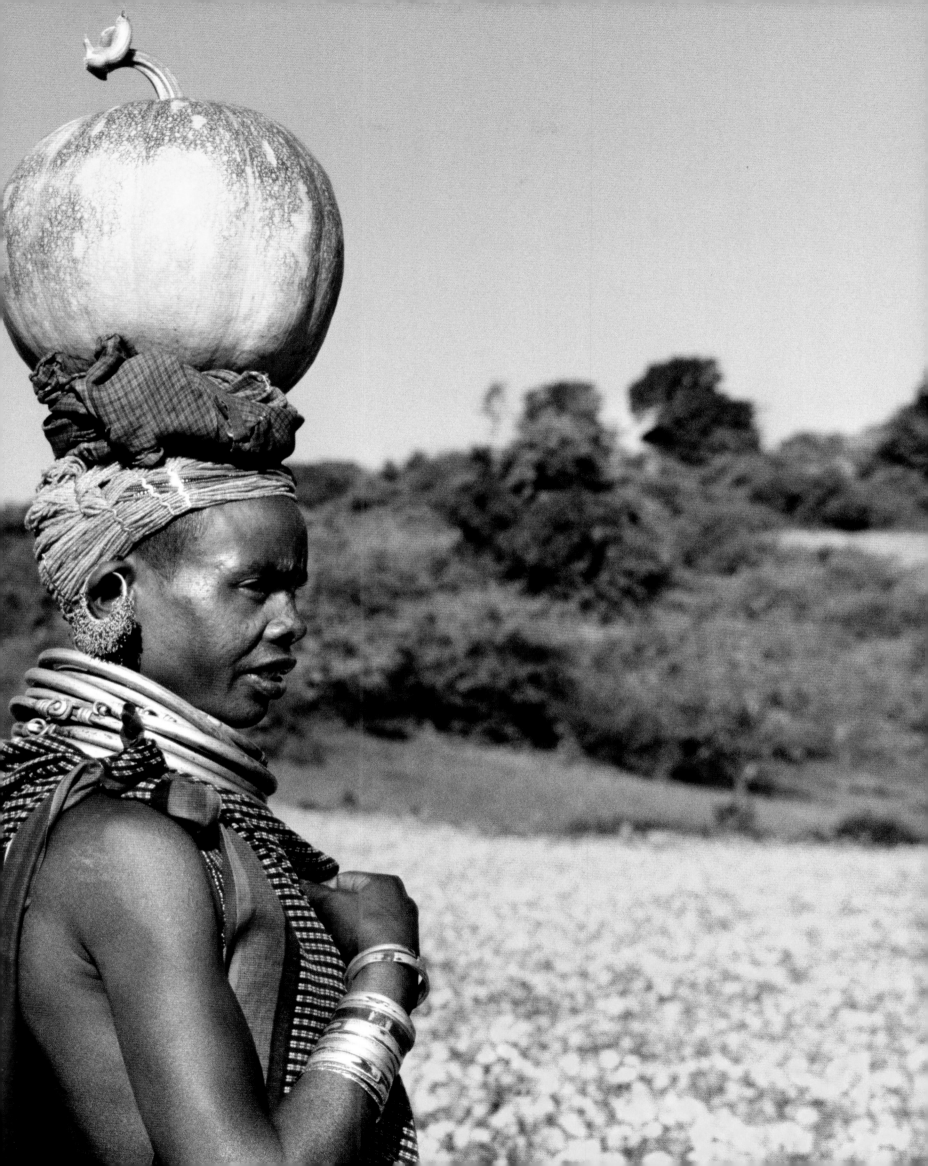

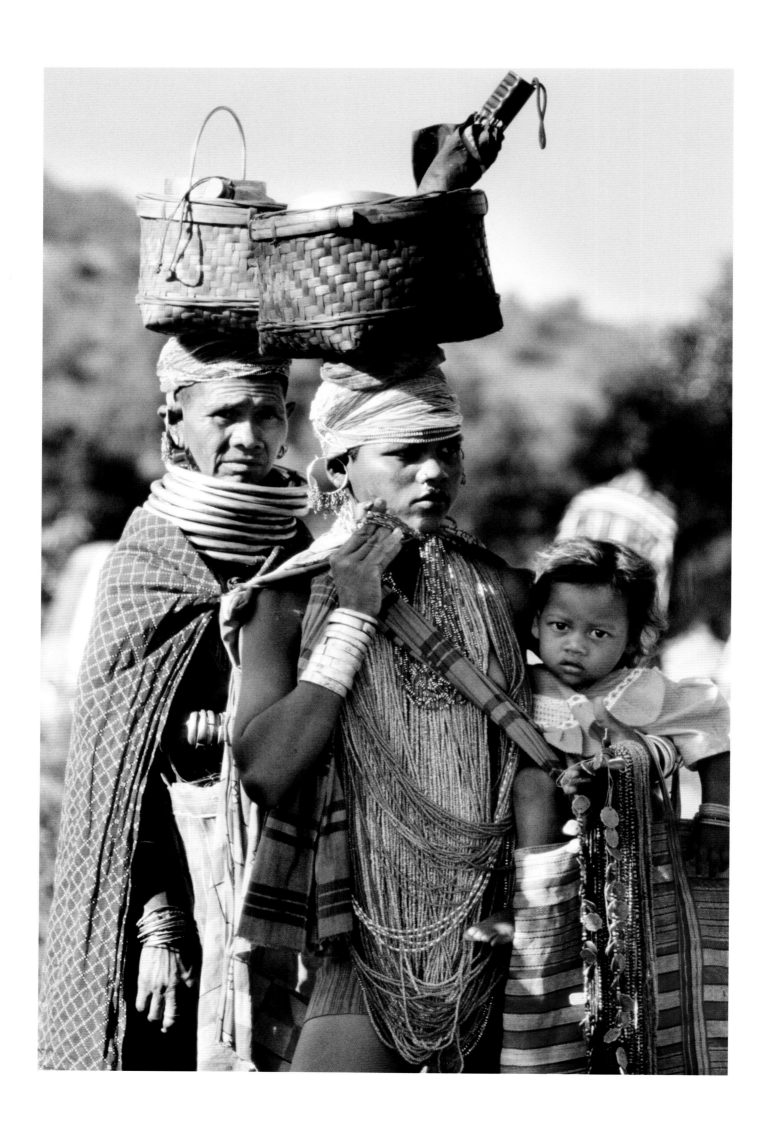

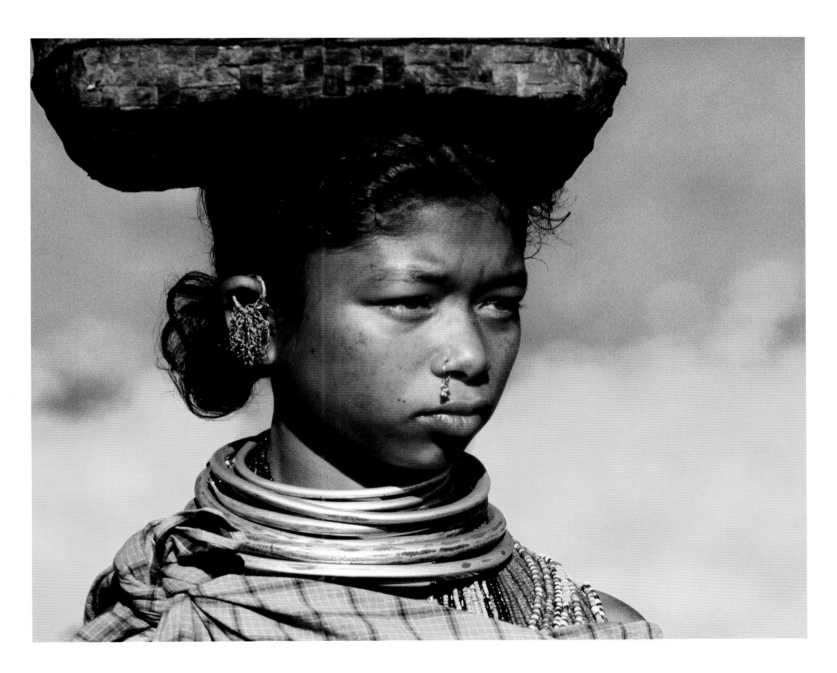

Pages 68–73: Images of women from the Bonda tribe, Orissa, on their way to the weekly tribal market.

Page 68: A woman displaying the colorful beaded cap, hollow silver necklaces,
large hoop earrings and multiple strands of beads typical of her tribe.

Page 69: A woman carrying a bundle of leaves to sell for the making of alcohol.

Left: Three generations of female Bonda.

"The roots below the earth claim no rewards for making the branches fruitful."

Pages 74–83: People buying, selling, and walking to the weekly tribal market, Orissa. They belong to the Bonda, Kondh, Paroja and Mali tribes.

Right: While the men barter, a woman nurses her baby.

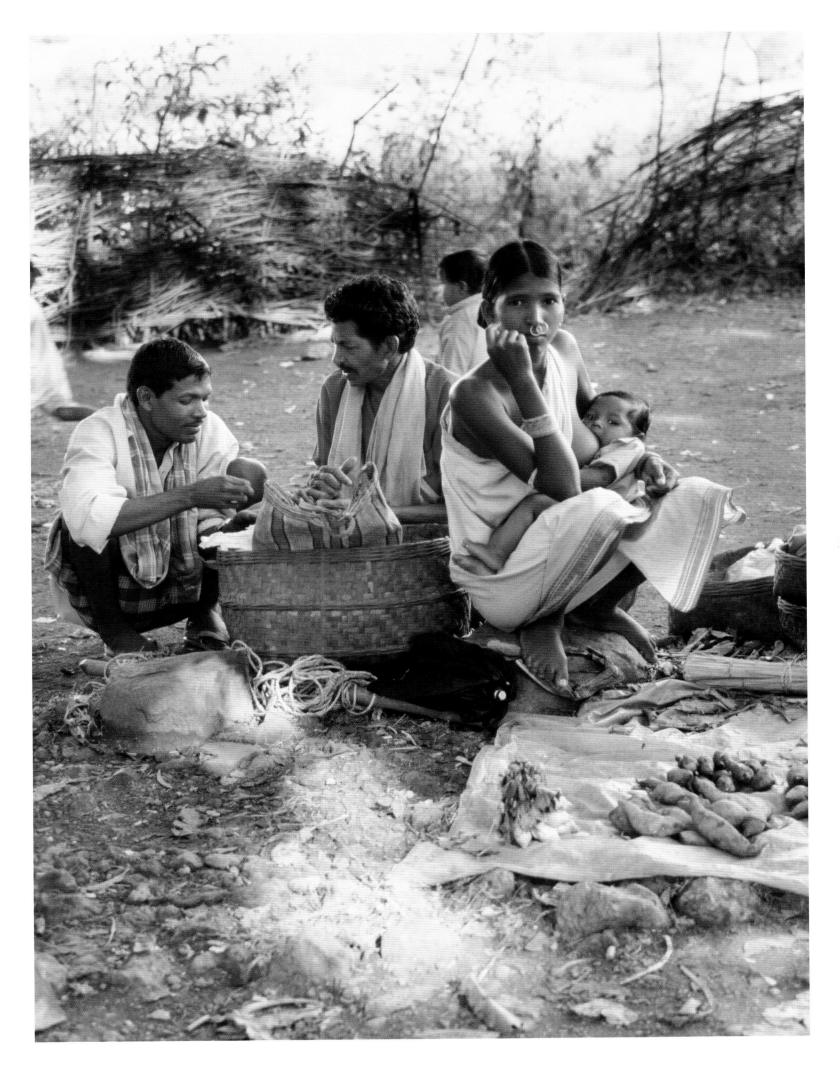

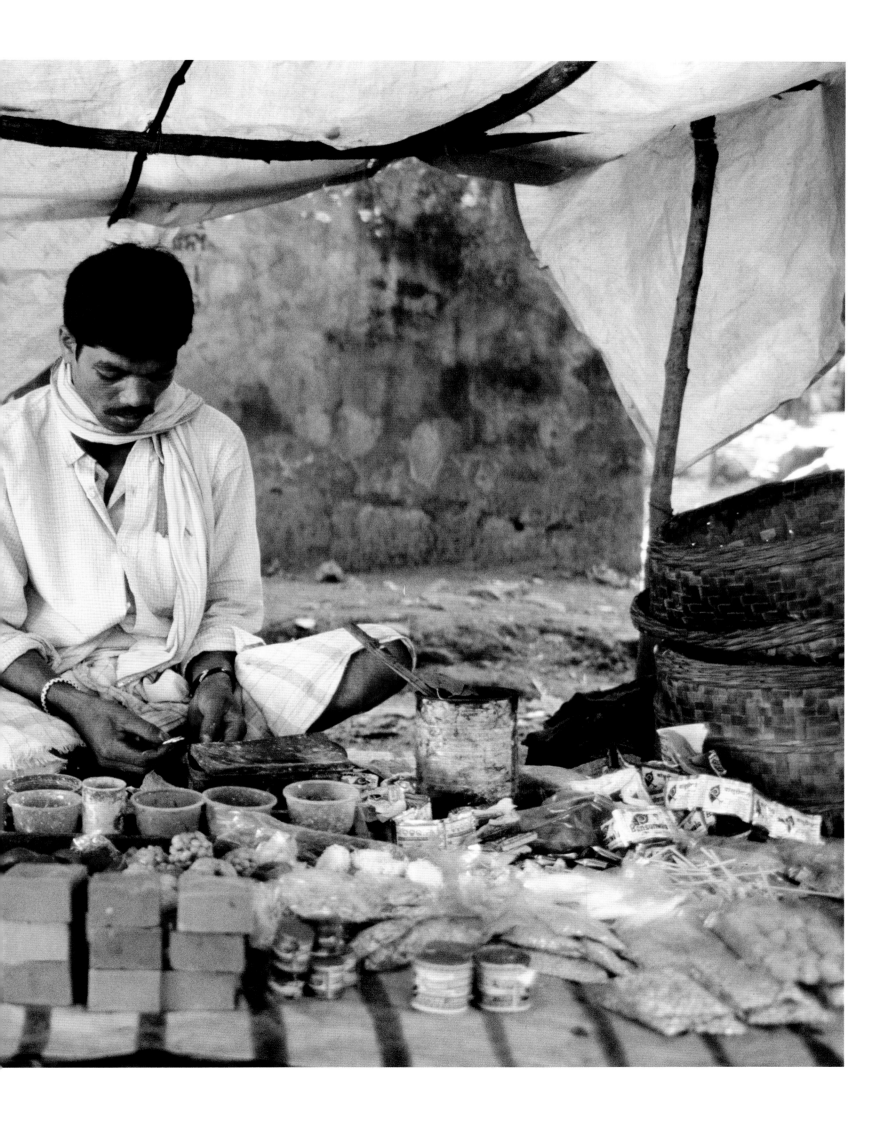

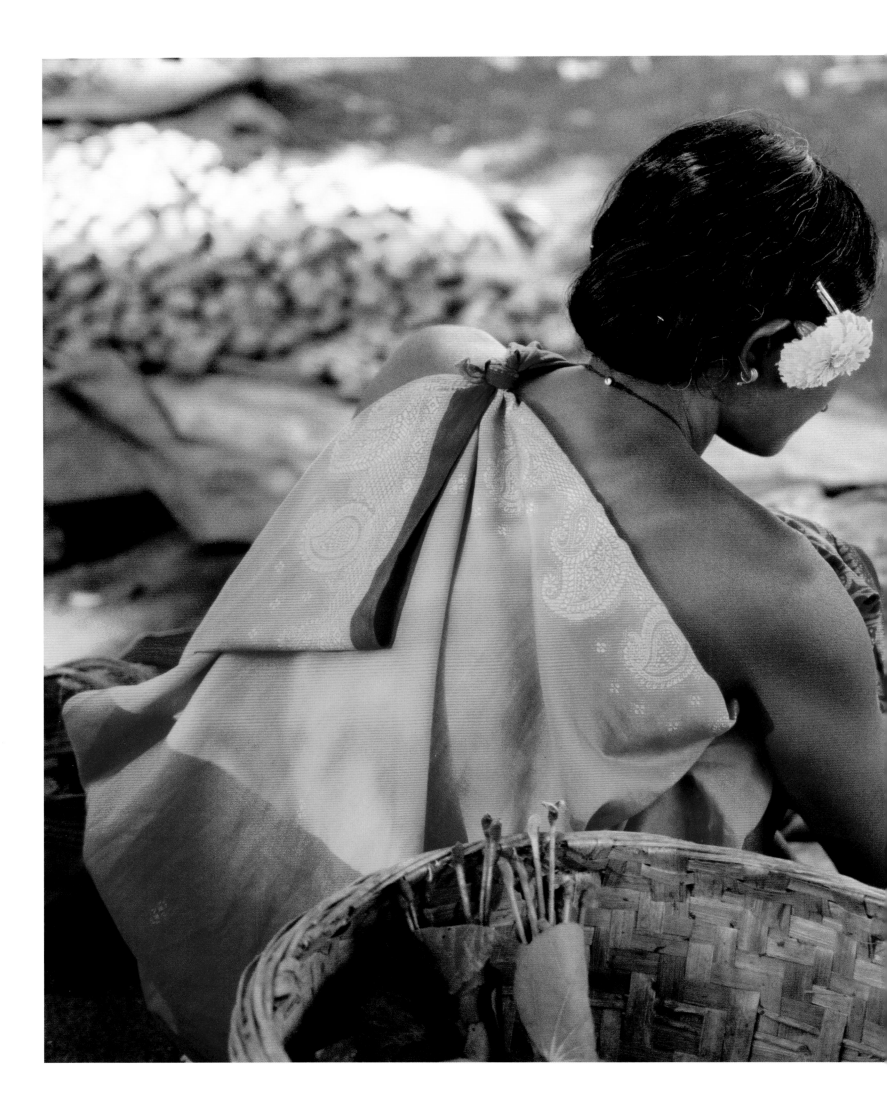

"Thoughts pass in my mind
like flocks of ducks in the sky.
I hear the voice of their wings."

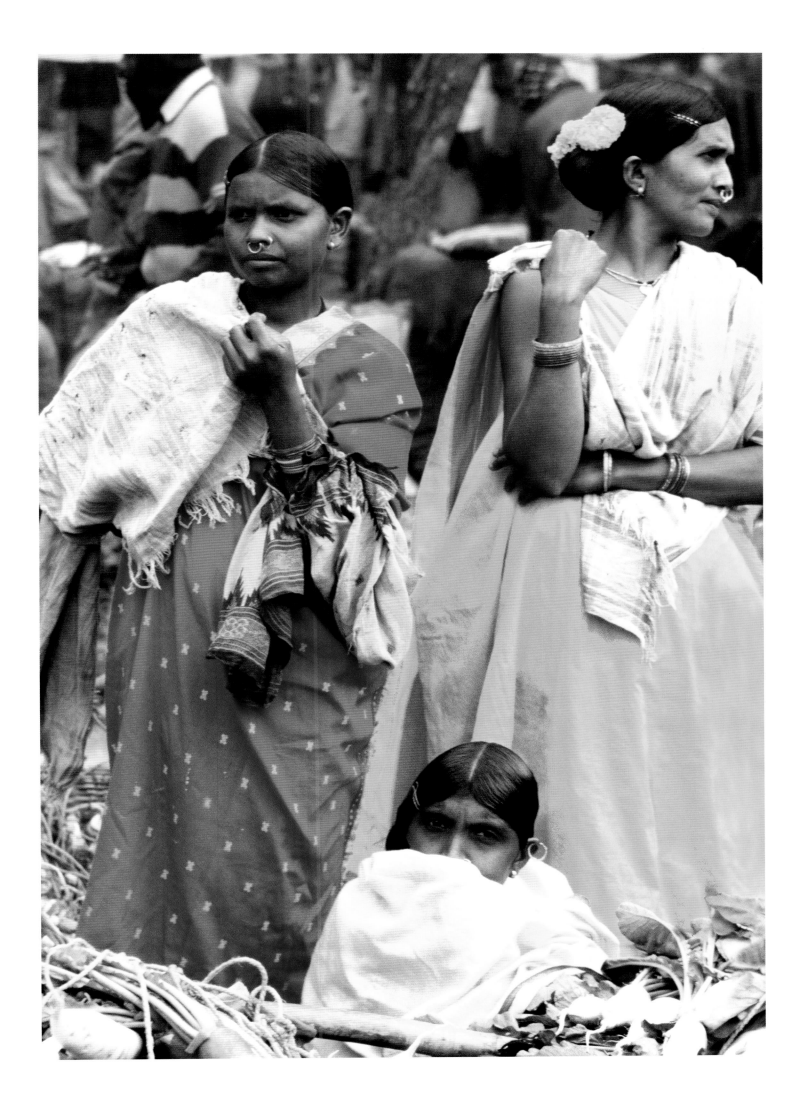

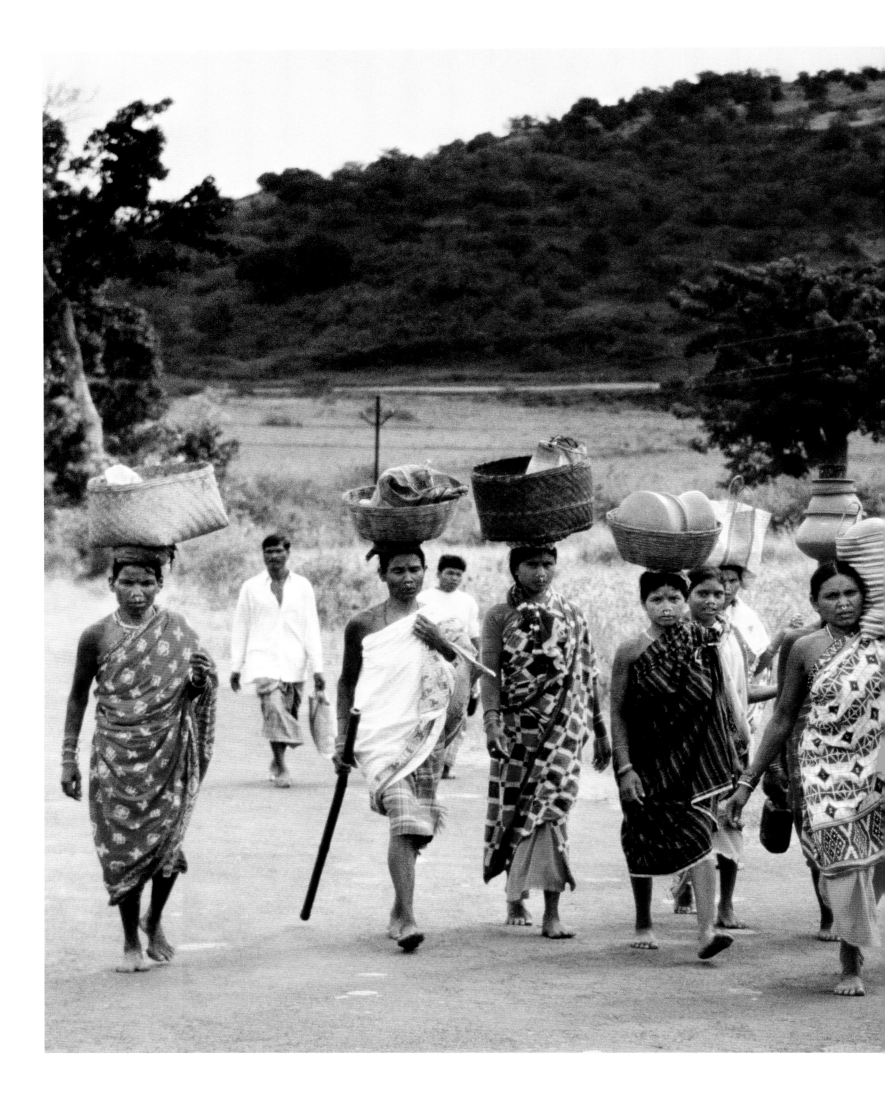

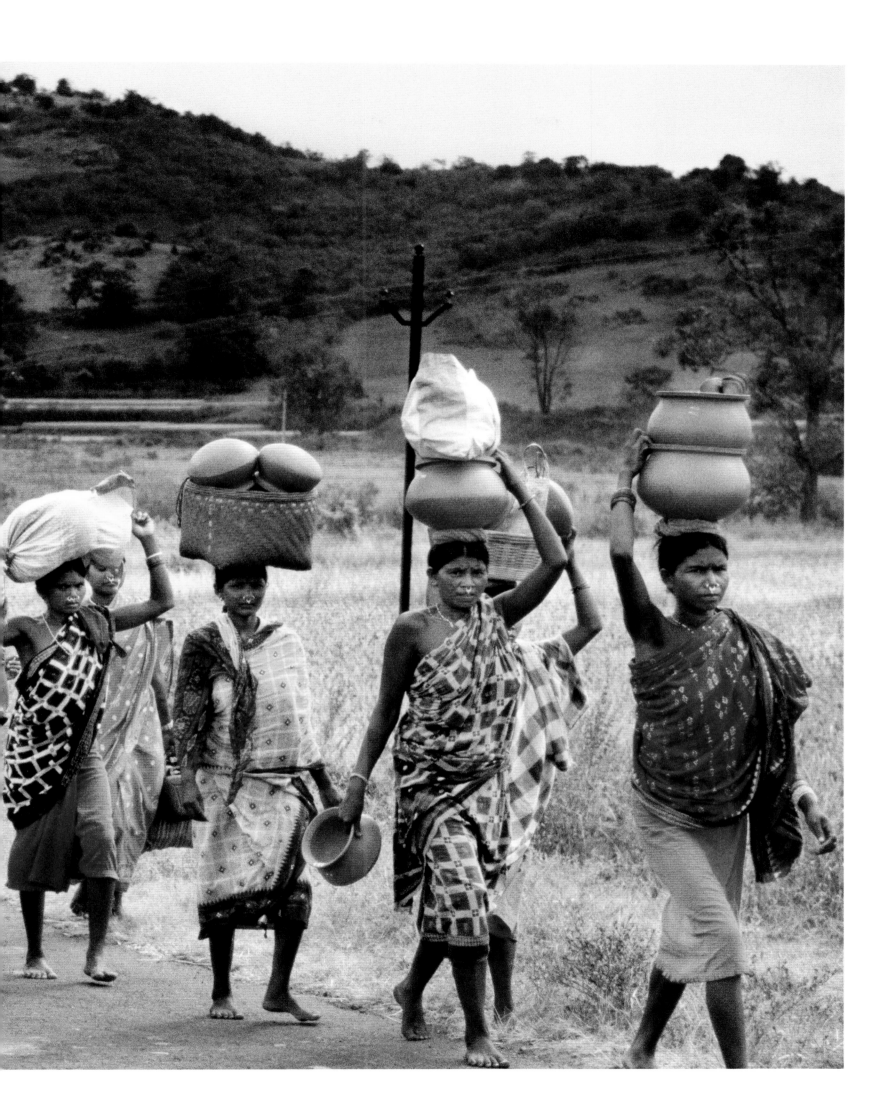

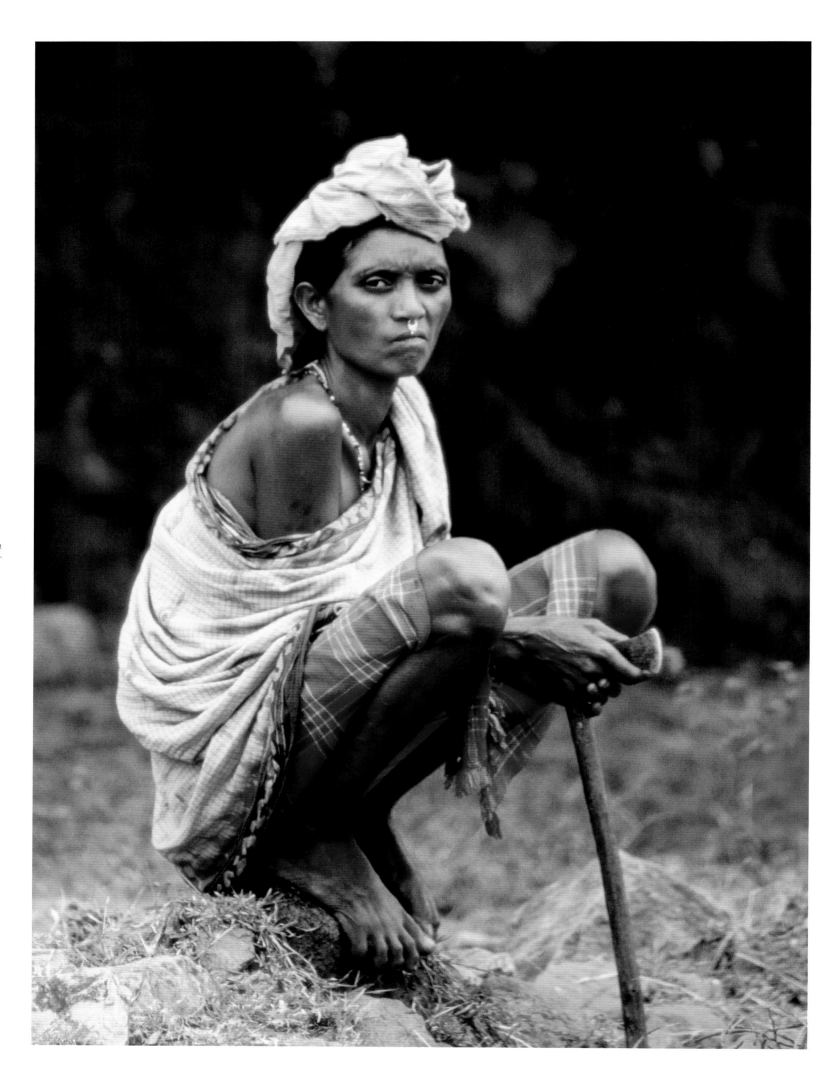

"*The bird wishes it were a cloud.*

The cloud wishes it were a bird."

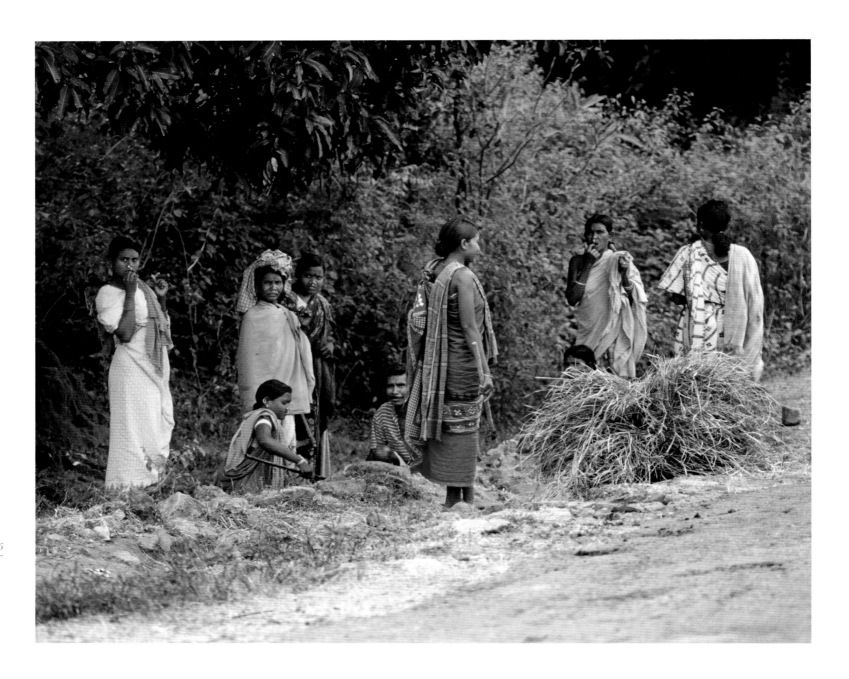

People resting at the roadside after chopping wood and harvesting hay.

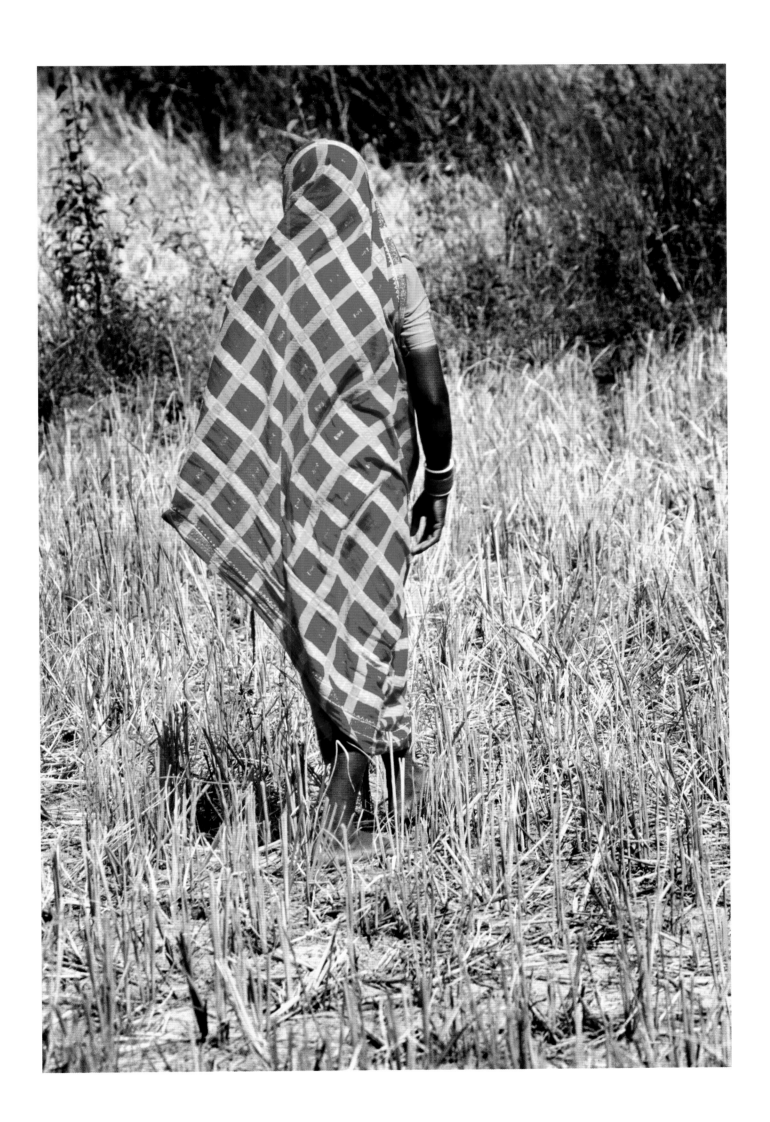

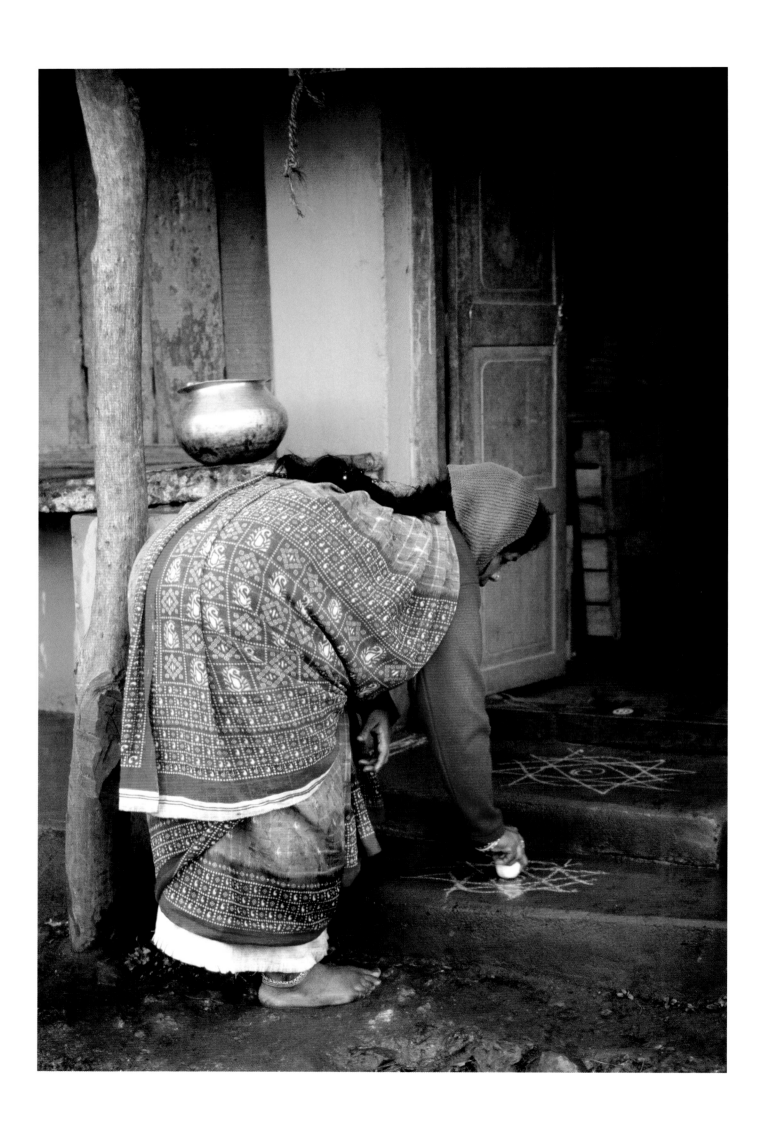

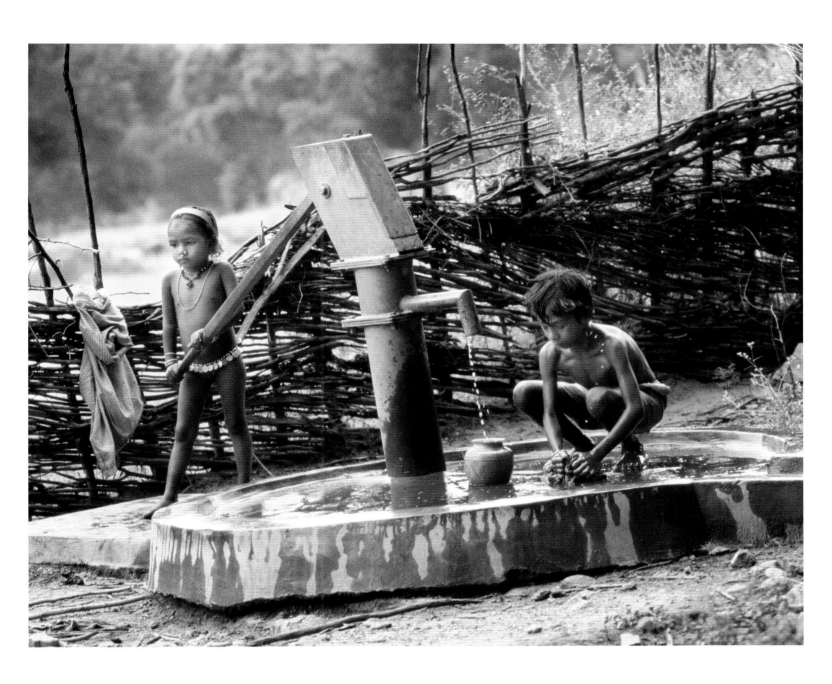

Pages 84-107: Orissa tribal areas and farmland, home to the Paroja and Gadaba and Mali peoples.

Left: Woman decorating the threshold of her home with a chitta drawing to attract the goddess Laxmi. These auspicious symbols are thought to bring health, good luck and happiness to the home.

Above: Brother and little sister at the village well.

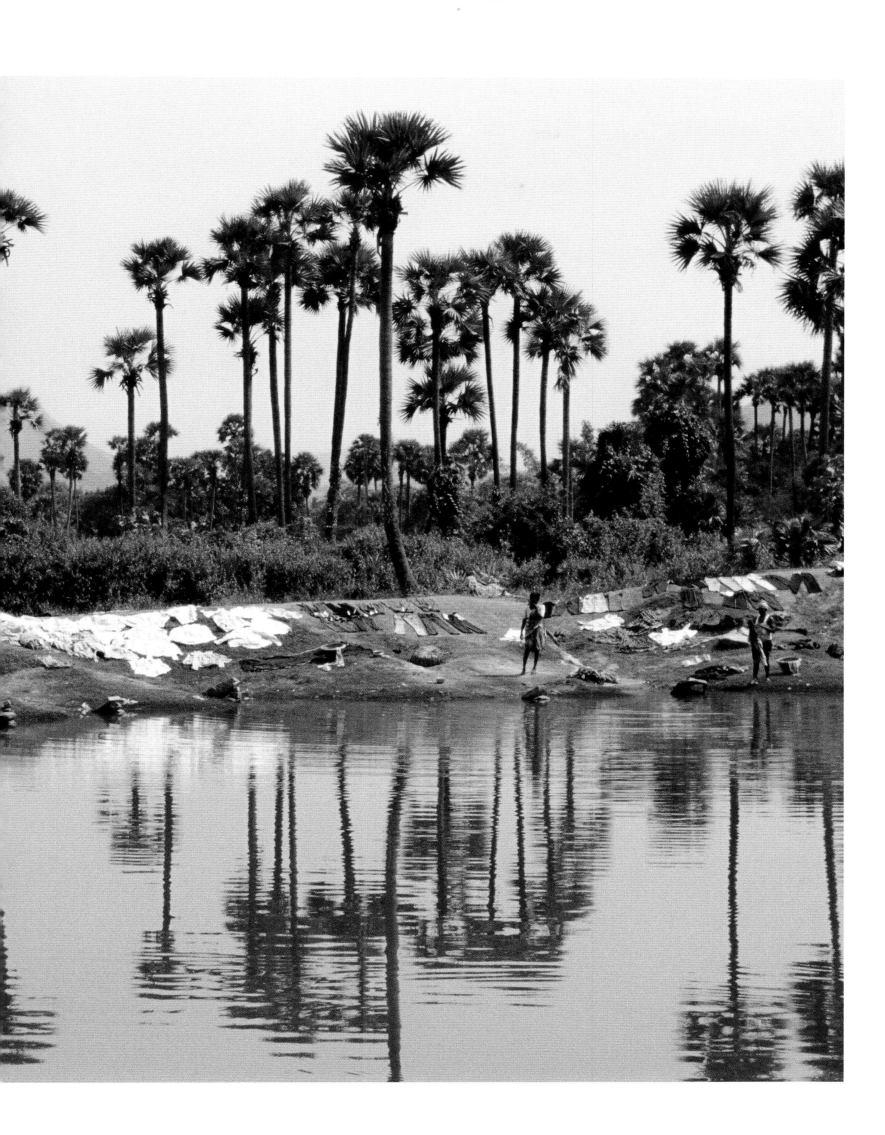

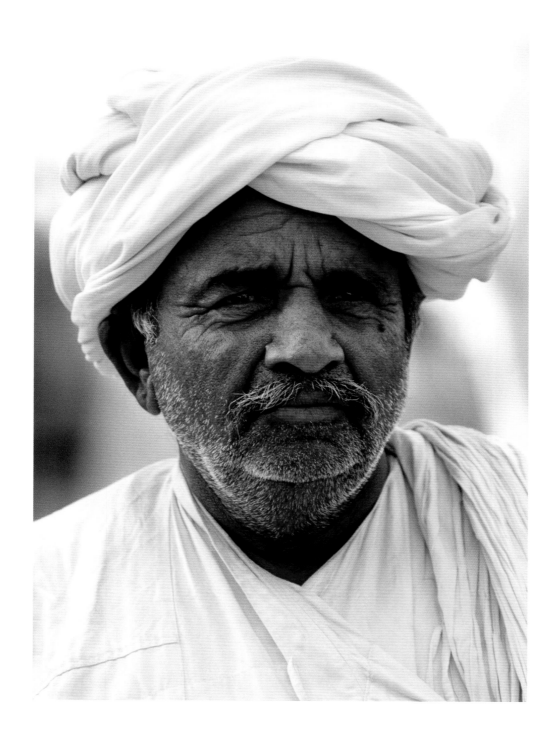

"Rest belongs to the work
as the eyelids to the eyes."

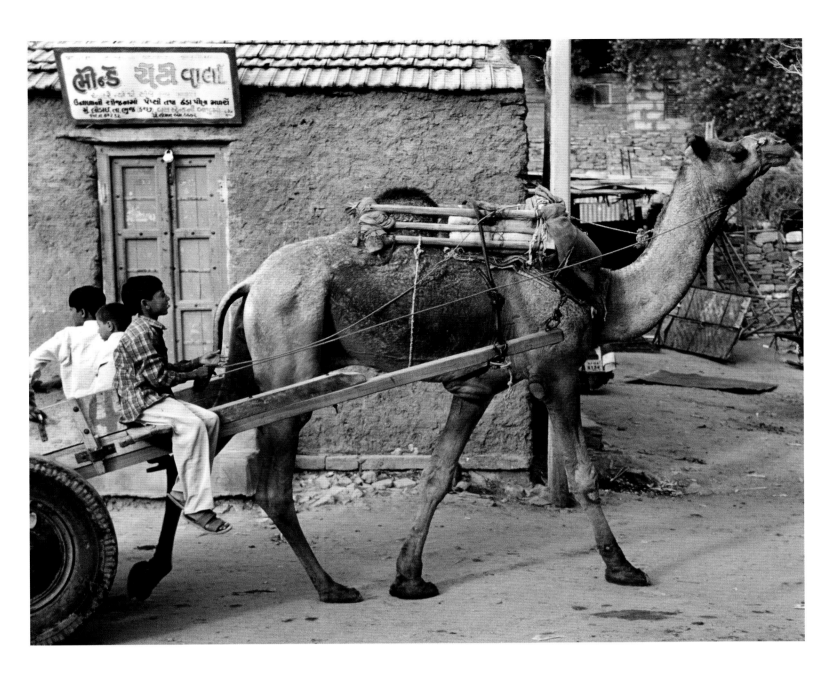

Boys being boys in a camel cart. The camel seems to like it.

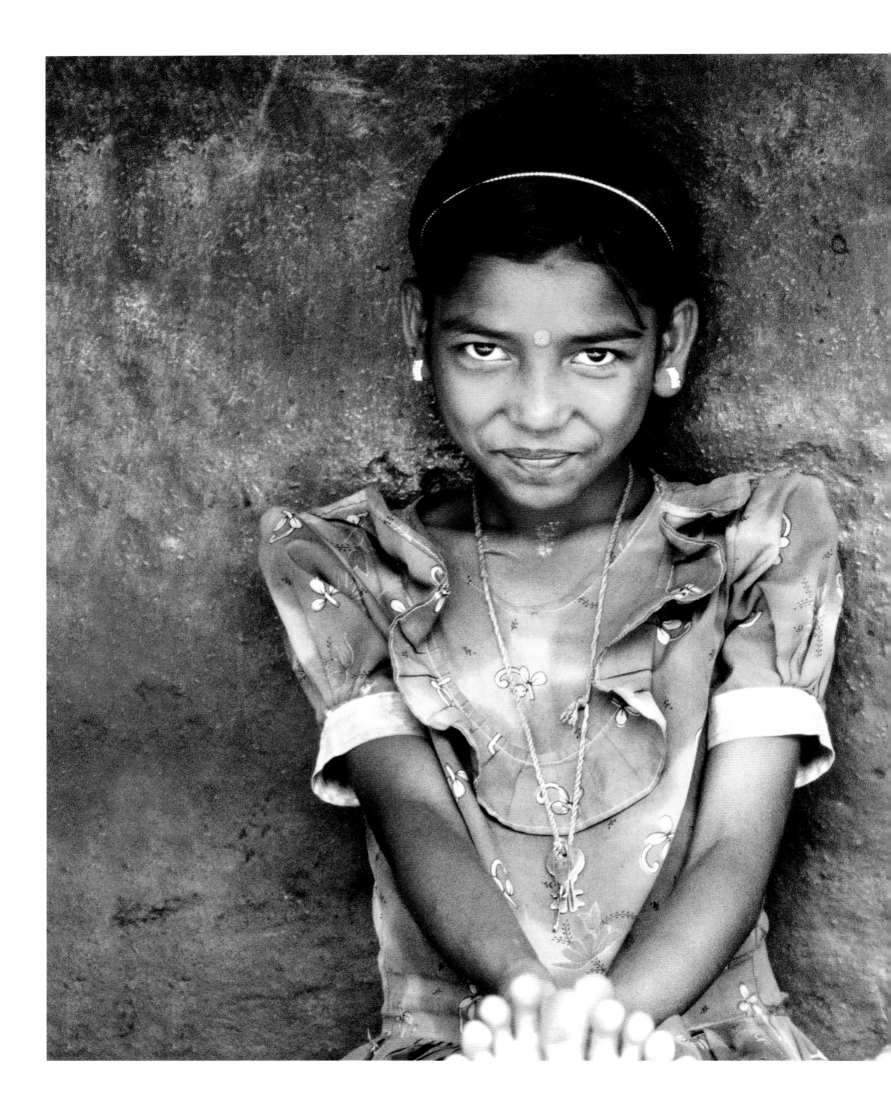

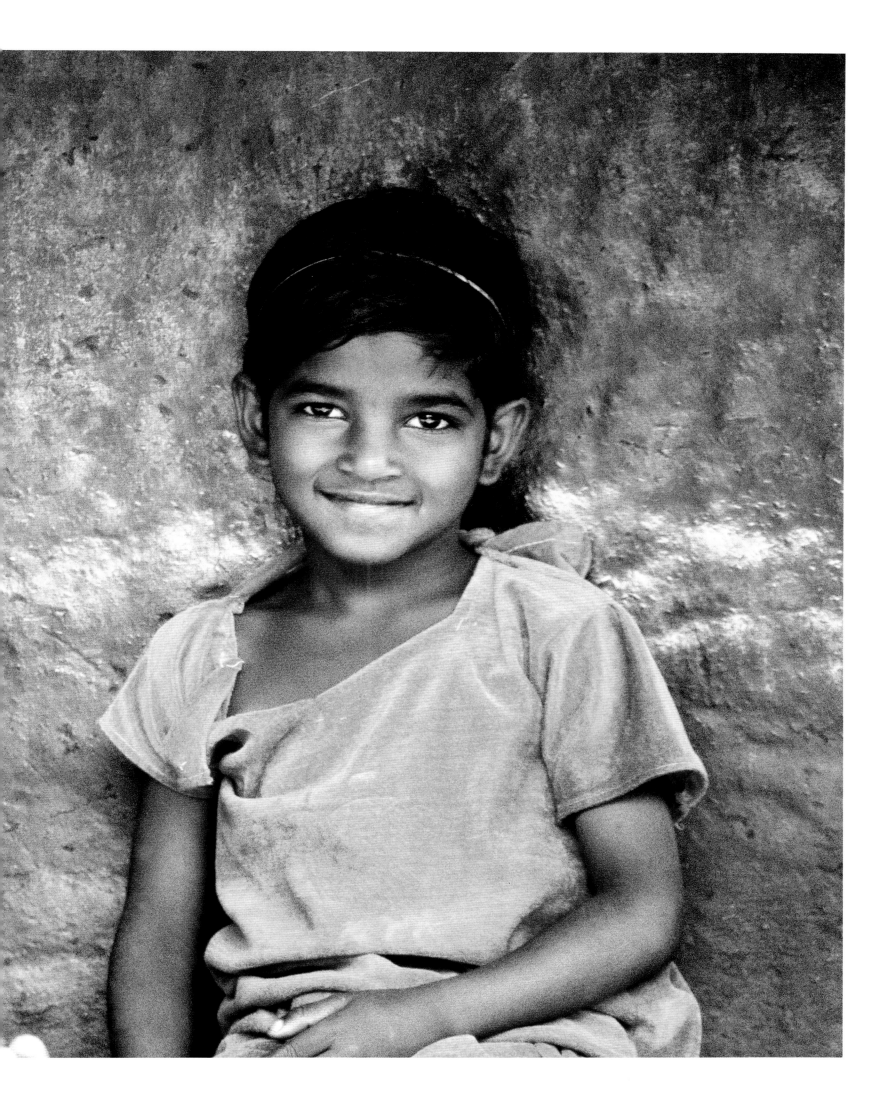

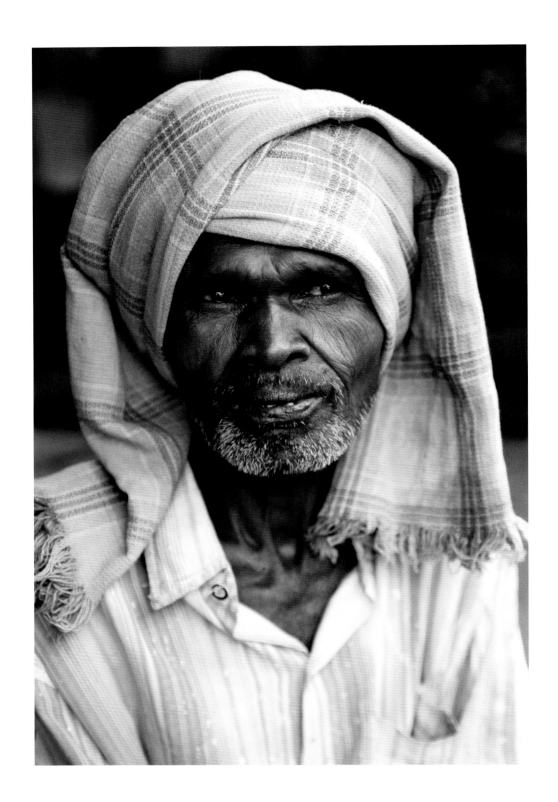

"Every child comes with the message that God is not yet discouraged of man."

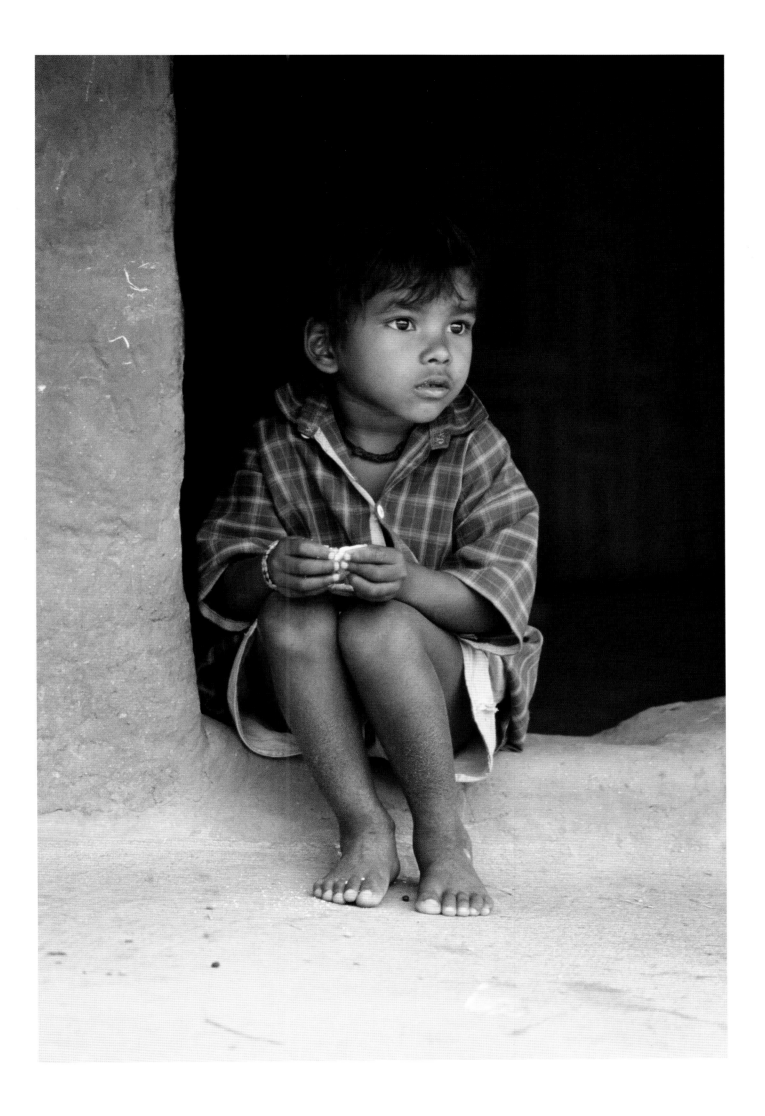

"The artist is the lover of Nature,
therefore he is her slave and her master."

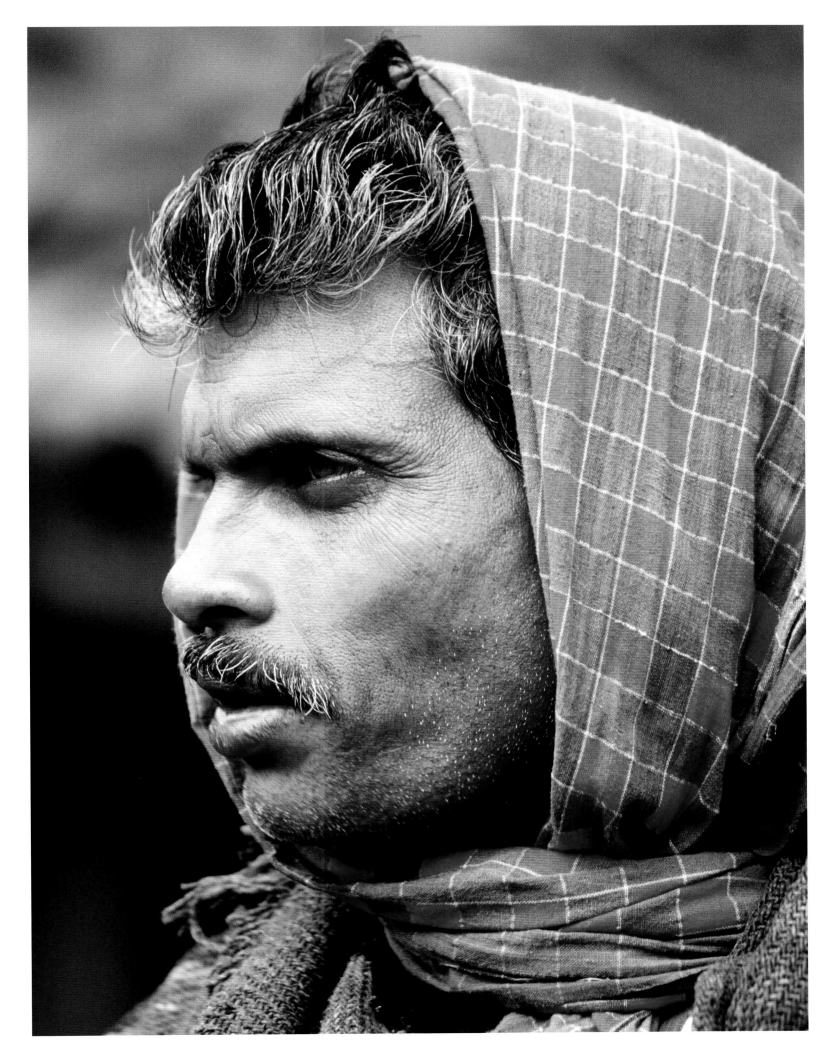

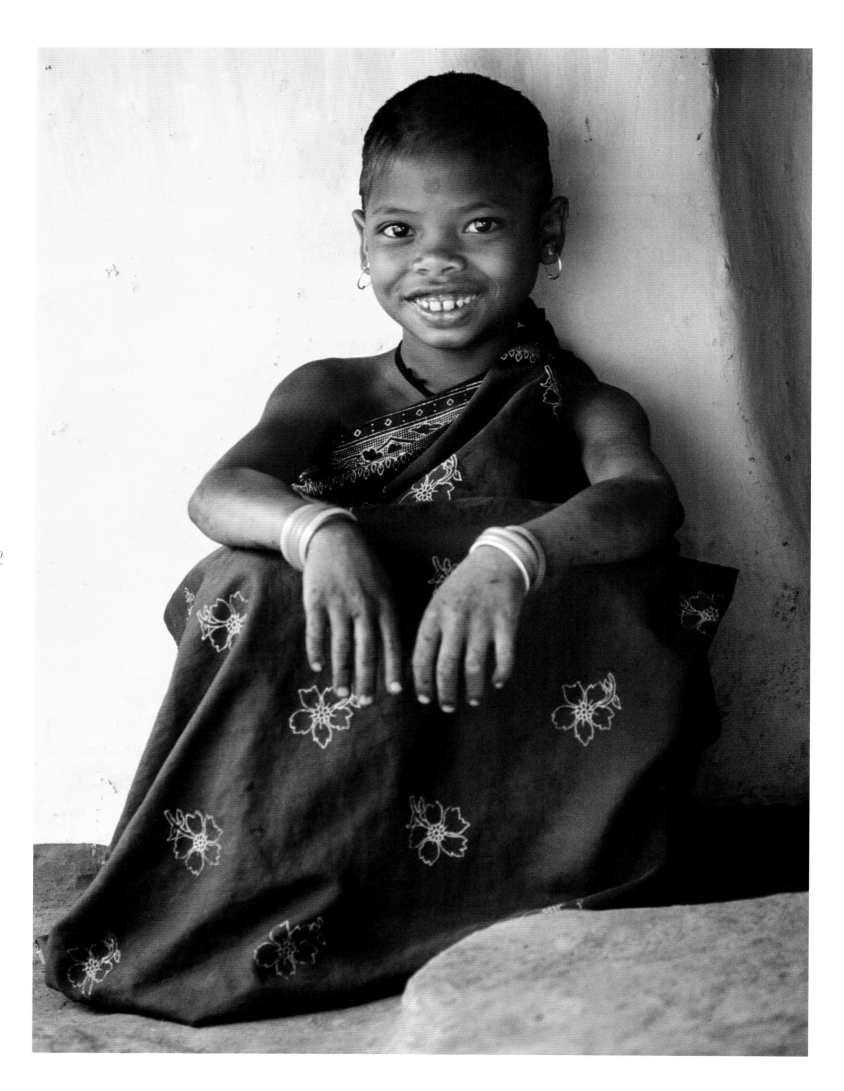

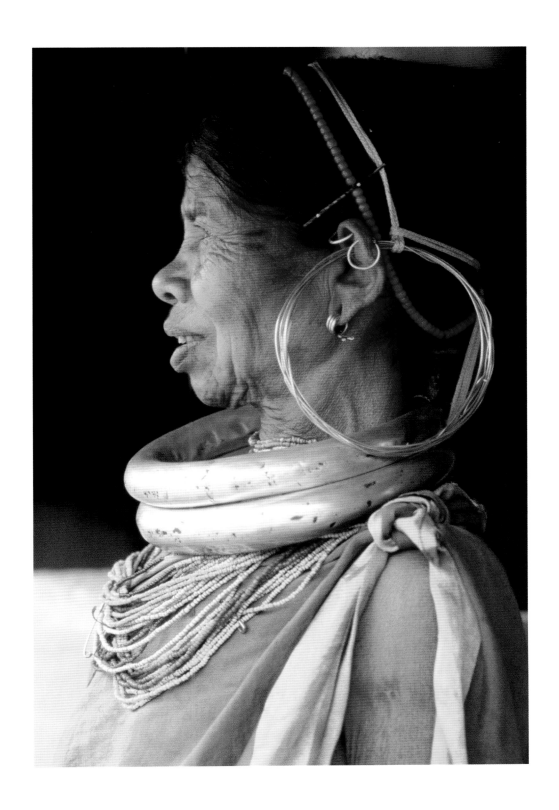

"I came to your shore as a stranger,
I lived in your house as a guest, I leave
your door as a friend, my earth."

"The day of work is done.

Hide my face in your arms,

Mother. Let me dream."

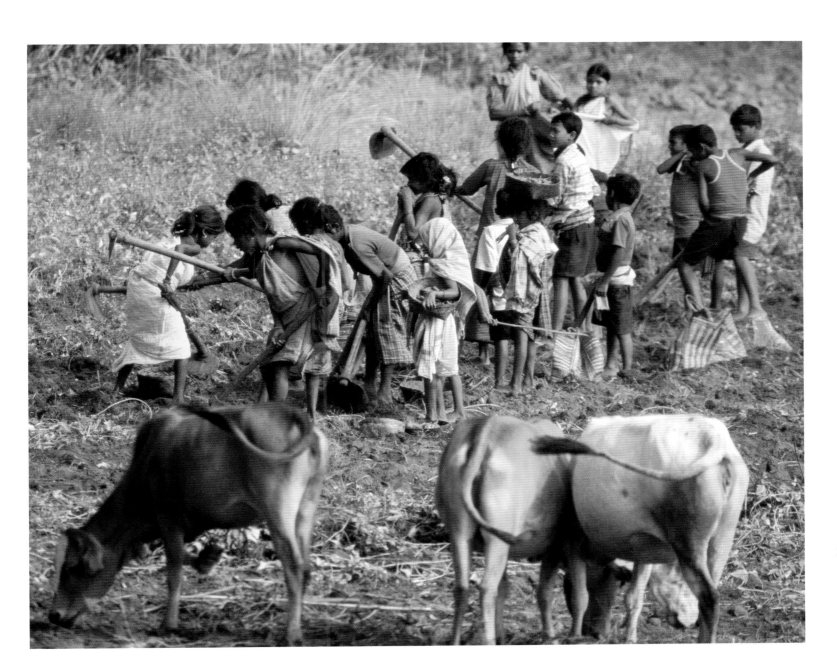

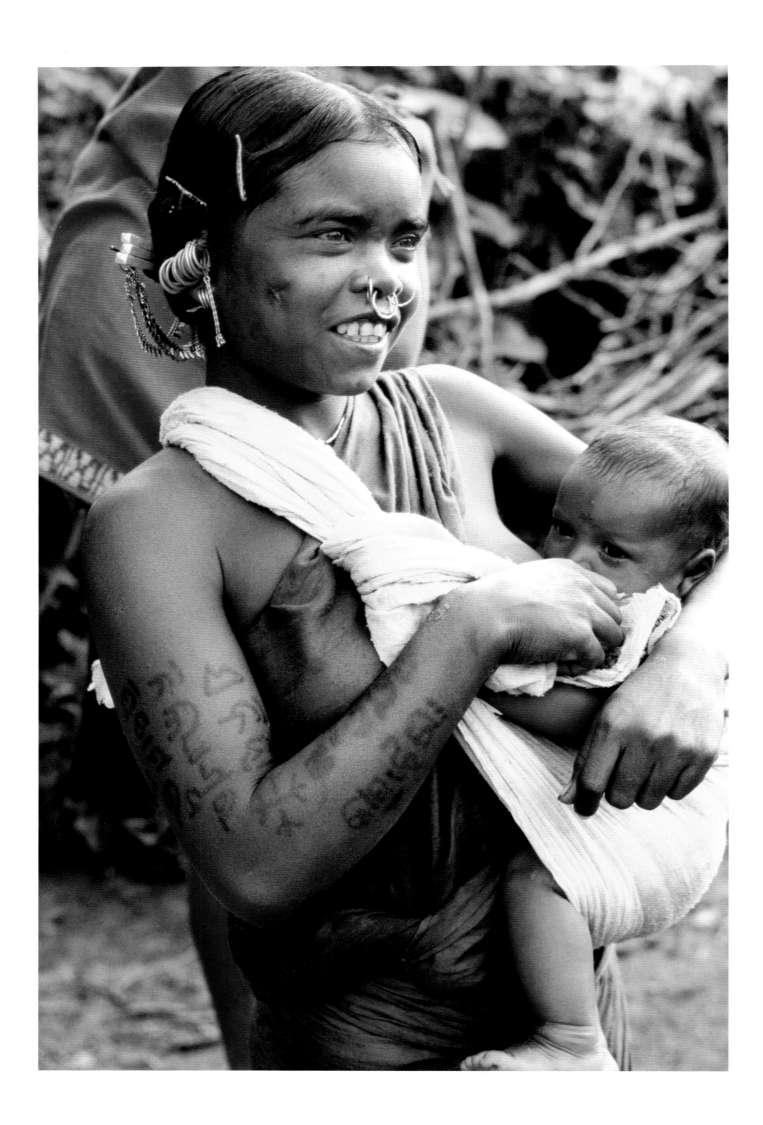

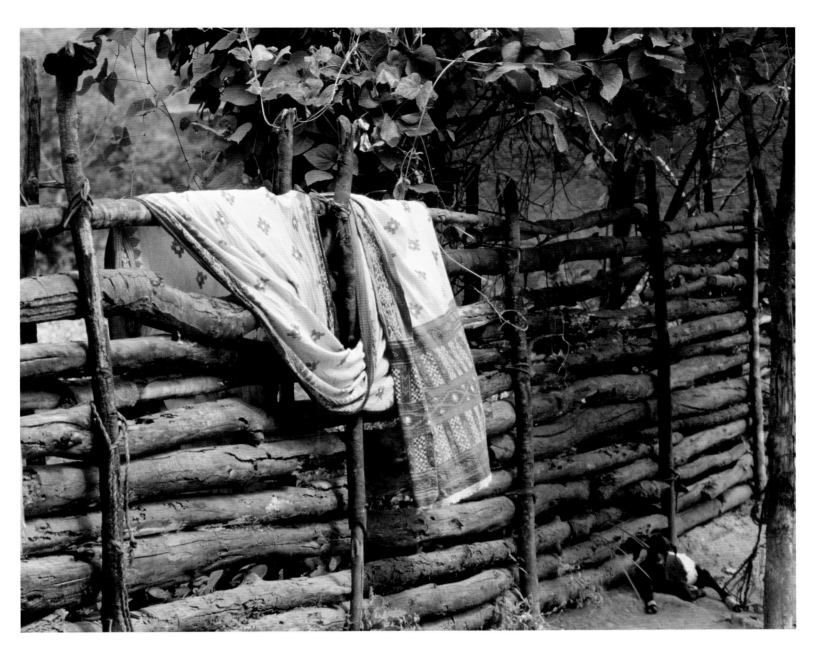

"*The mist is like the earth's desire.*

It hides the sun for whom she cries."

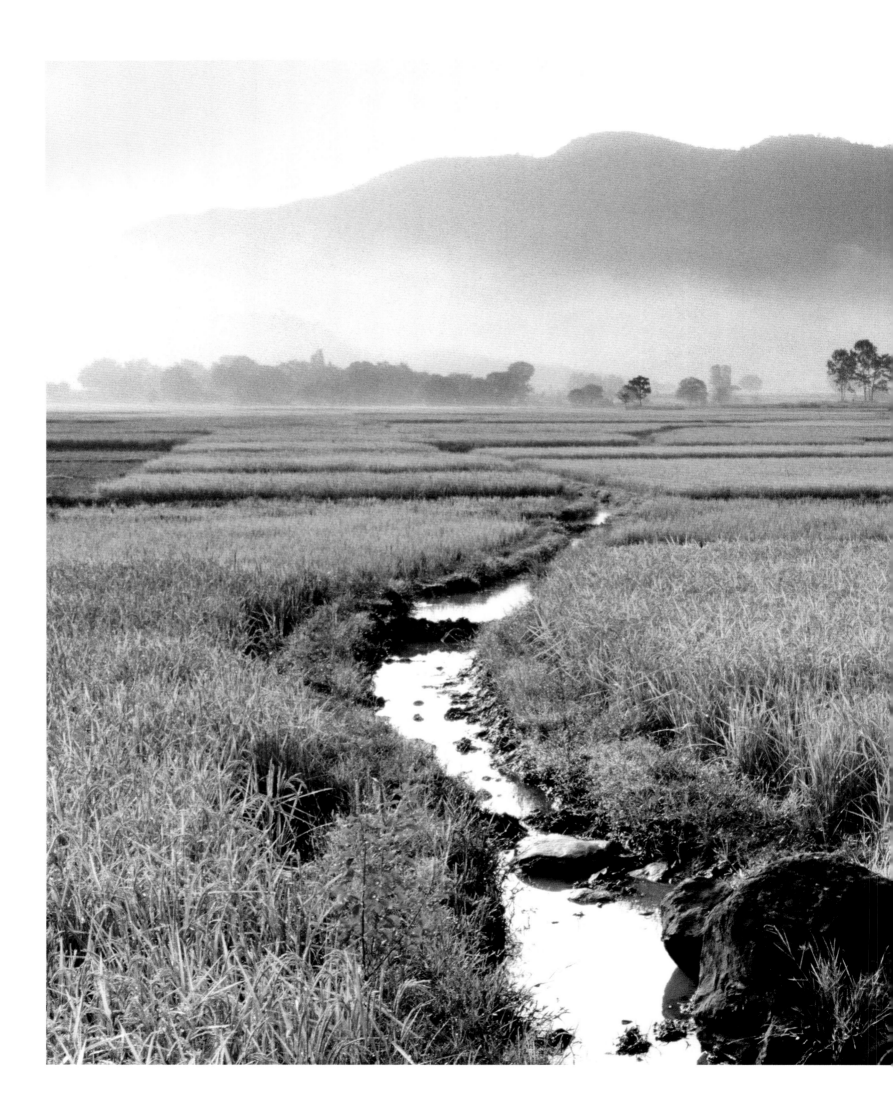

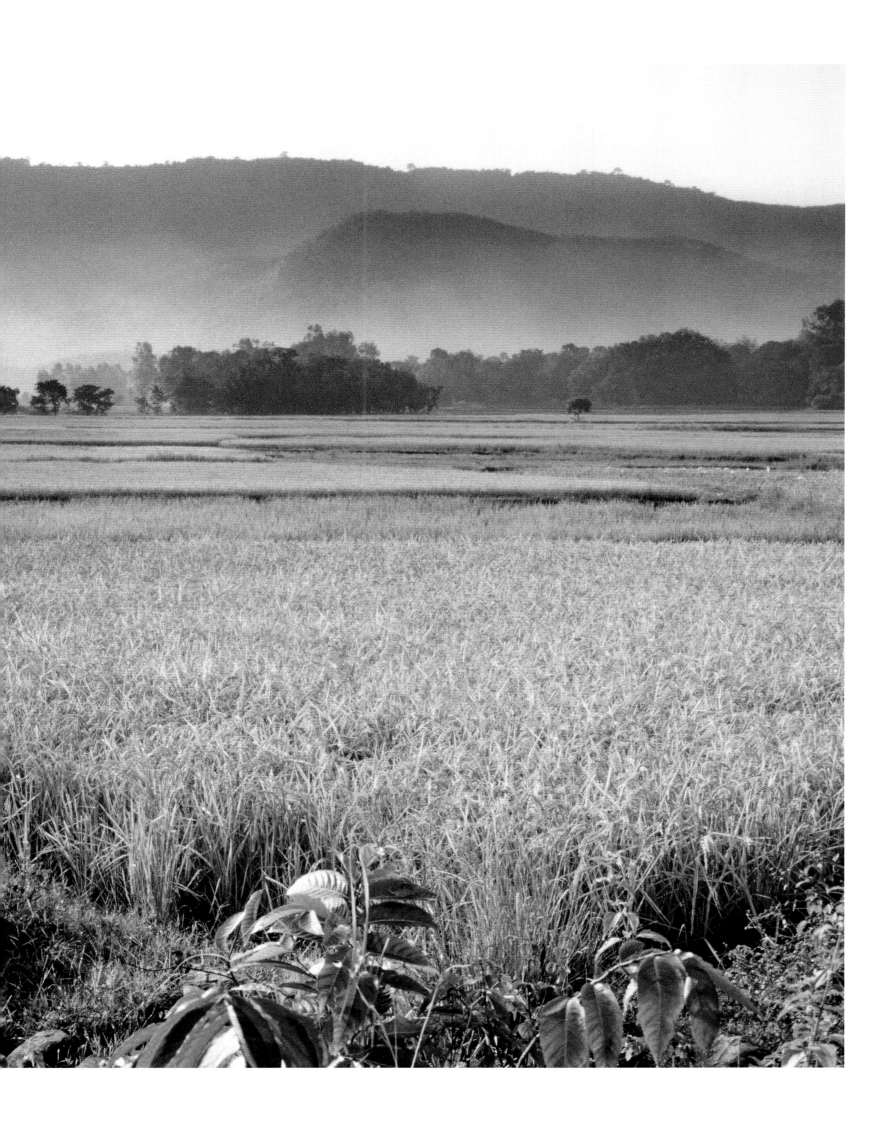

"*I spill water from my water jar as I walk on my way. Very little remains for my home.*"

Pages 109–111: Girls fetching water from the village well.
This is a daily task which gives the women a rare opportunity to socialize.

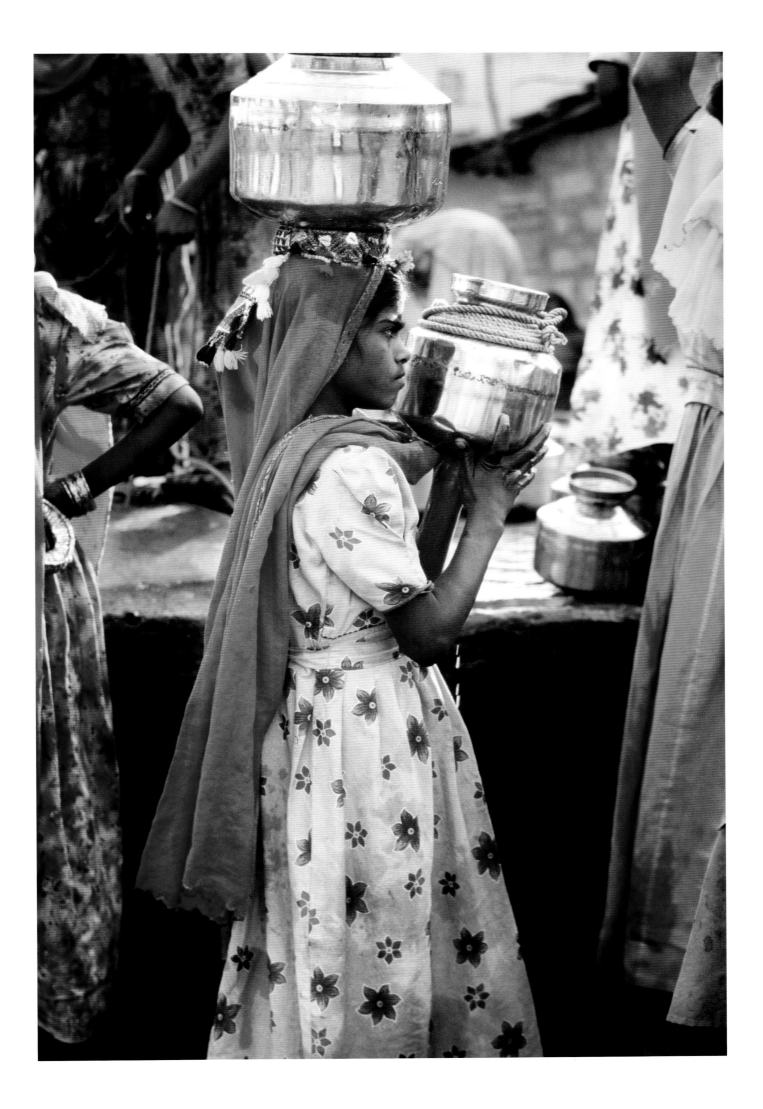

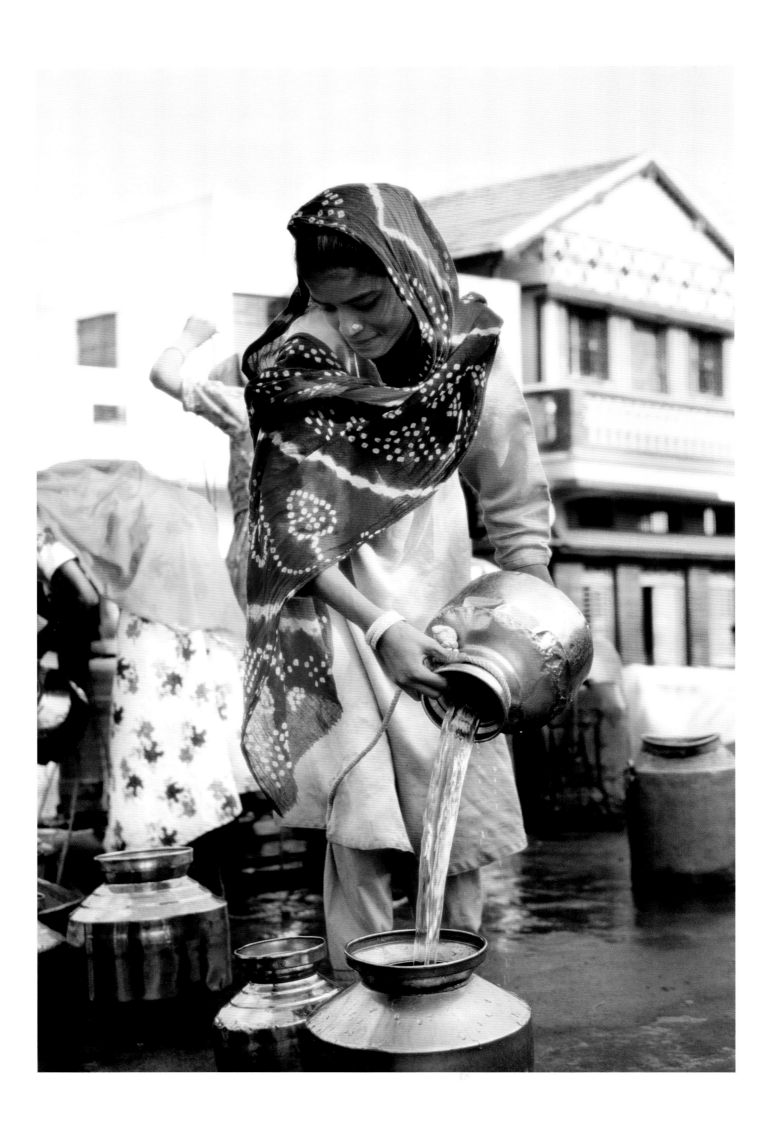

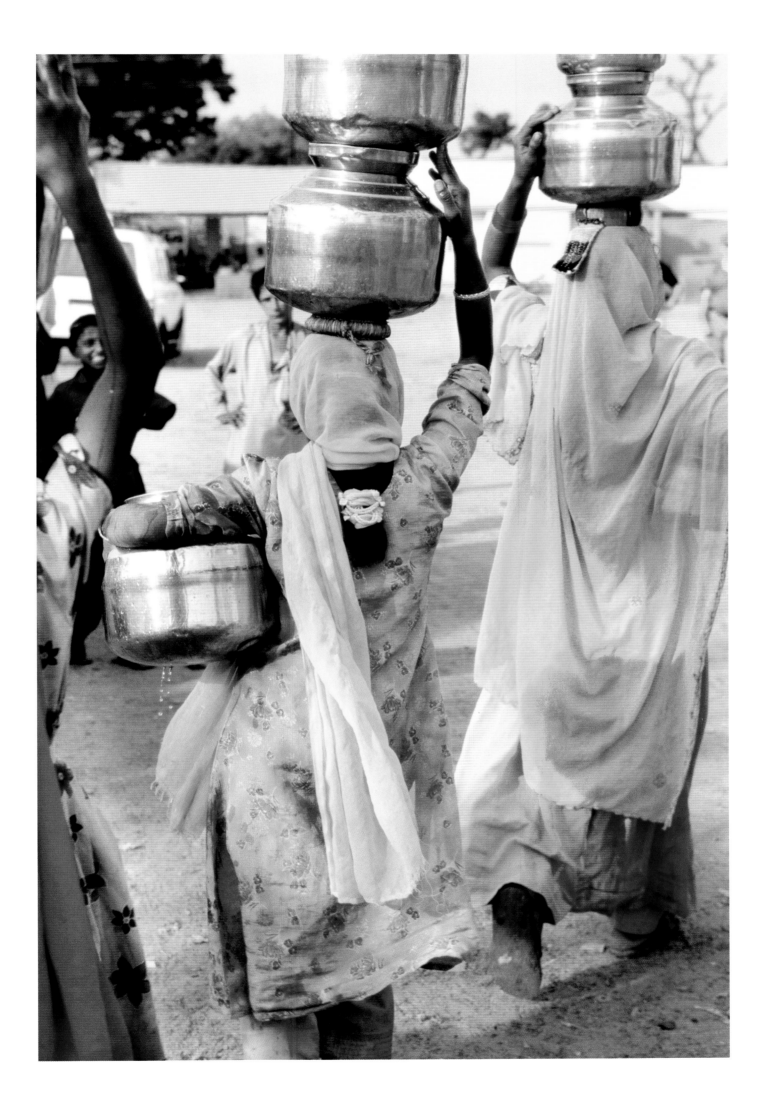

"Some day *I* shall sing to thee
in the sunrise of some other world.
I have seen thee before in the light
of the earth, in the love of man."

Right: A young sadhu in the Jagarnath temple of Koraput.

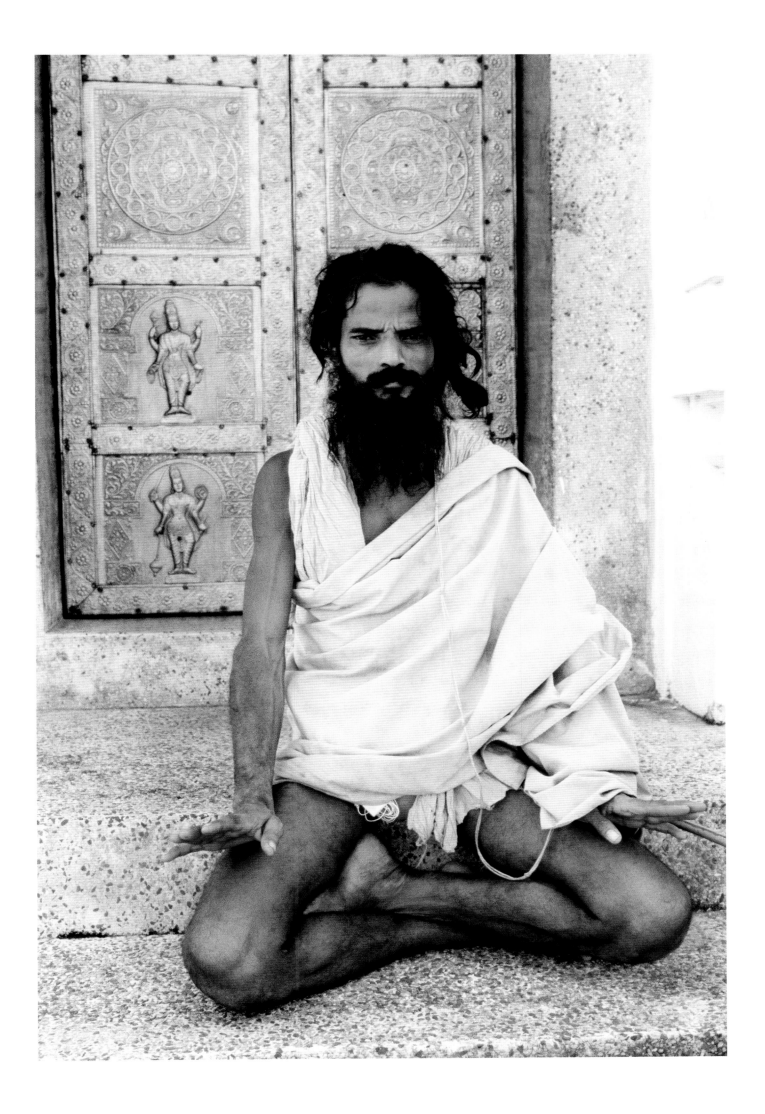

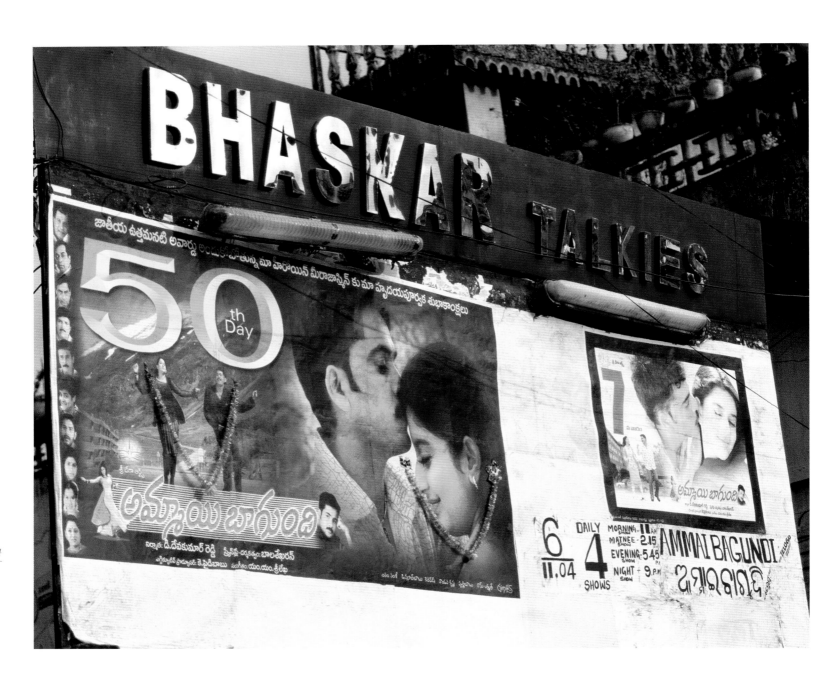

Movies are central to Indian society. Note the garlands of flowers celebrating the performers in the poster.

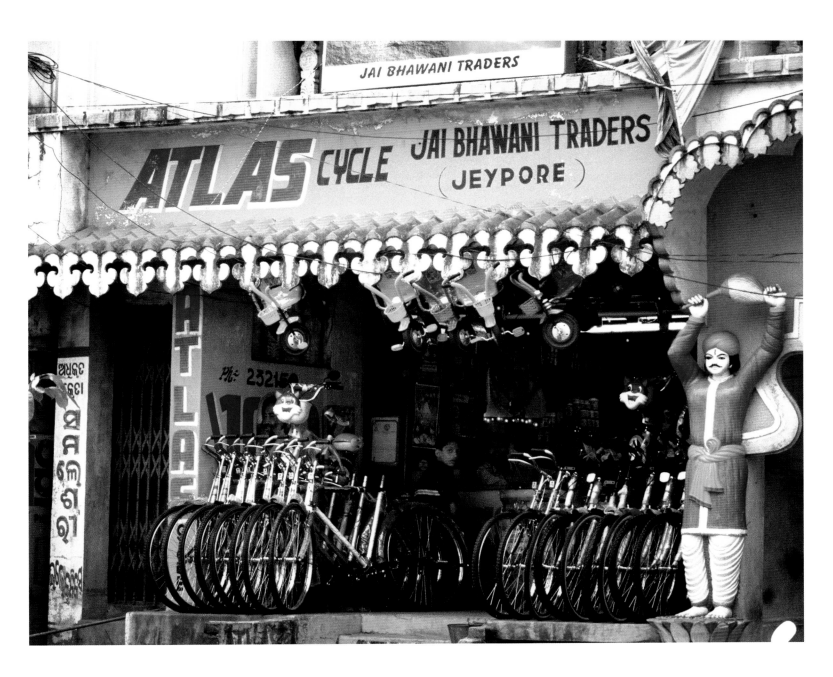

Like many stores in Jeypore, this one is set high off the ground to prevent flooding during the monsoon season.

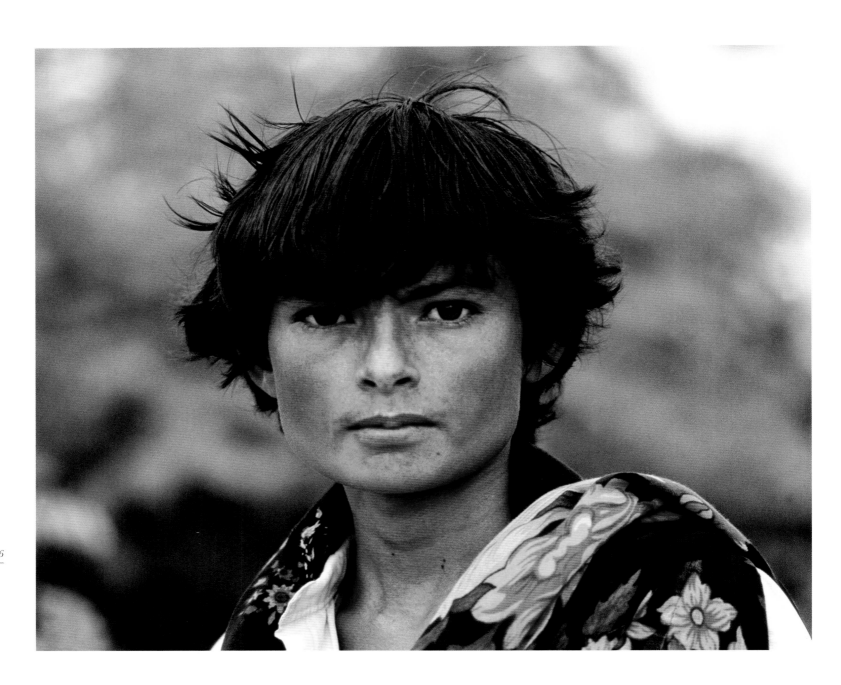

Above: A shy teenage boy of the Jat tribe, Gujarat

Right: A woman from the Jat tribe wearing a large gold nose ring decorated
with a fluted emerald bead. The fabric of her festive clothing is handmade.

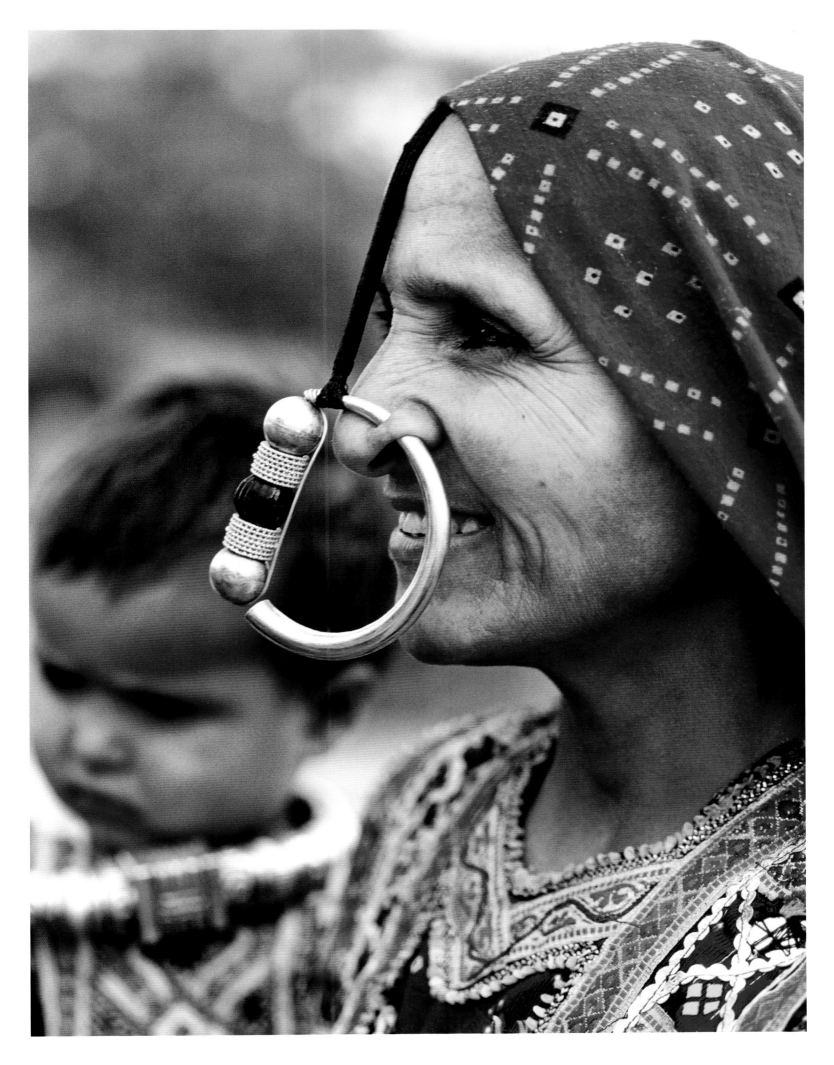

"*The stars are not afraid*

to appear like fireflies."

Right: Women on their way to the festivities at a tribal fair.

Pages 120–121: Dancers in competition at the fair.

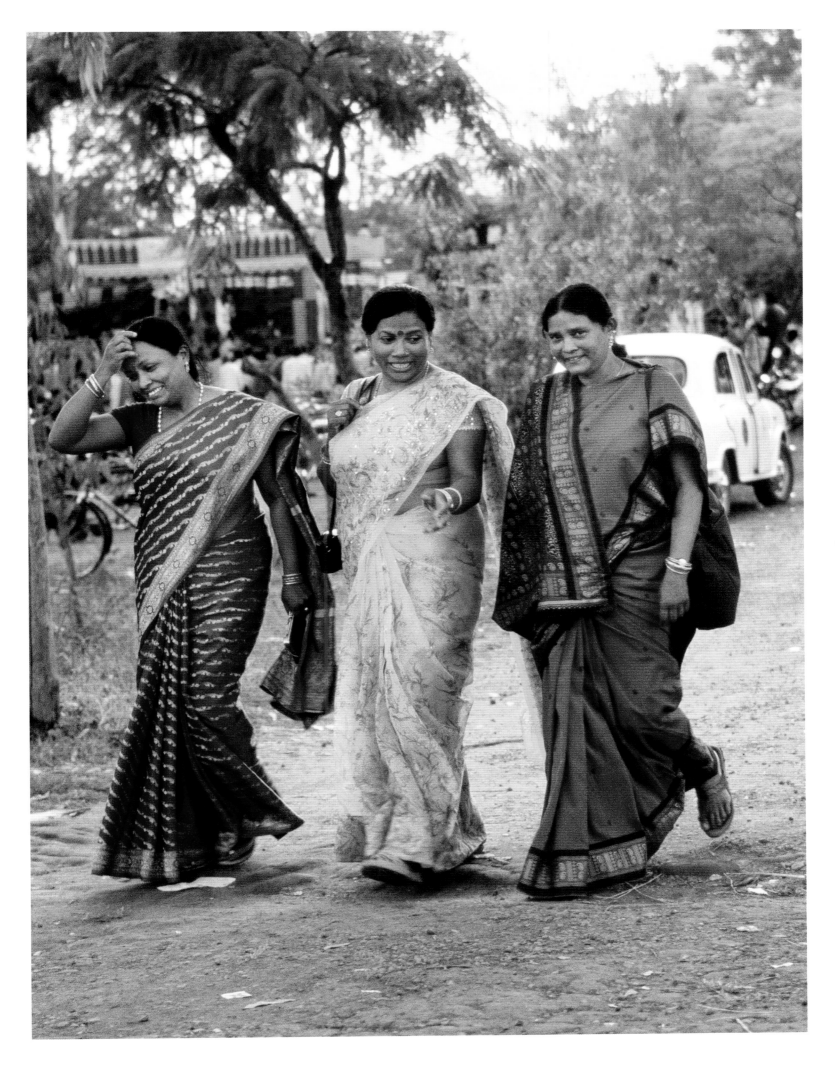

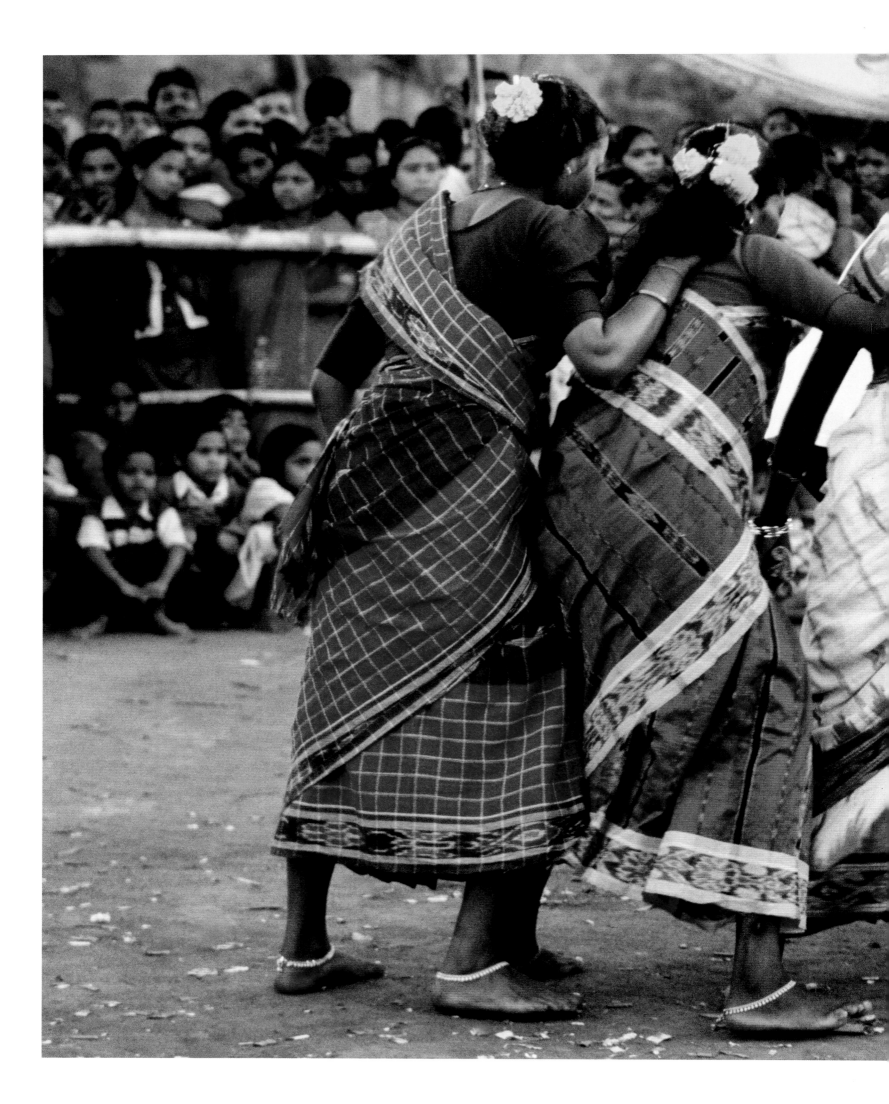

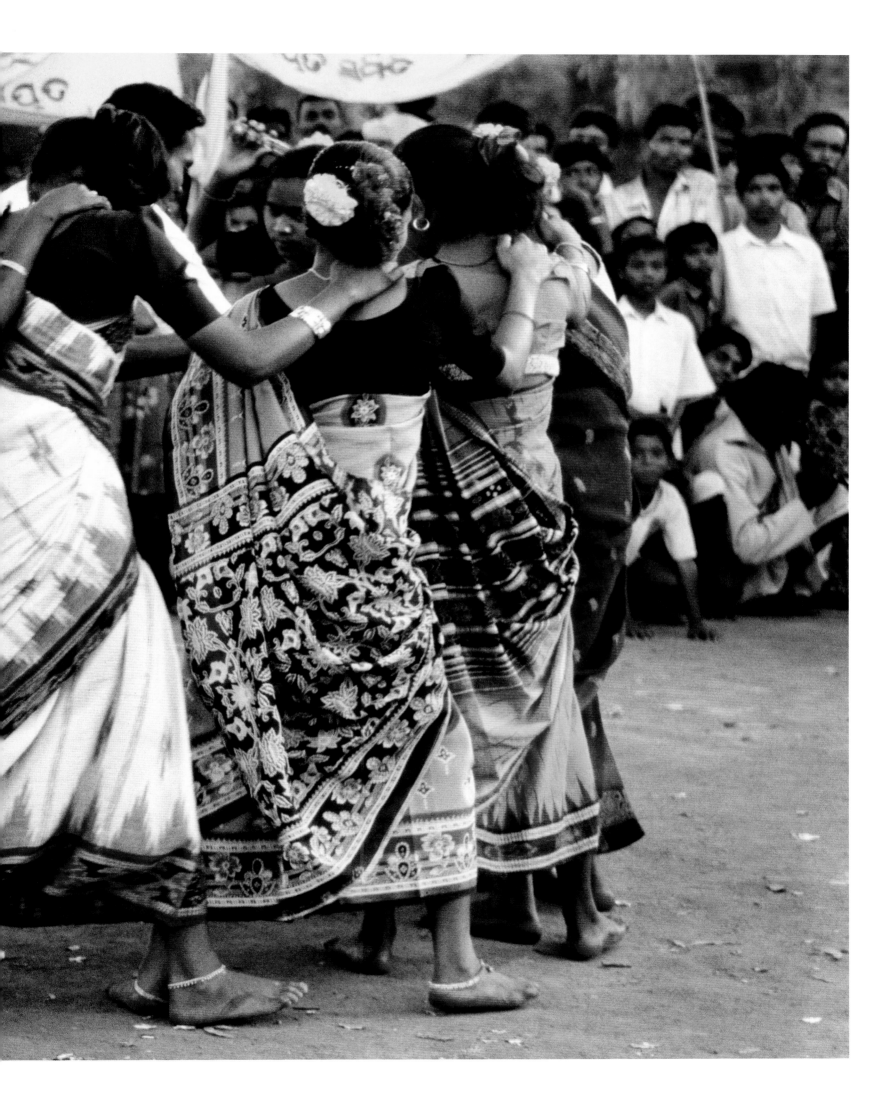

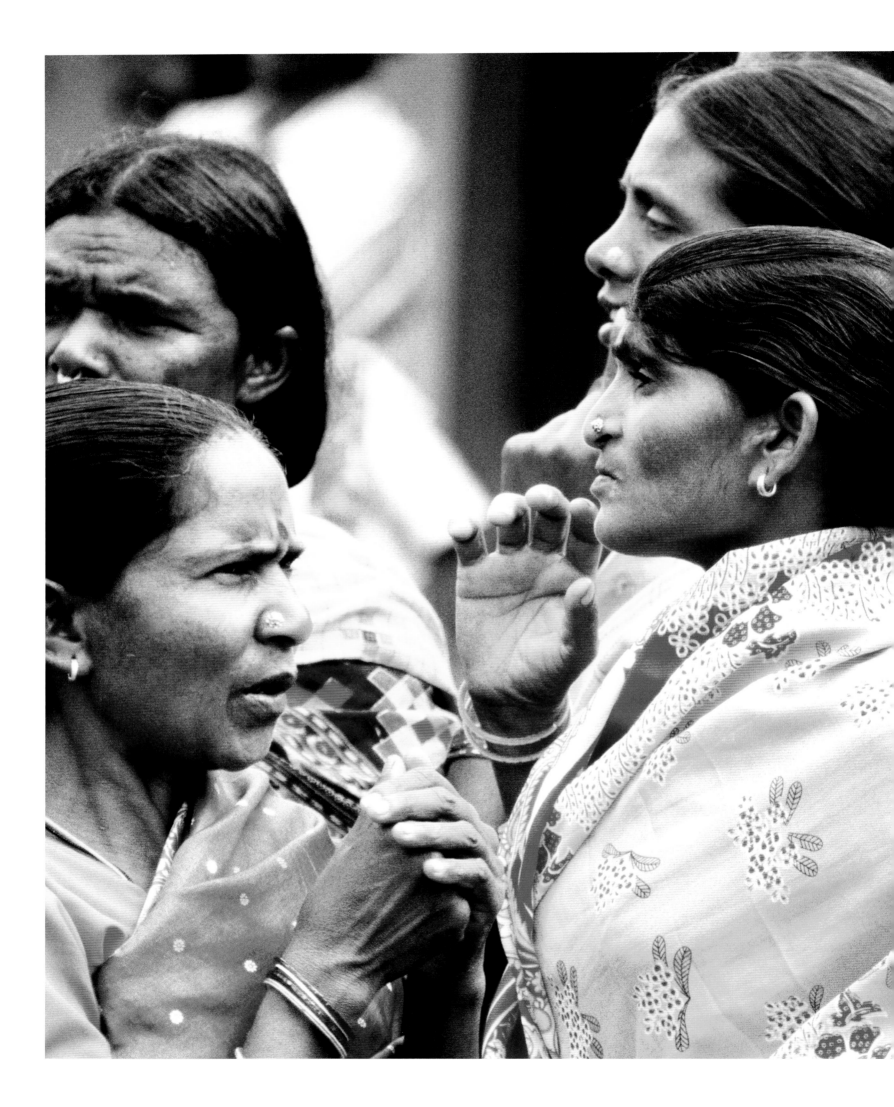

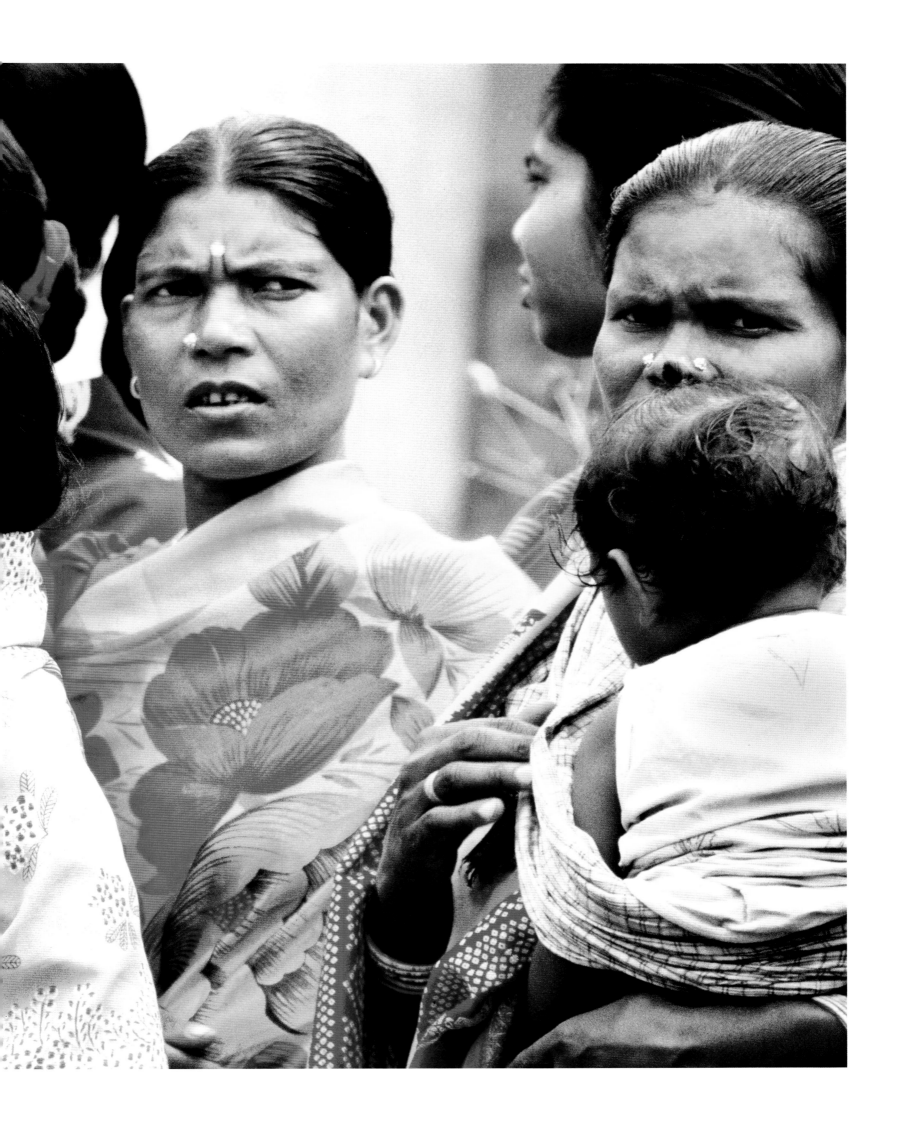

Pages 122–123: Women of the Rana community wearing wedding clothes on a visit to the fair.

Left: Girls watching and waiting their turn to perform in the Gotipua dance competition at the fair.

Pages 126–127: The Hawa Mahal.

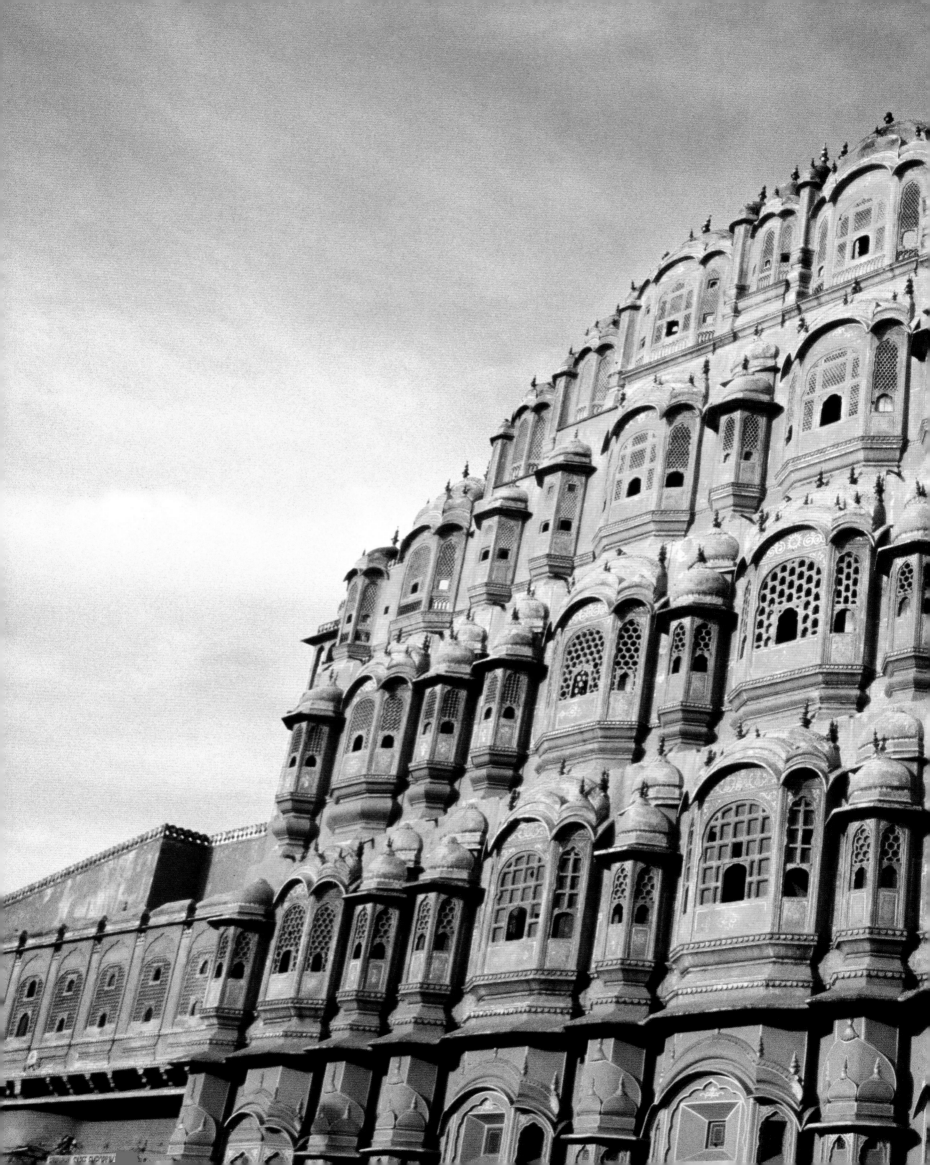

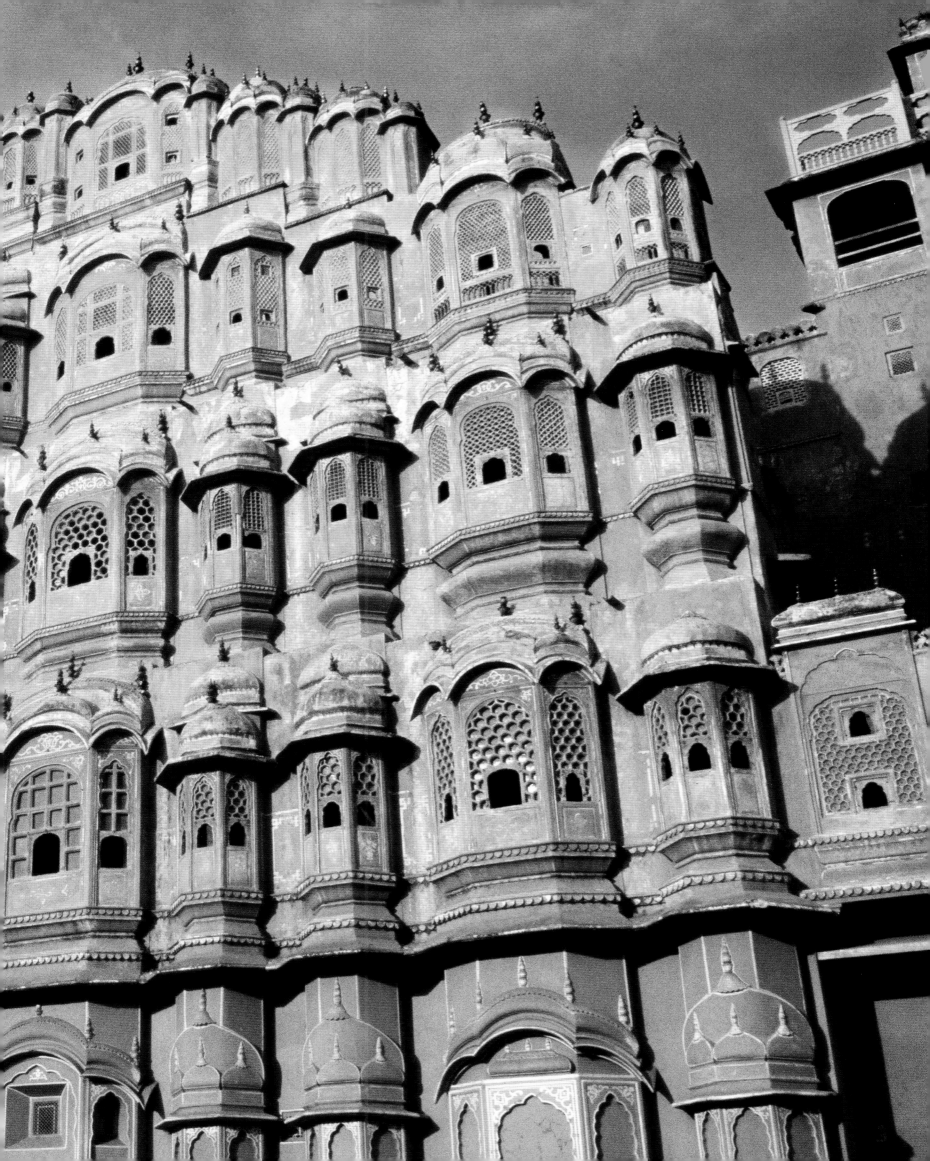

"While I was passing with the crowd in the road I saw your smile from the balcony and I sang and forgot all noise."

Pages 126–135: Images in Jaipur.

Right: Antique door carvings shown with embroidered and silk fabrics.

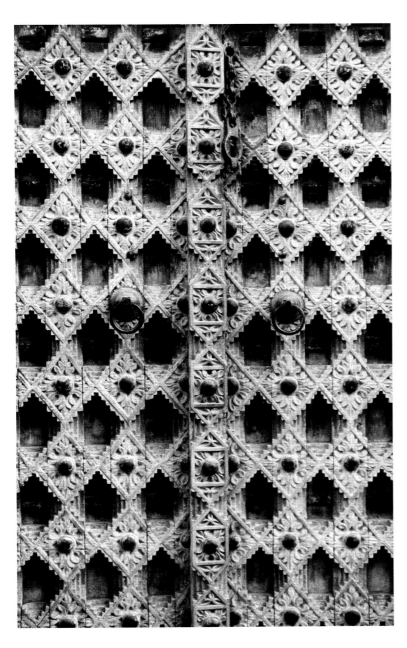

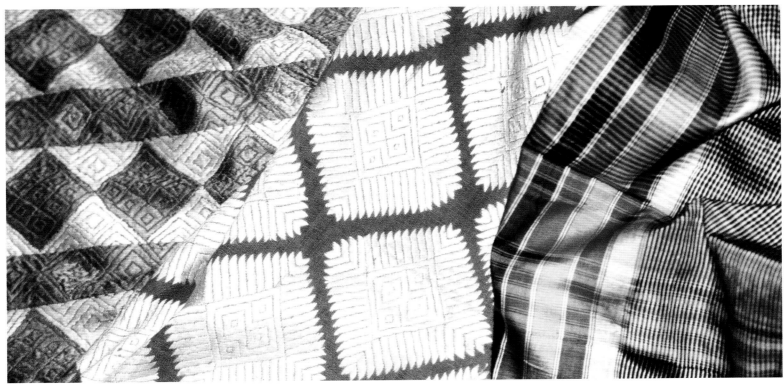

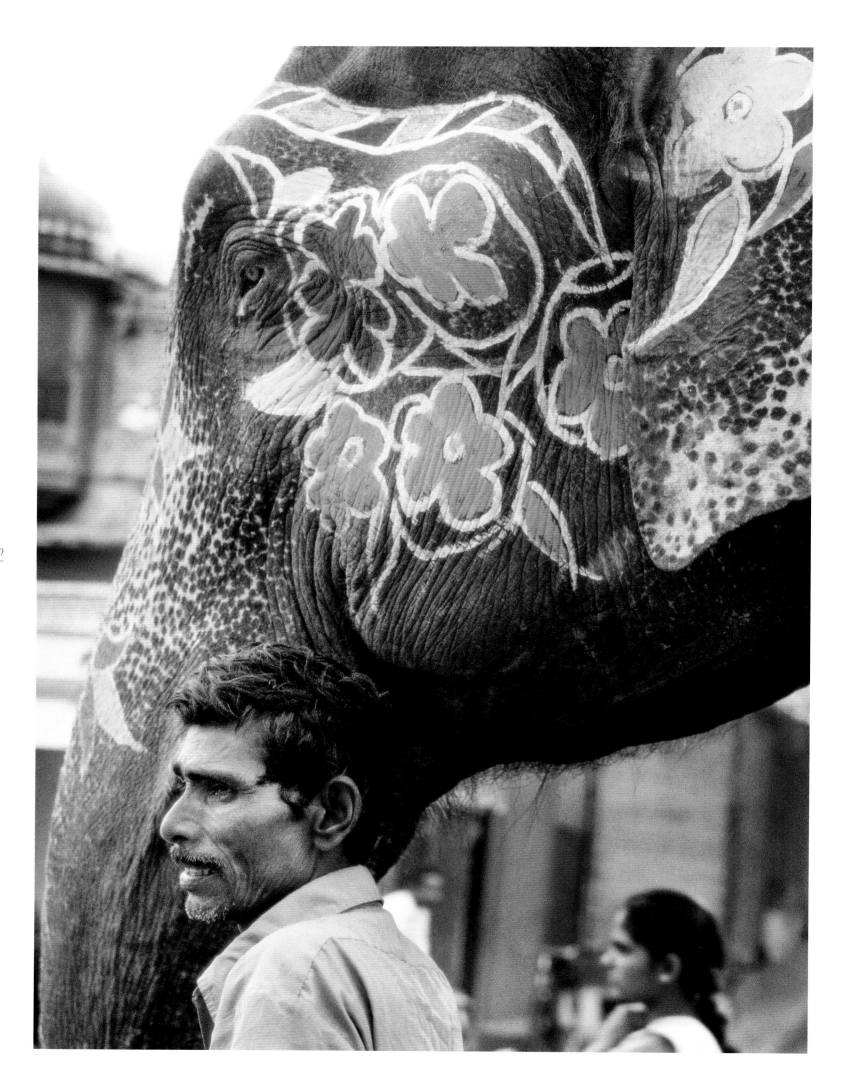
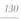

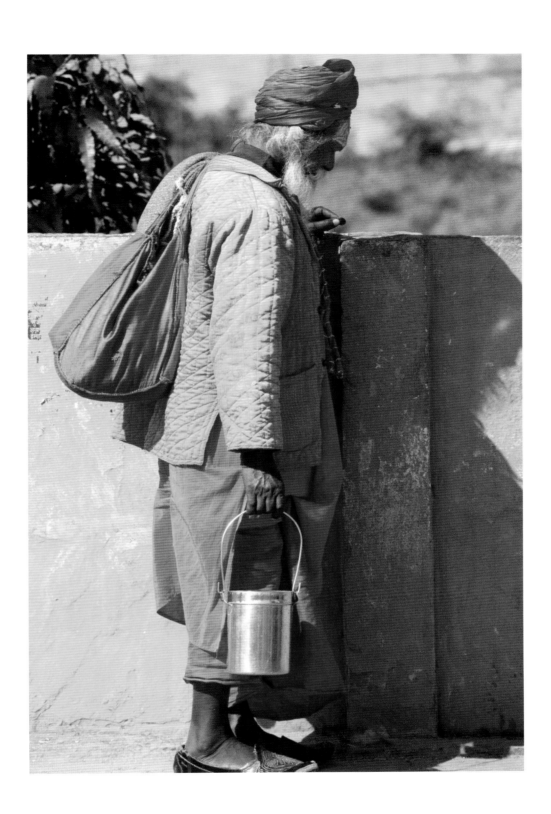

Brilliant color in the "pink city" of Jaipur is everywhere to be found.

Pages: 134–135: The "Water Palace" or Jal Mahal, reflected in the Man Sagar lake.

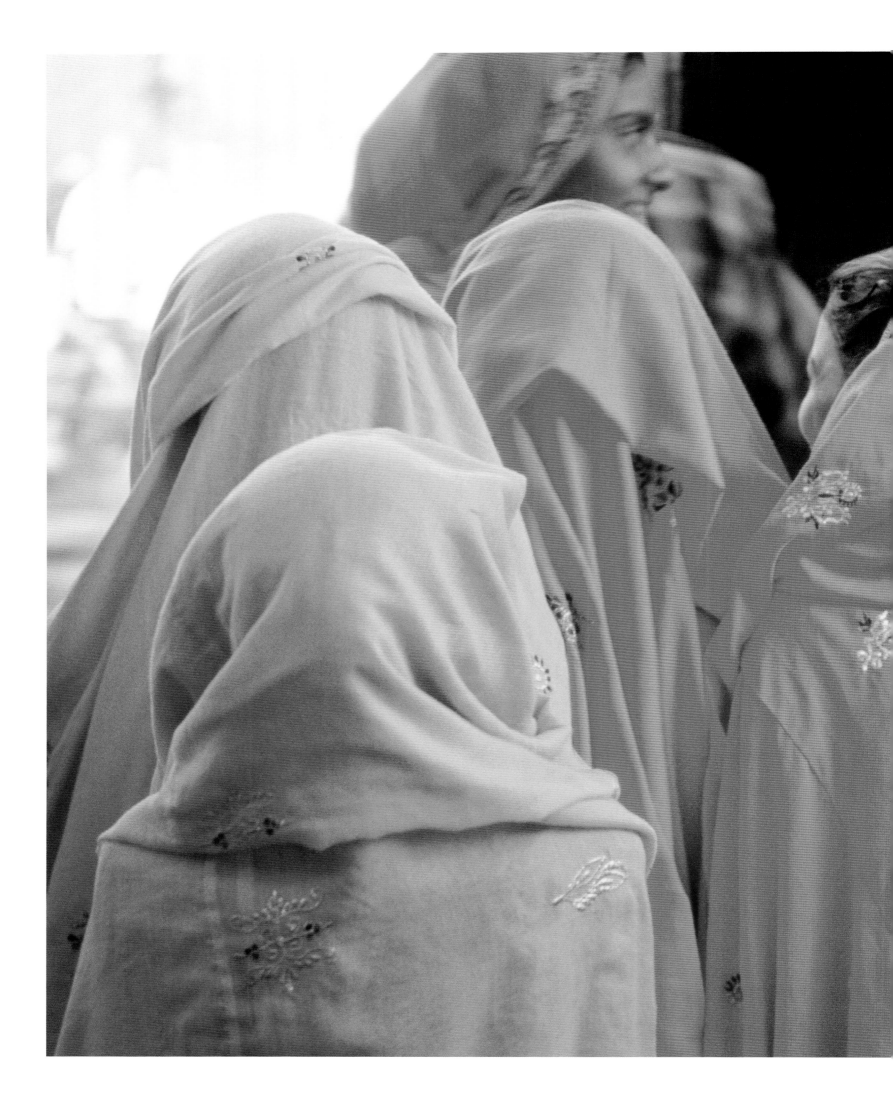

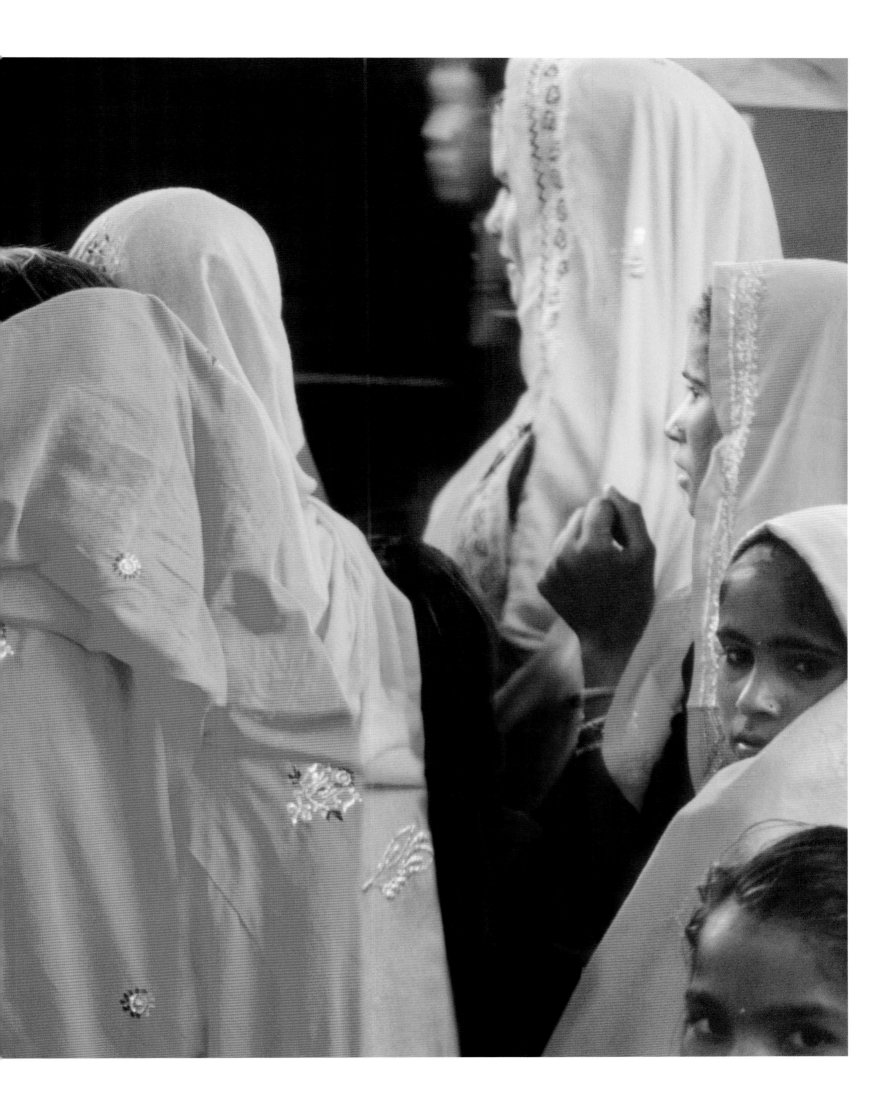

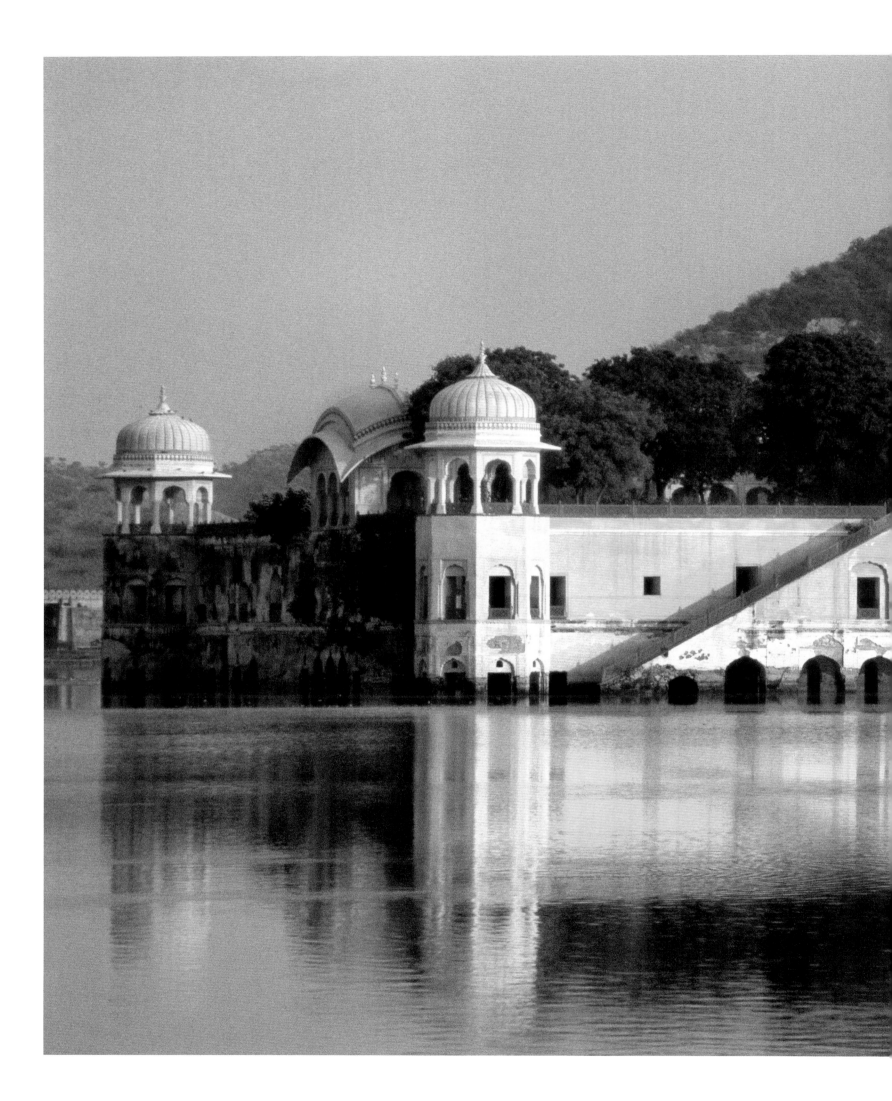

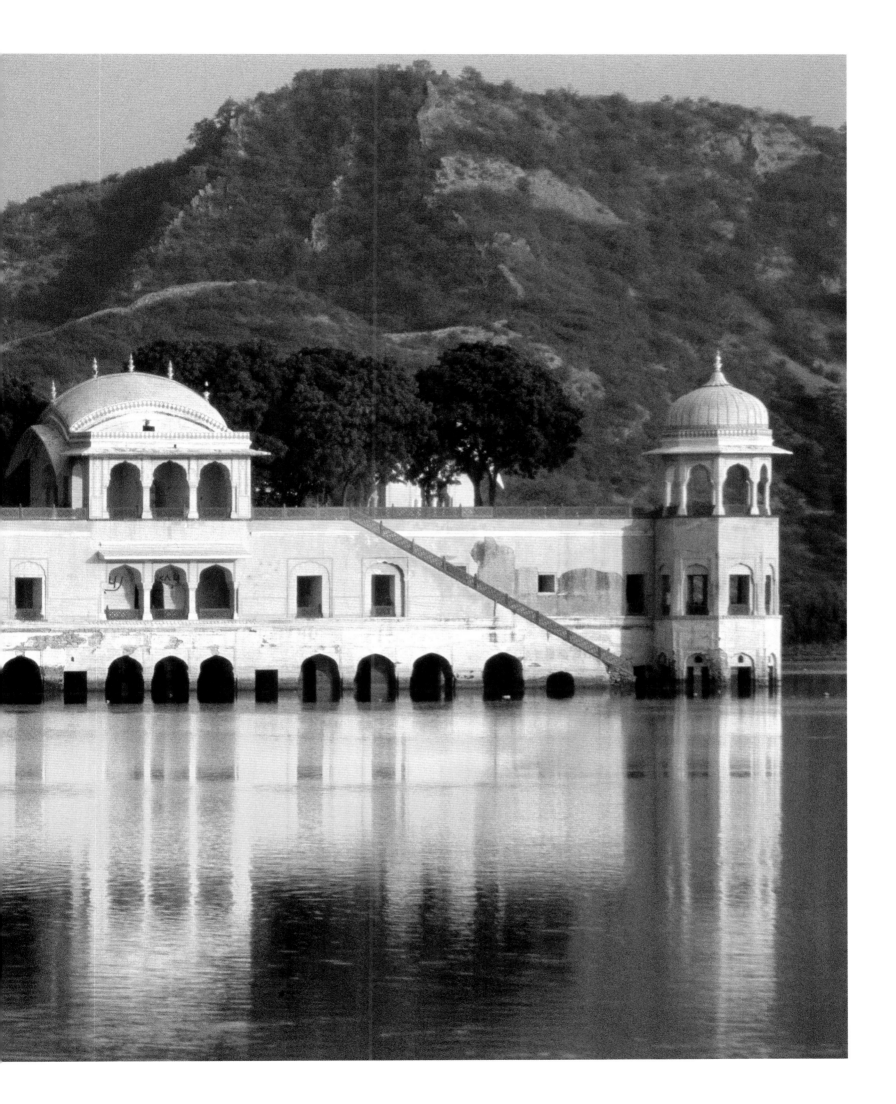

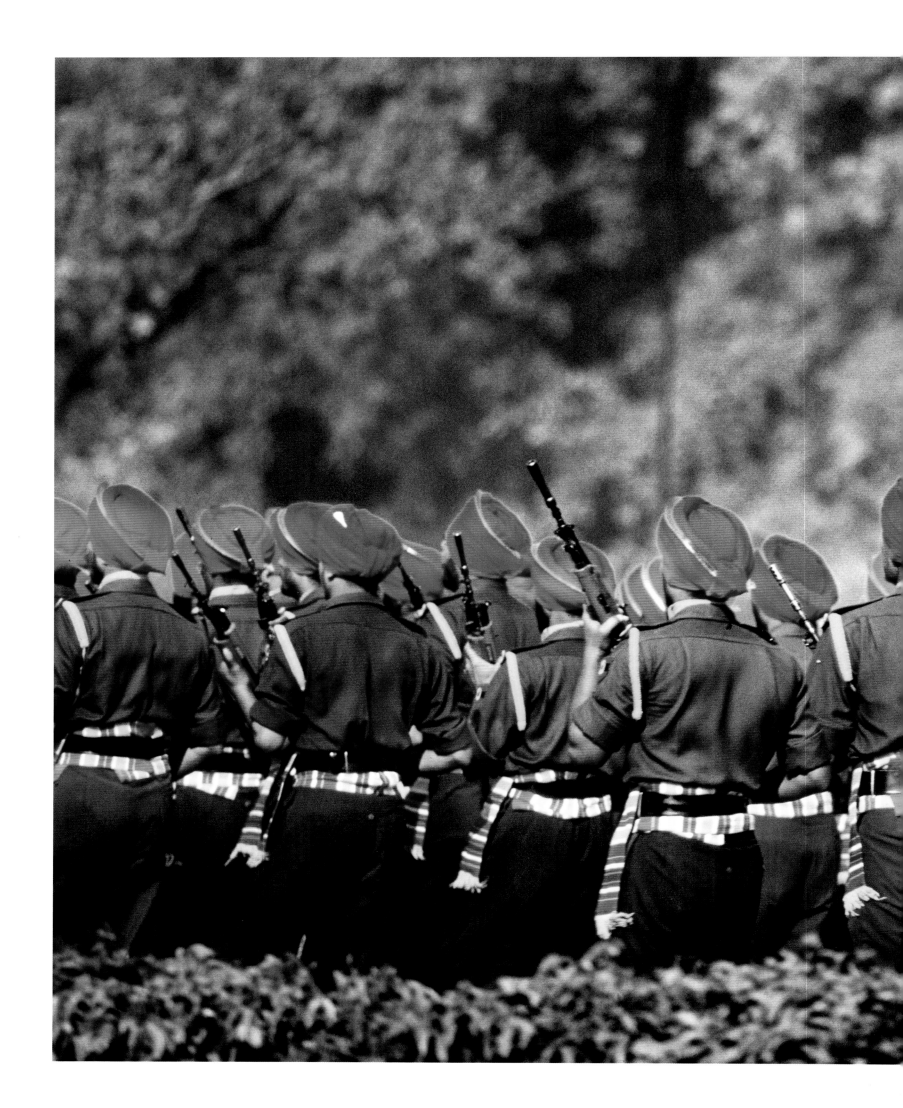

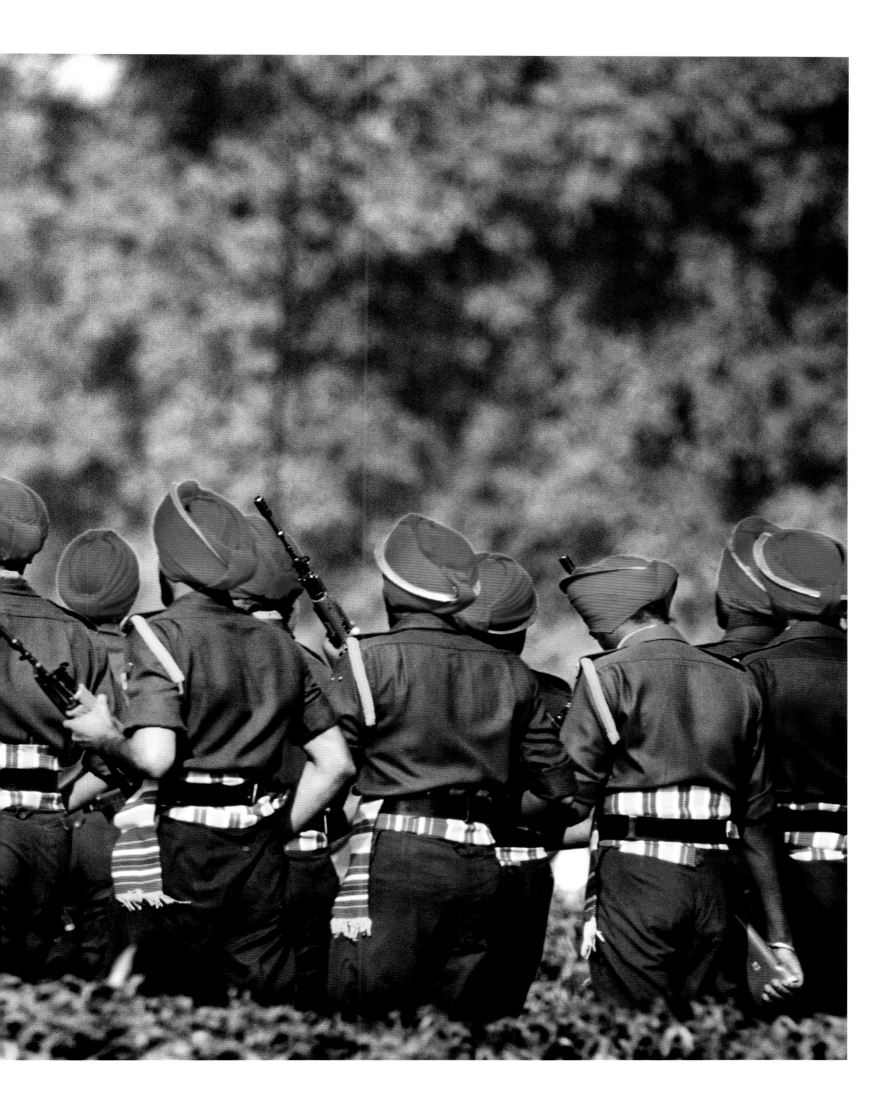

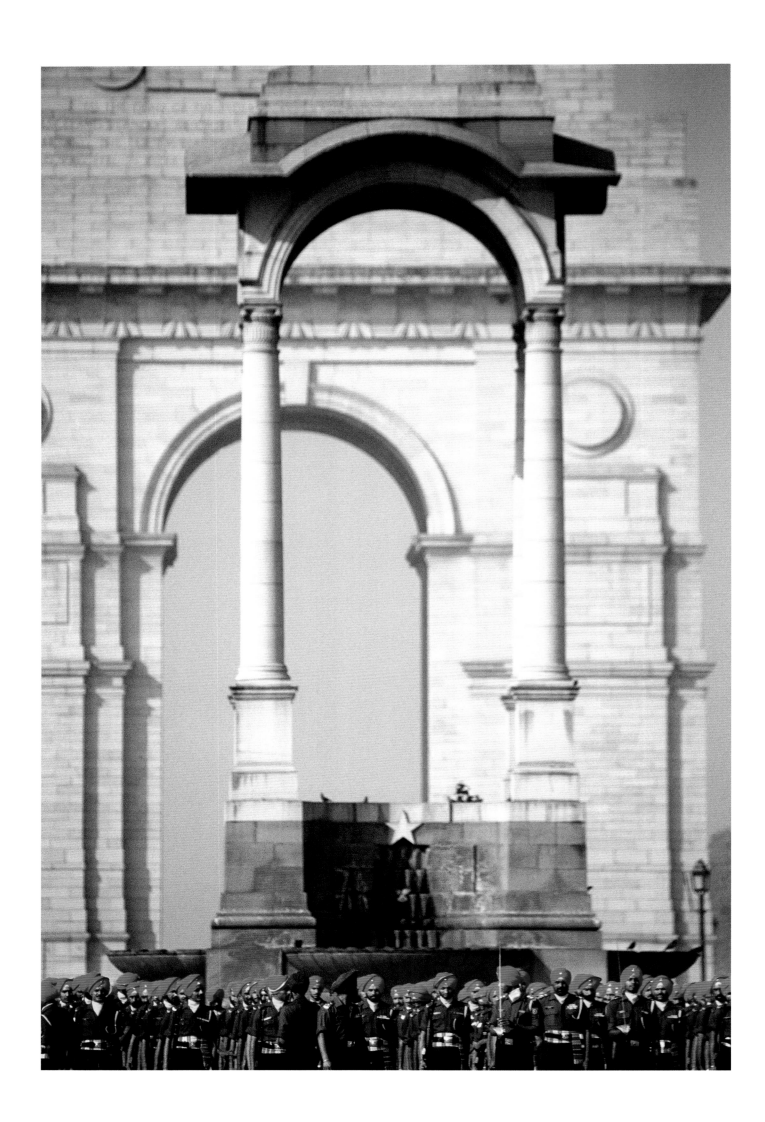

"*I cannot choose the best,*

the best chooses me."

Pages 136–139: The elite Sikh Regiment in New Delhi.

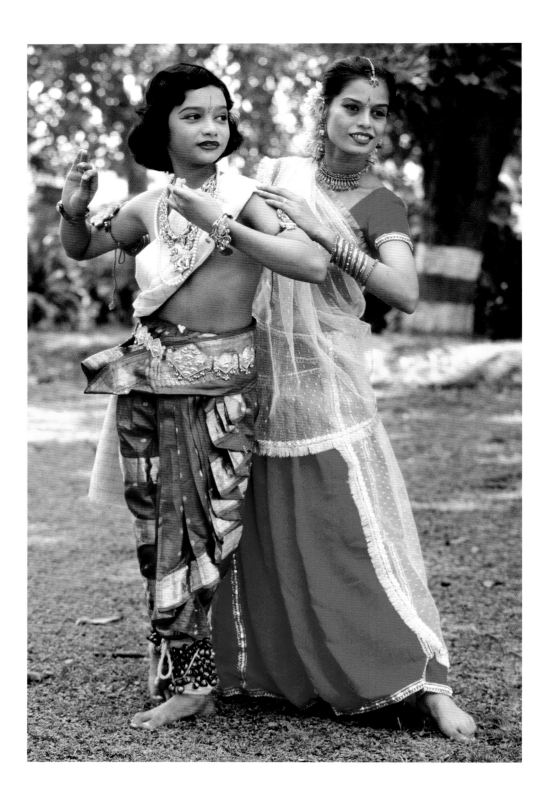

Pages 140–143: Indian Formal Dancers, Kolkata.

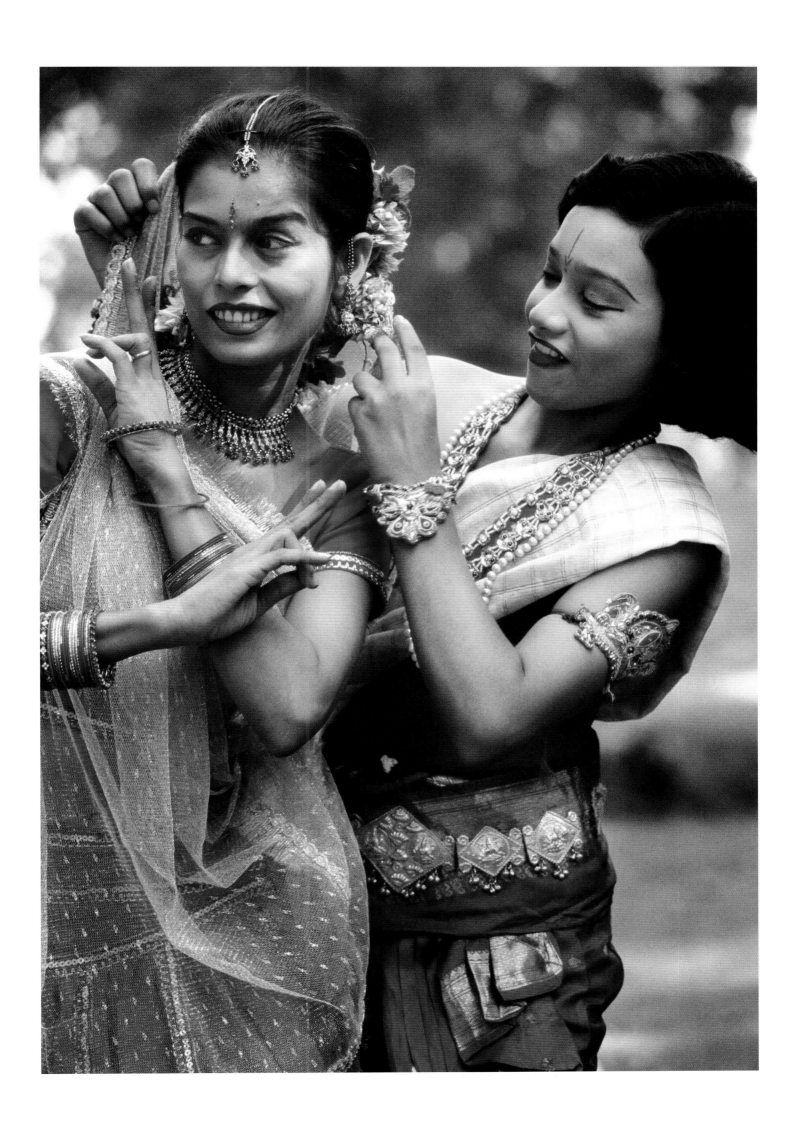

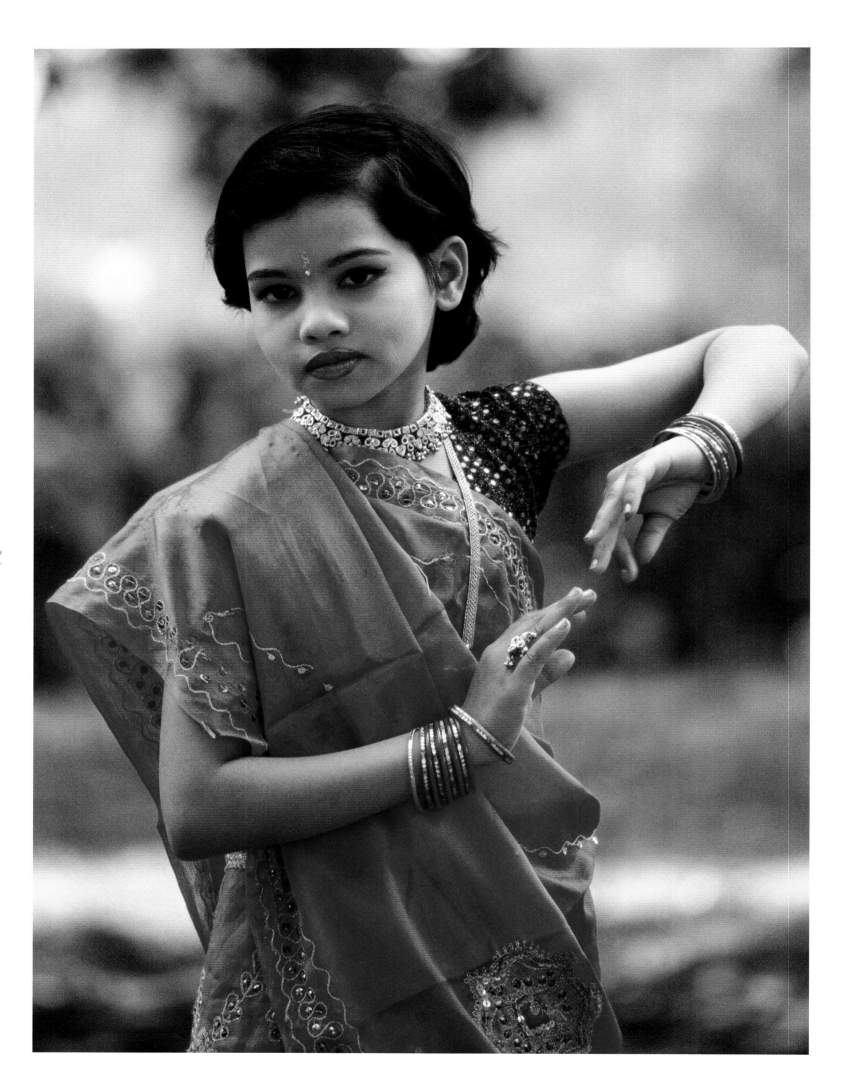

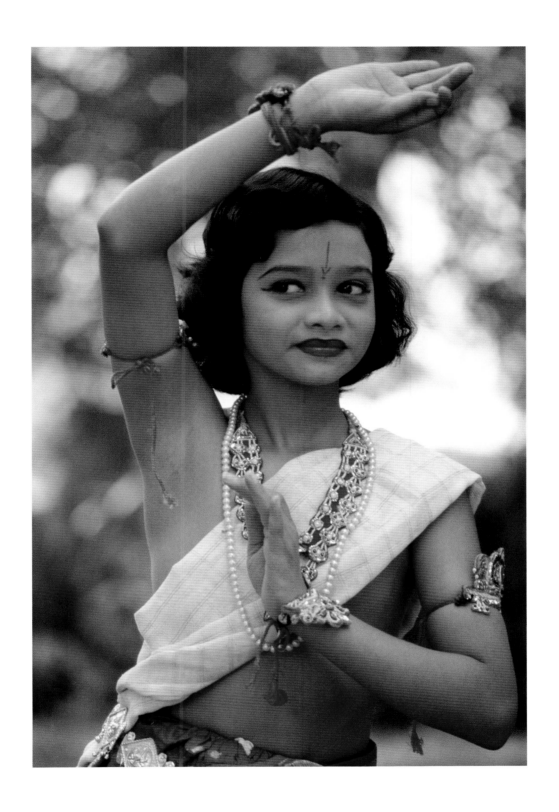

"You are the big drop of dew under the lotus leaf, I am the smaller one on its upper side, said the dewdrop to the lake."

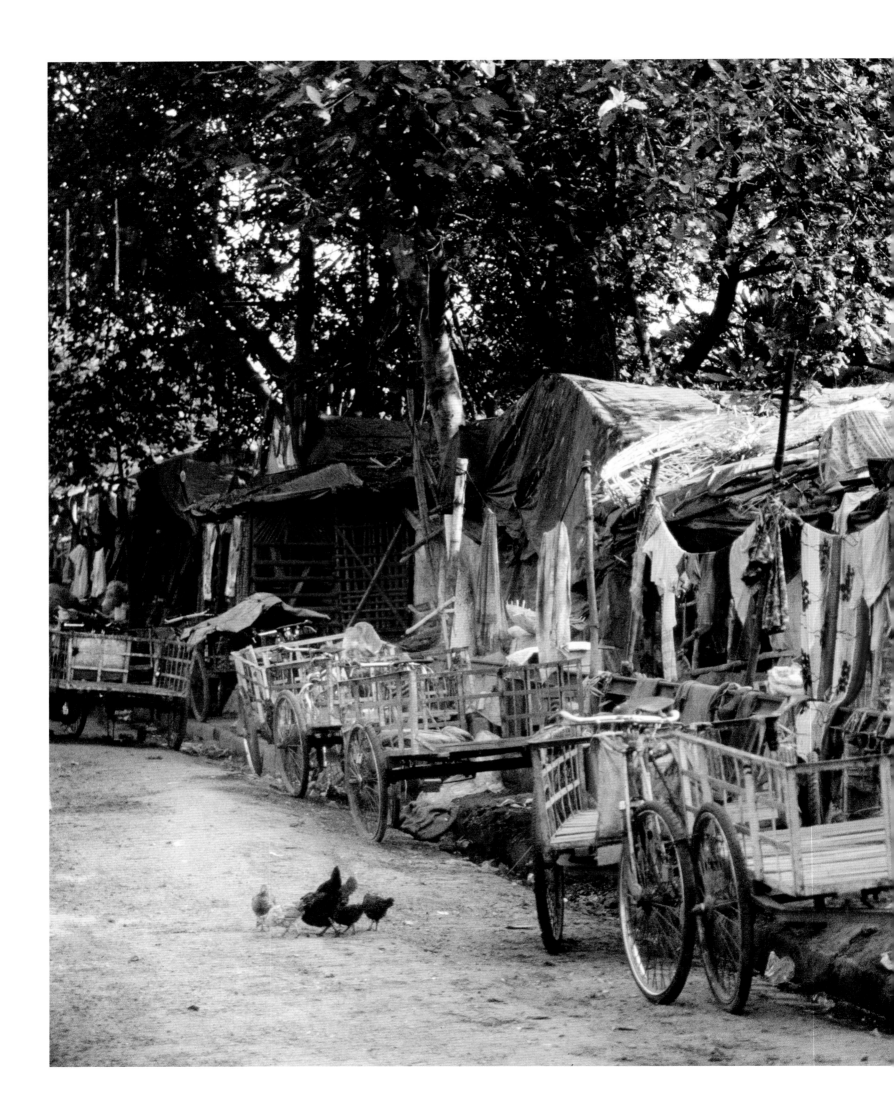

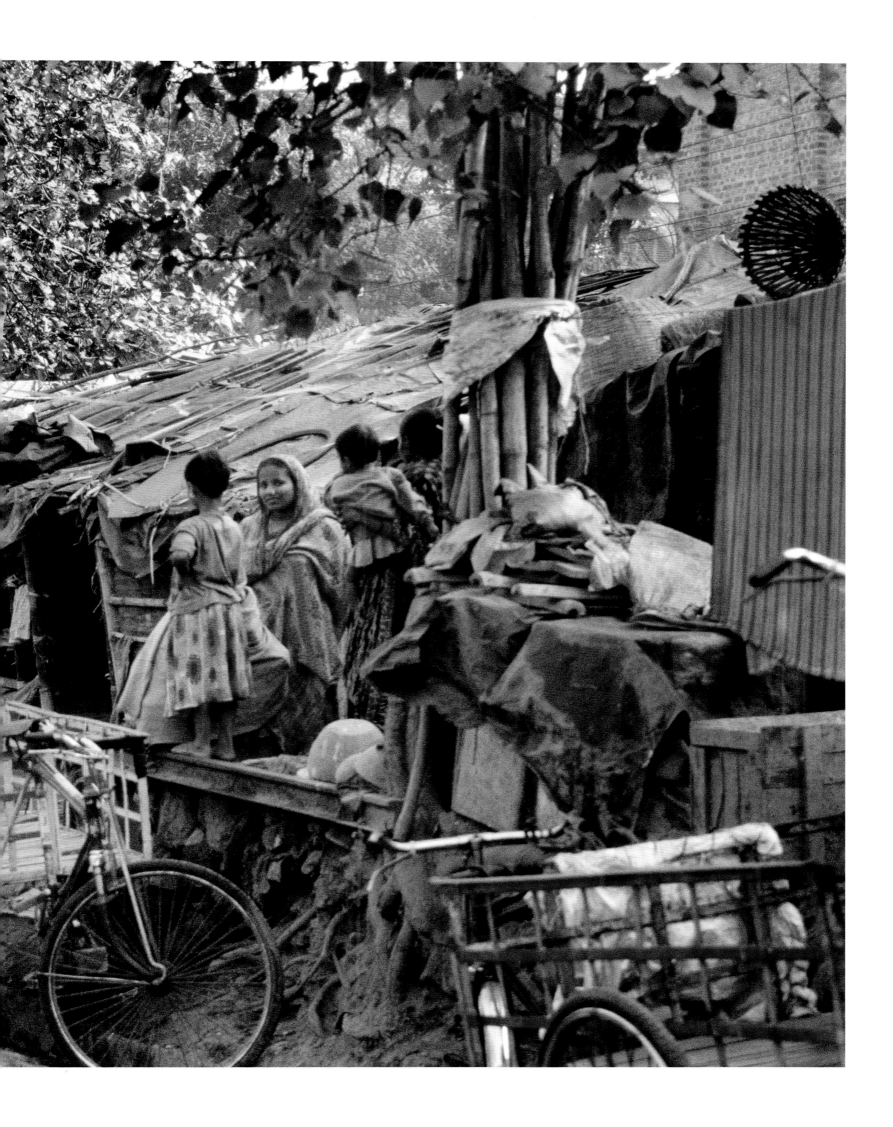

"*Woman, when you move about in your household service your limbs sing like a hill stream among its pebbles.*"

Pages 144–159: At the wholesale flower market in Kolkata.

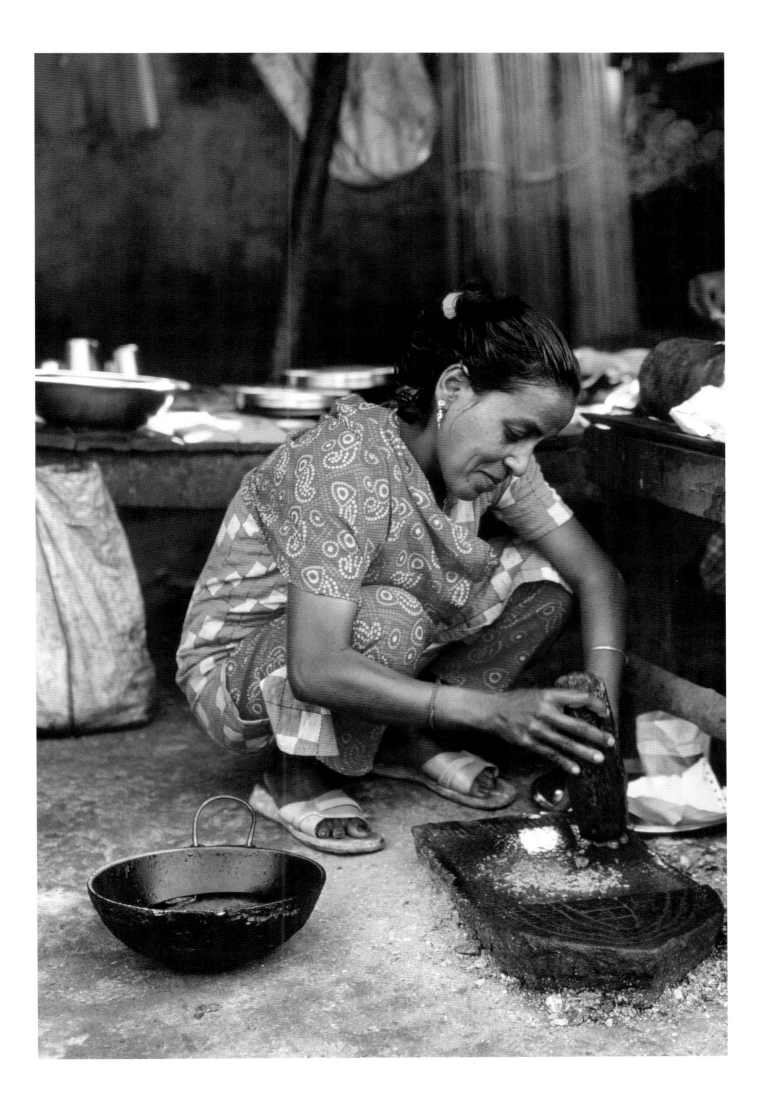

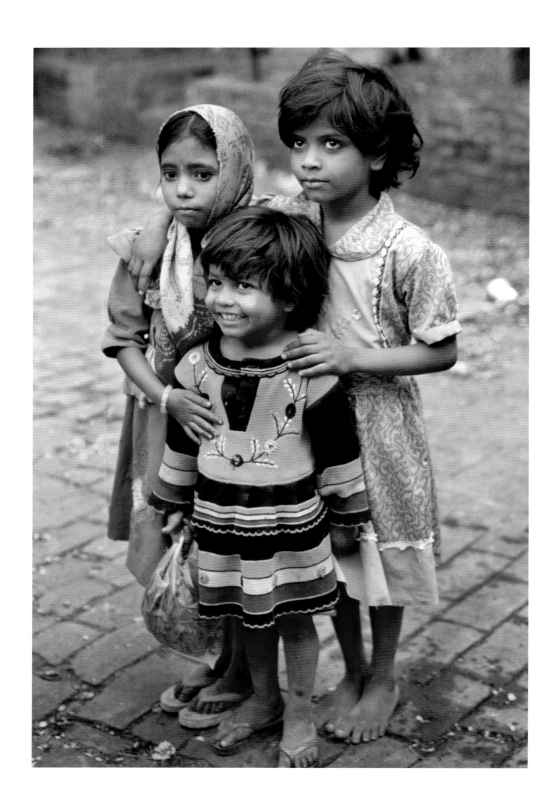

"Where is the fountain that throws up
these flowers in a ceaseless
outbreak of ecstasy?"

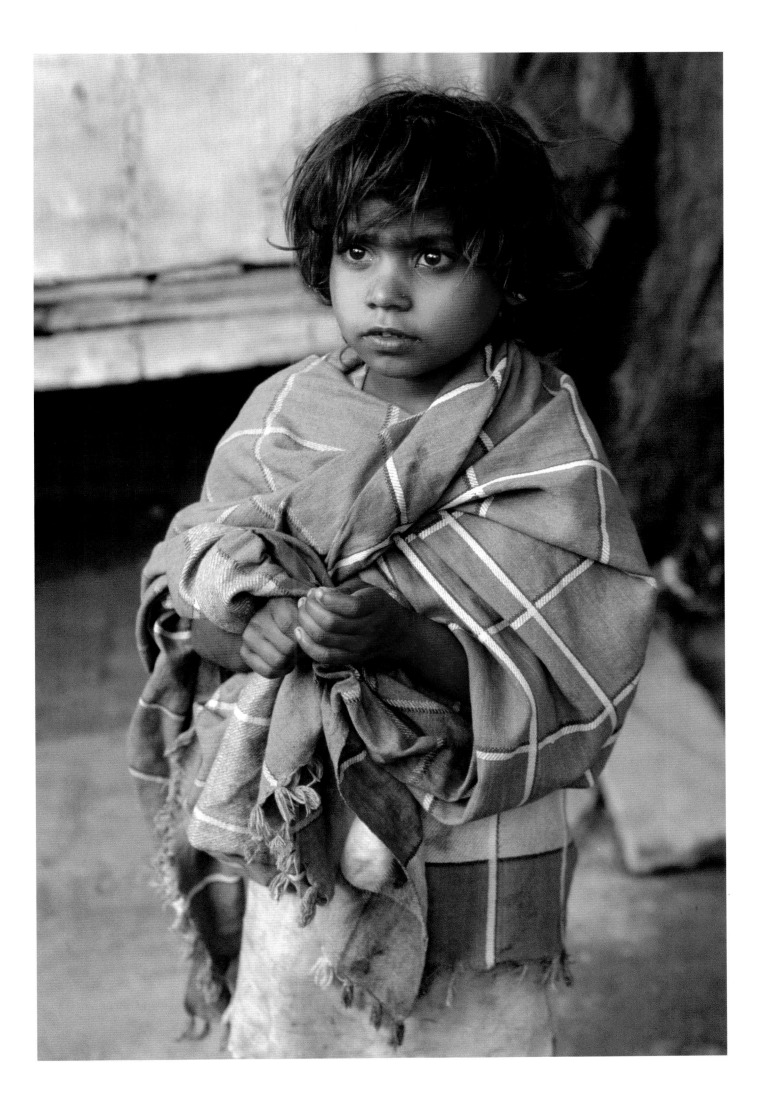

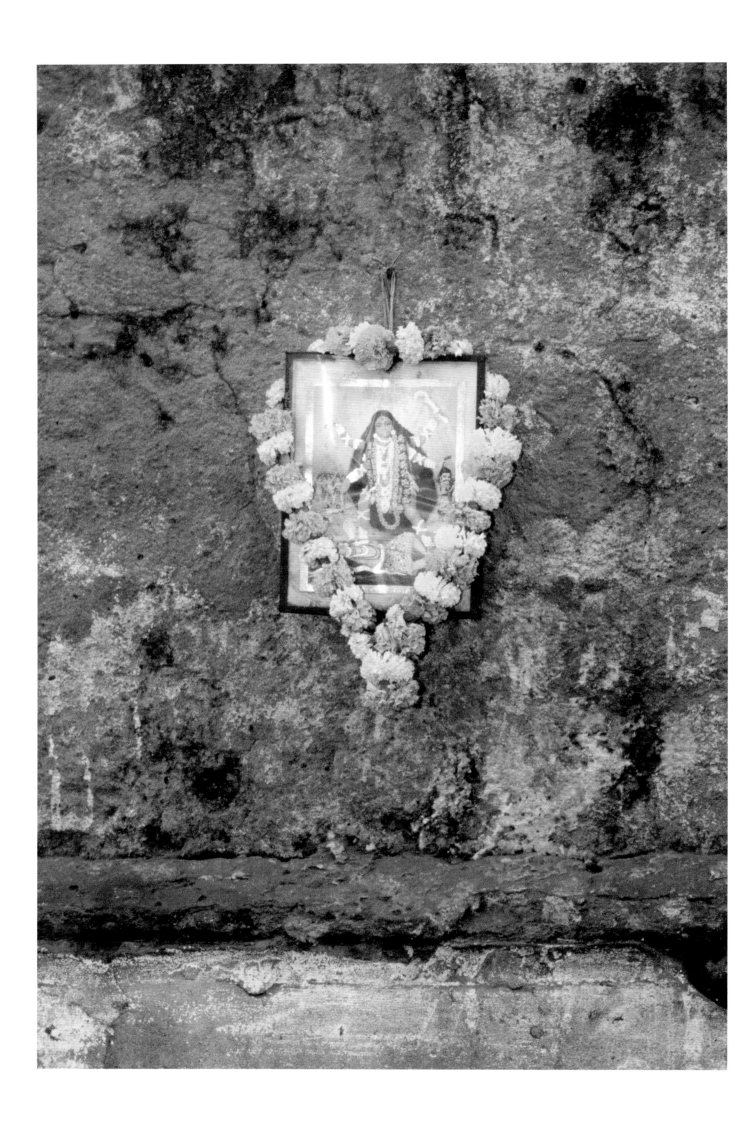

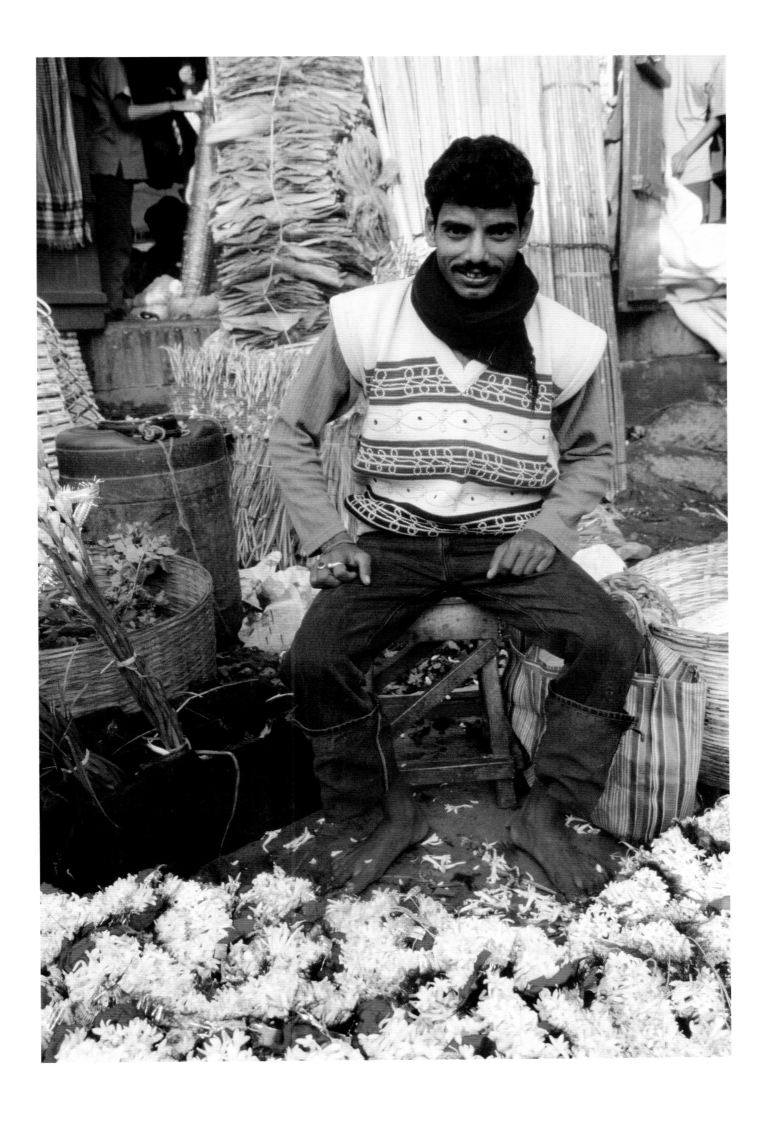

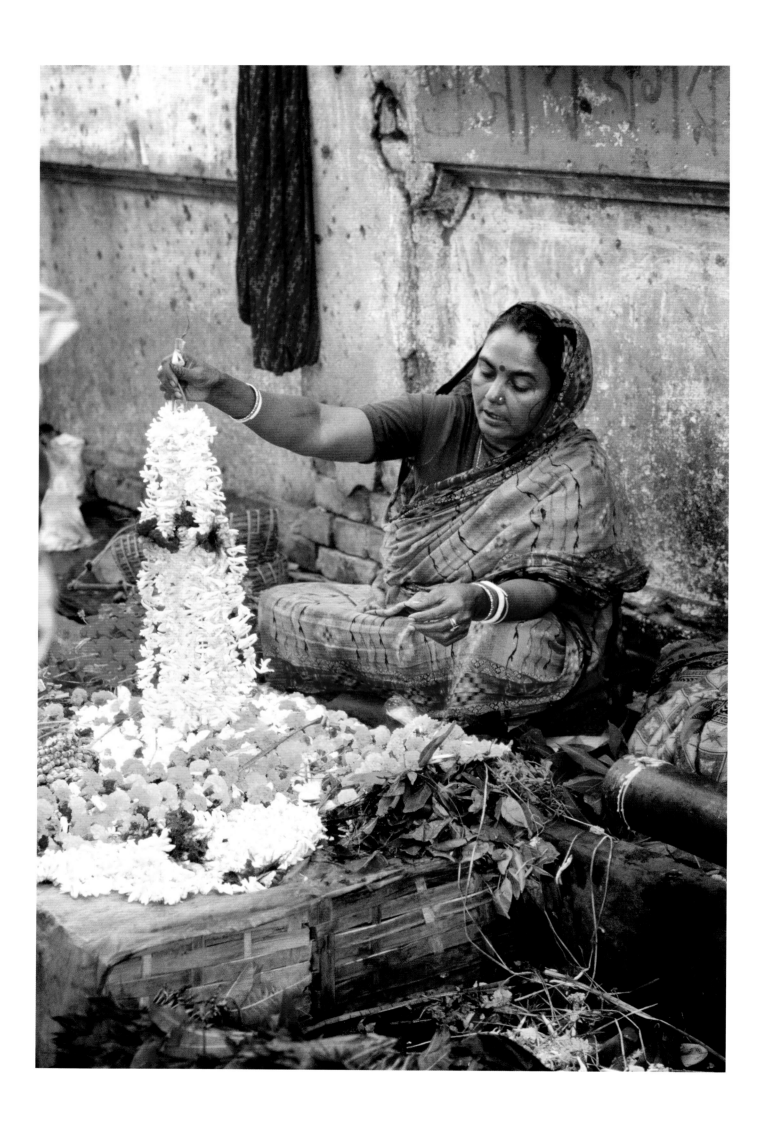

Color is a way of life in India.

*"It is the tears of the earth
that keep her smiles in bloom."*

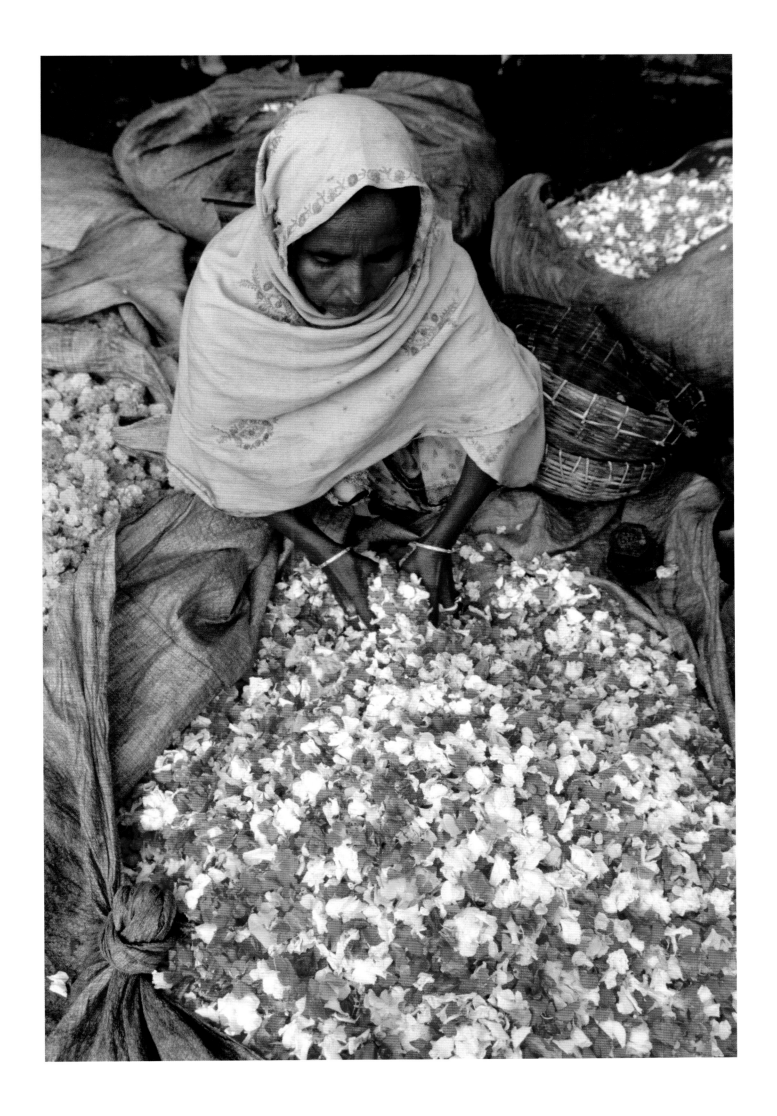

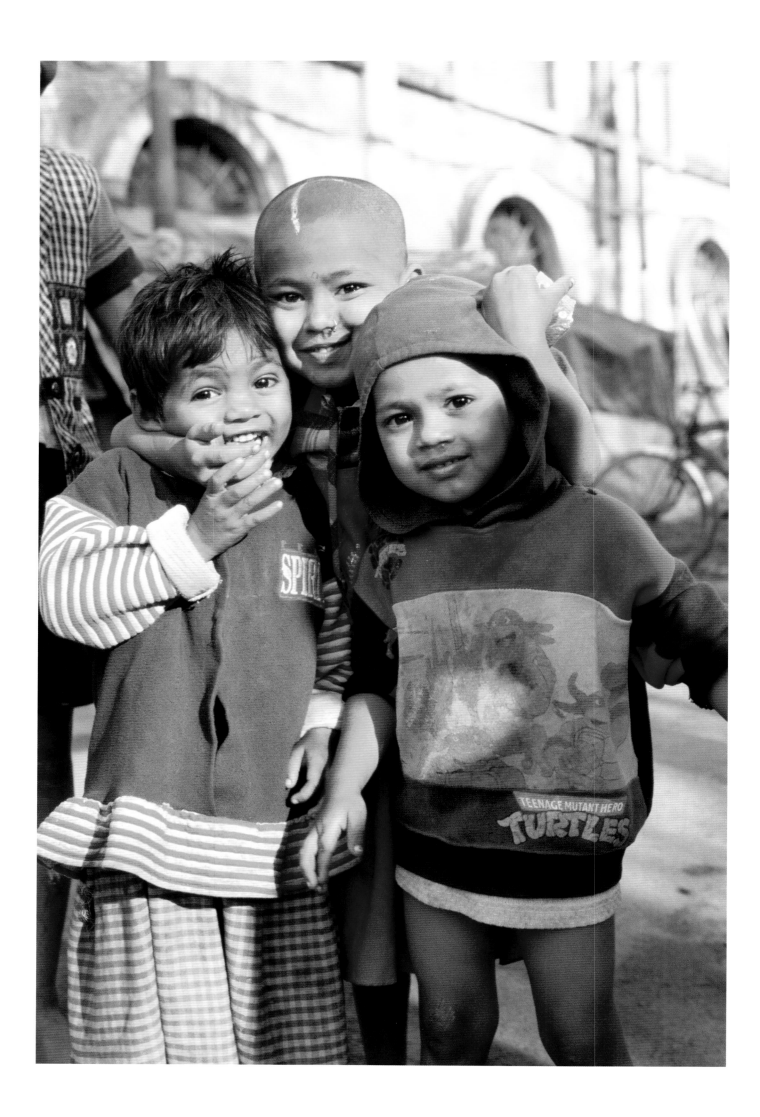

"The bird-song is the echo of the morning light back from the earth."

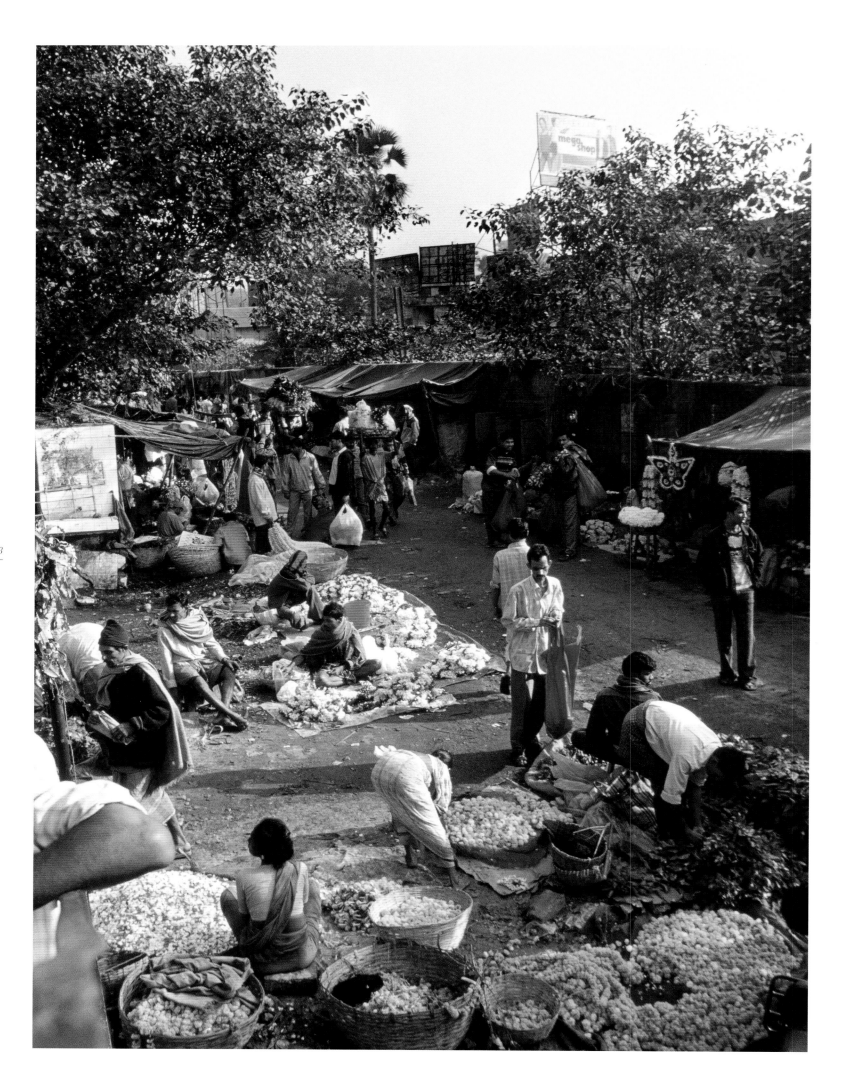
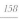

"Wayside grass, love the star, then your dreams will come out in flowers."

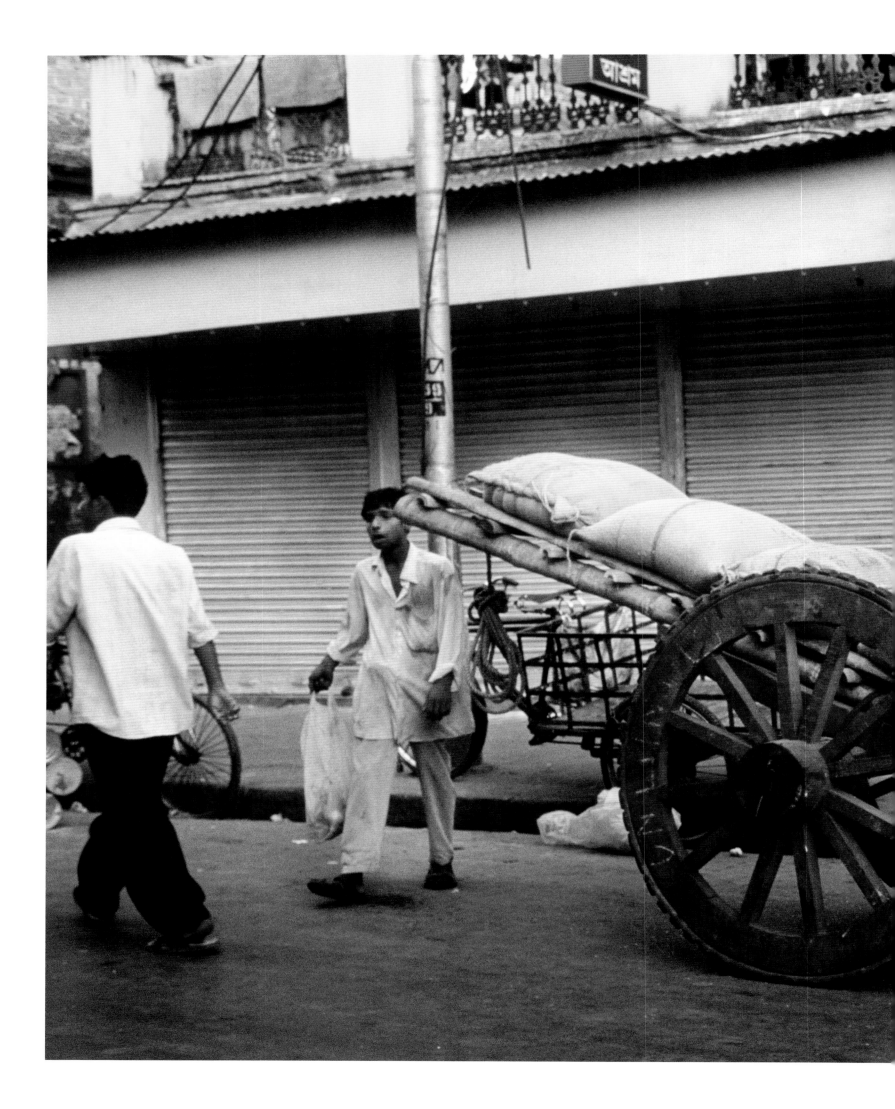

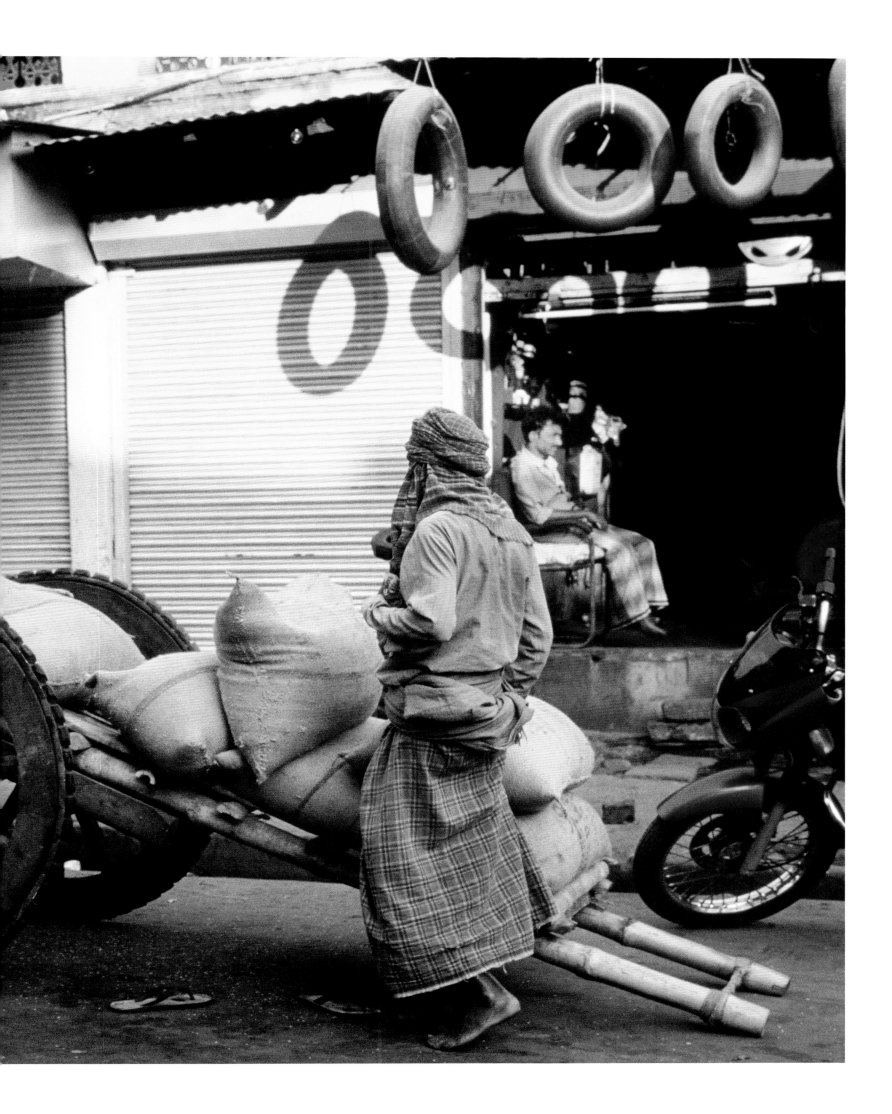

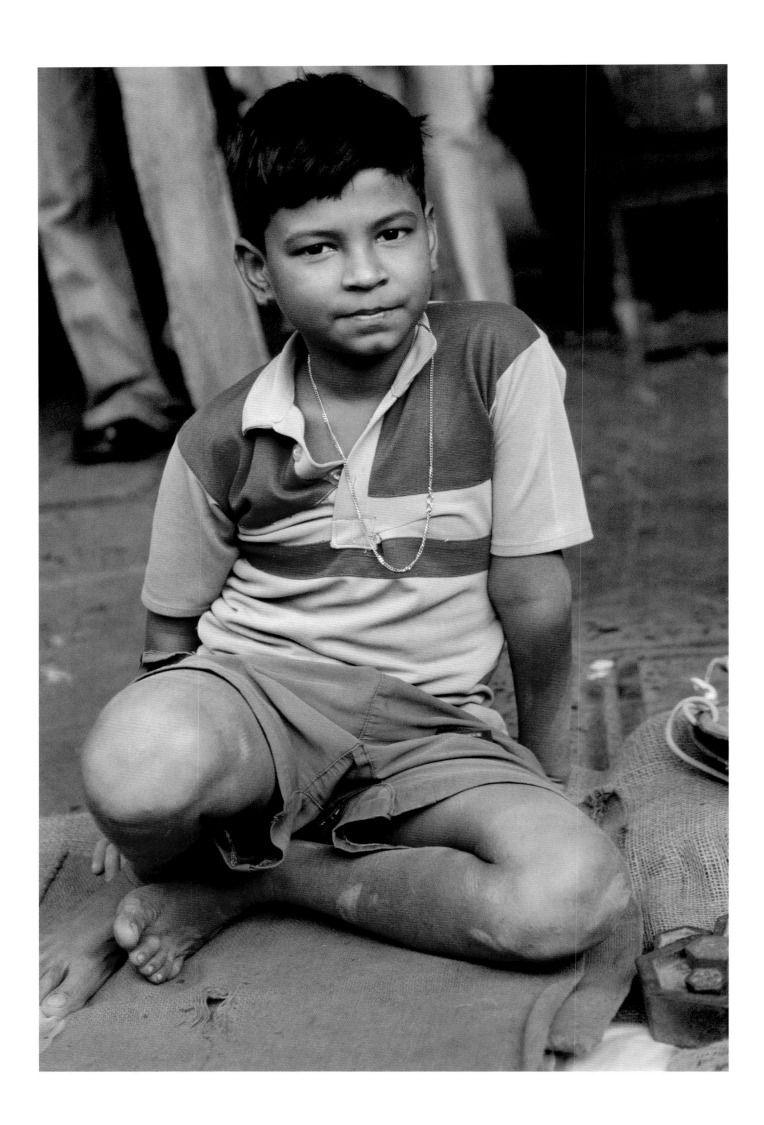

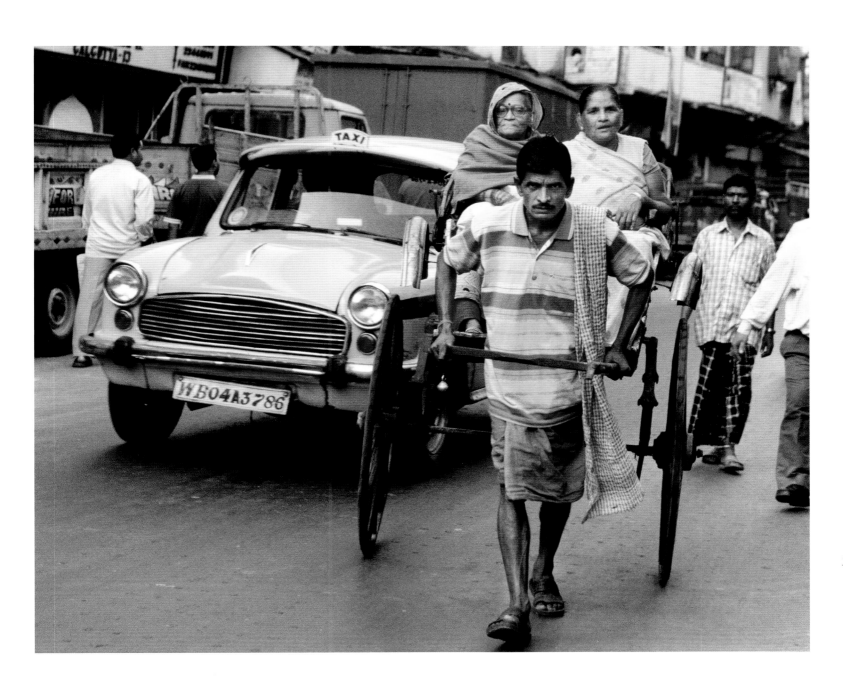

Pages 160–167: An area of specialty shops selling herbs and spices, Kolkata.

Left: A boy selling potatoes on the street.

Above: Rickshaw, taxi and truck.

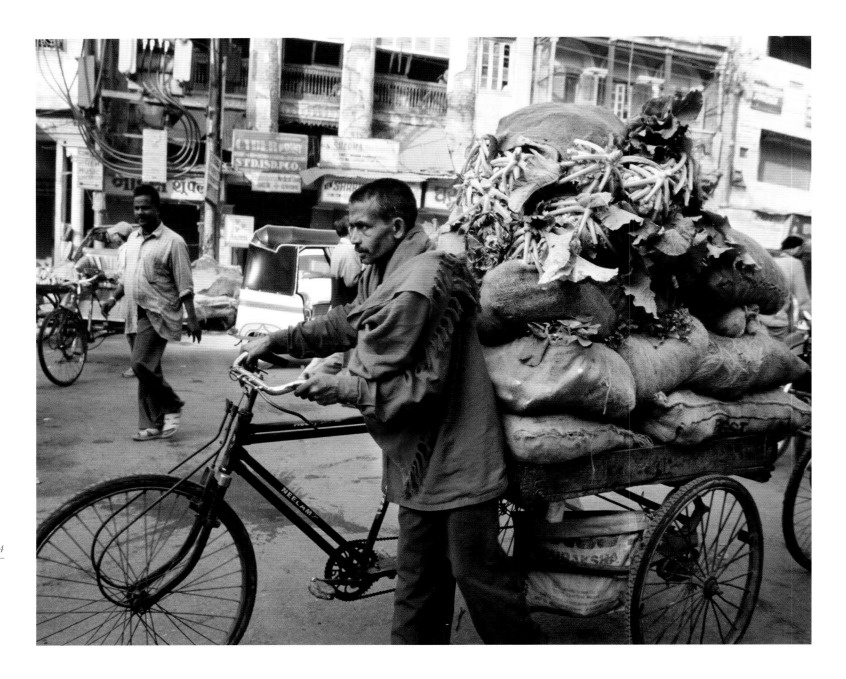

All manner of vehicles on the road.
Three wheel bicycle cart.

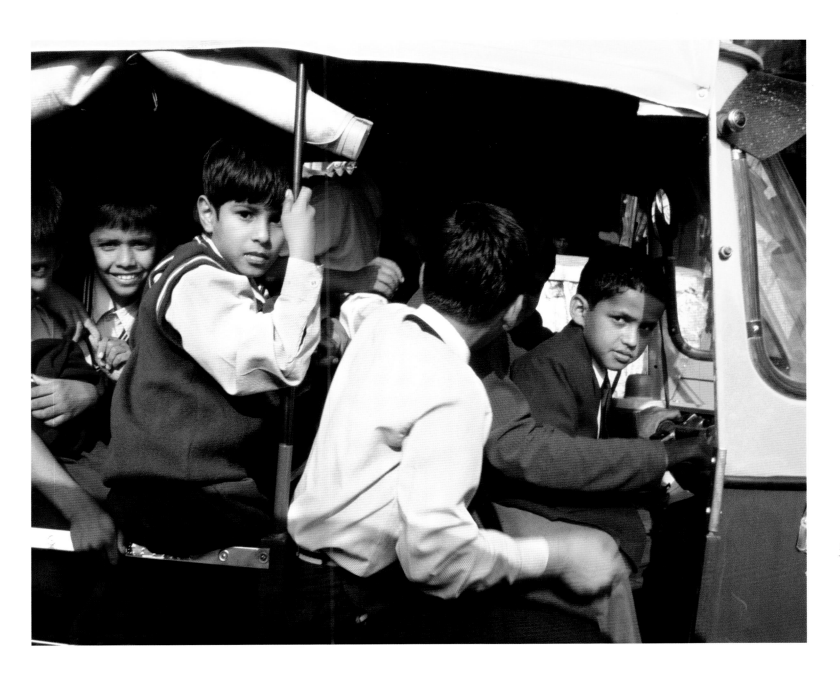

Three wheel school bus.

"We live in this world when we love it."

A riot of colorful clothing for sale on a street vendor's stand.

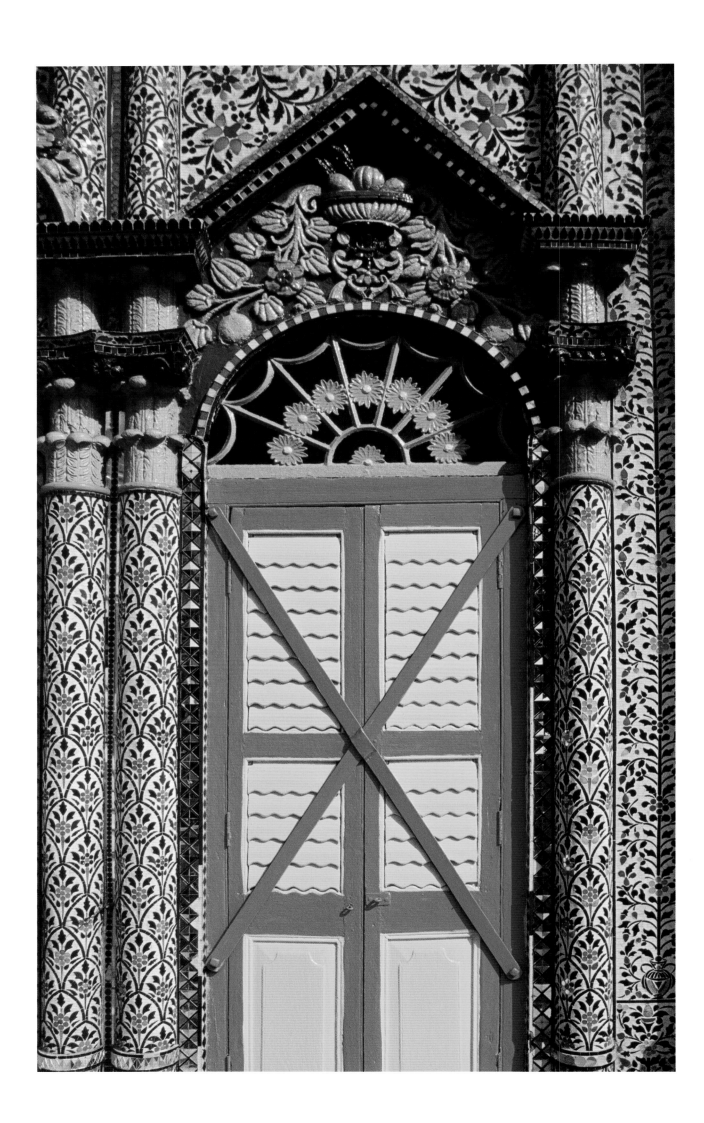

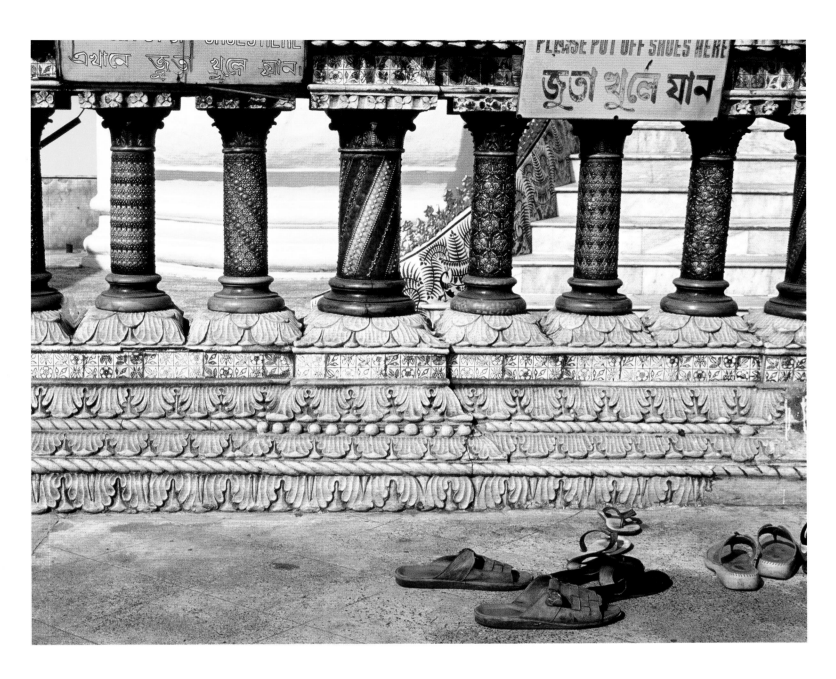

Left: Inlaid colored glass and stones set in a Jain Temple door surround in Kolkata.

Above: The entry area to the Jain Temple incorporating fine ceramic decorative elements imported from Royal Doulton in England.

Pages 170–171: Victoria Monument in reflecting pond, Kolkata.

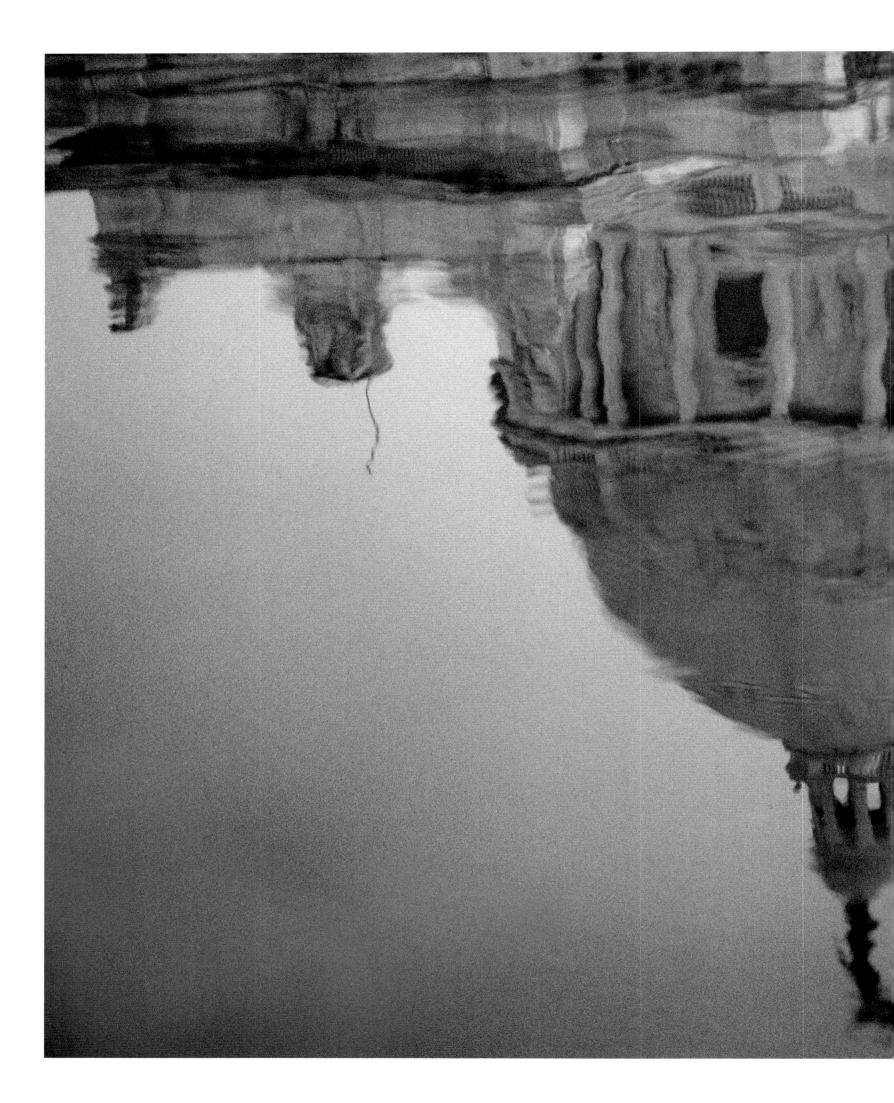

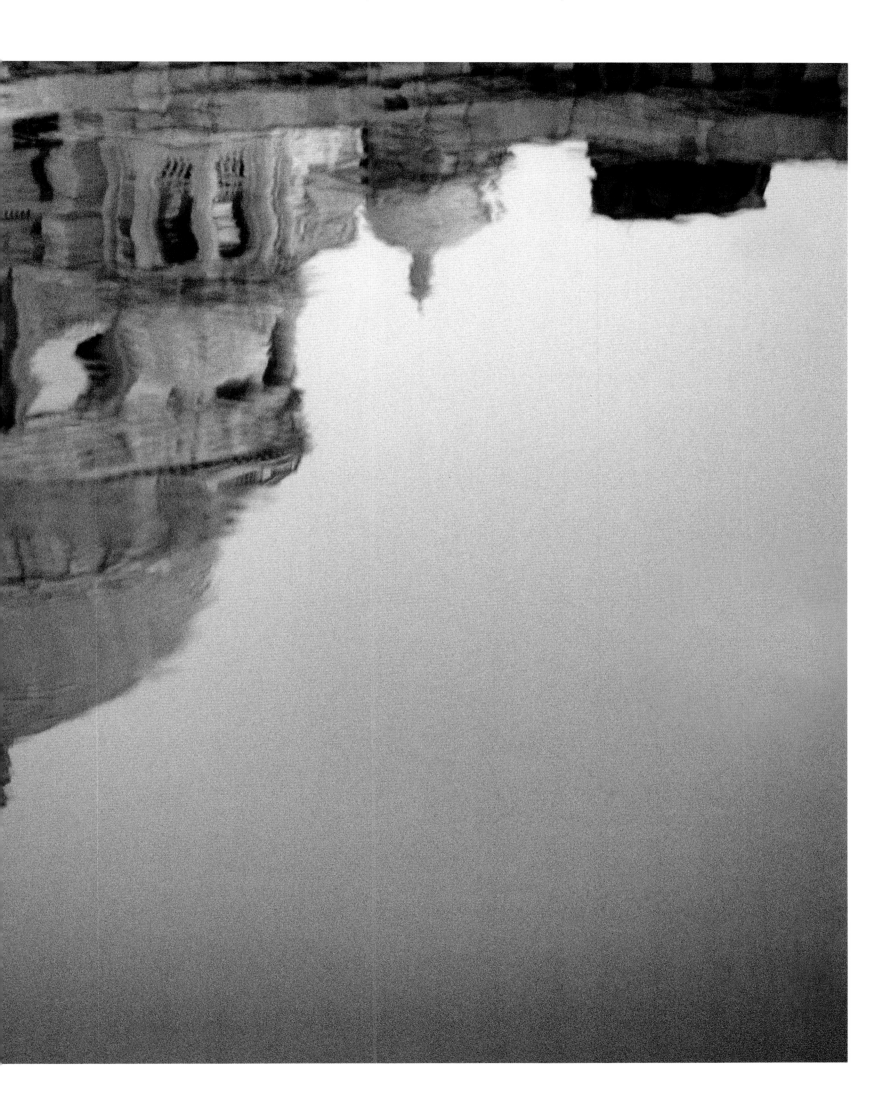

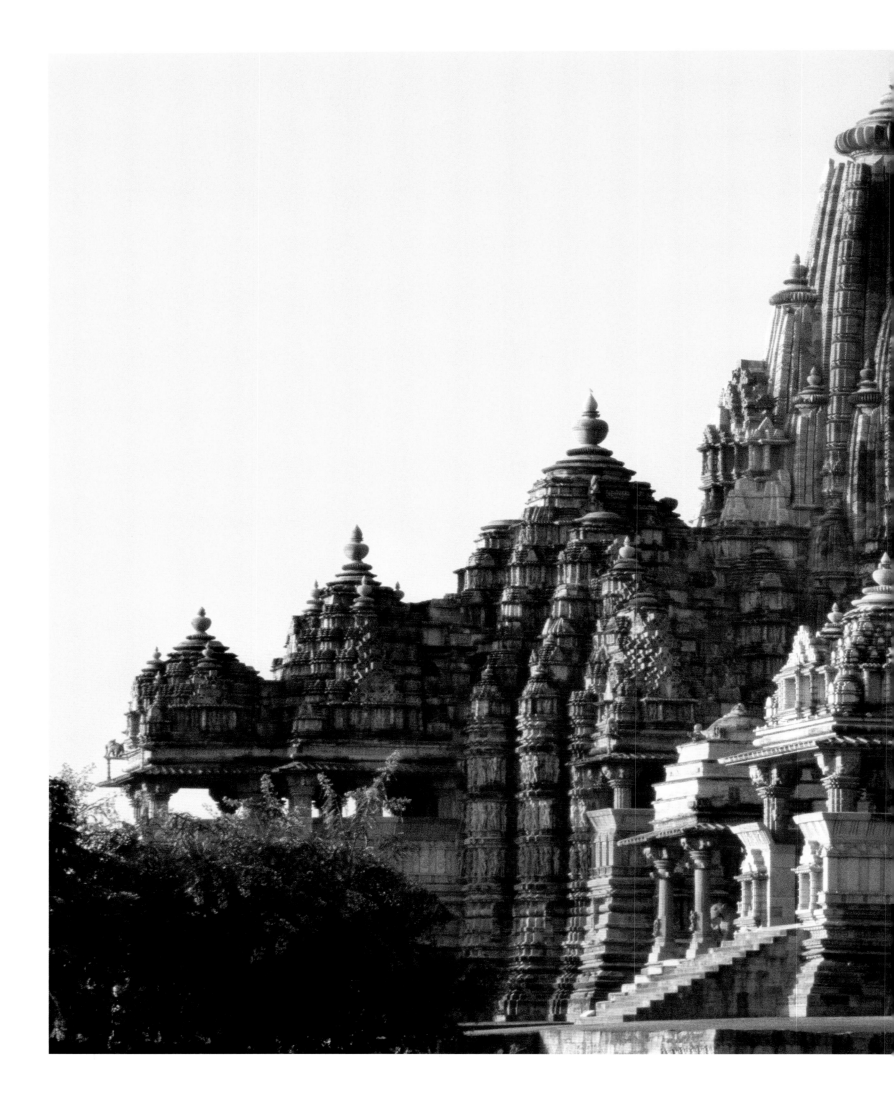

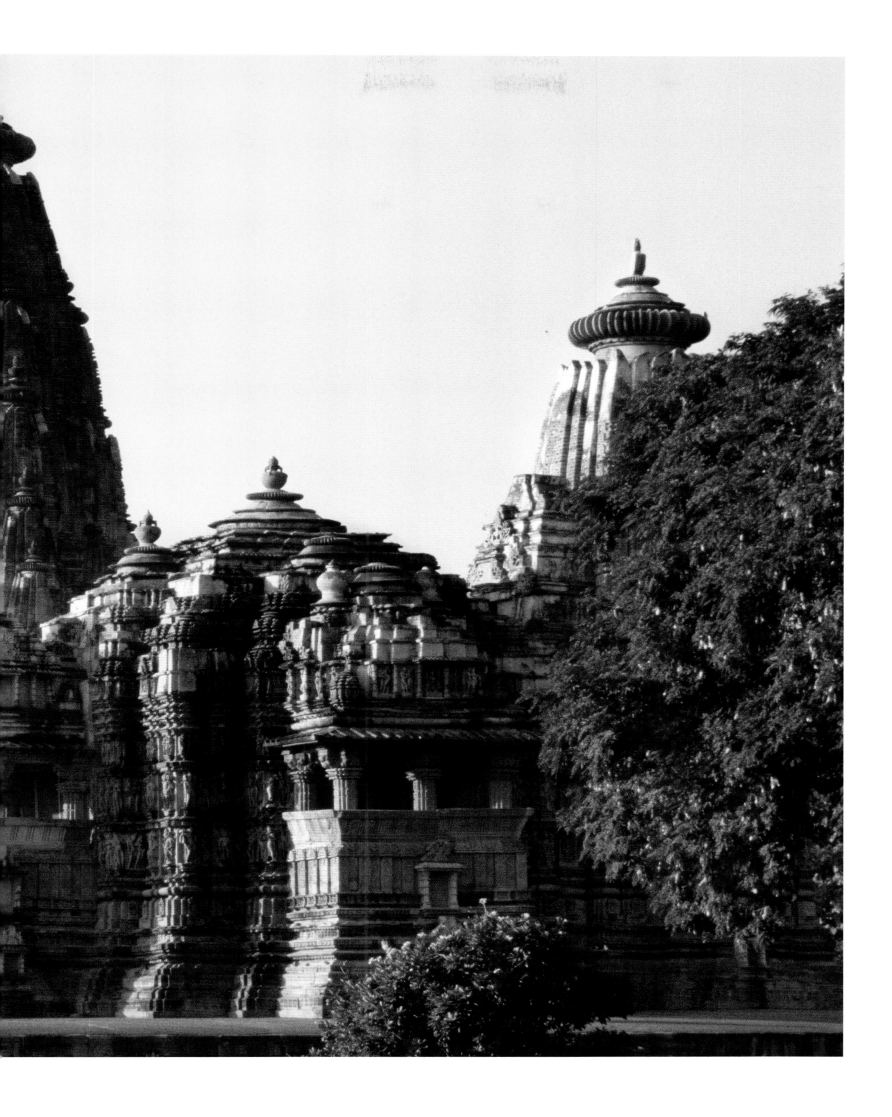

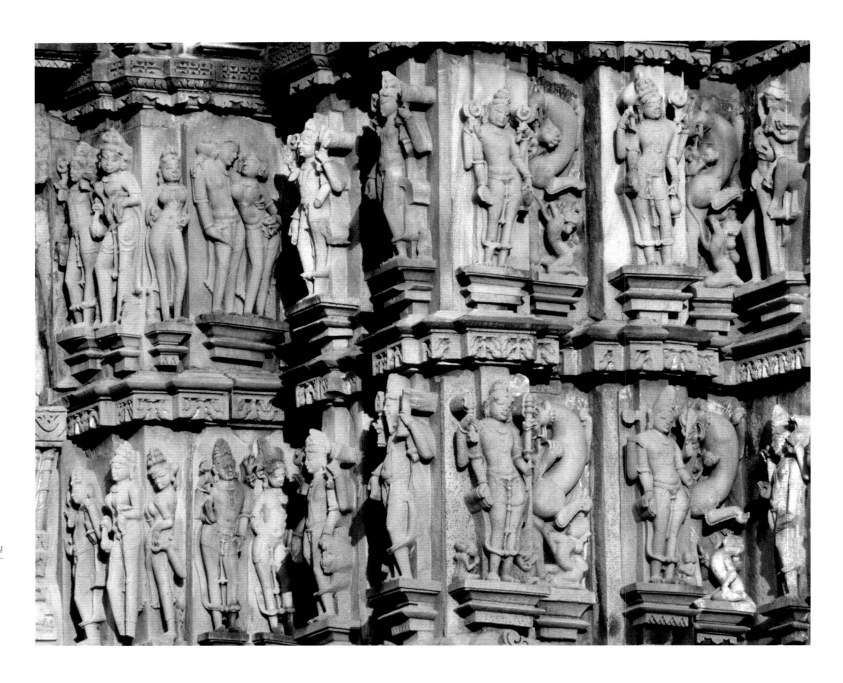

Pages 172–177: Antiquities in Khajuraho. The temple and stone carvings.

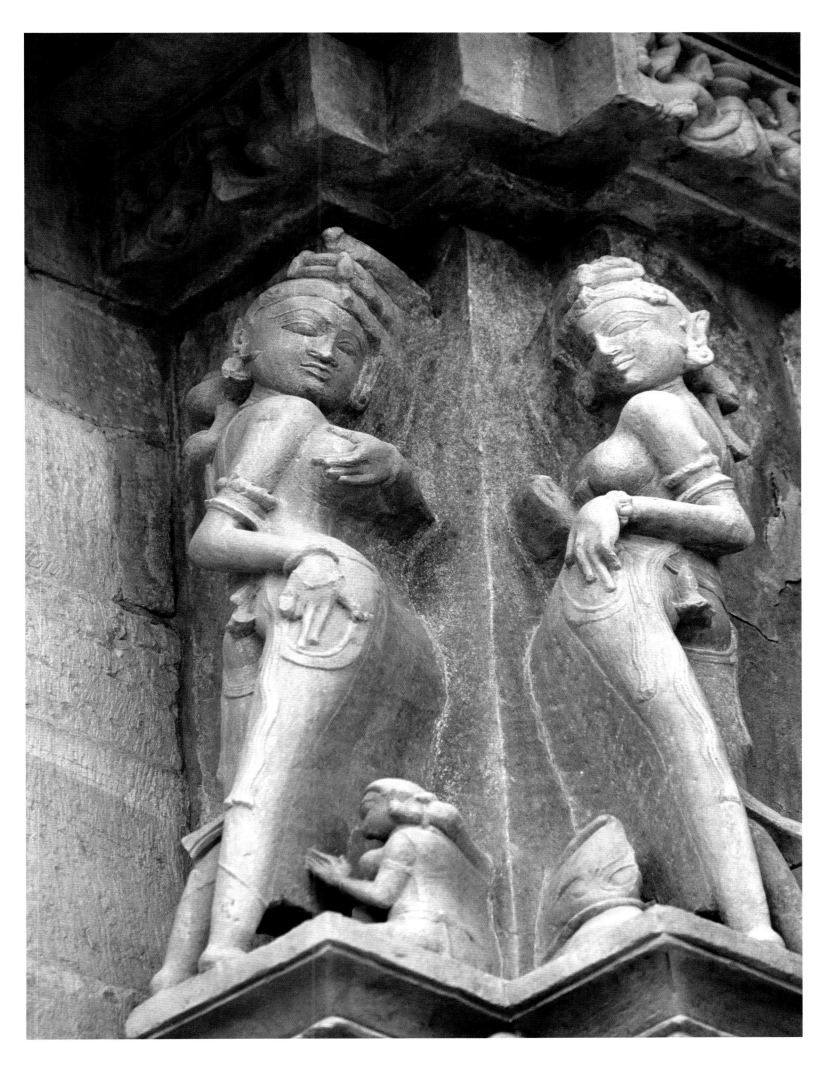

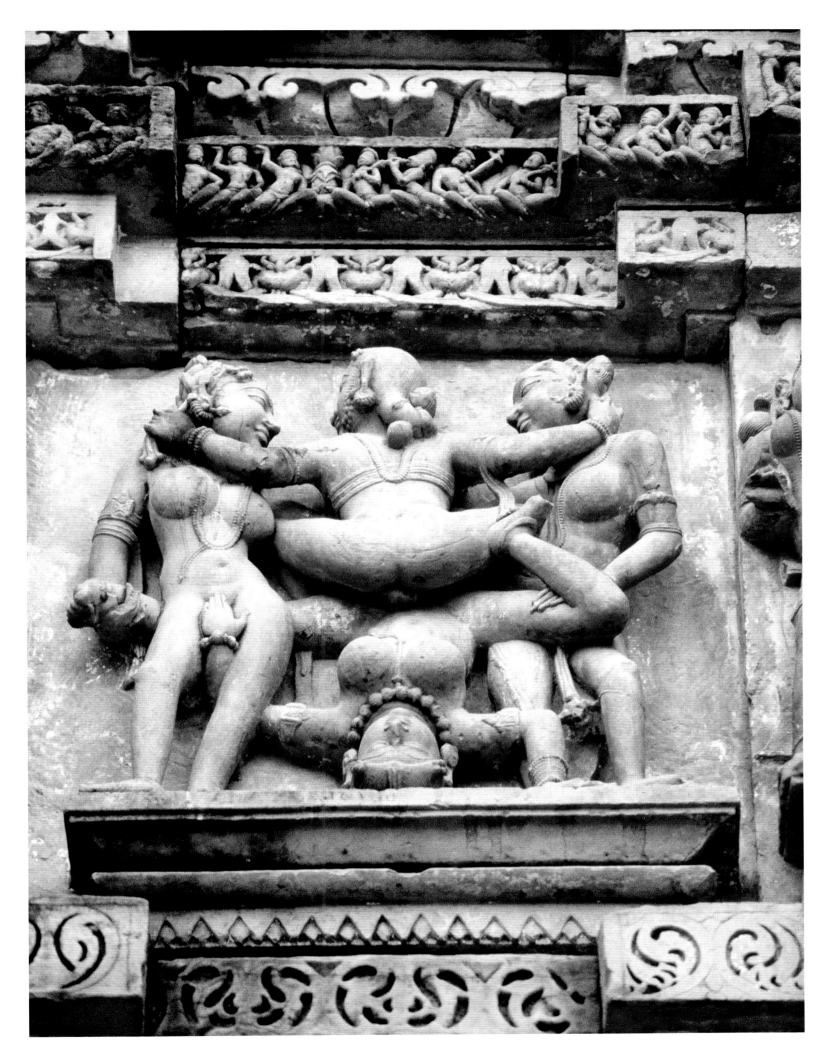

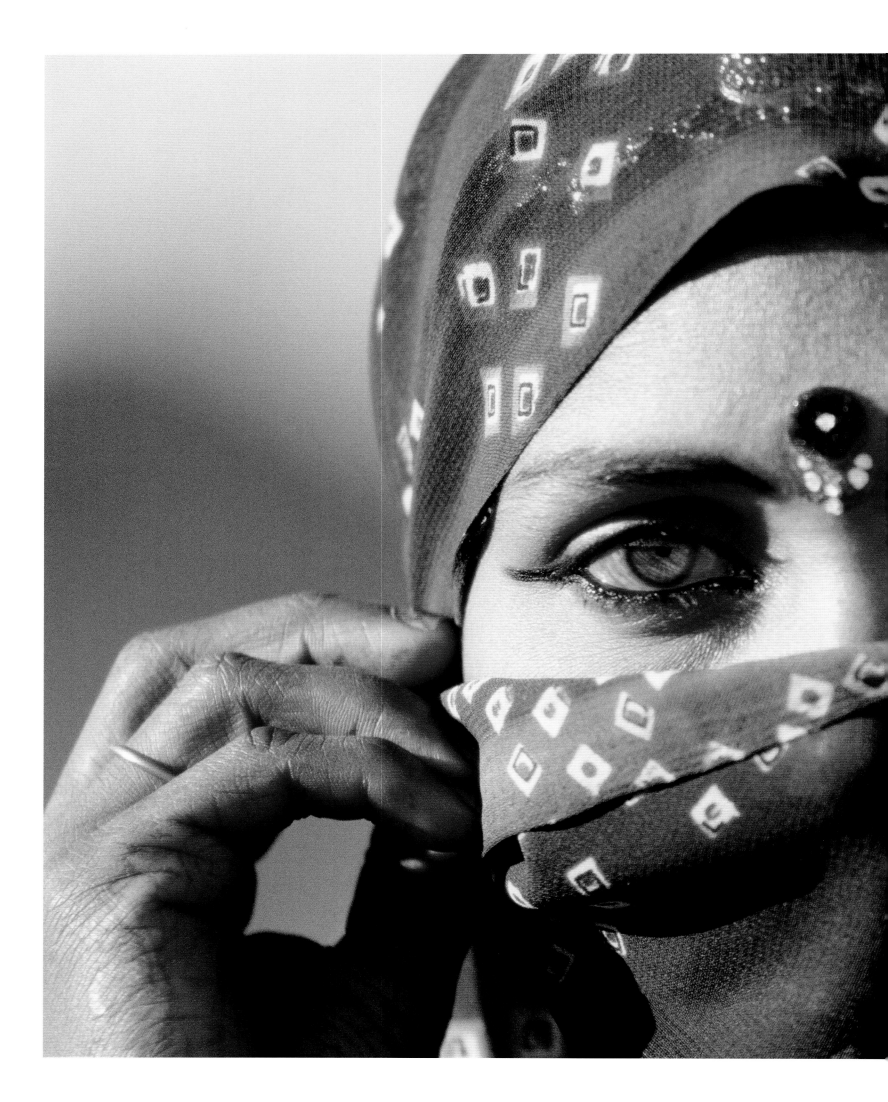

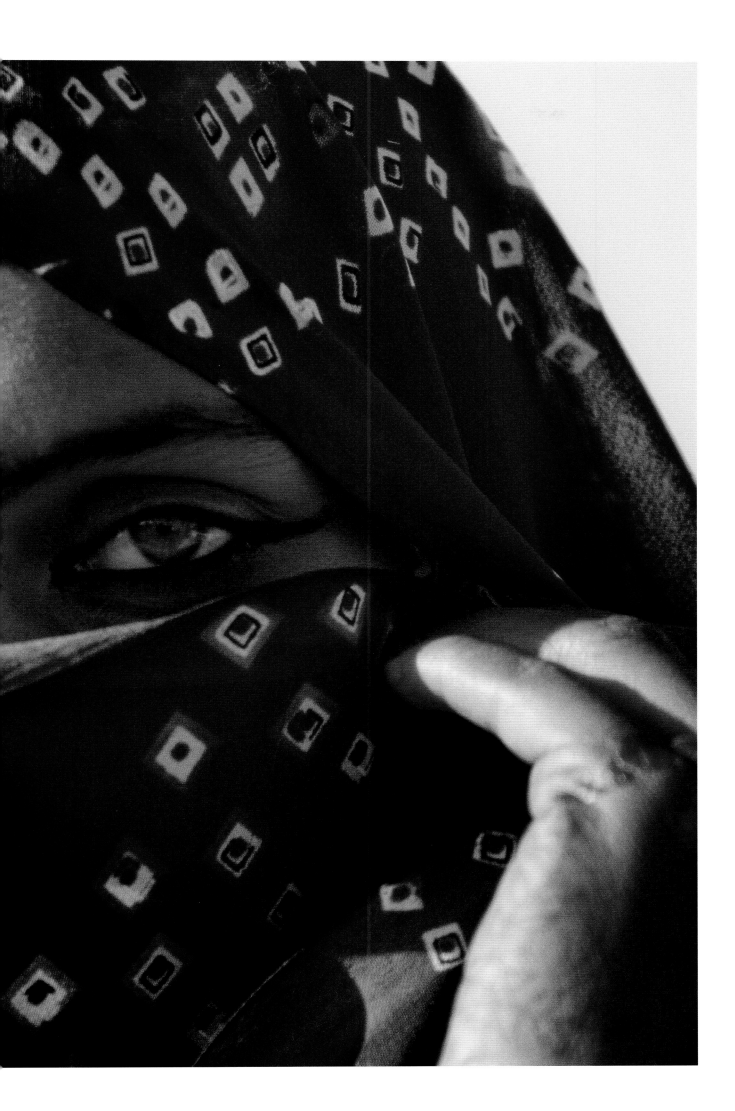

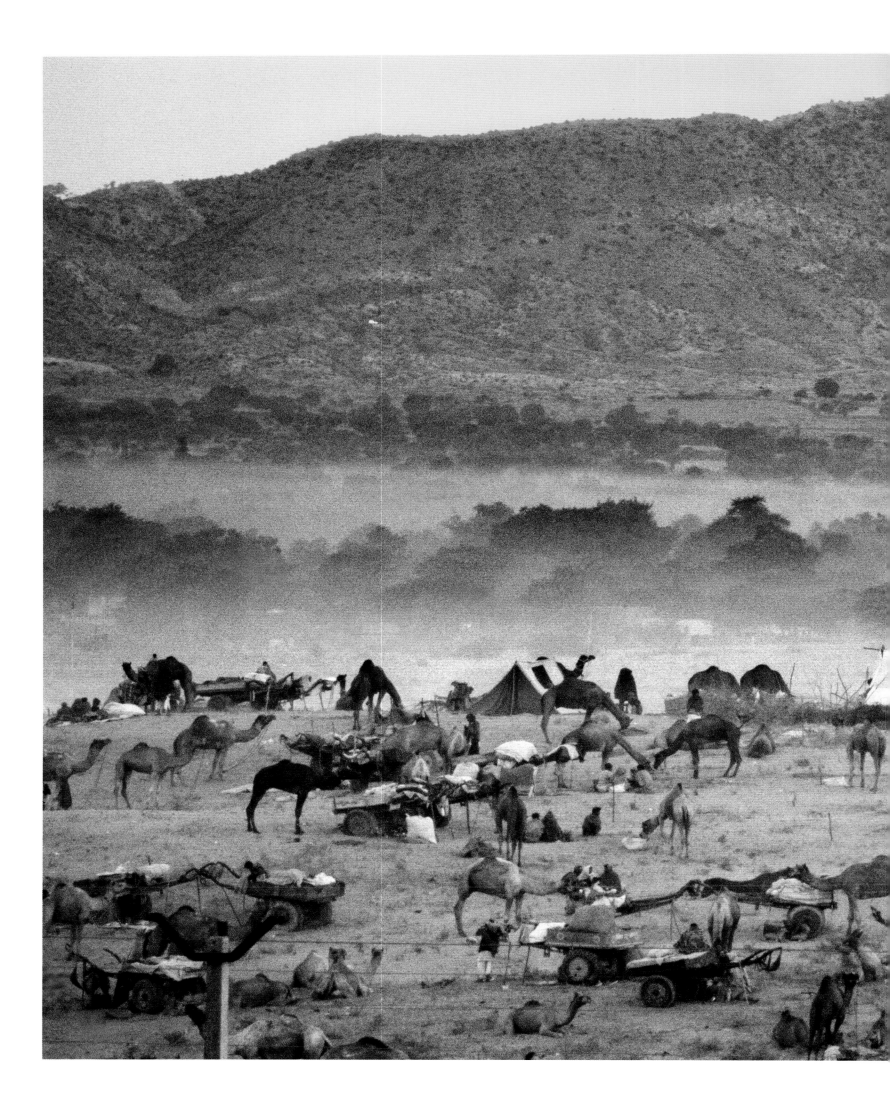

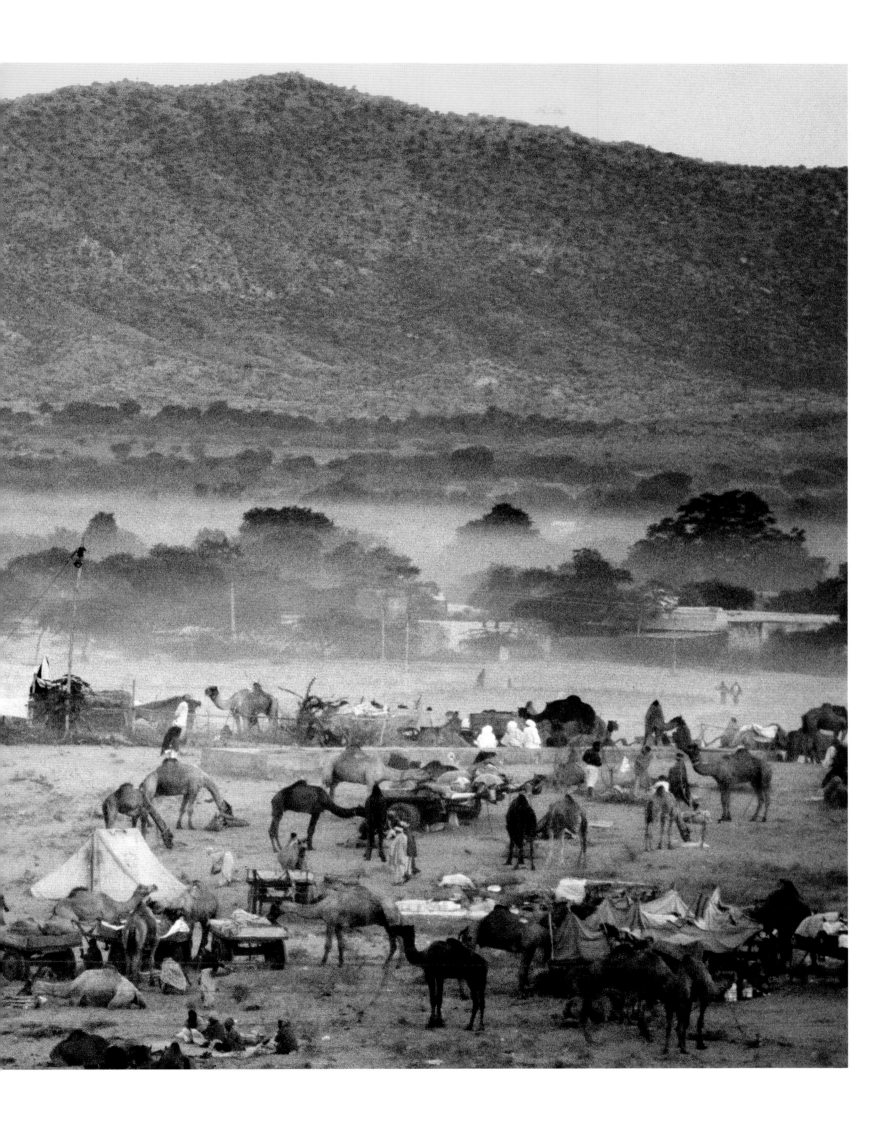

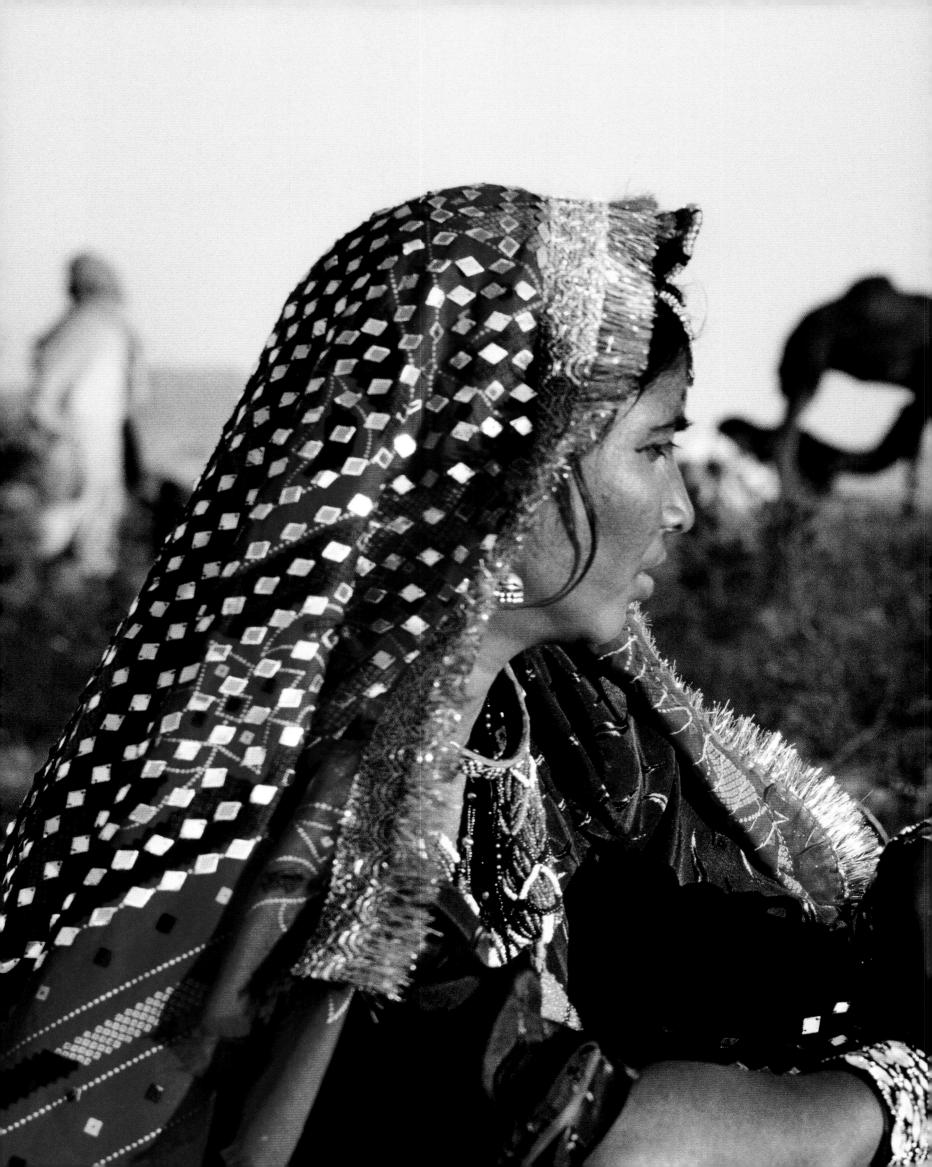

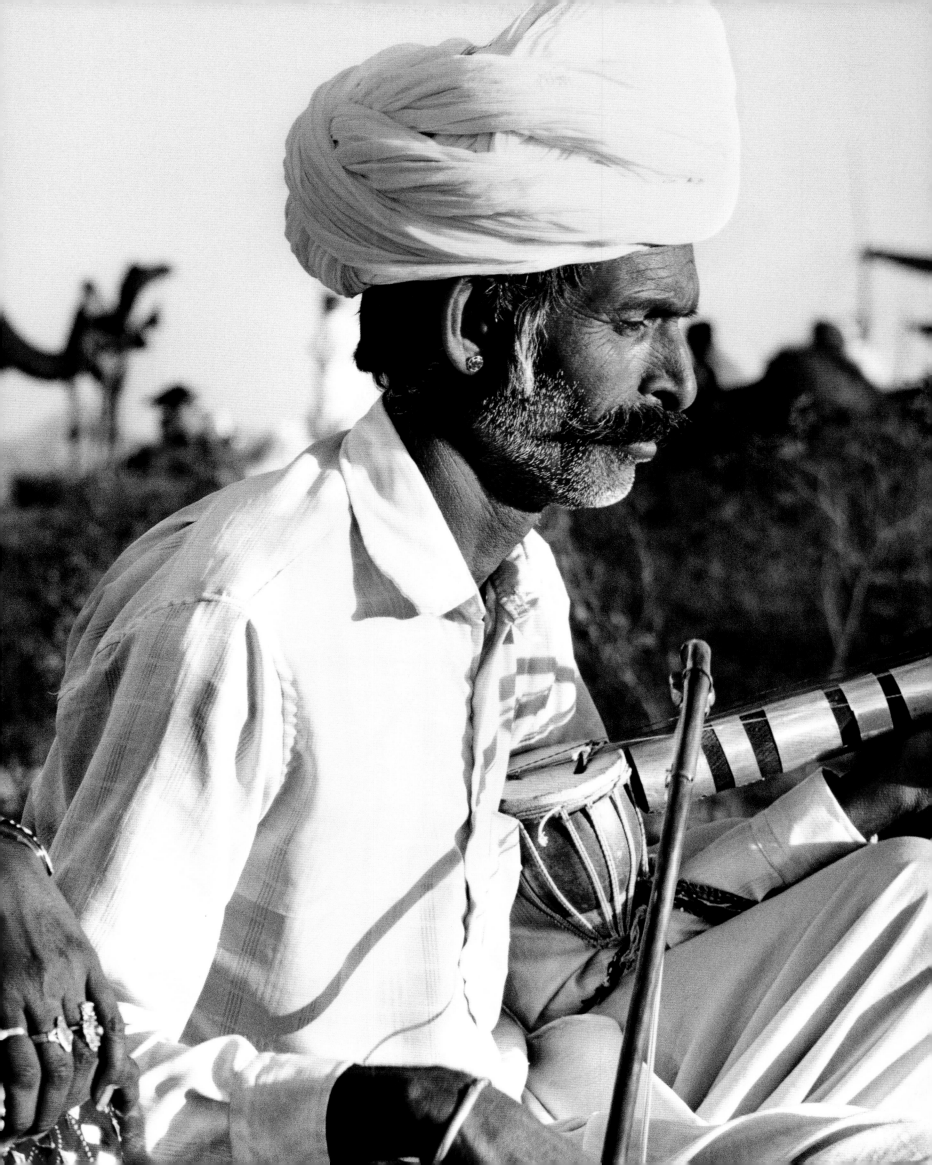

"Do not say, "It is morning," and
dismiss it with a name of yesterday.
See it for the first time as a
new-born child that has no name."

Pages 178–199: In Rajasthan at the Pushkar Fair. Livestock are bought and traded,
performers sing, dance and play instruments, campfires are lit and entire families take part.

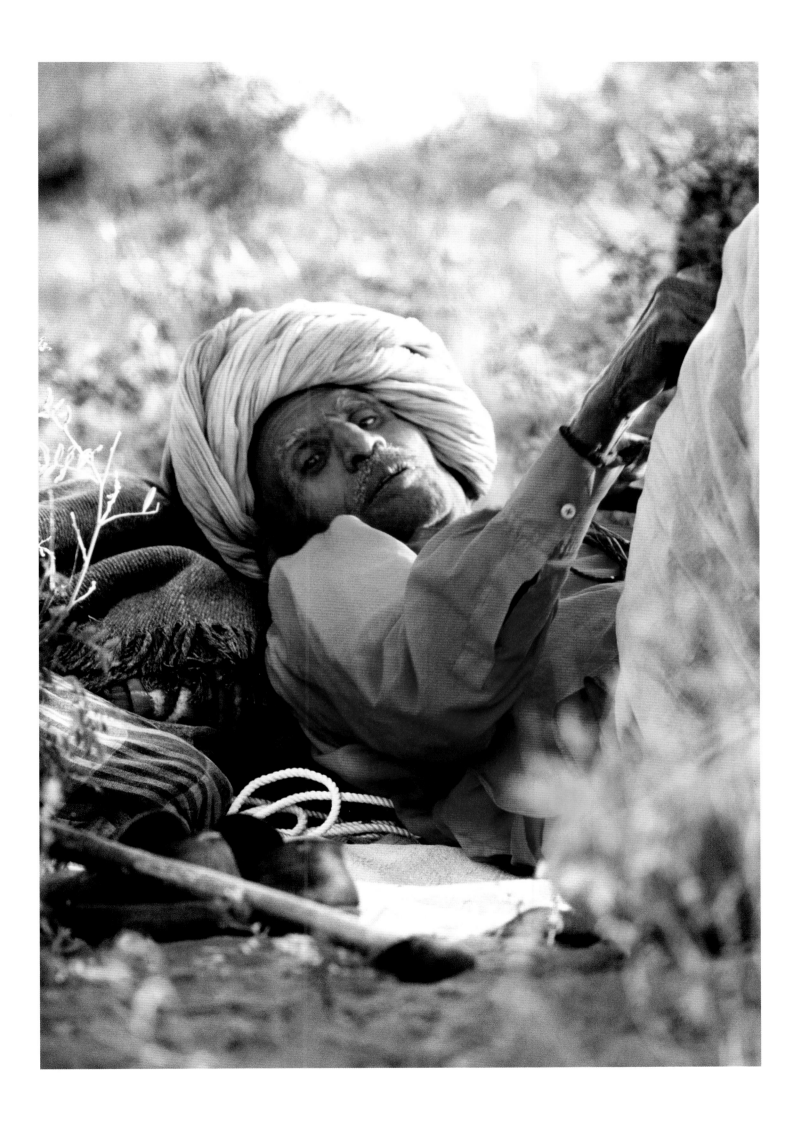

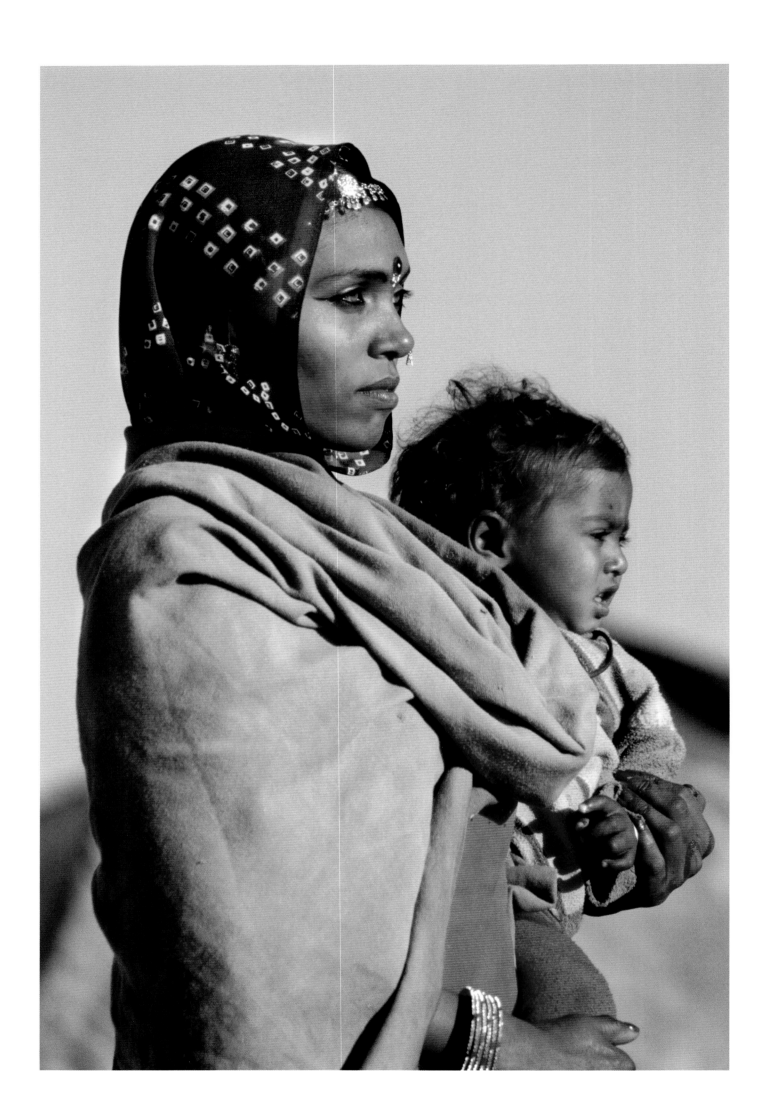

"The movement of life has its rest in its own music."

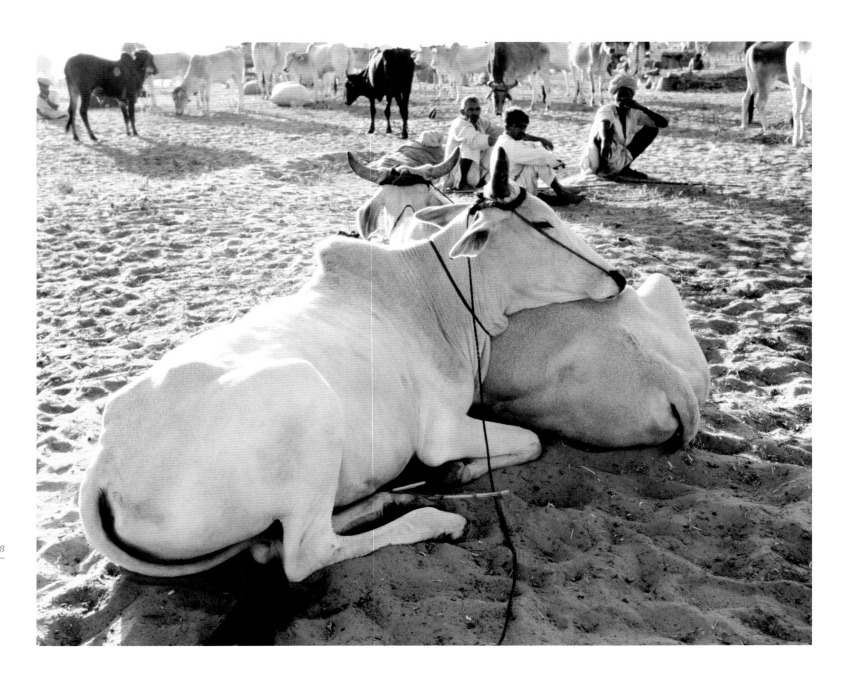

"God finds himself by creating."

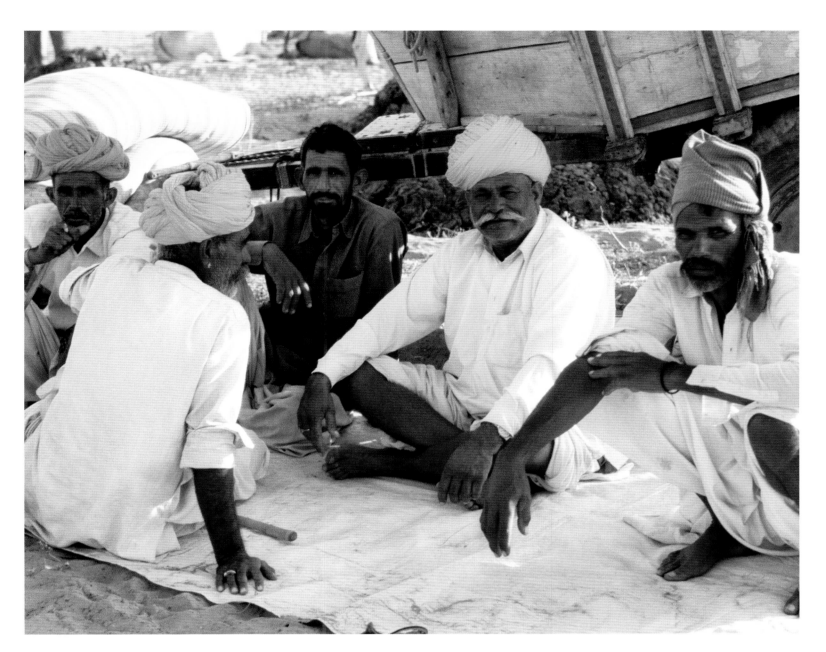

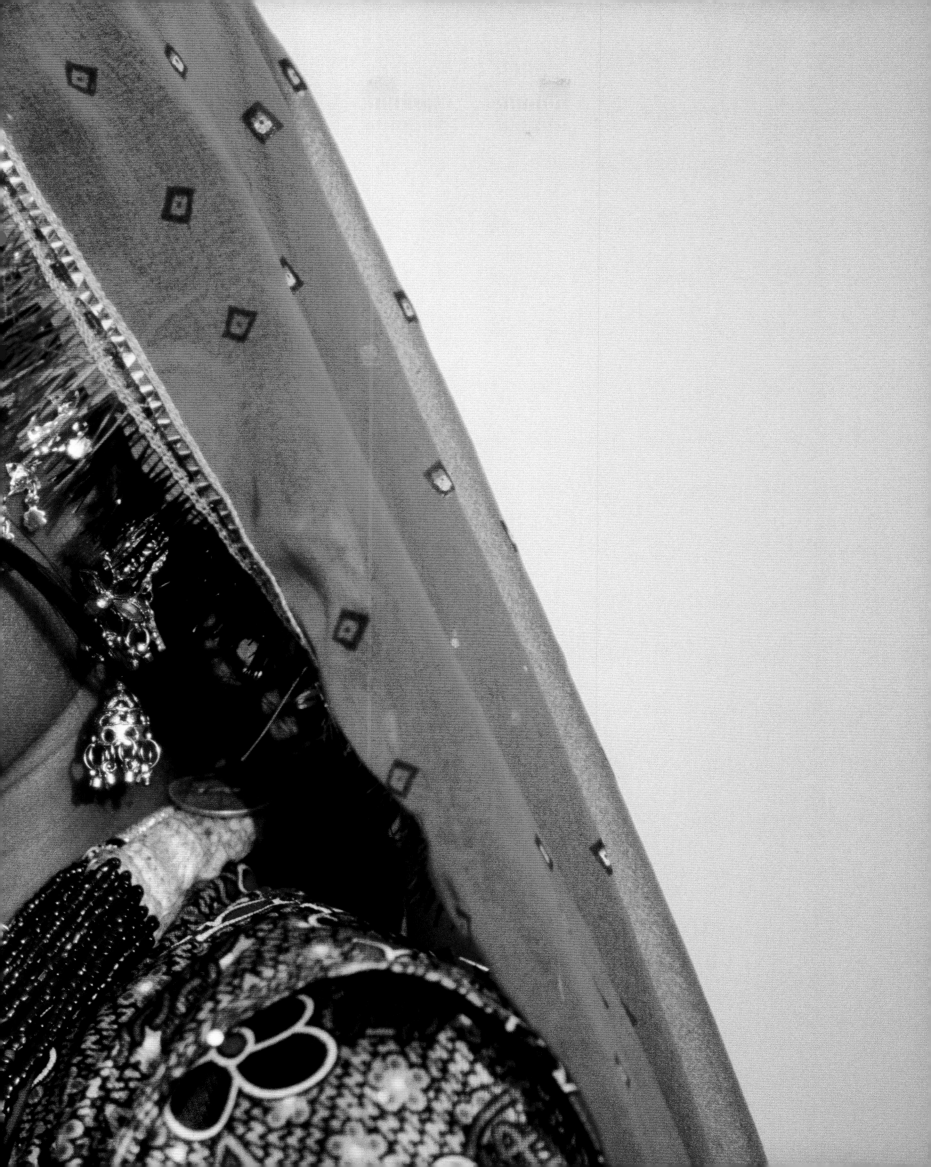

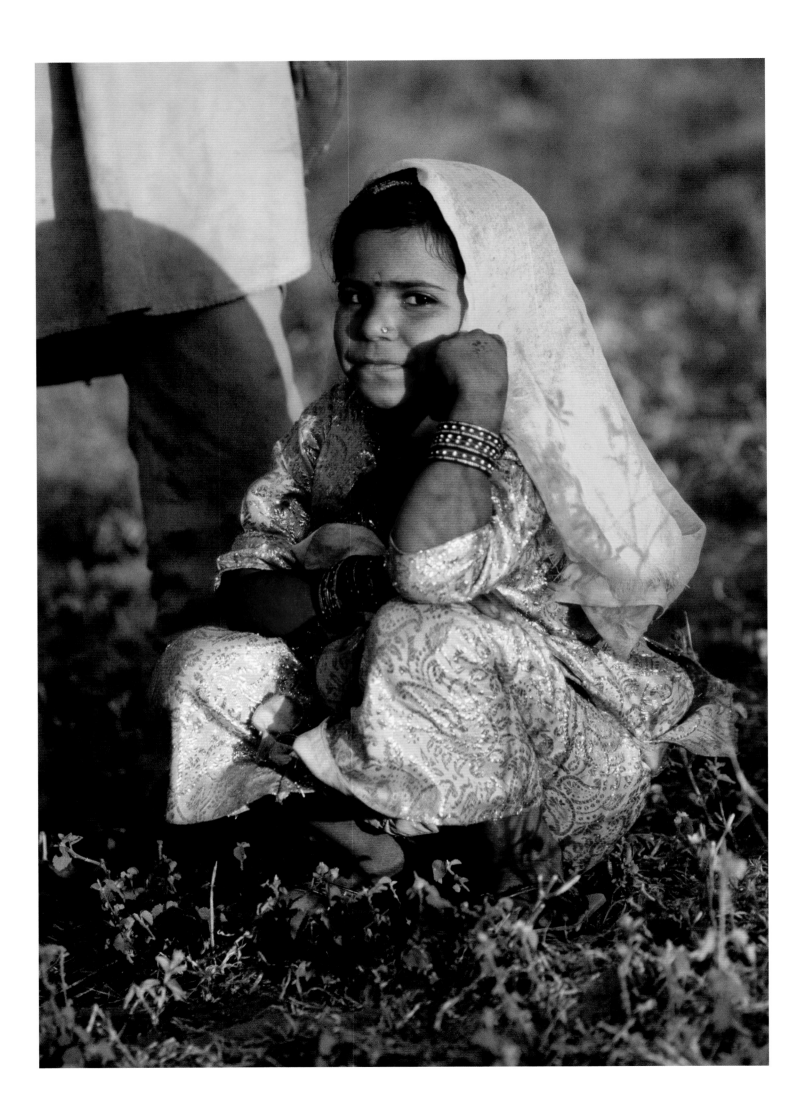

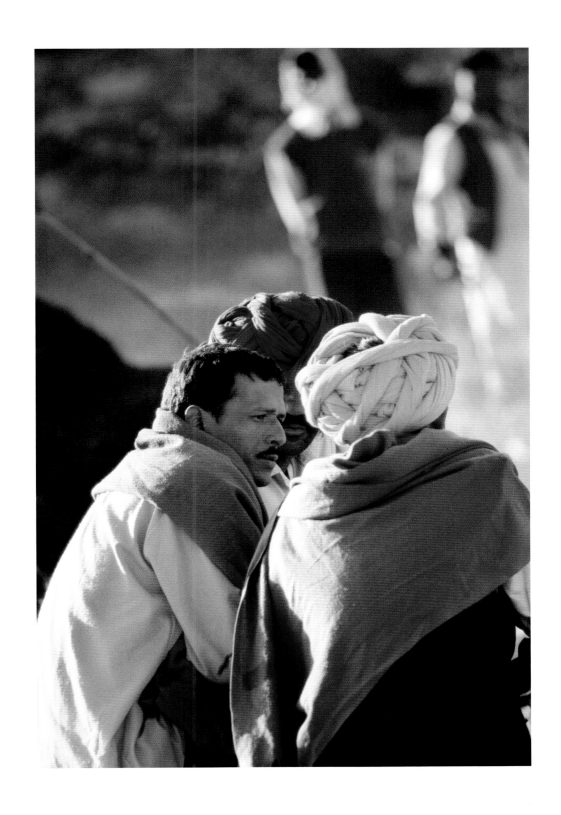

*"The prelude of the night is commenced
in the music of the sunset, in its solemn
hymn to the ineffable dark."*

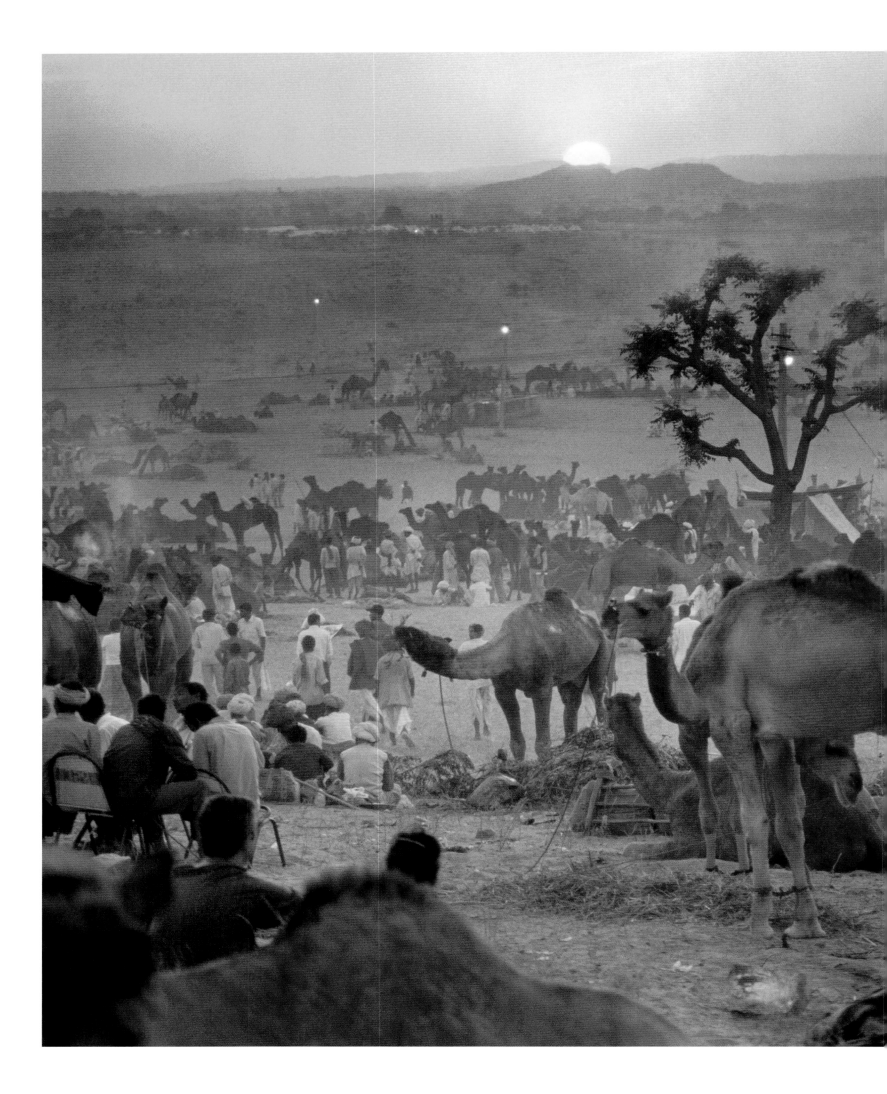

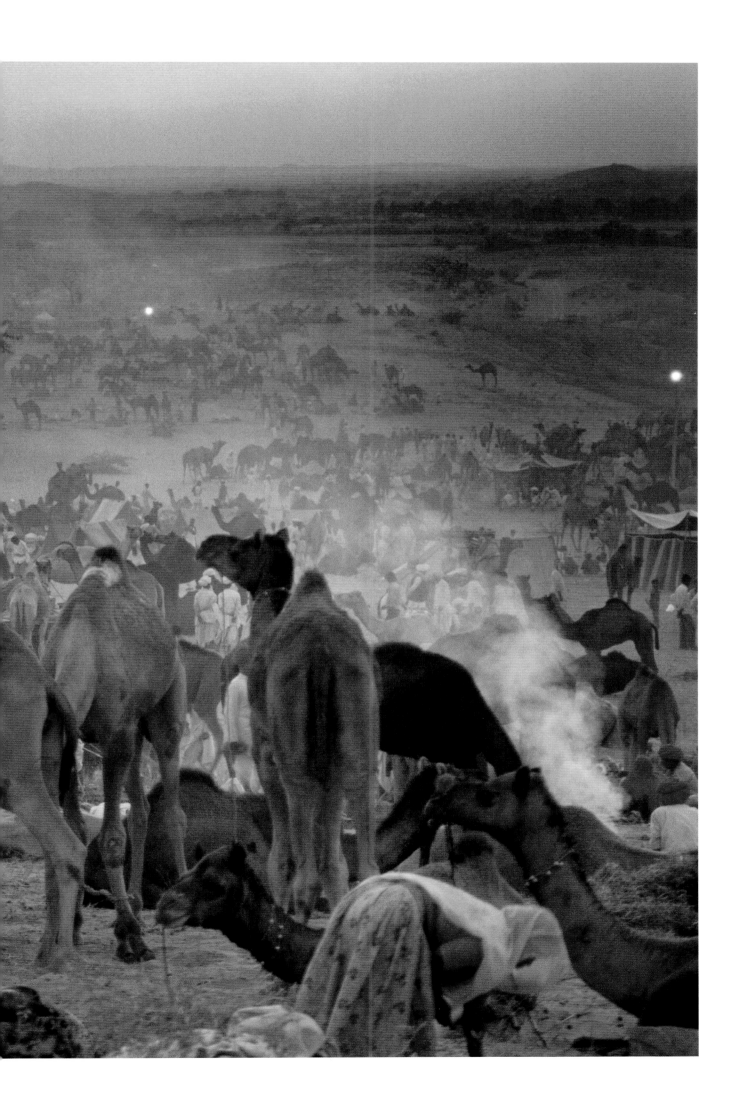

"Woman, with the grace of your fingers
you touched my things and order came
out like music."

Pages 196–199: Gypsy musician and dancers.

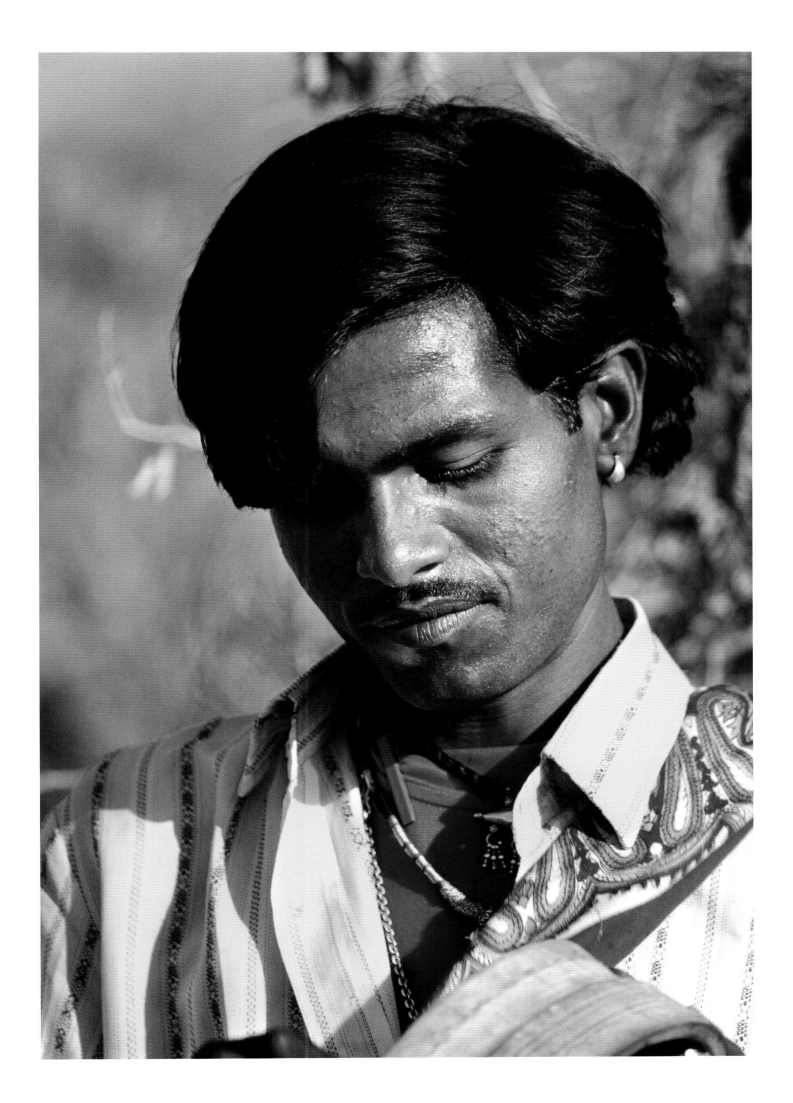

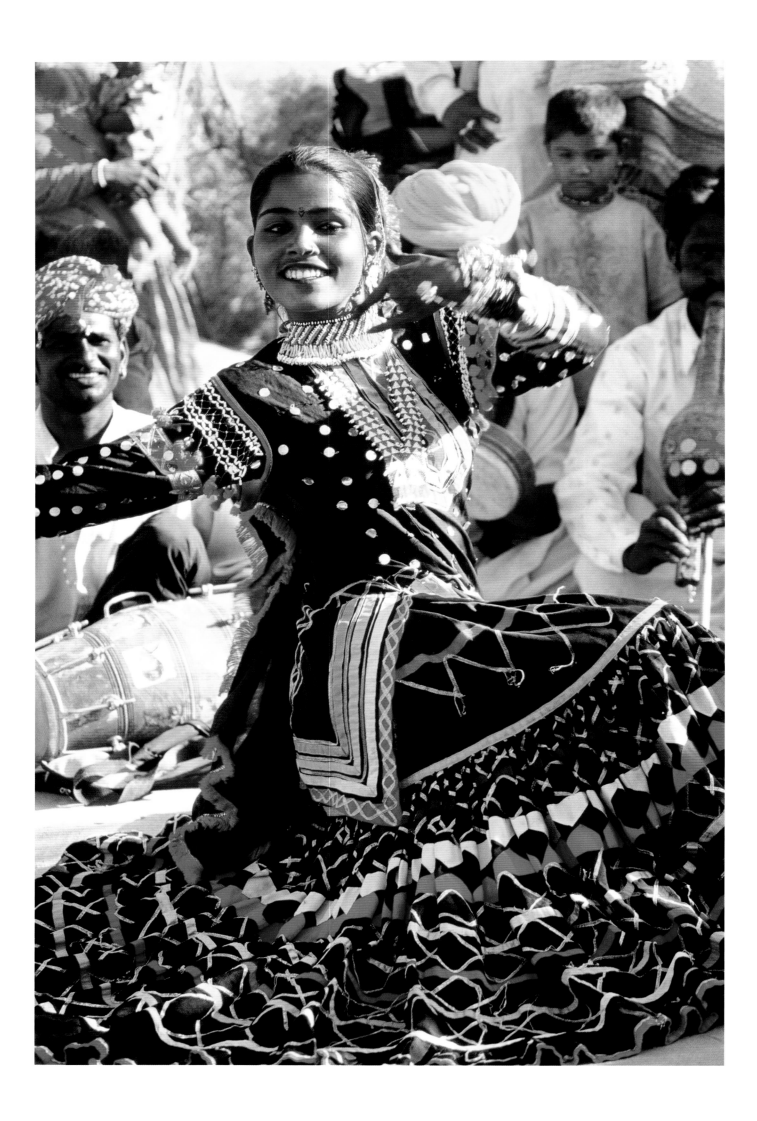

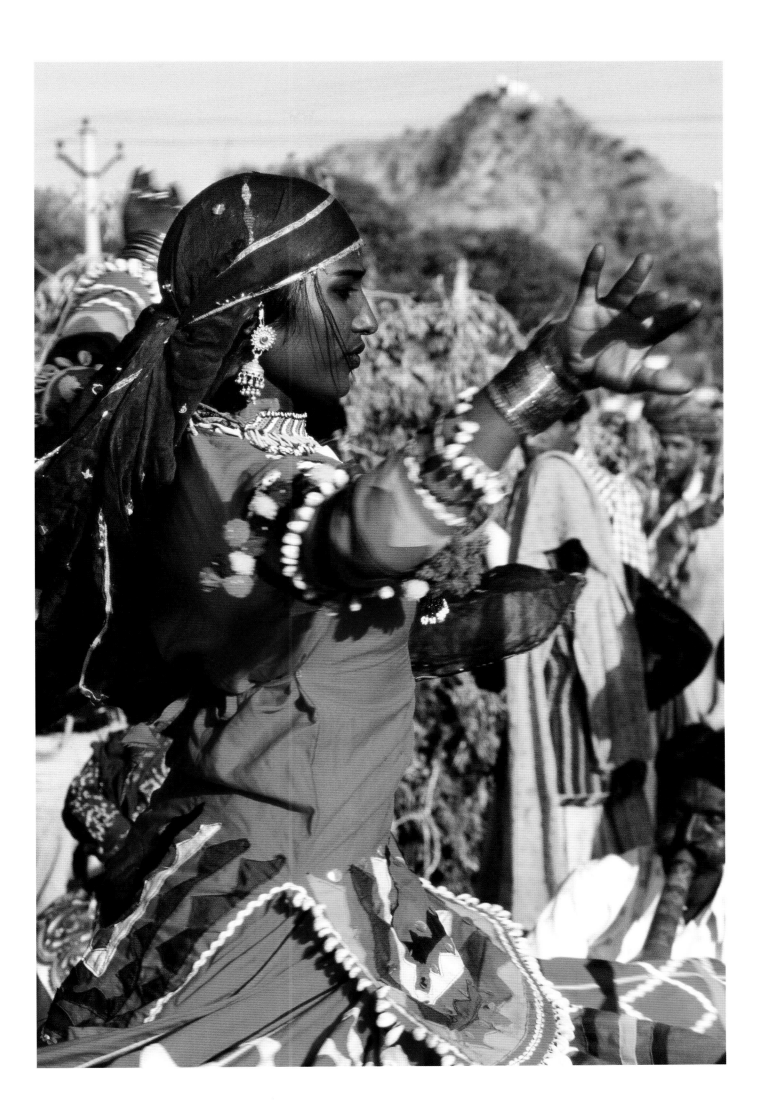

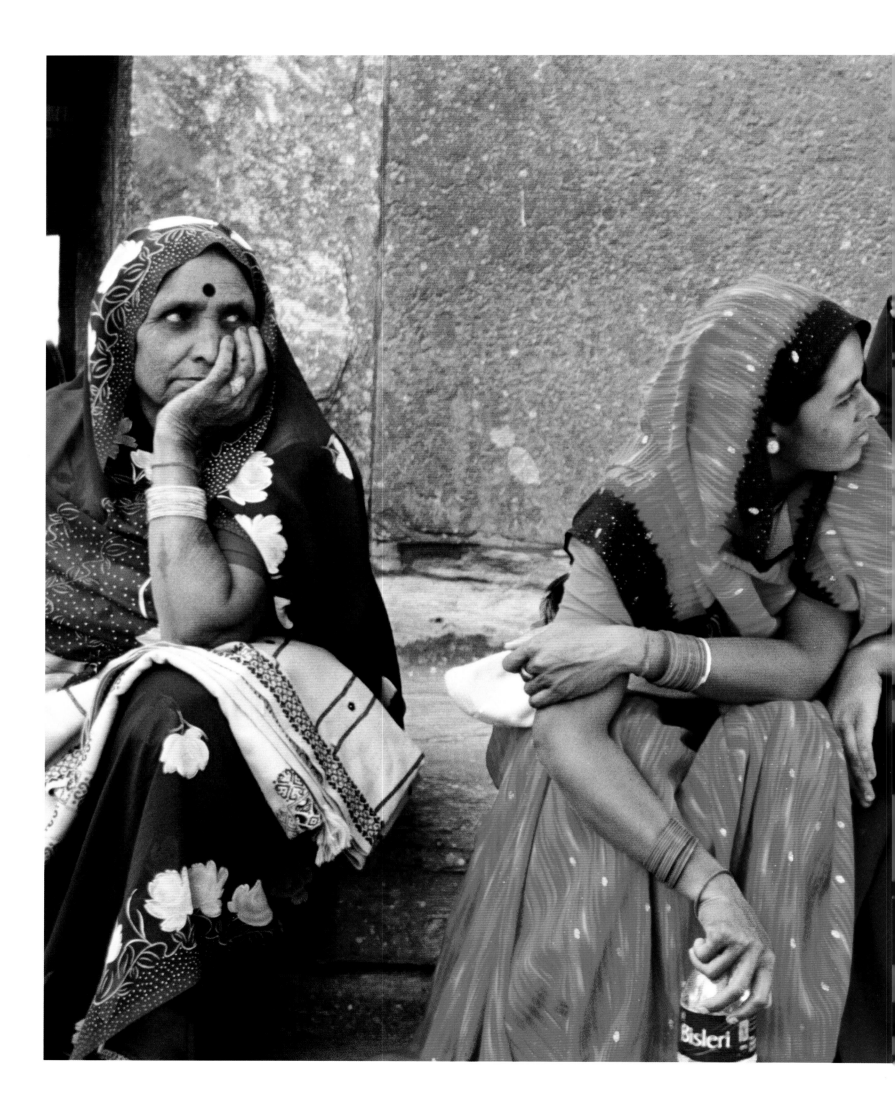

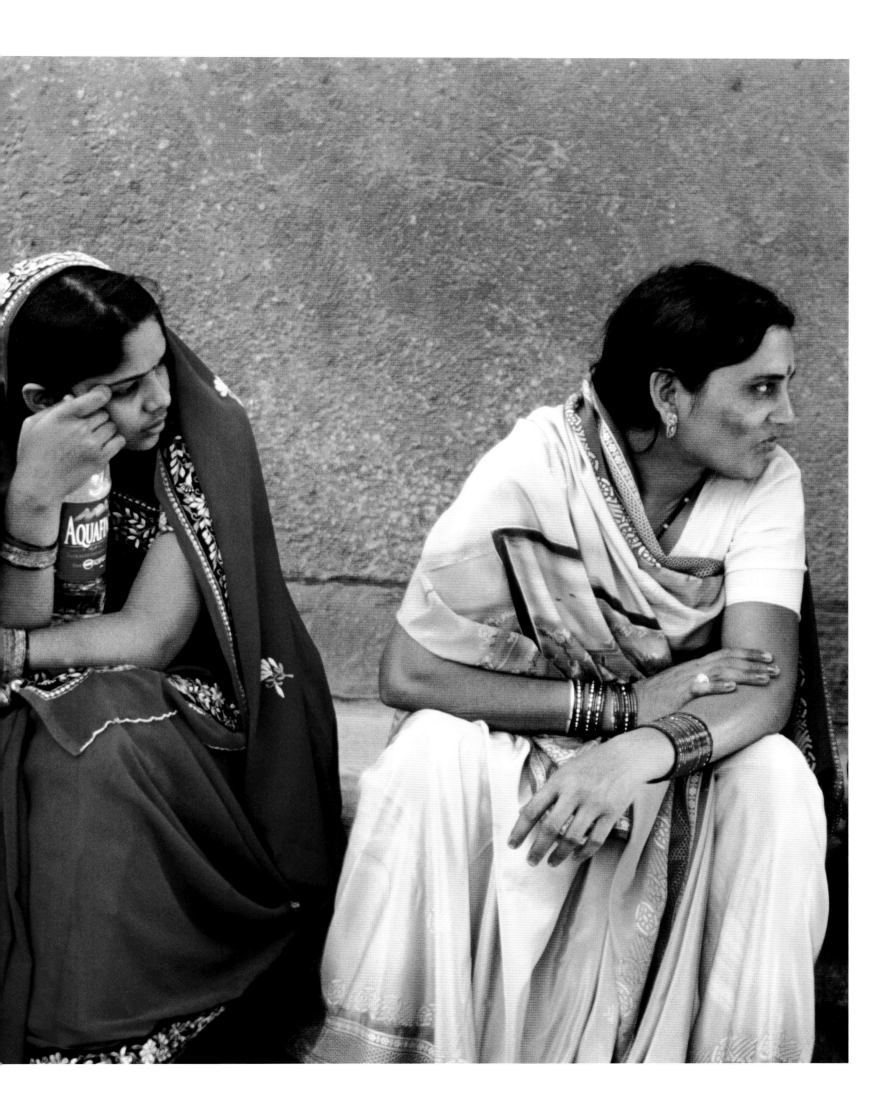

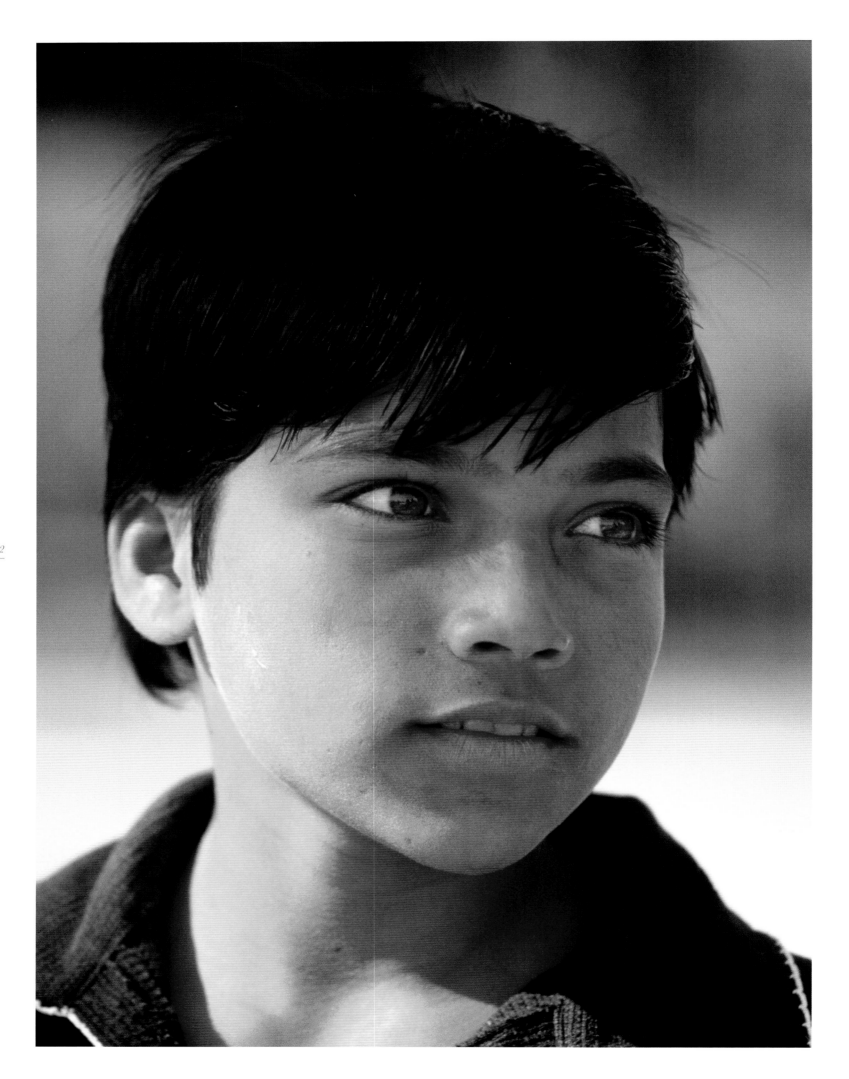

"The bird thinks it is an act of kindness

to give the fish a lift in the air."

Pages 200–203: Visitors to the Taj Mahal, Agra.

Pages 204–205: The Taj Mahal from across the Yamuna River.

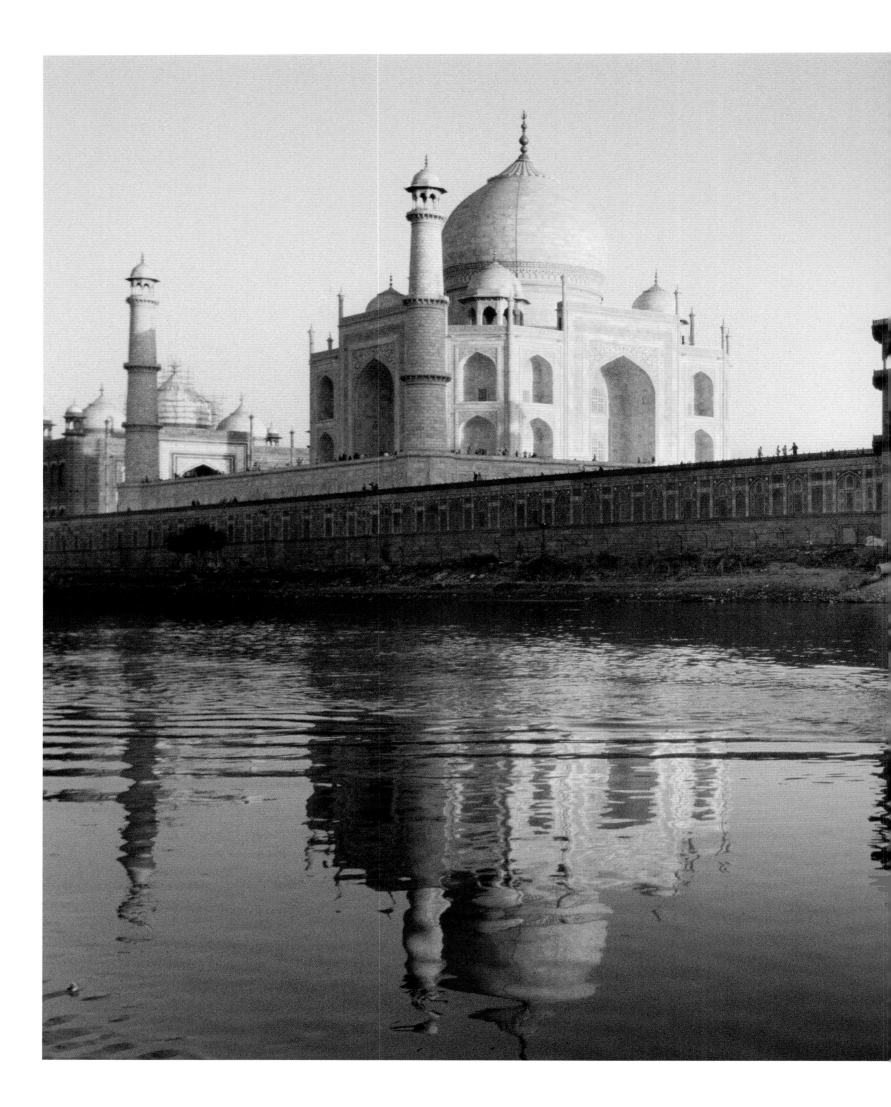

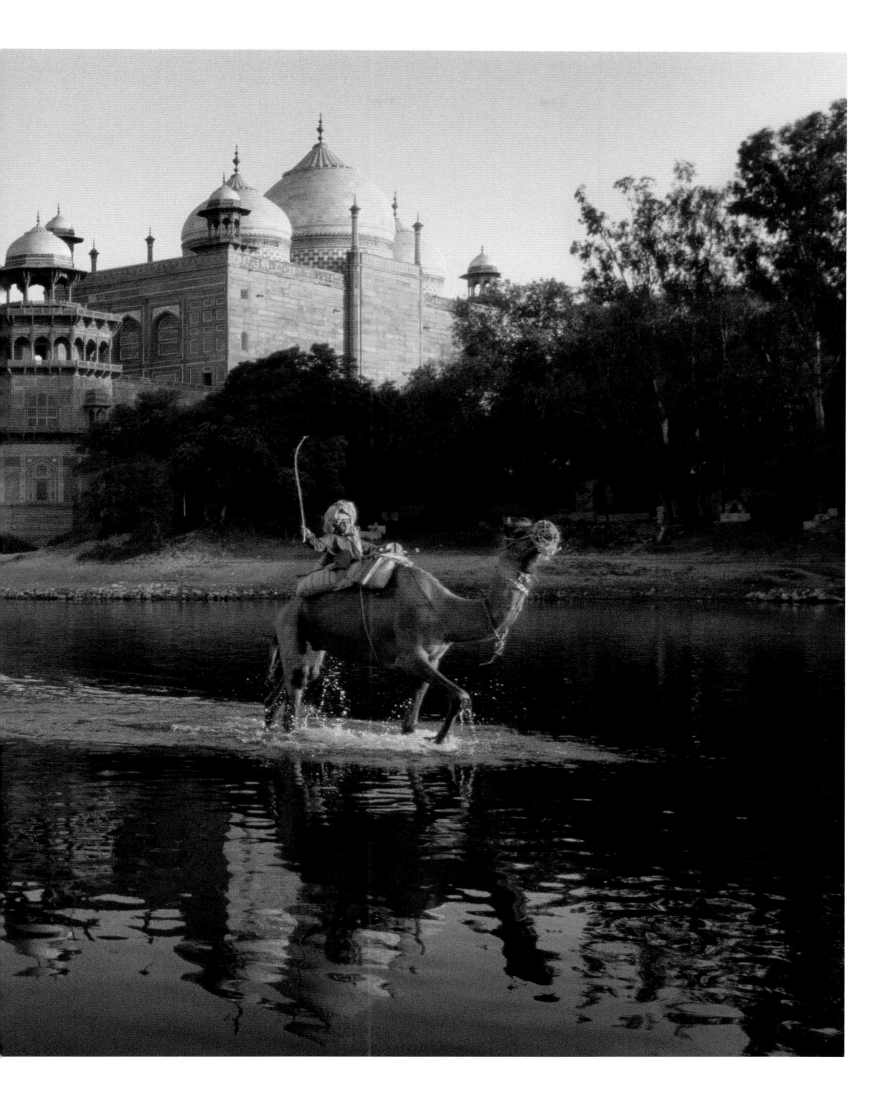

"*The mighty desert is burning for the love of a blade of grass who shakes her head and laughs and flies away.*"

Right: A Thar desert lake at sunset, Rajasthan.

Pages 208–209: The same lake with flamingoes and other water birds.

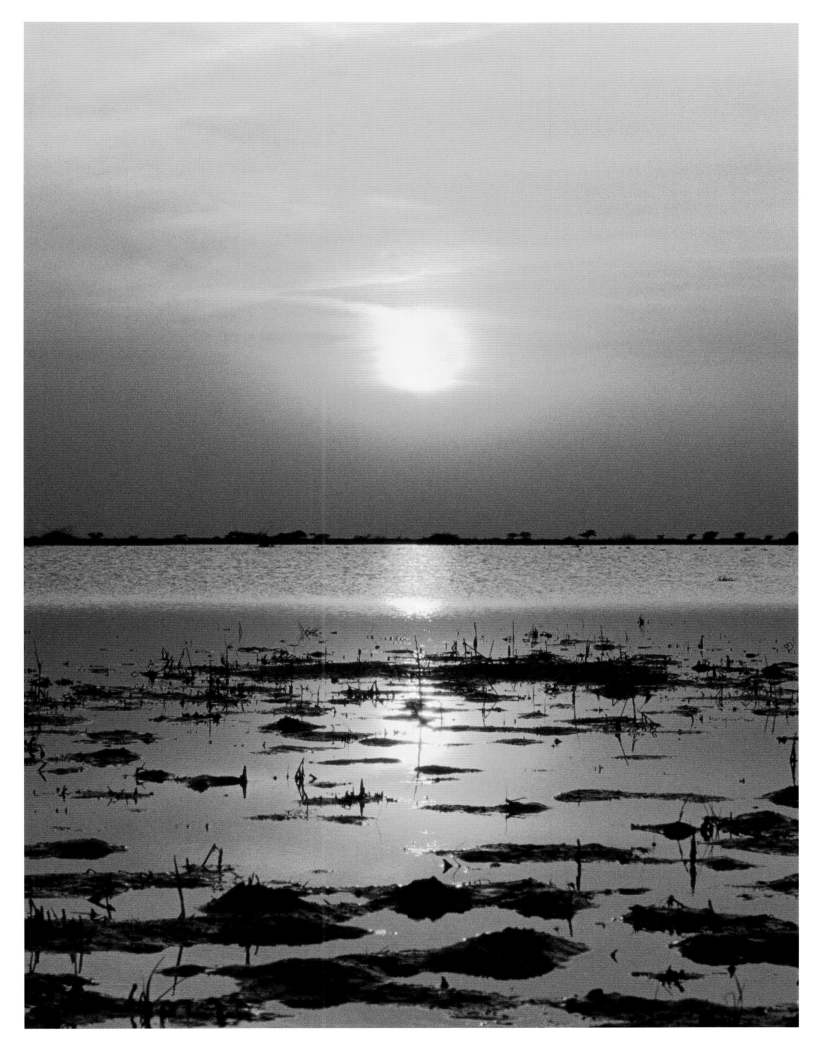

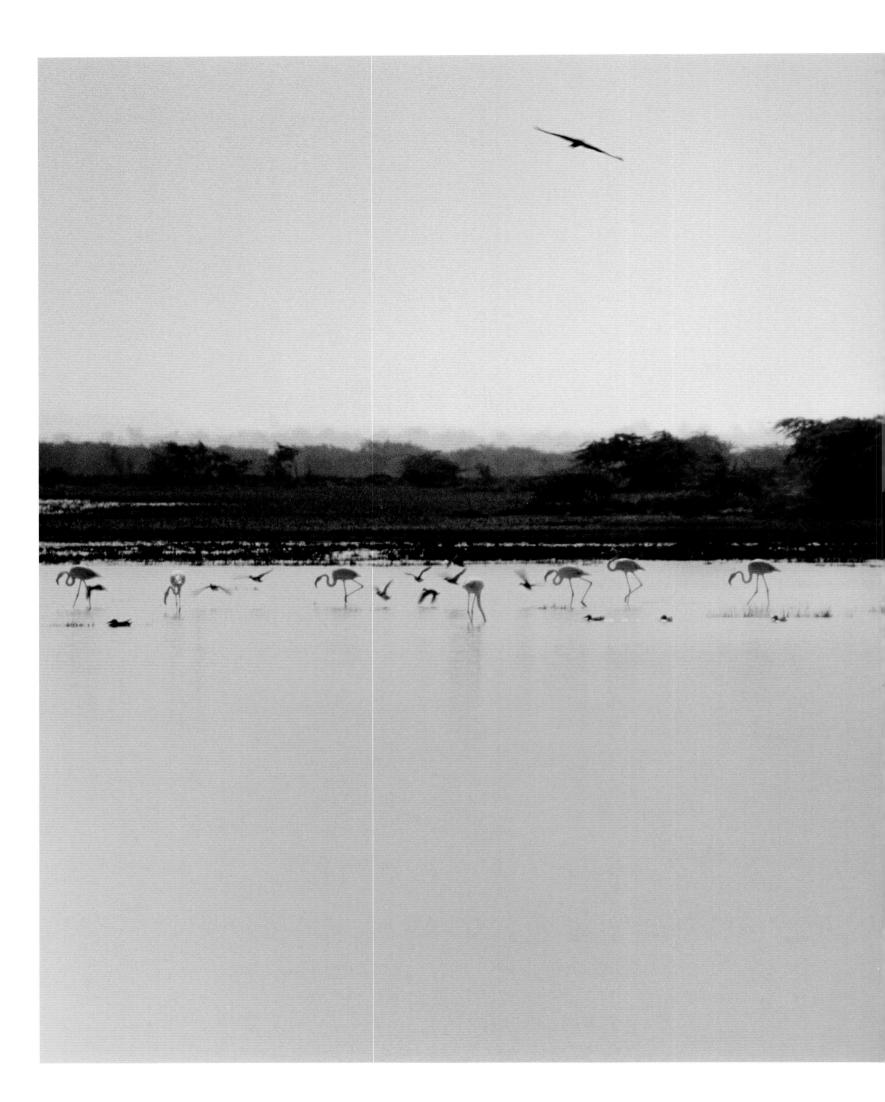

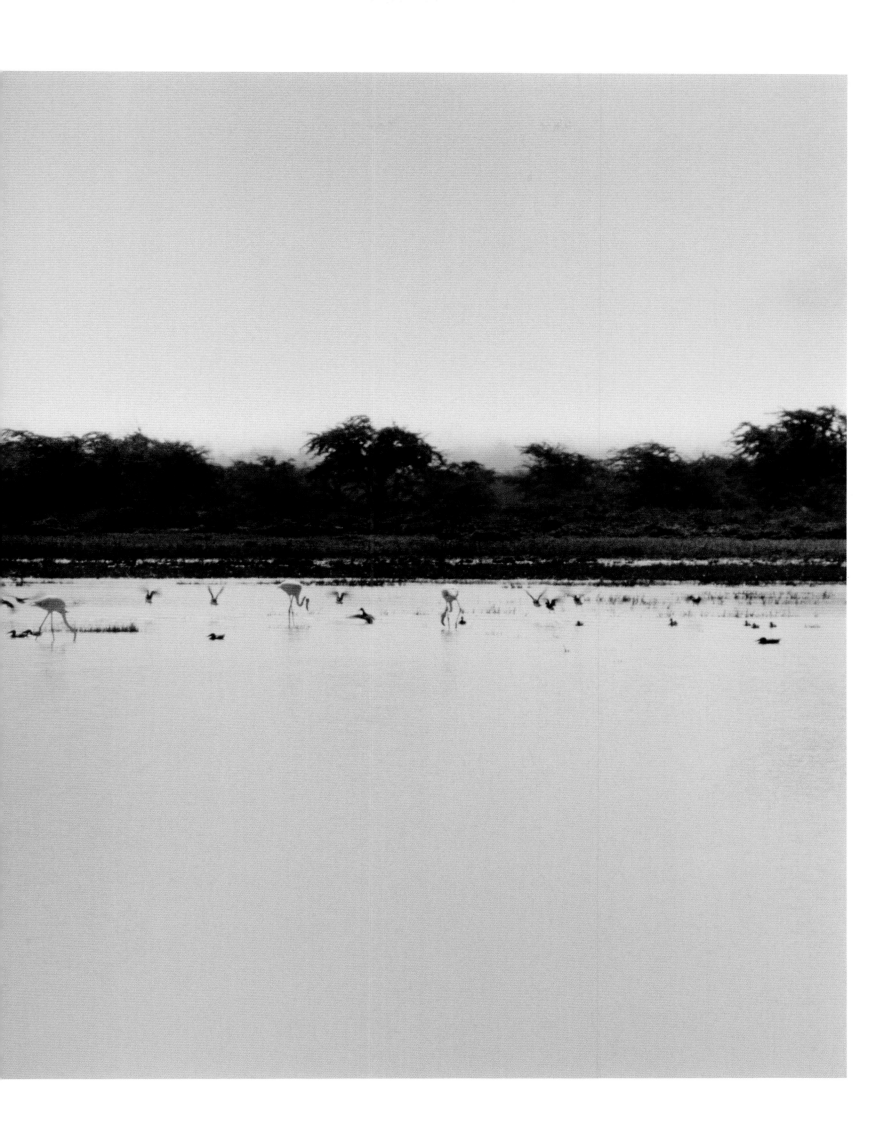

"Let the world find its way to you."

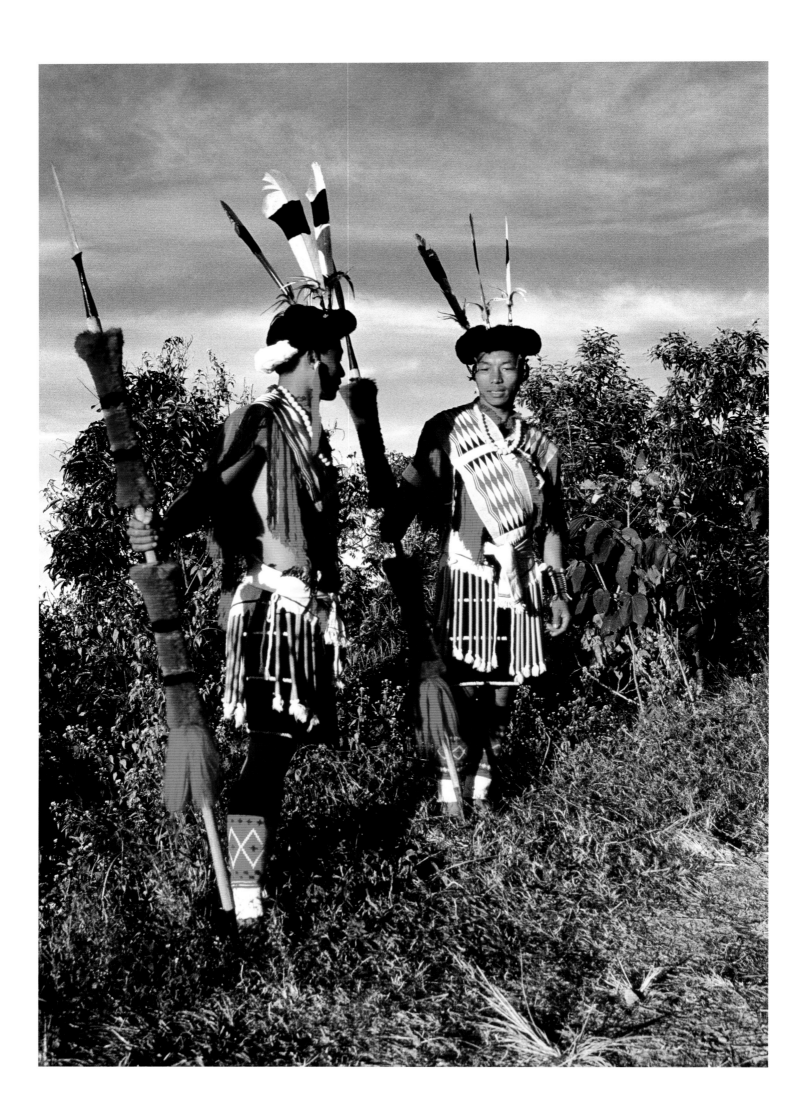

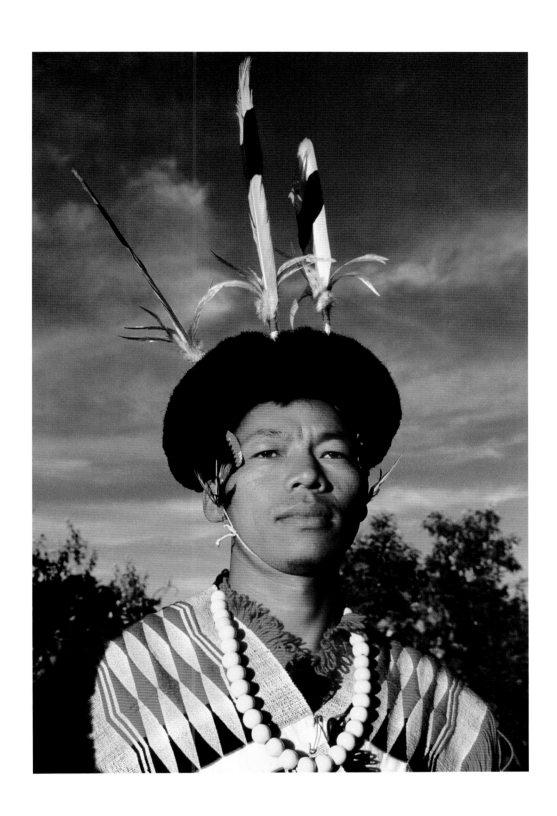

Naga men in ceremonial dress at sunrise.

Pages 214–223: Daily life in Kiphoma.

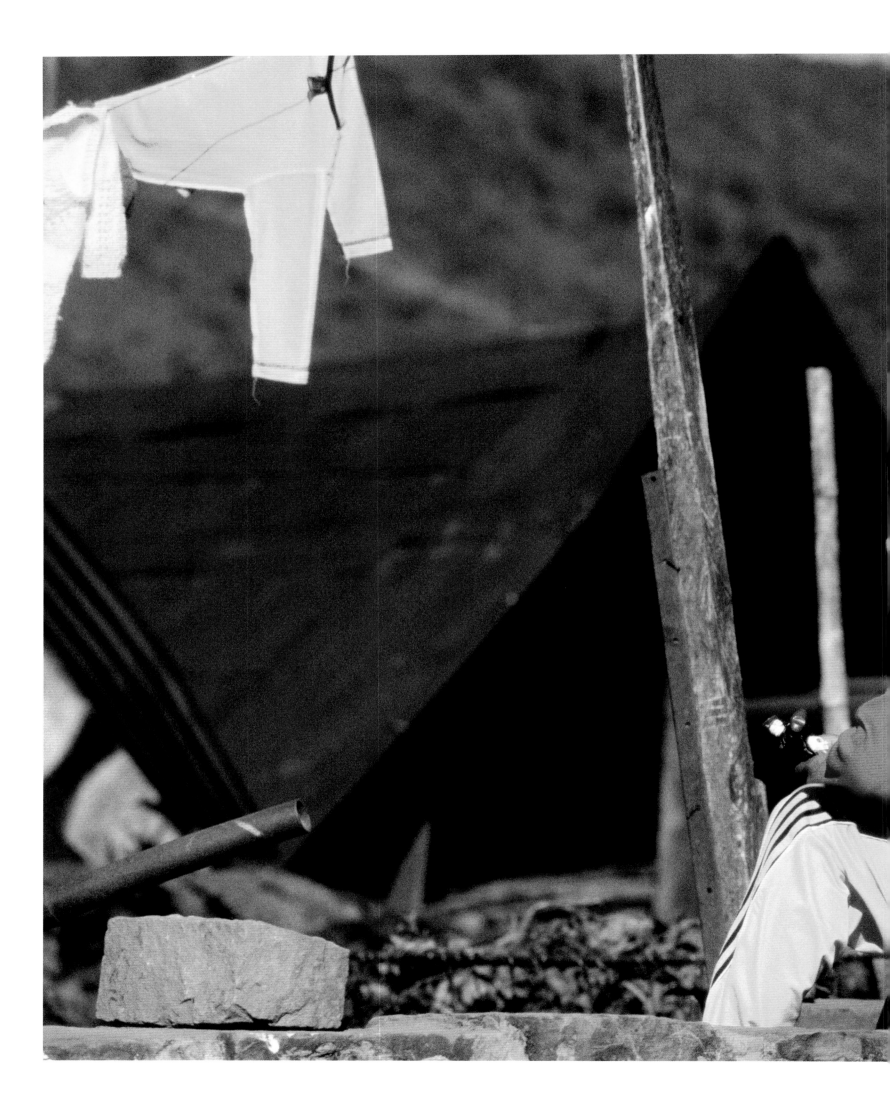

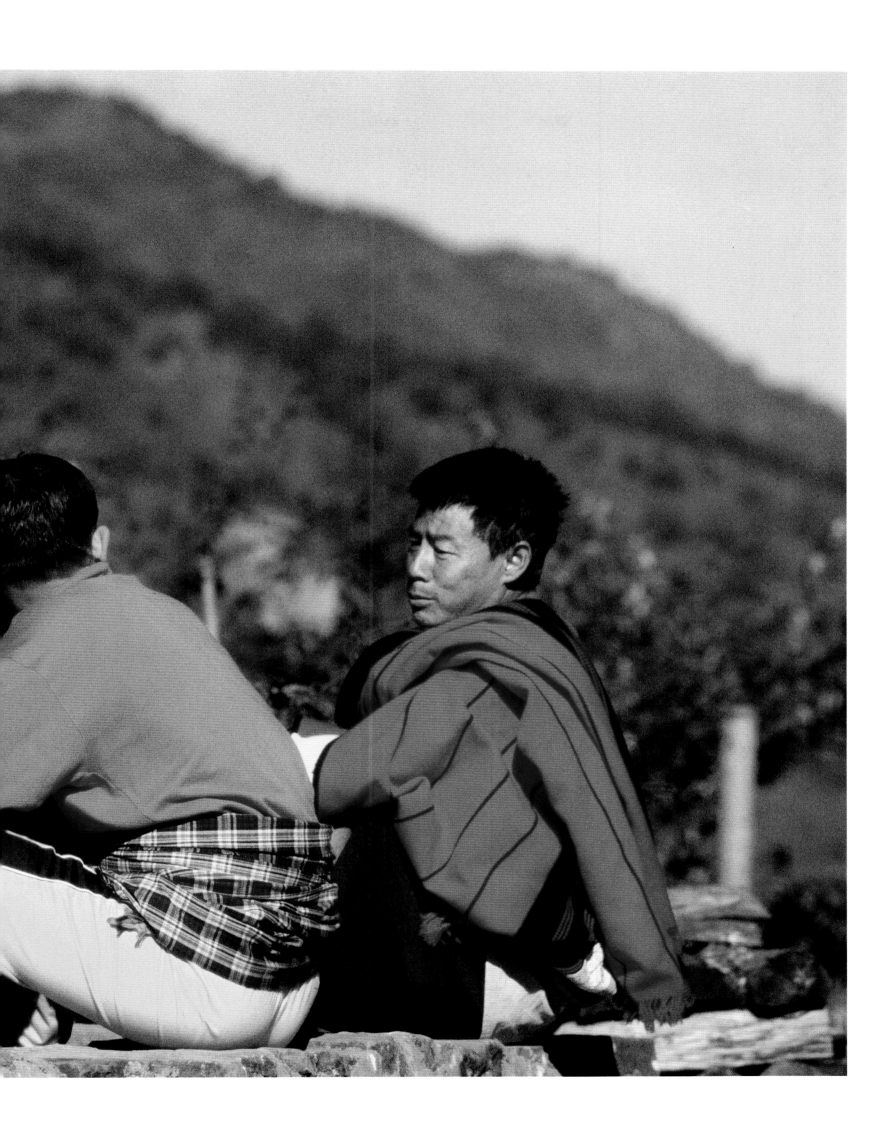

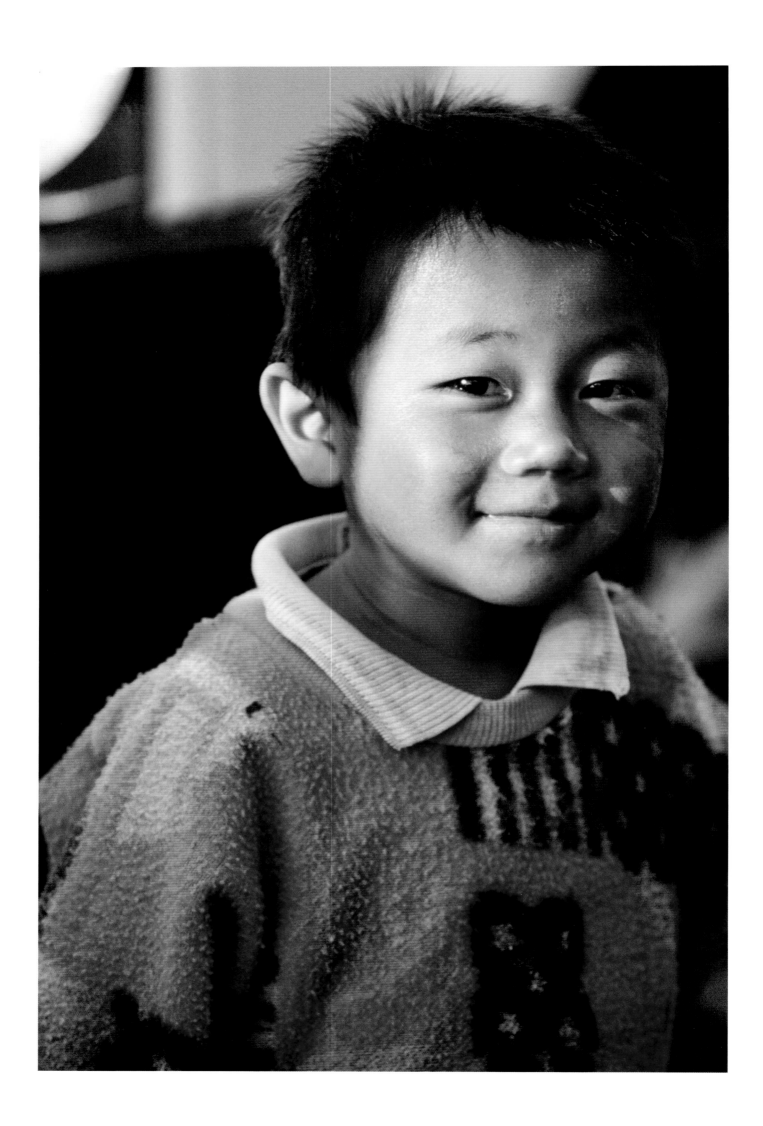

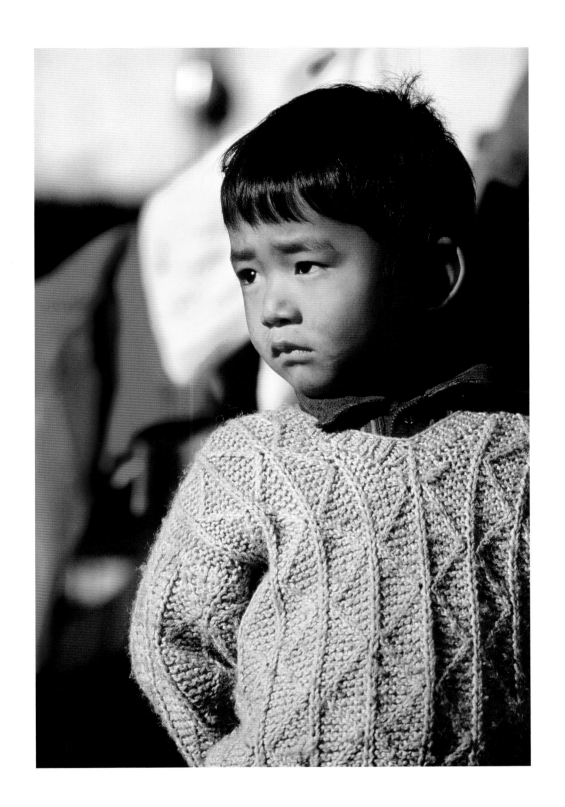

"Man is a born child,
his power is the power of growth."

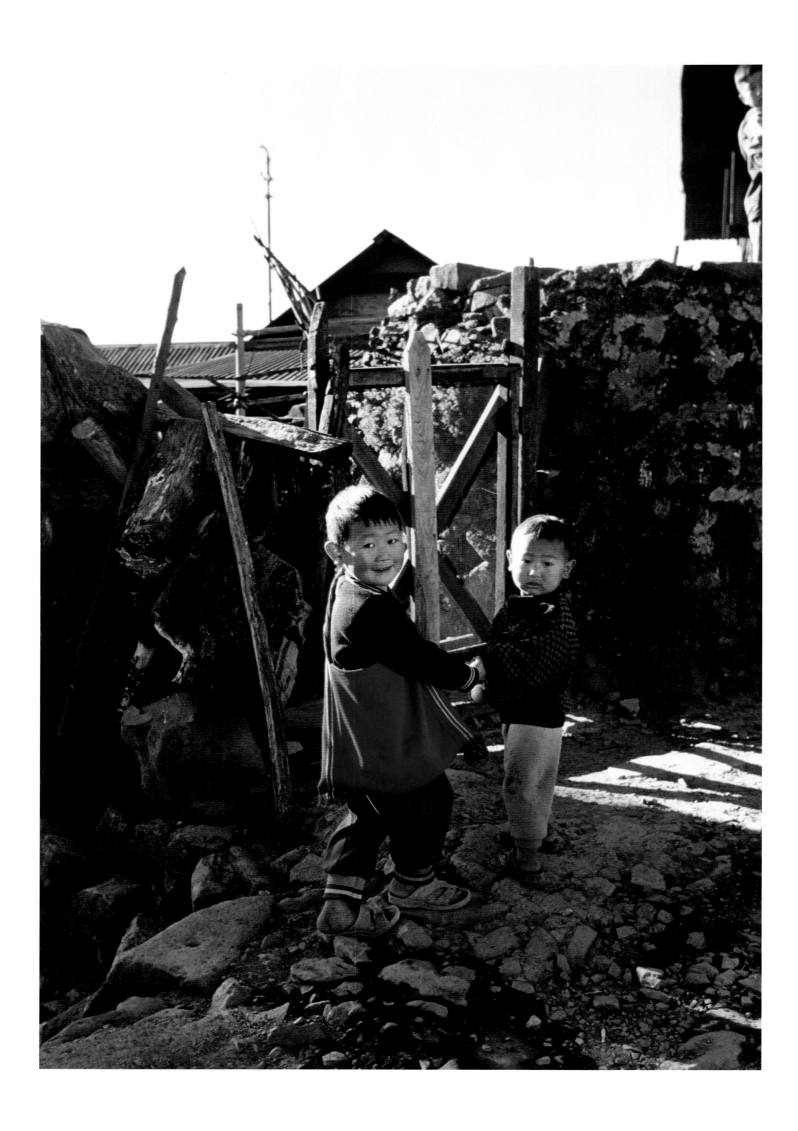

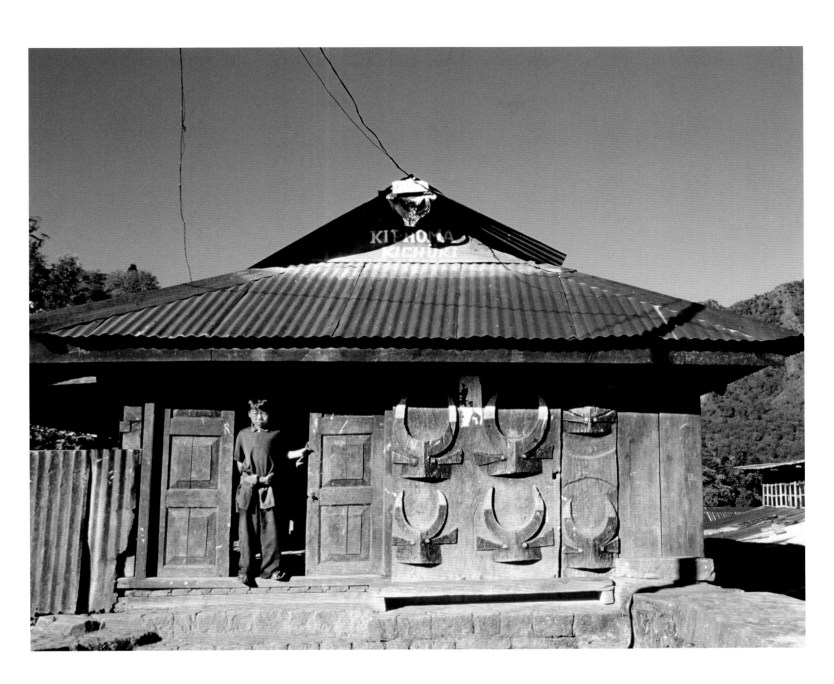

Left: Siblings on the way to school.

Above: Boy at the doorway to his home which has Naga symbols on the outside wall.

"My heart, with its lapping waves of song,
longs to caress this green world
of the sunny day."

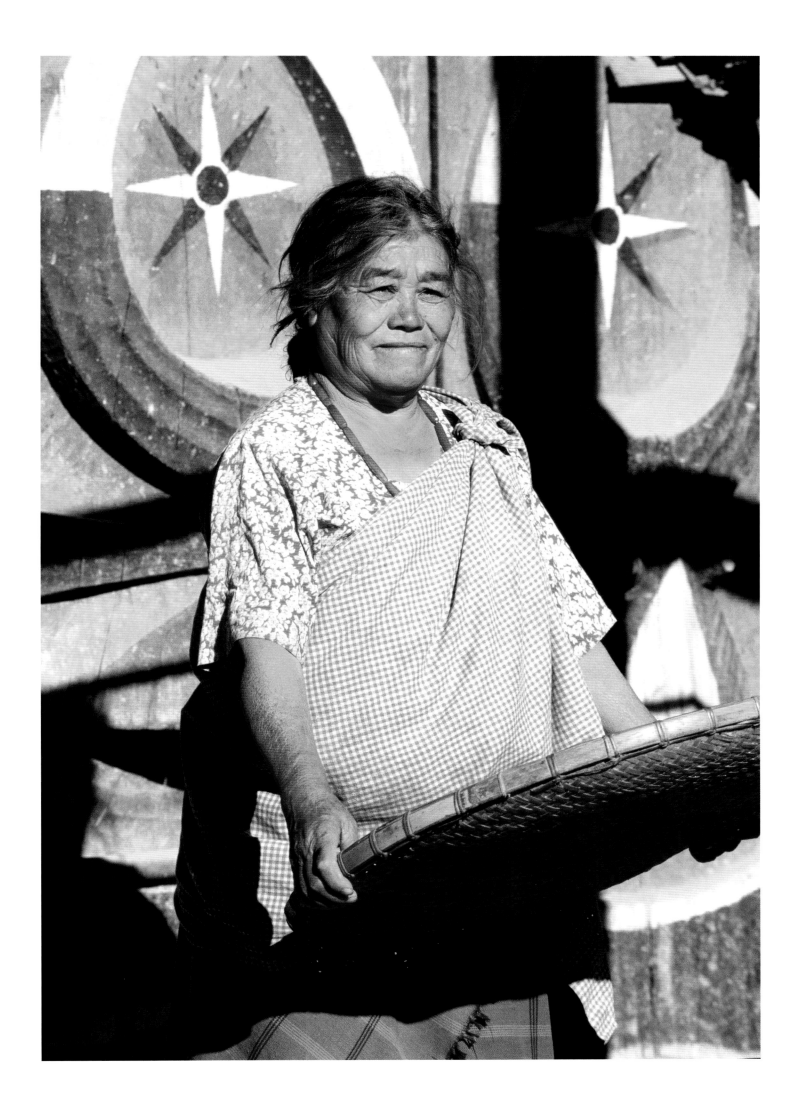

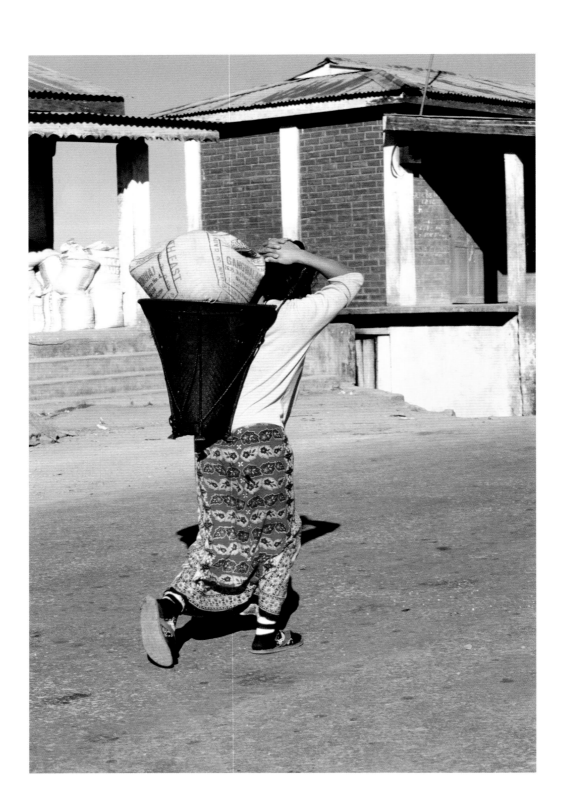

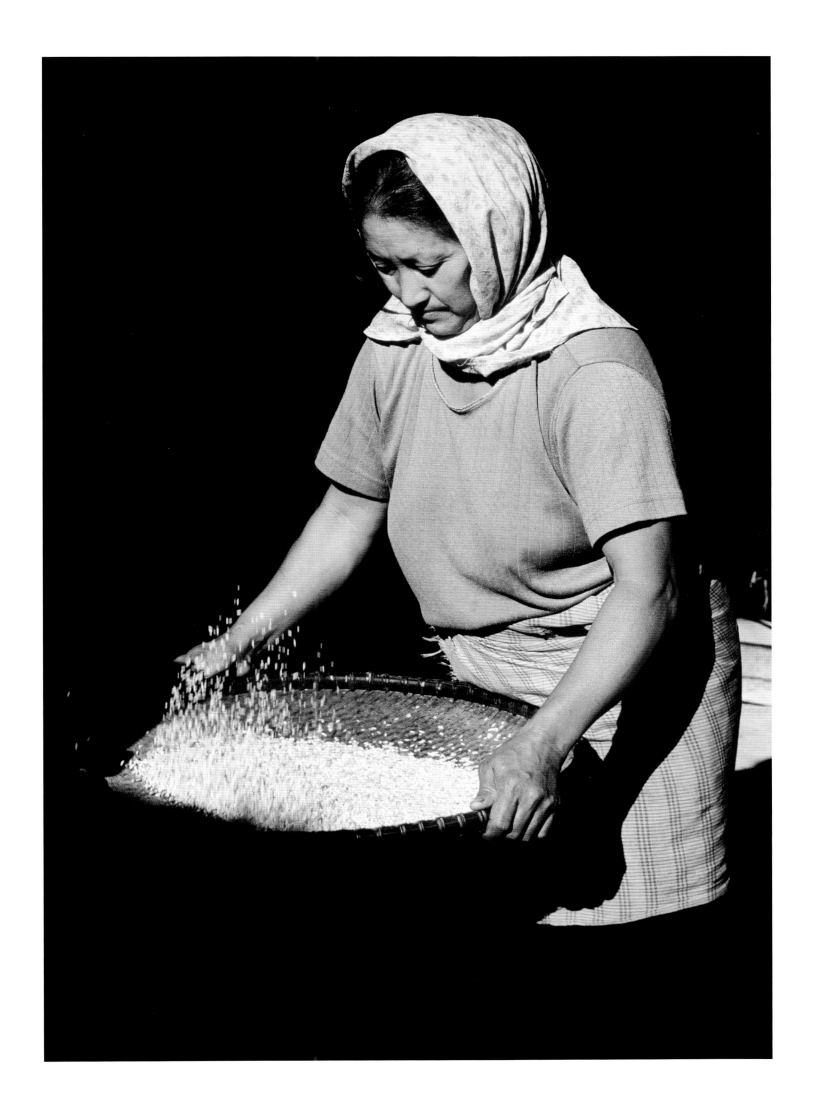

"The false can never grow into
truth by growing in power."

Pages 224–235: Naga tribal peoples wearing ceremonial dress
at the annual government-sponsored Hornbill Festival.

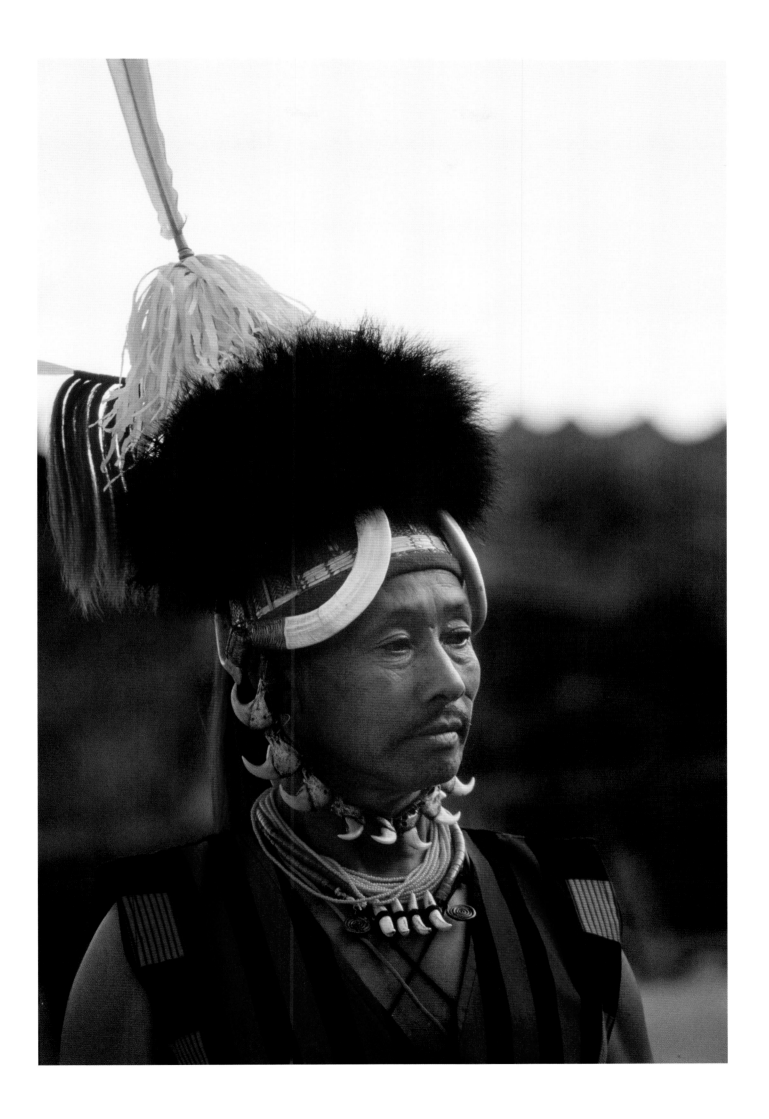

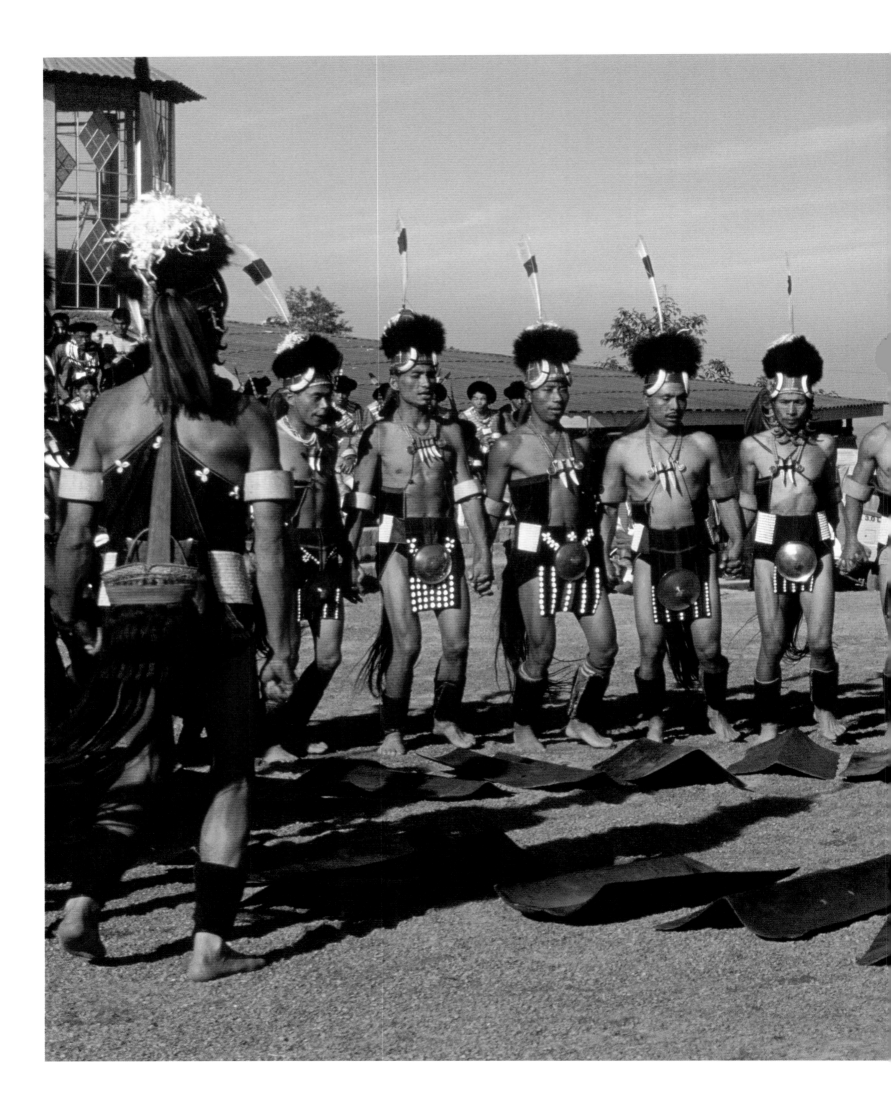

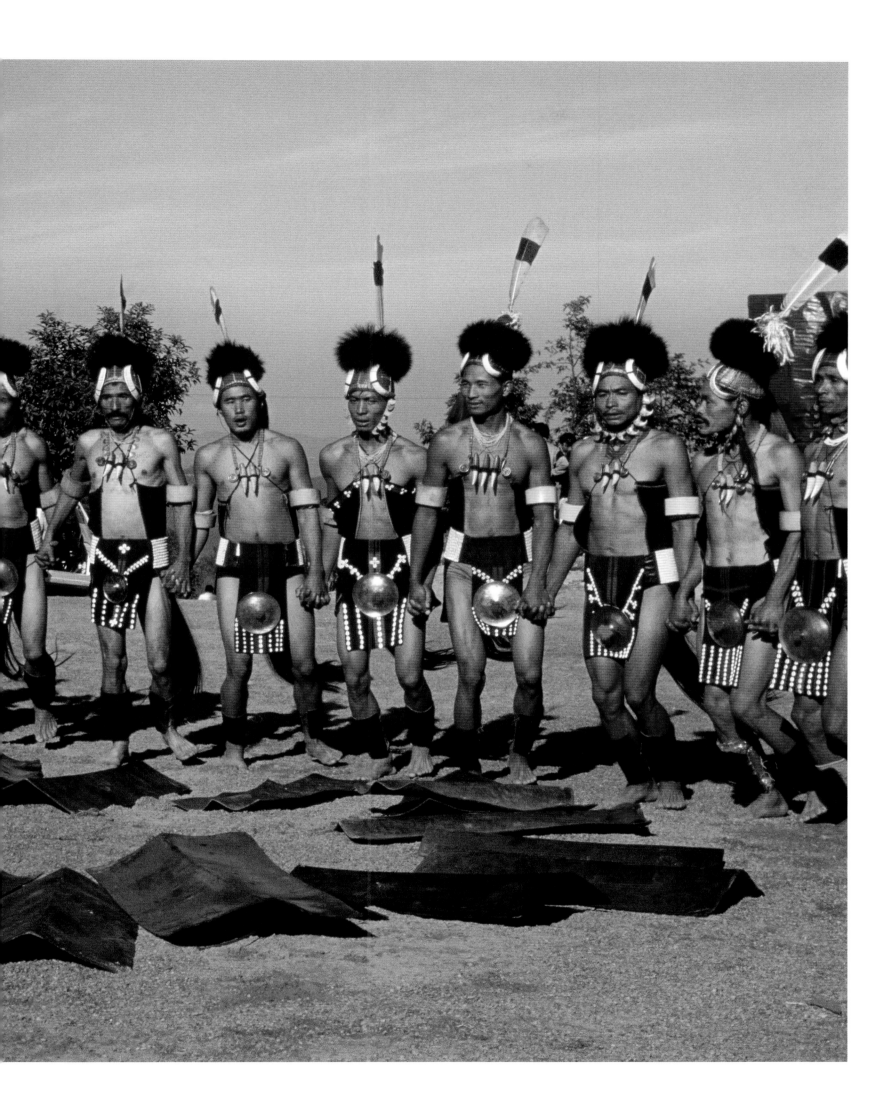

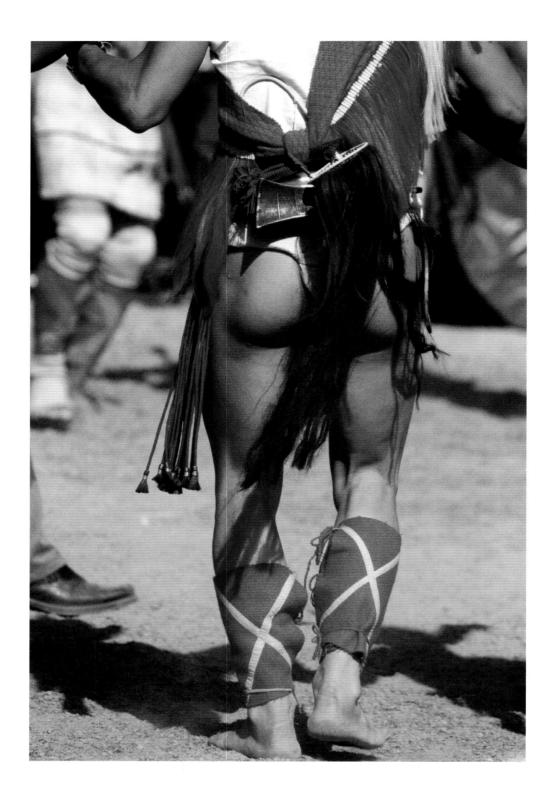

Pages 226–228: Nagas taking part in a warrior dance. Note the shields on the ground.

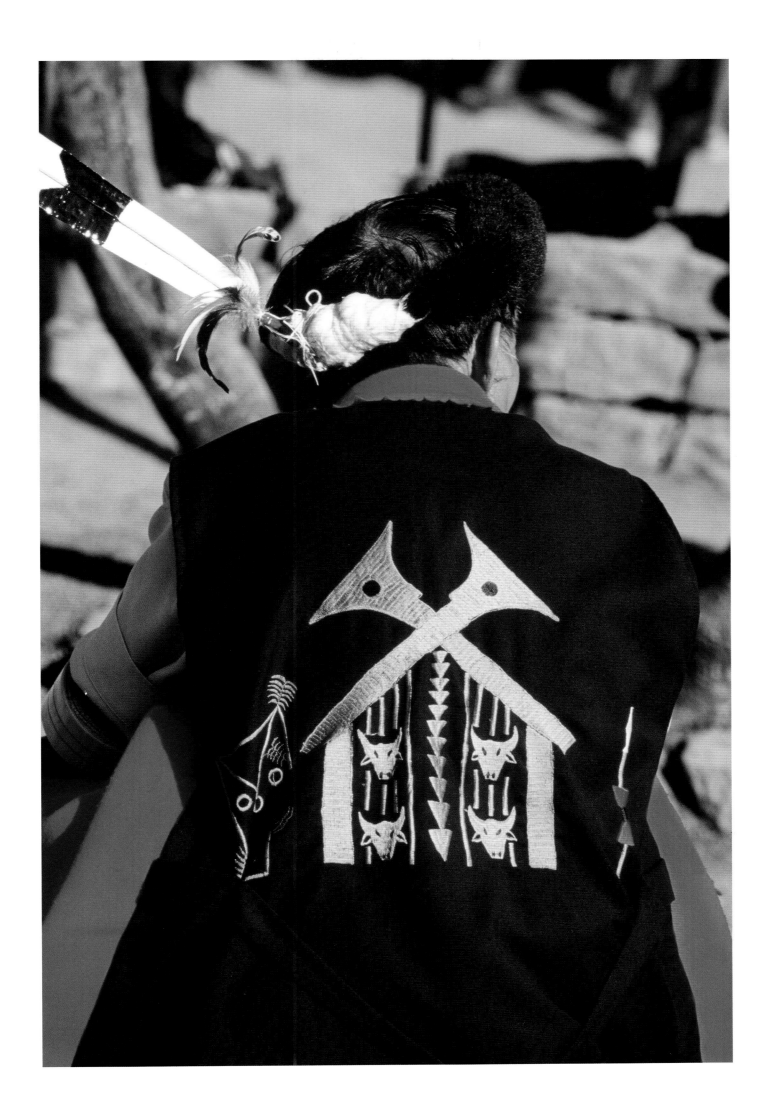

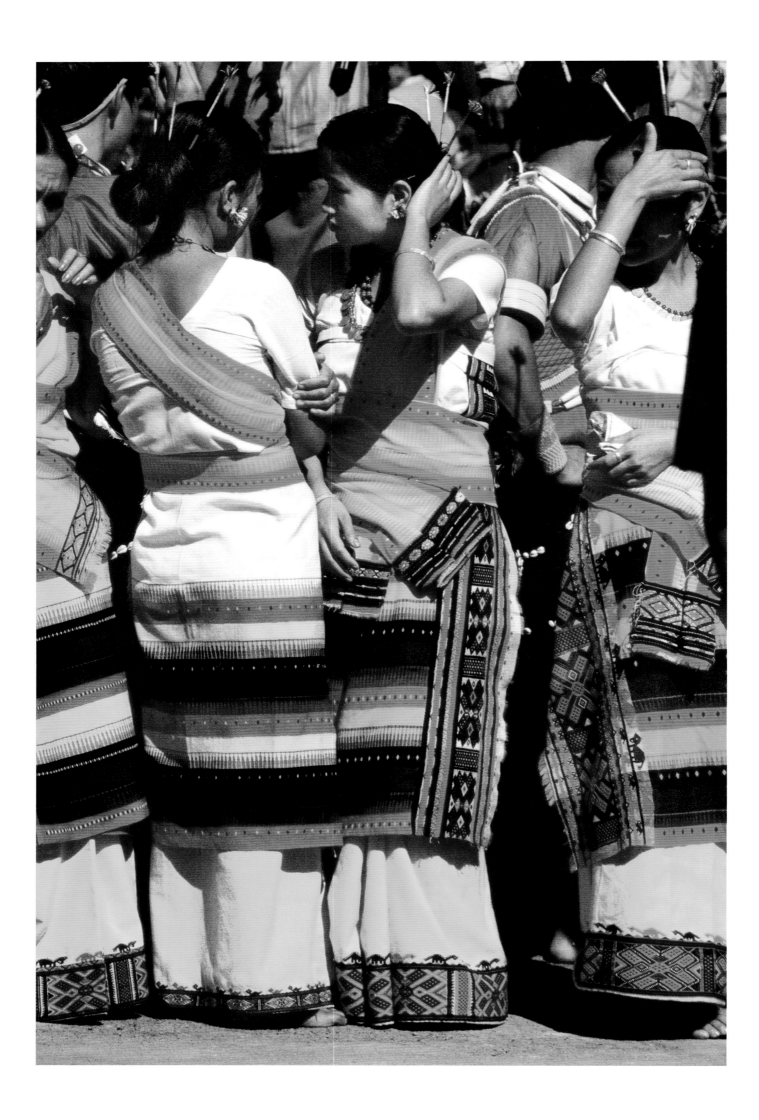

Naga girls dressed for a tribal dance competition.

Pages 232–233: Man in ceremonial headdress celebrating the sun.

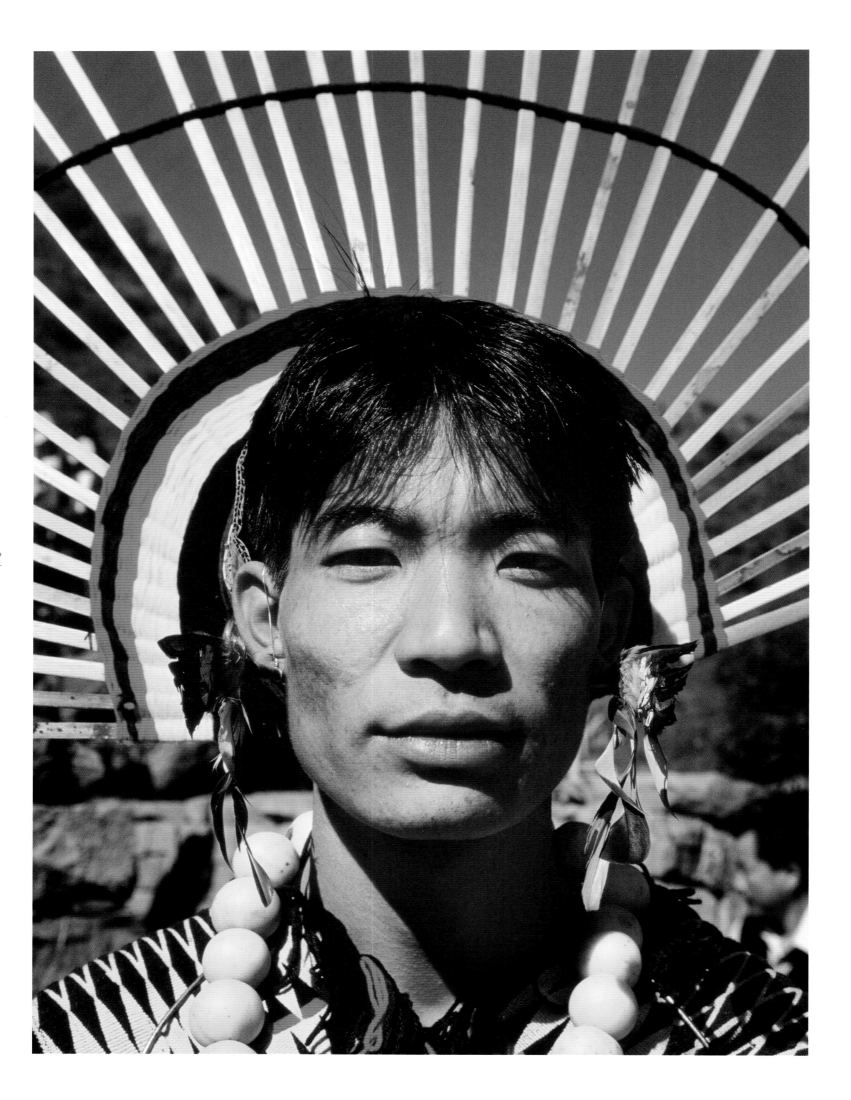

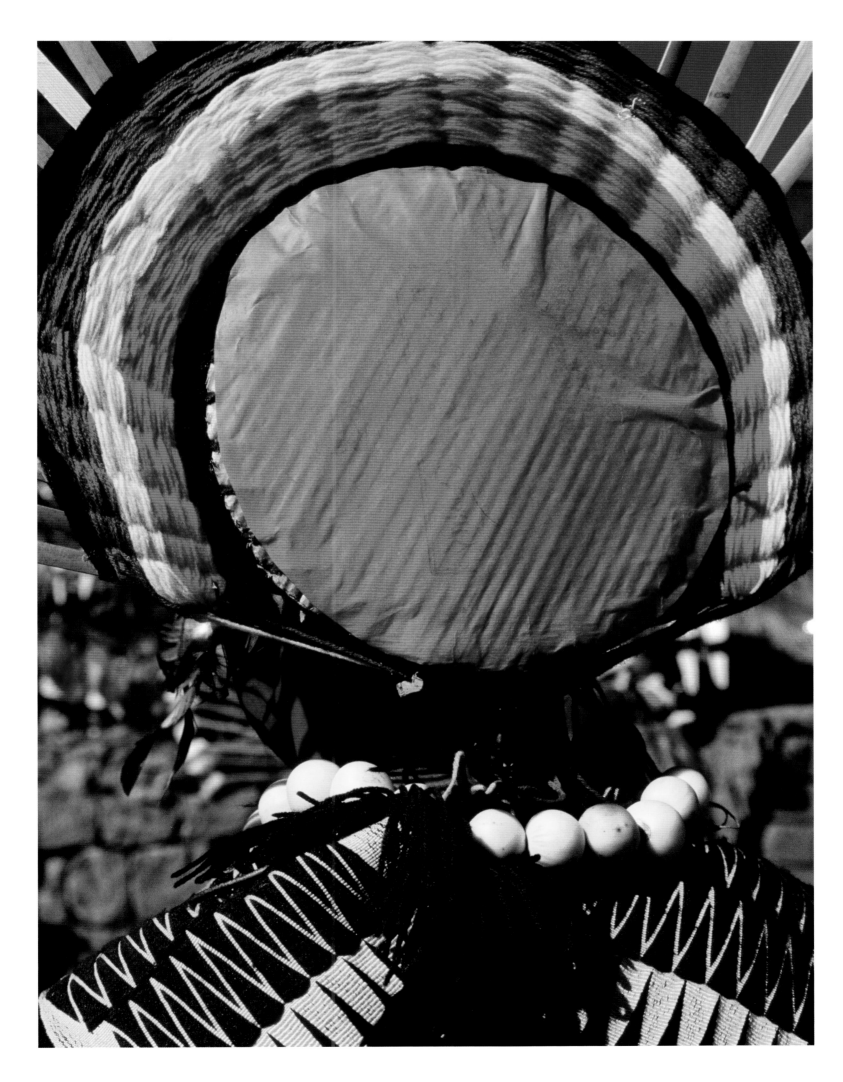

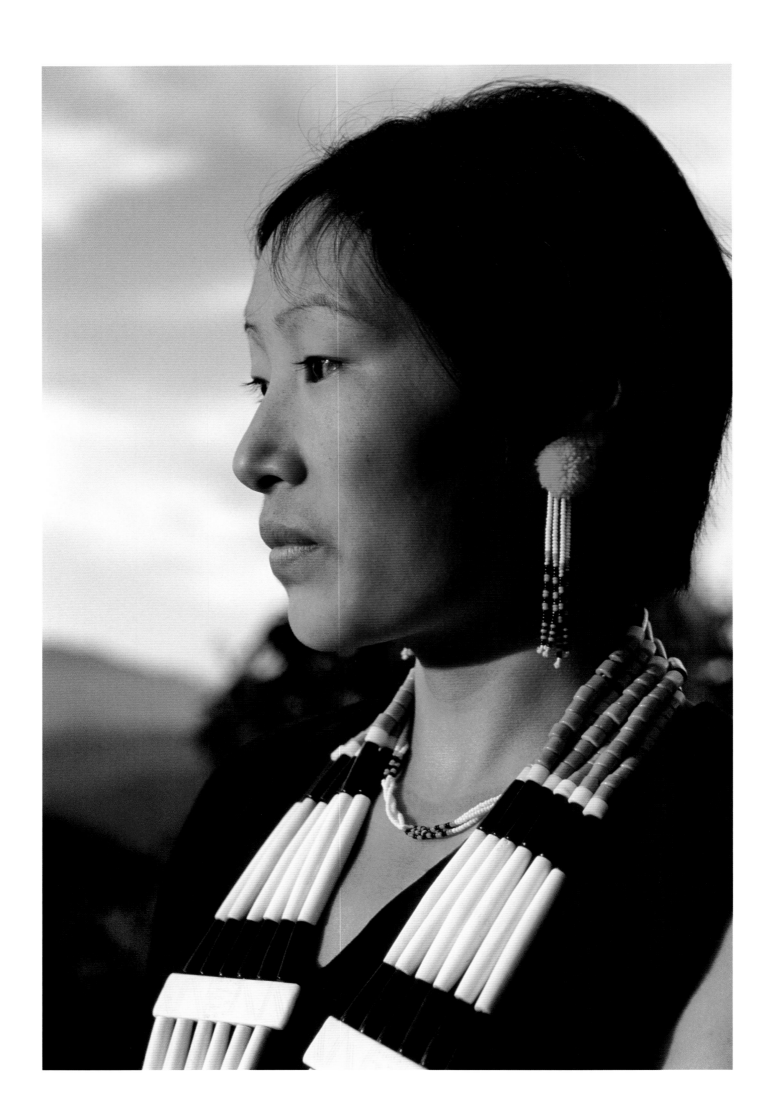

"Woman, thou hast encircled the world's heart with the depth of thy tears as the sea has the earth."

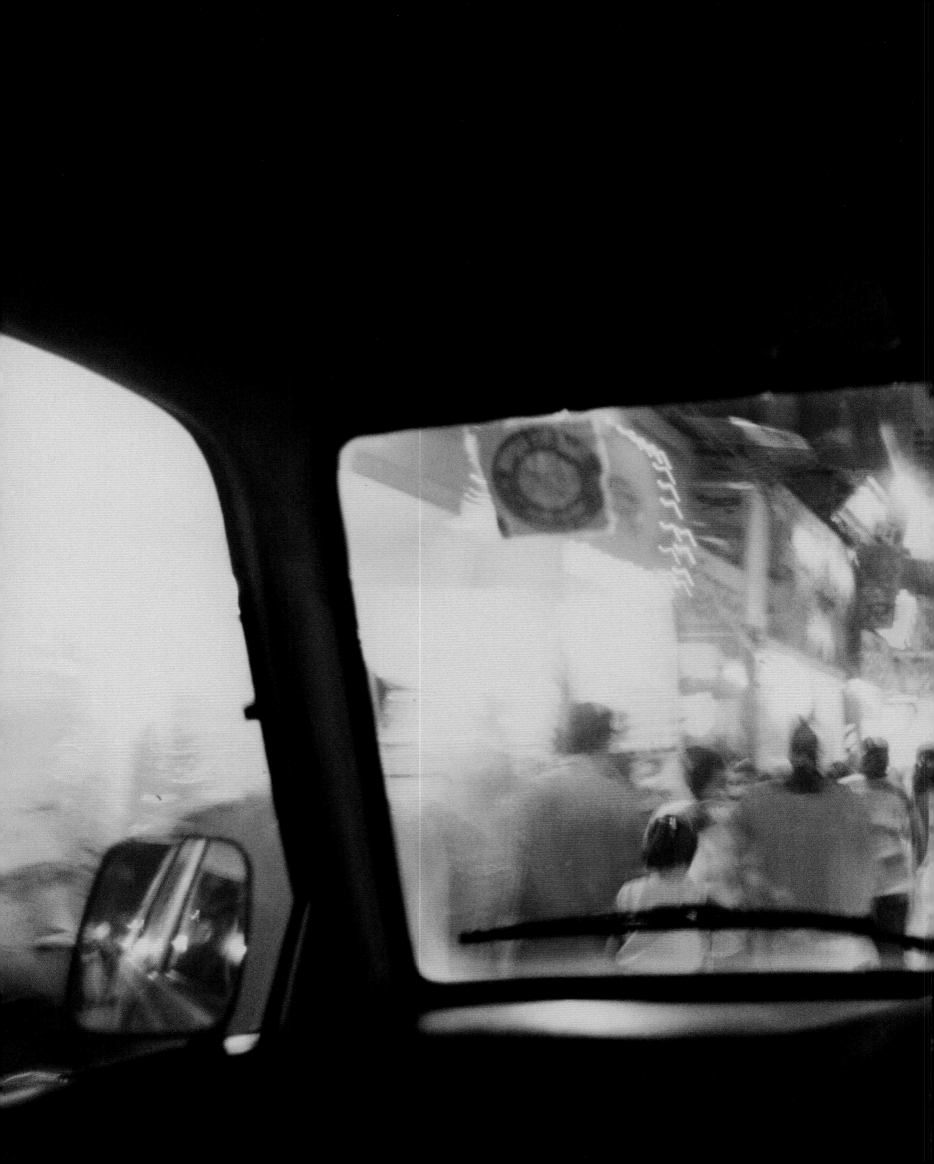

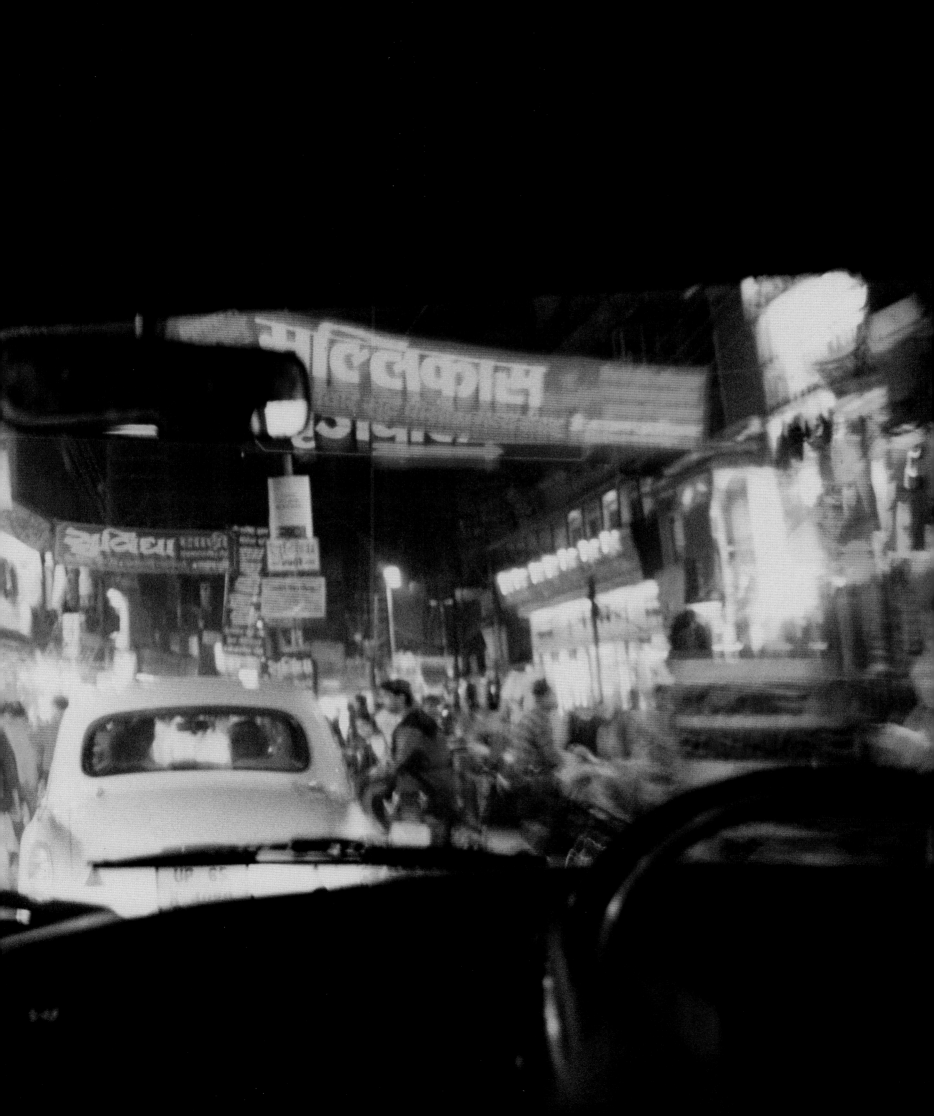

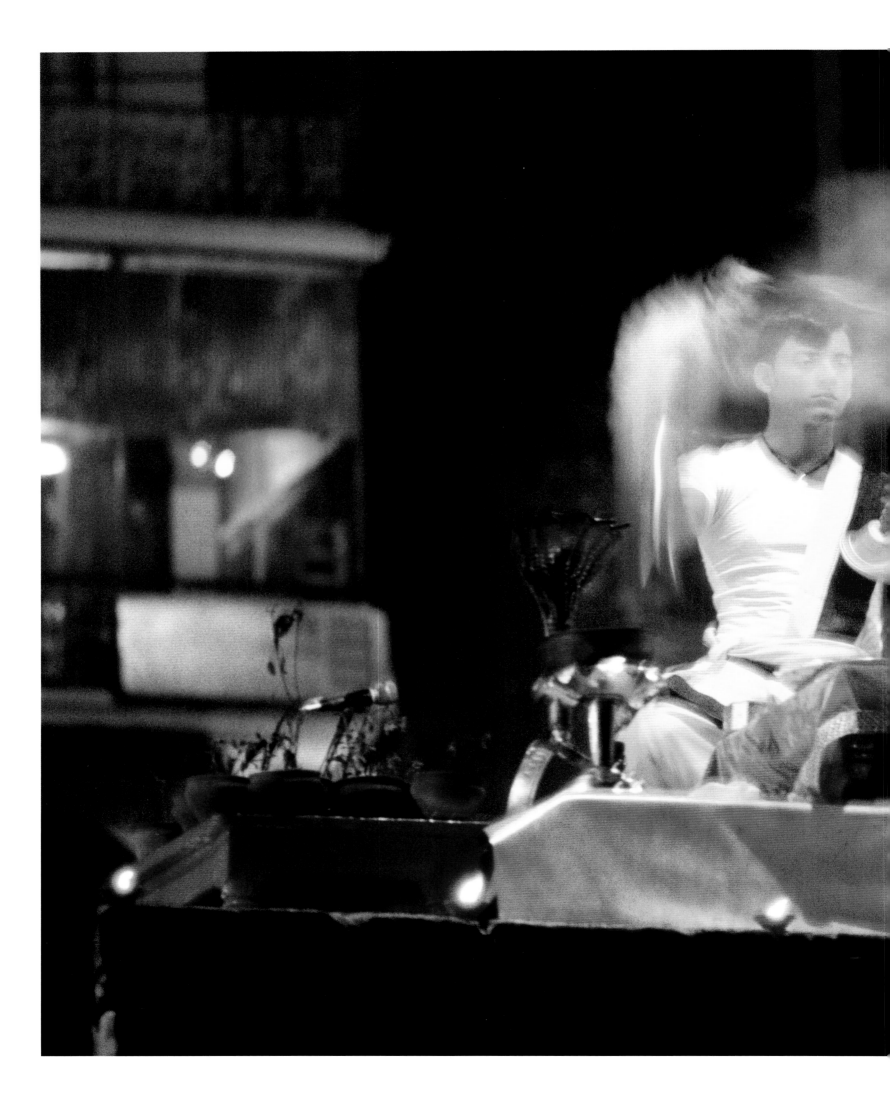

"The world has opened its heart of light in the morning. Come out, my heart, with thy love to meet it."

Pages 236–271: The holy city of Varanasi and the Ganges River, at night, pre-dawn and in the early morning light.

Right: Woman ascending the ghats.

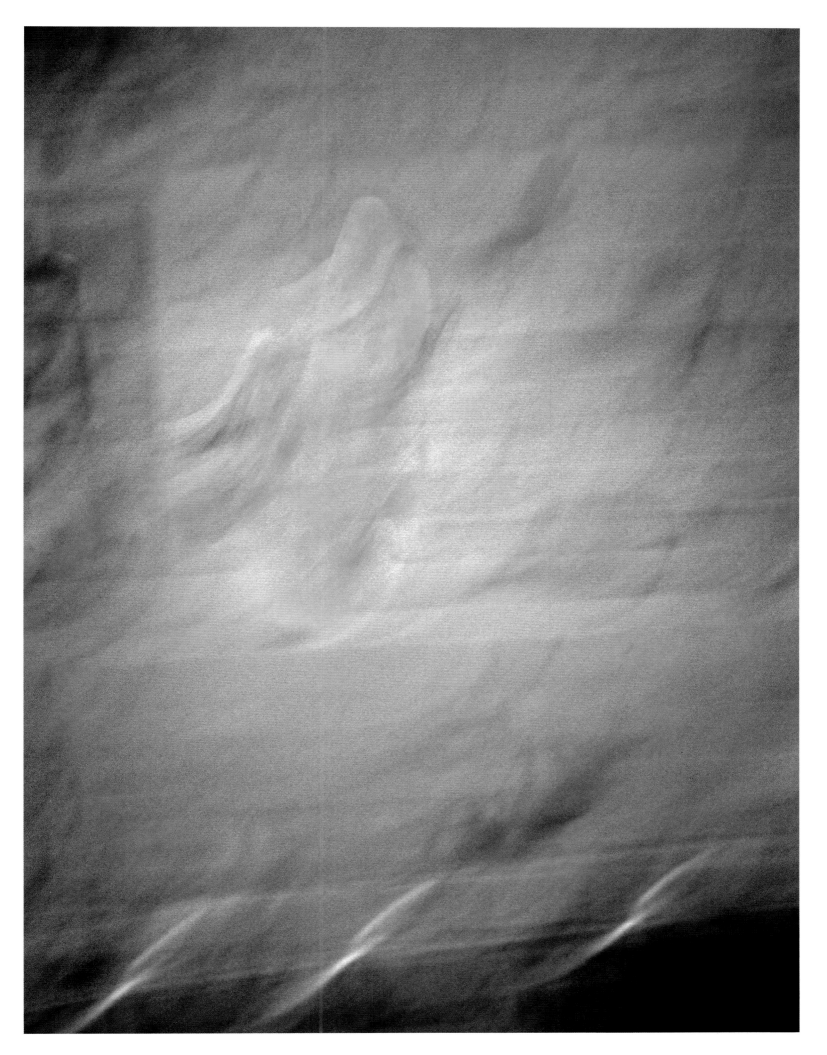

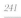

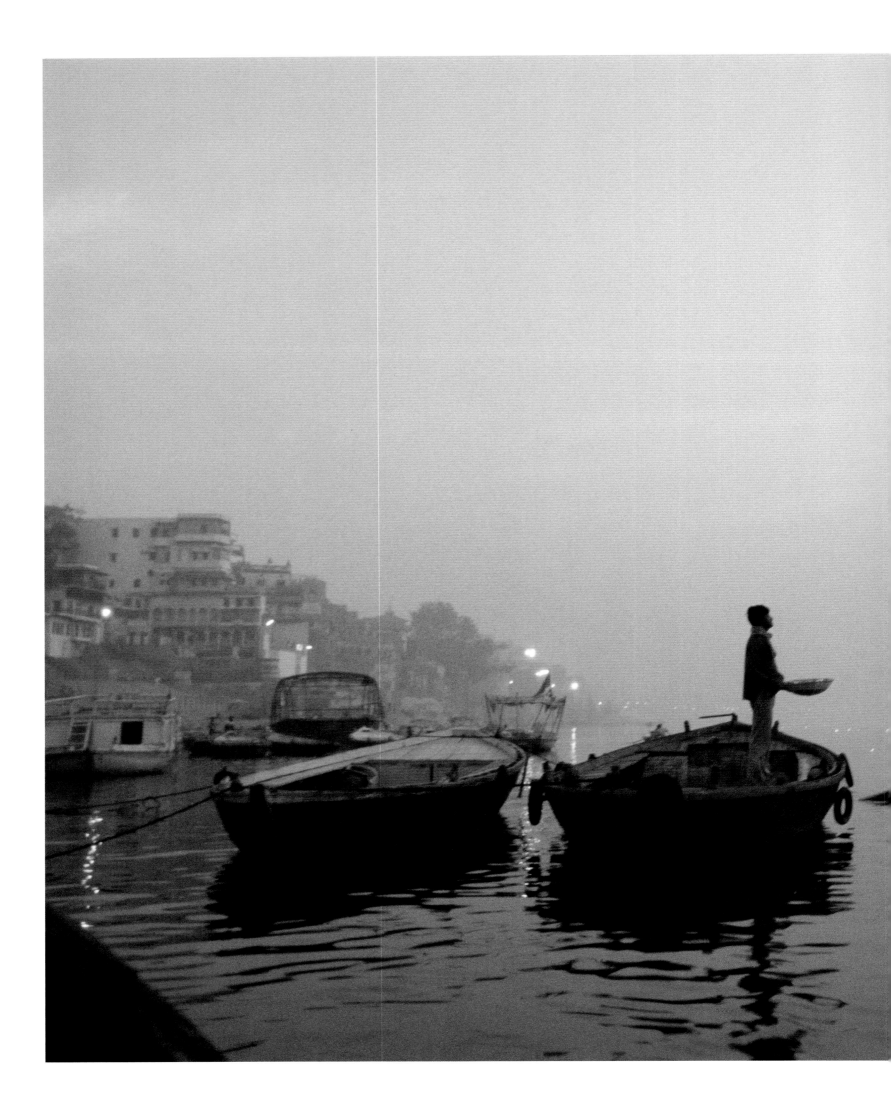

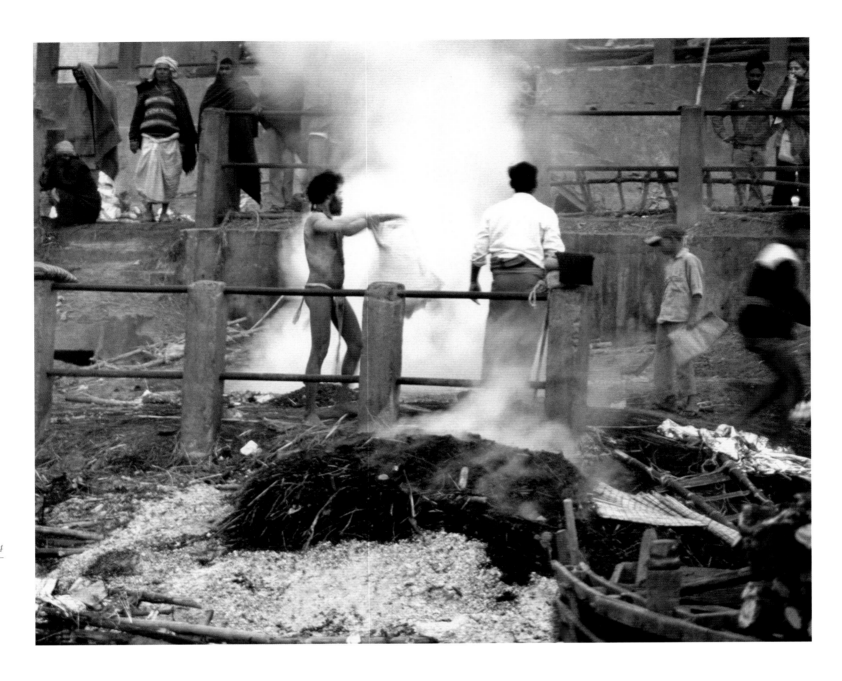

A religious sadhu and a cremation ceremony.

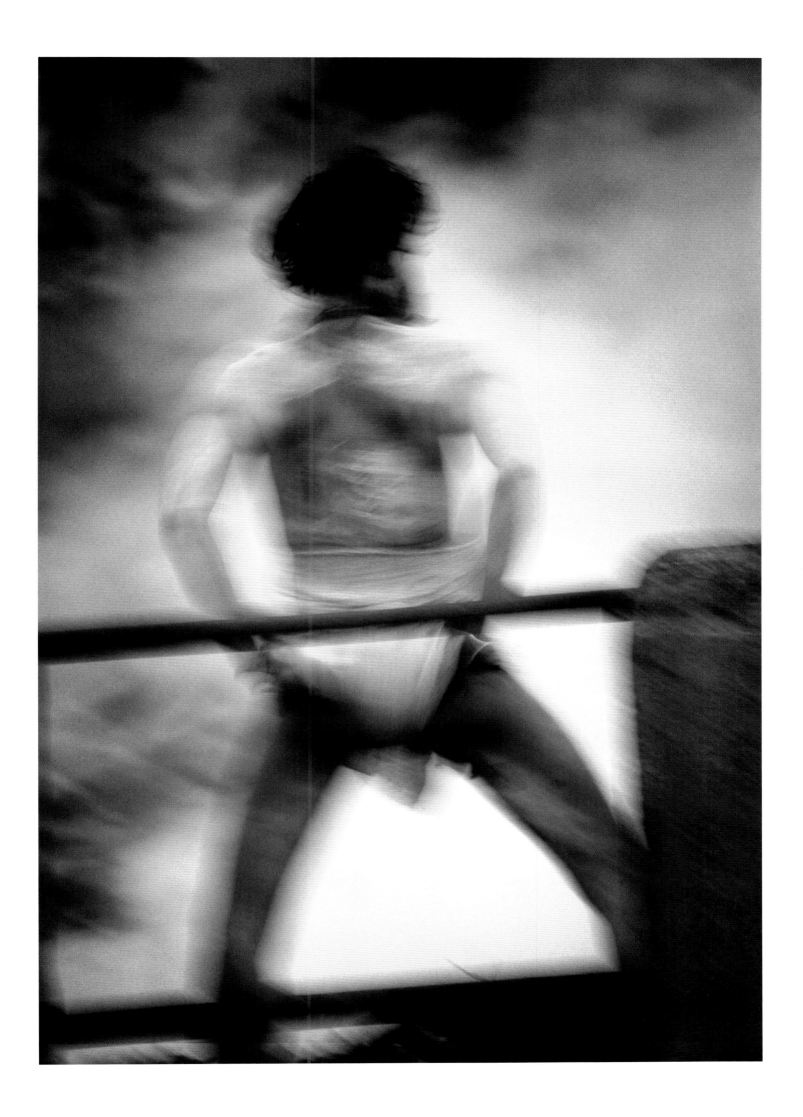

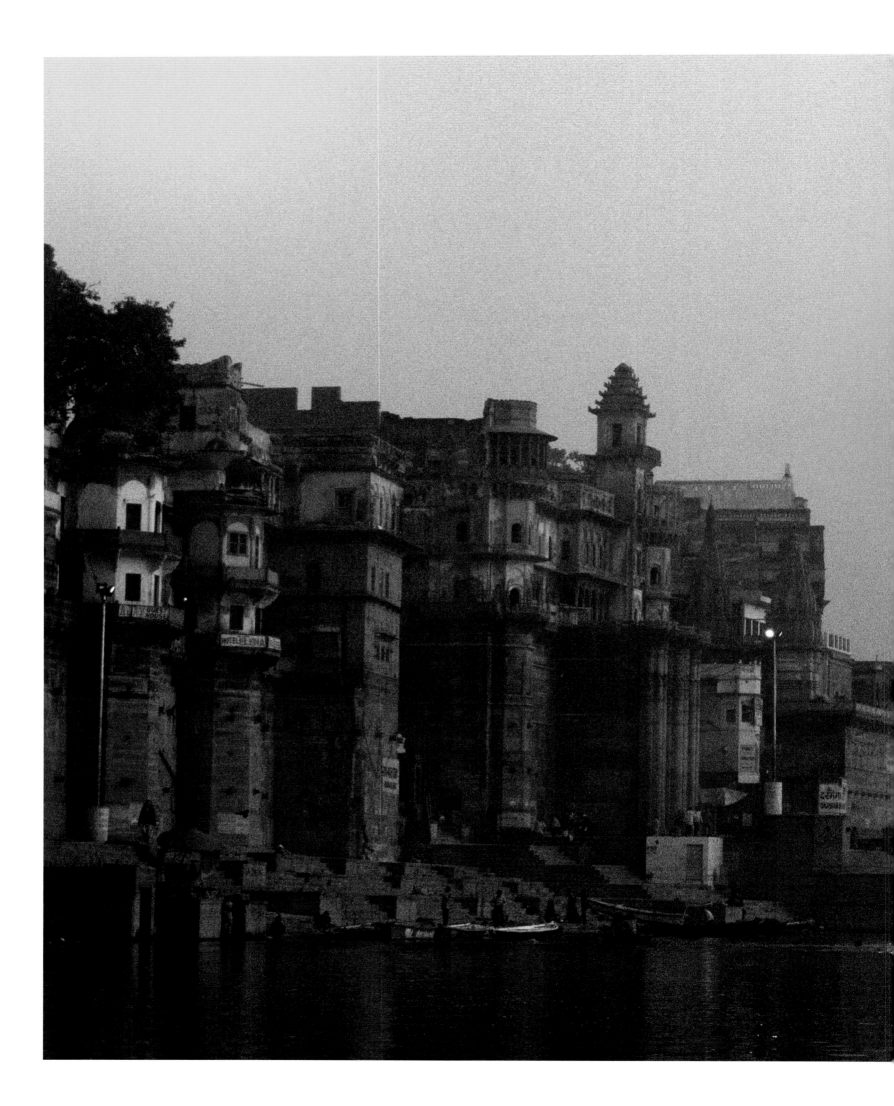

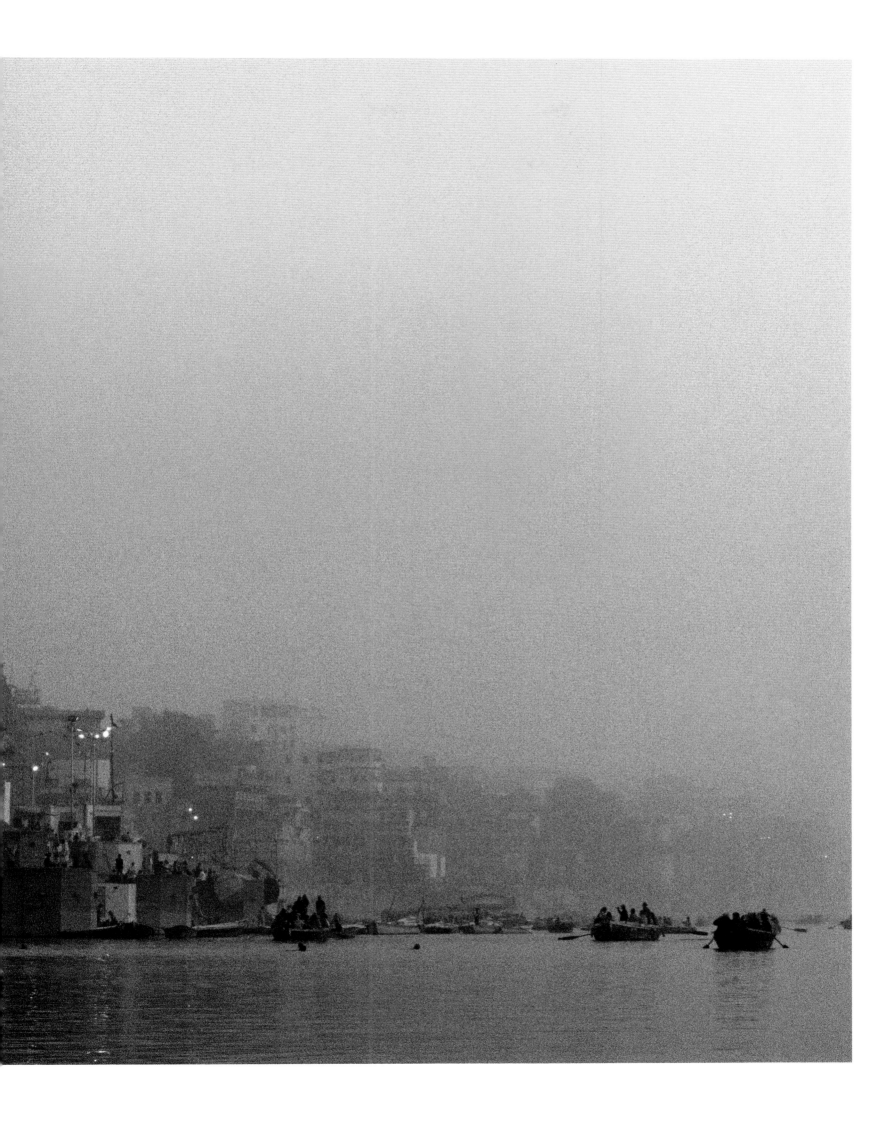

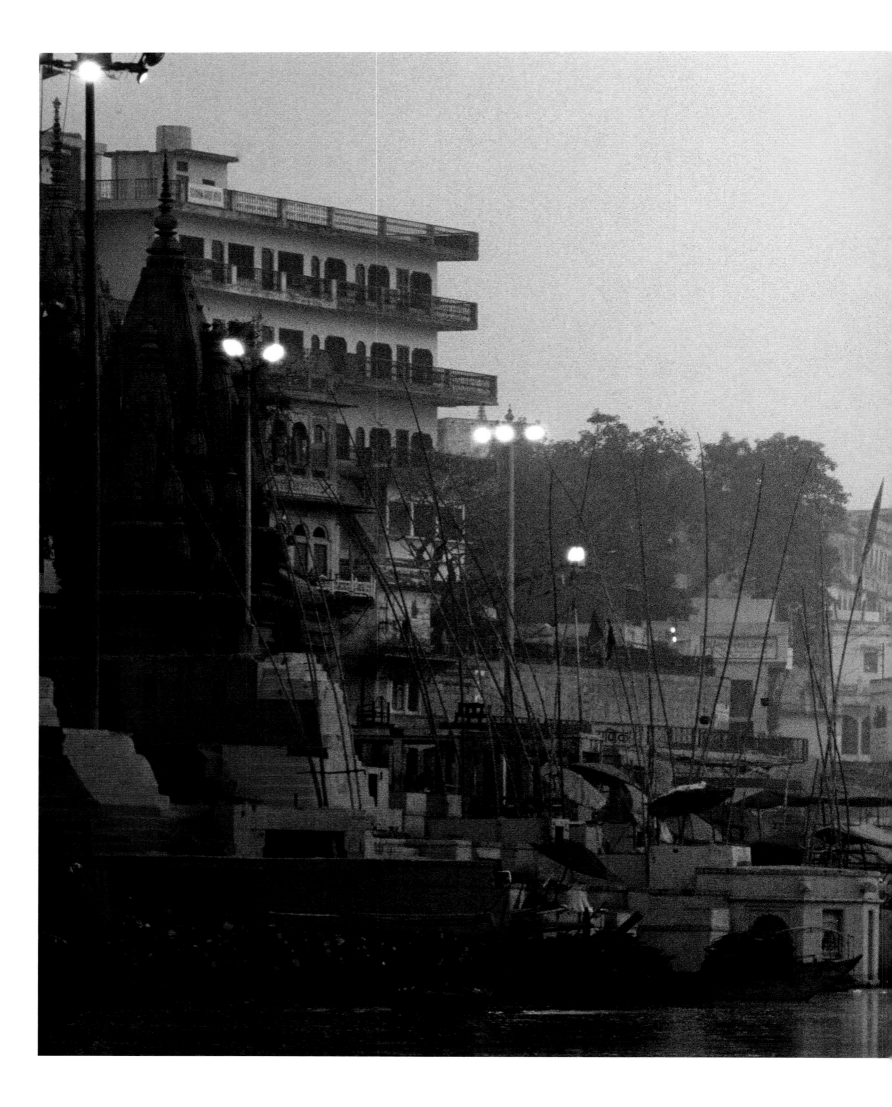

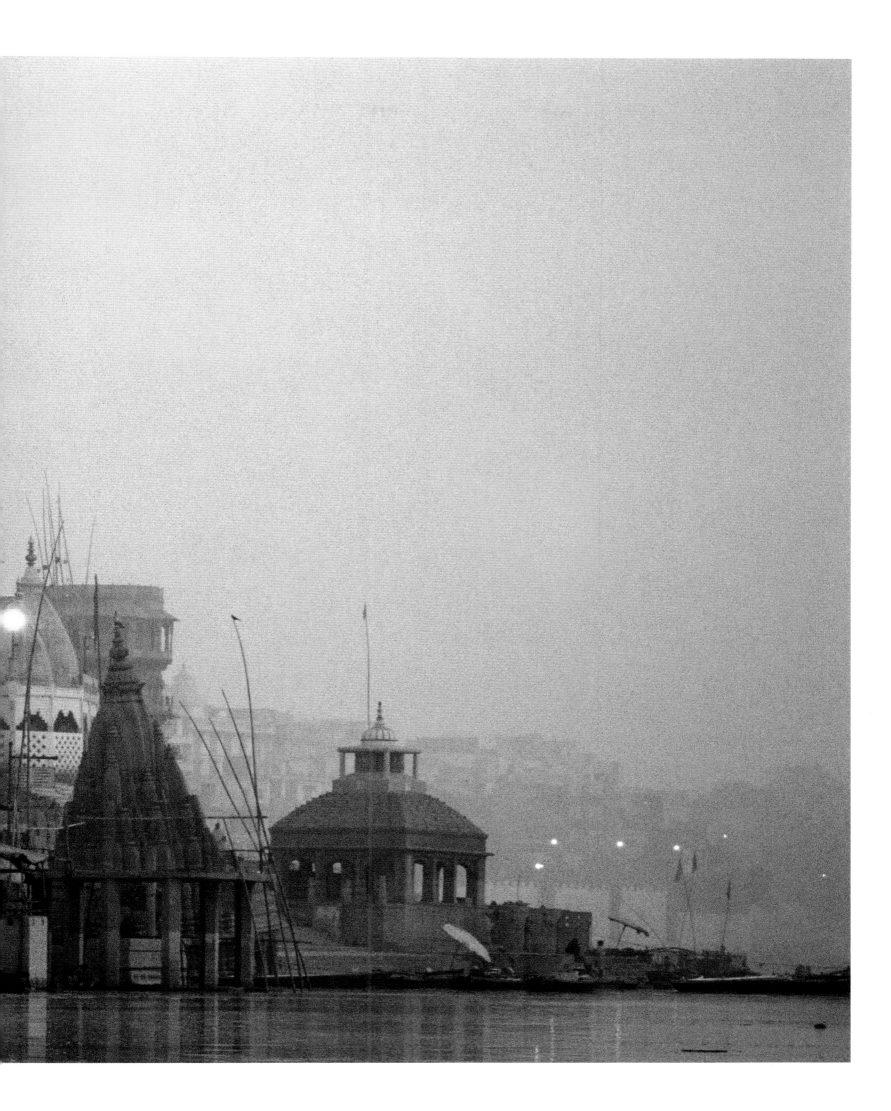

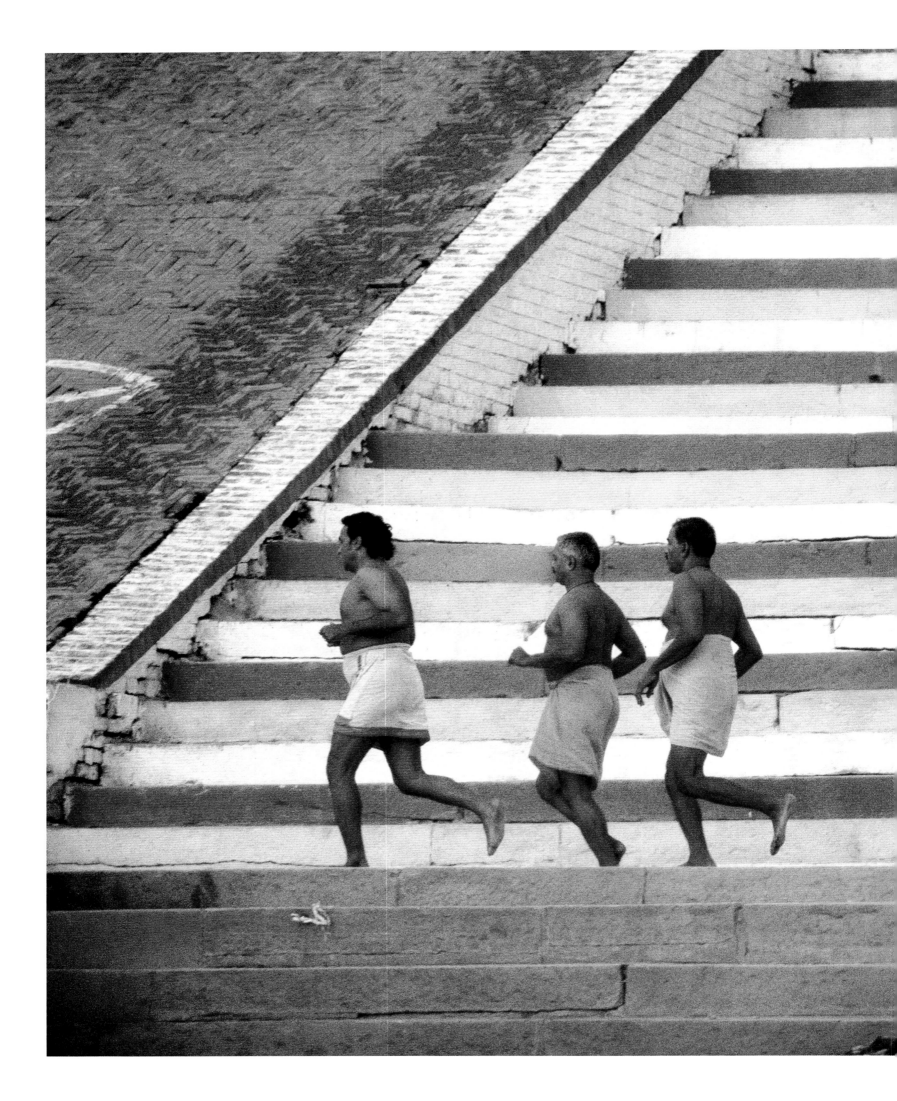

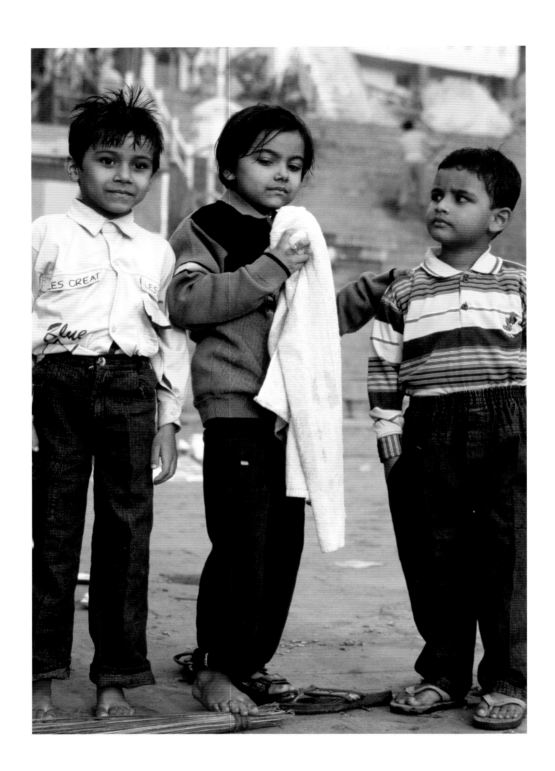

Pages 250–251: Wrestlers jogging at dawn, Janki Ghat.

Above: Boys toweling dry after a plunge in the holy river.

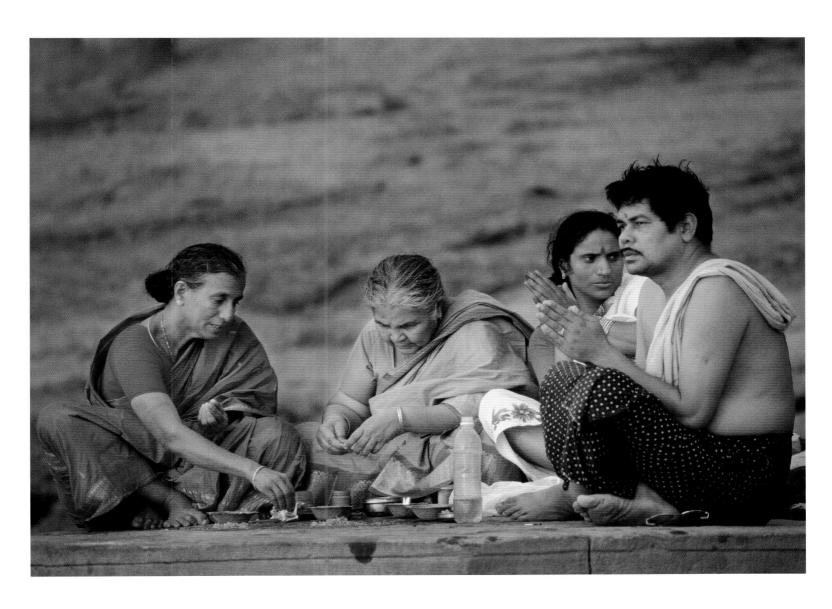

"When we rejoice in our fullness, then we
can part with our fruits with joy."

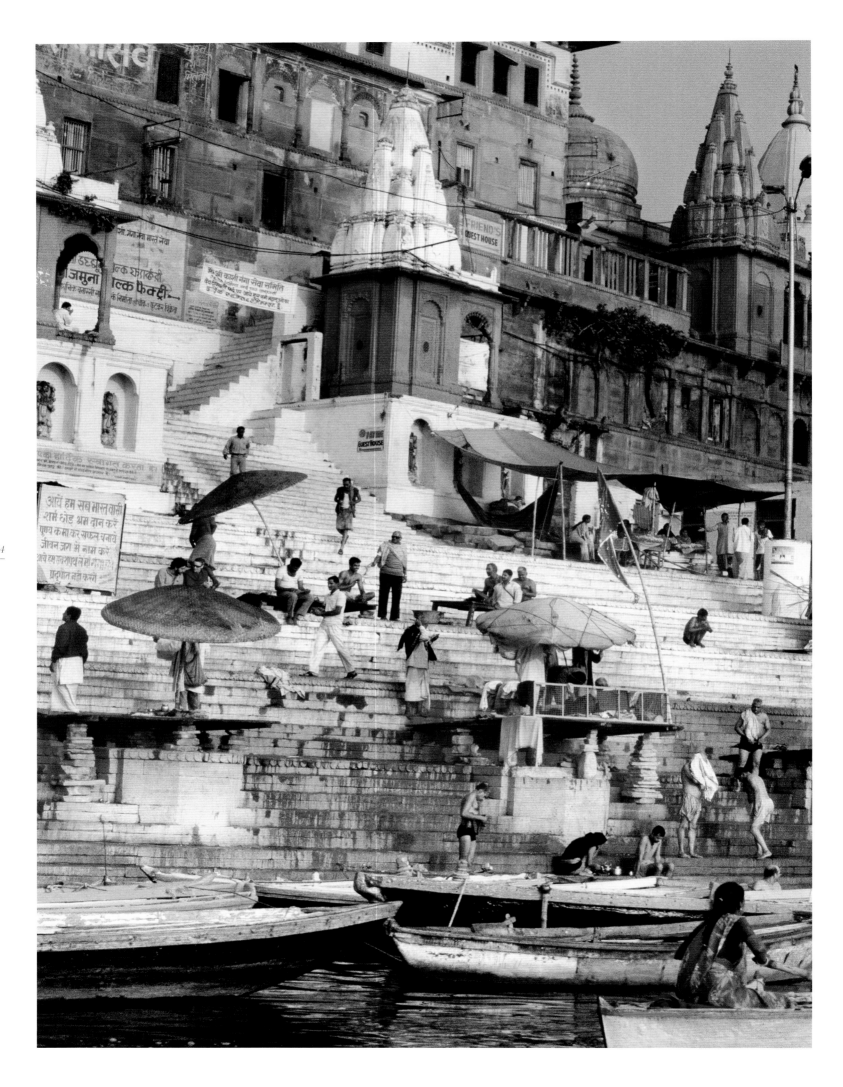

"Man goes into the noisy crowd to drown his own clamour of silence."

Dasashvamedha Ghat.

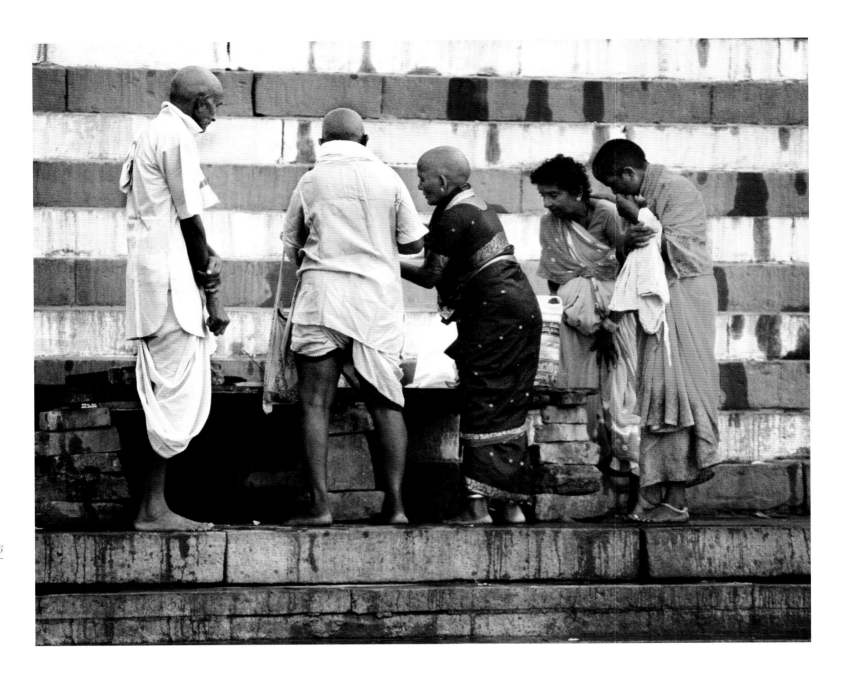

Above: A family making offerings after the death of a loved one.

Right: A woman in prayer.

Pages 258–259: Sadhus on the ghat.

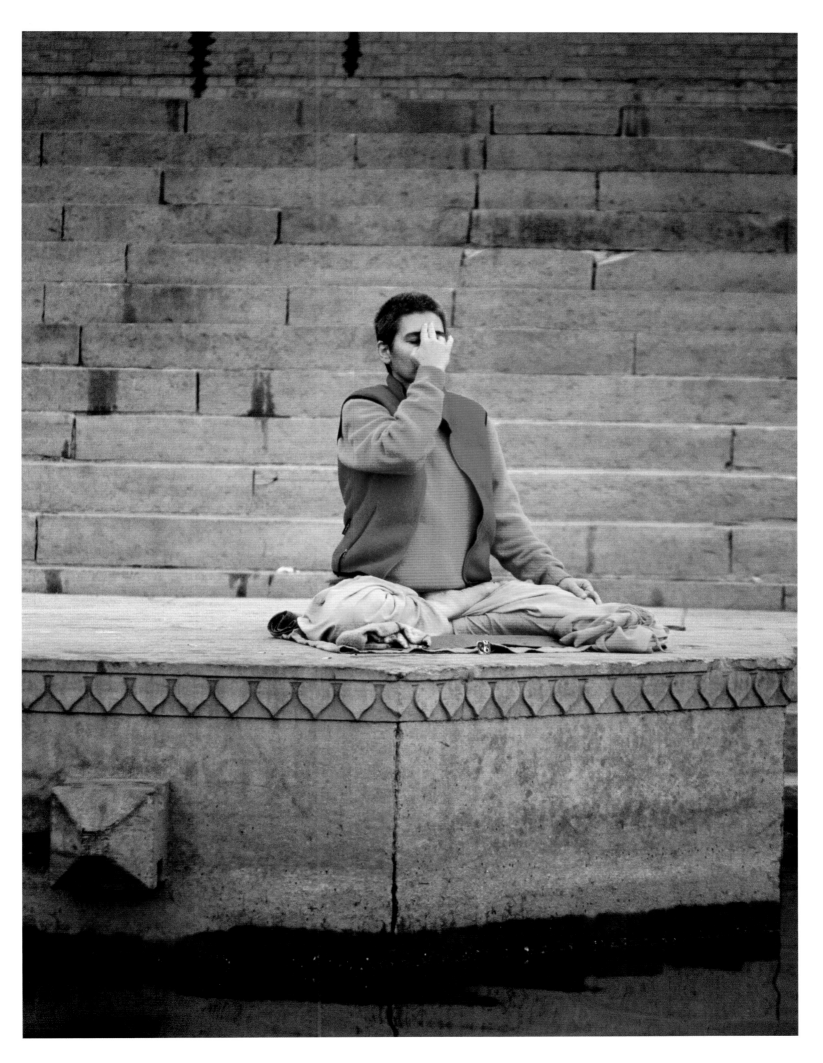

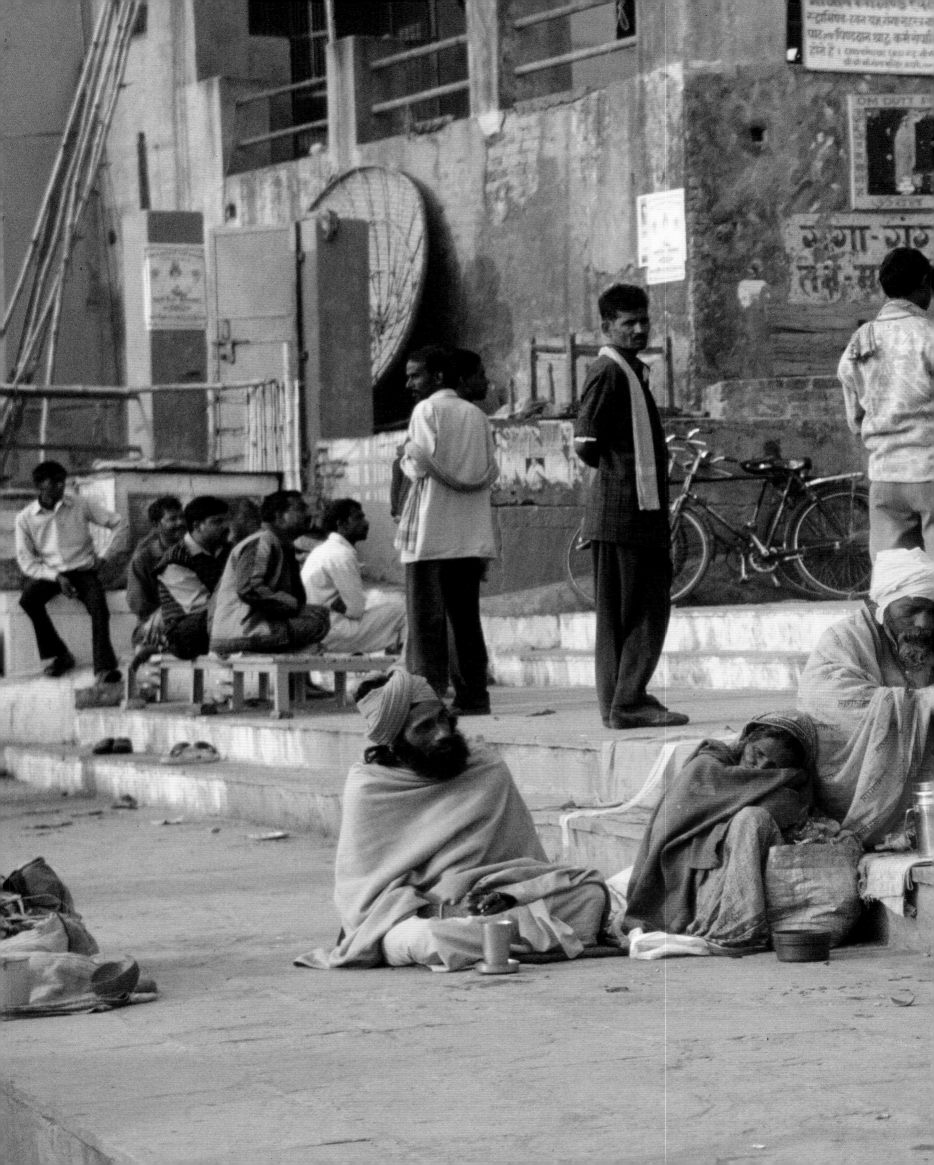

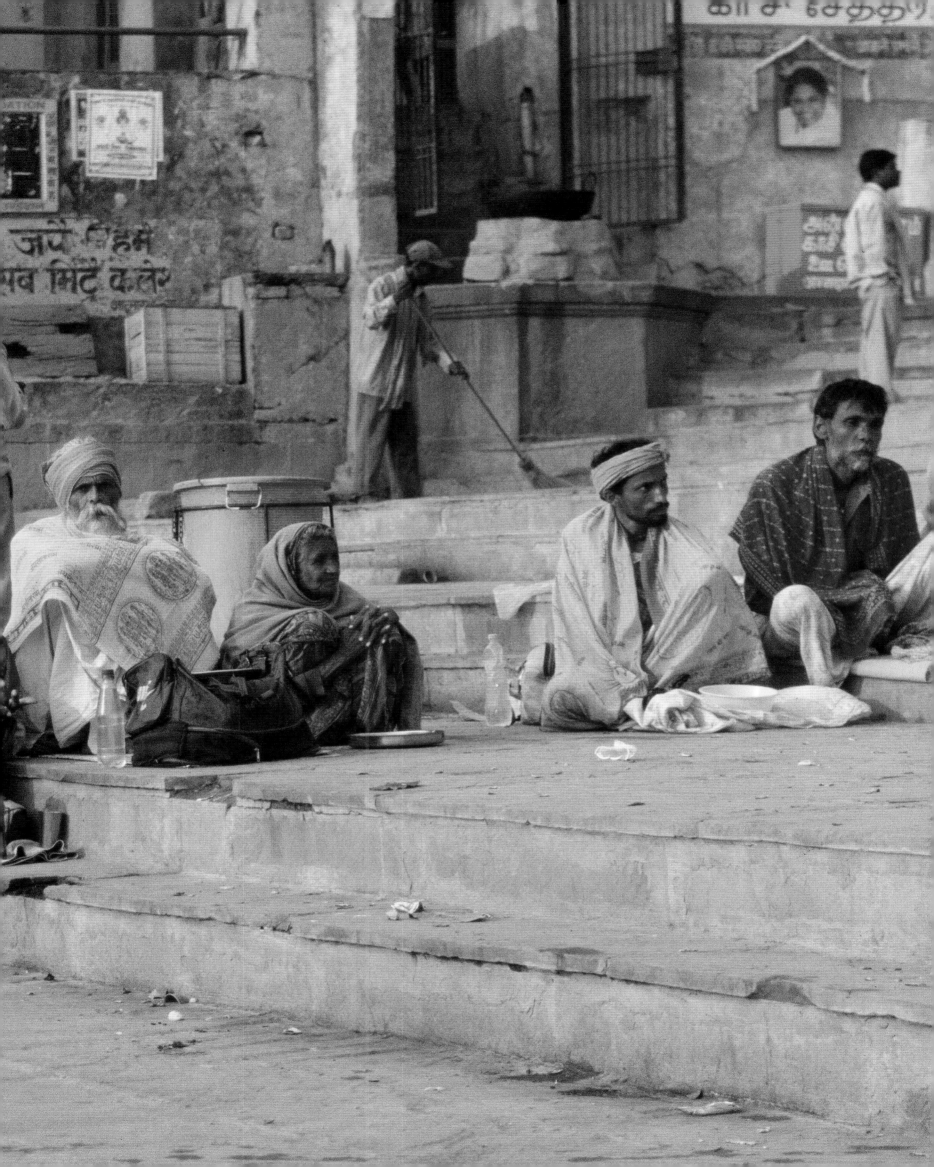

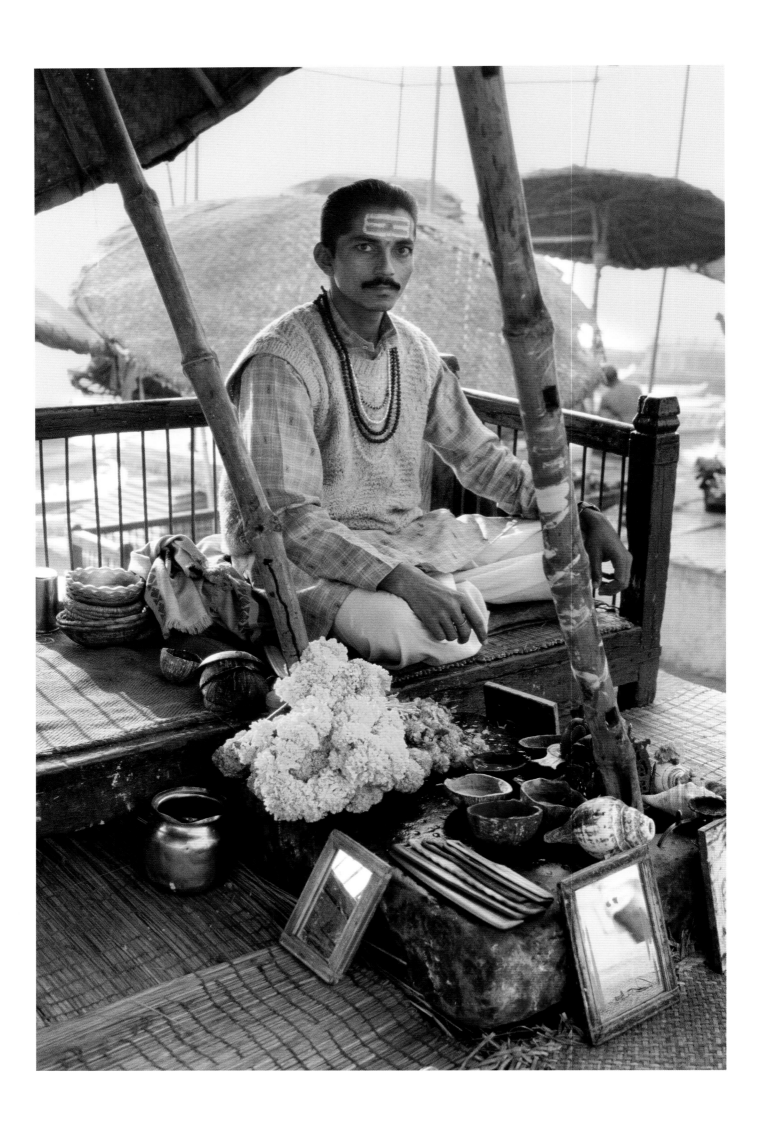

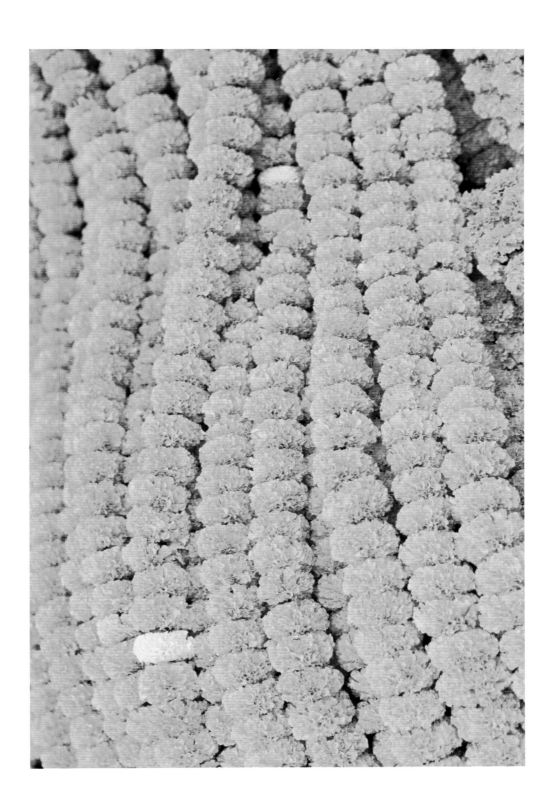

Left: A Brahmin performs ritual prayers.

Right: Garlands of marigolds to celebrate Diwali and a visit to the holy Ganges.

"The grass blade is worthy of the

great world where it grows."

A barber shaving the head of a man in mourning.

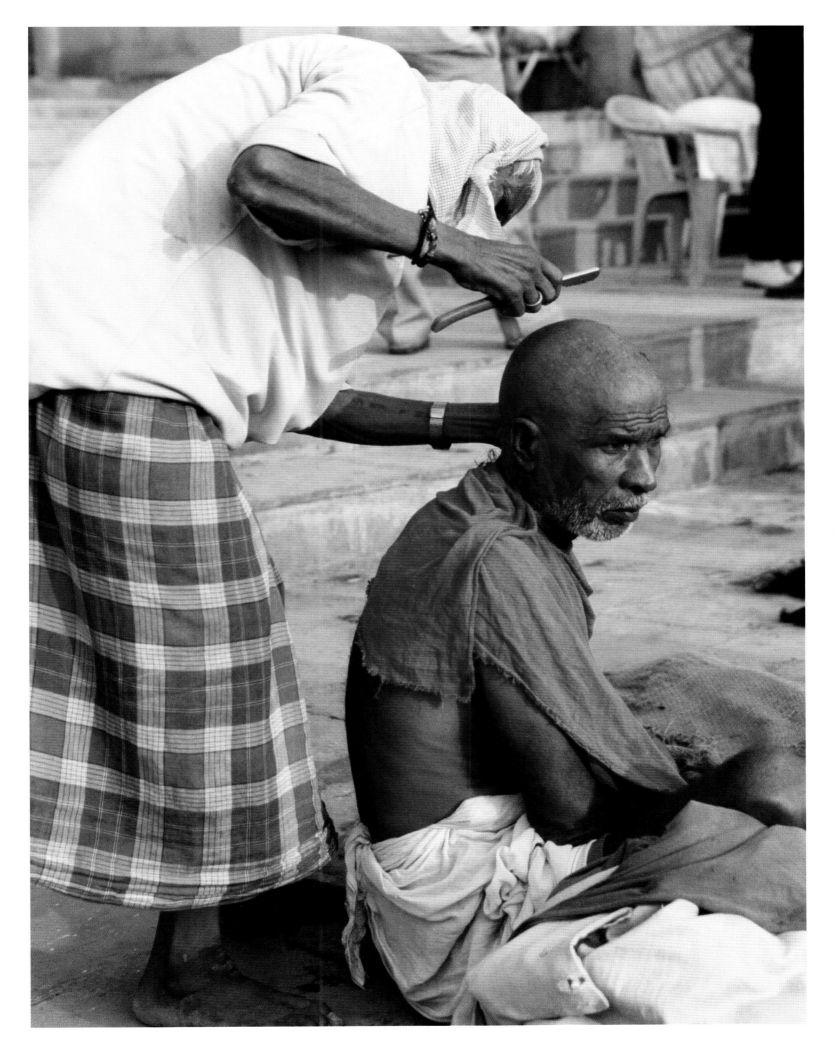

Marigolds and orange robes represent devotion.

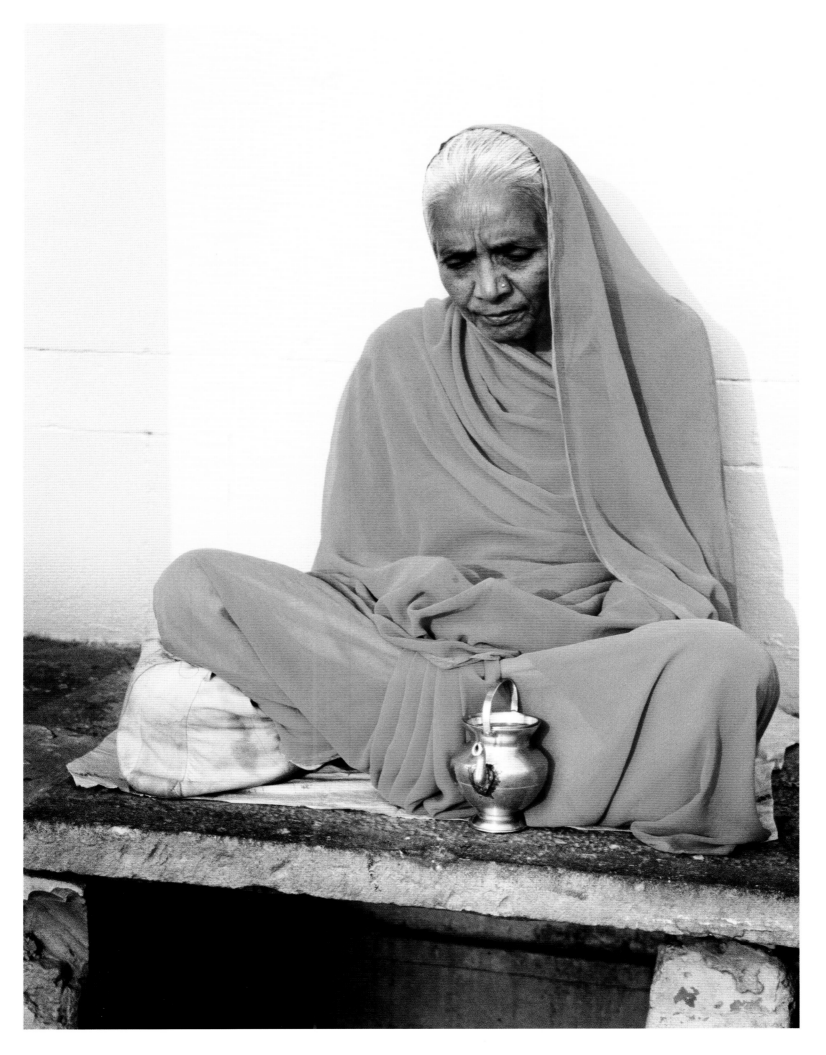

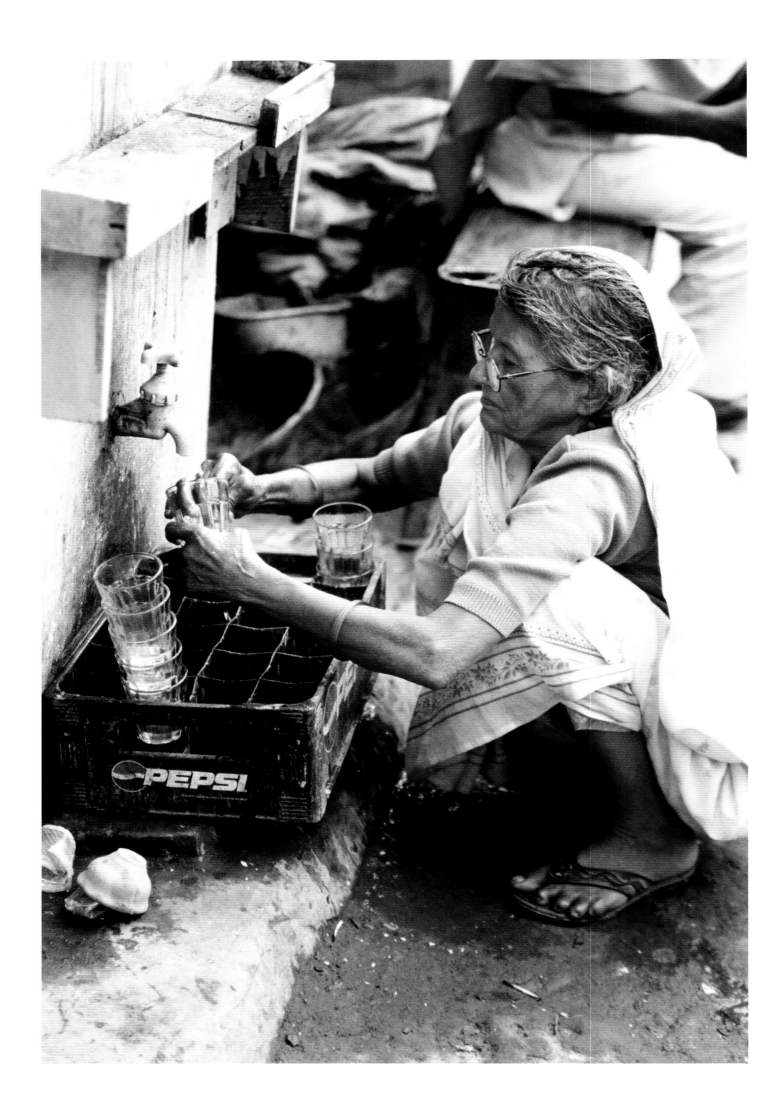

"Let me think that there is one among those stars that guides my life through the dark unknown."

"Your smile was the flowers of your own fields, your talk was the rustle of your own mountain pines, but your heart was the woman that we all know."

Pages 270–271: An experience of joy: People bathing in the holy river, Ganga.

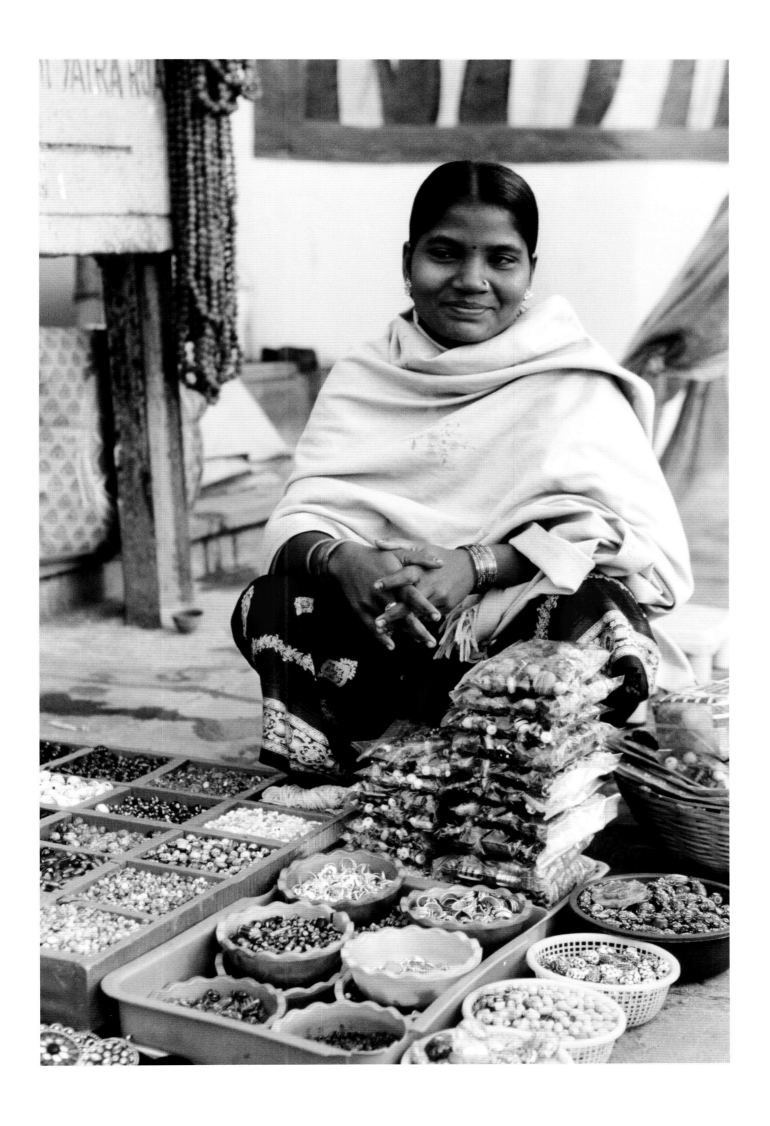

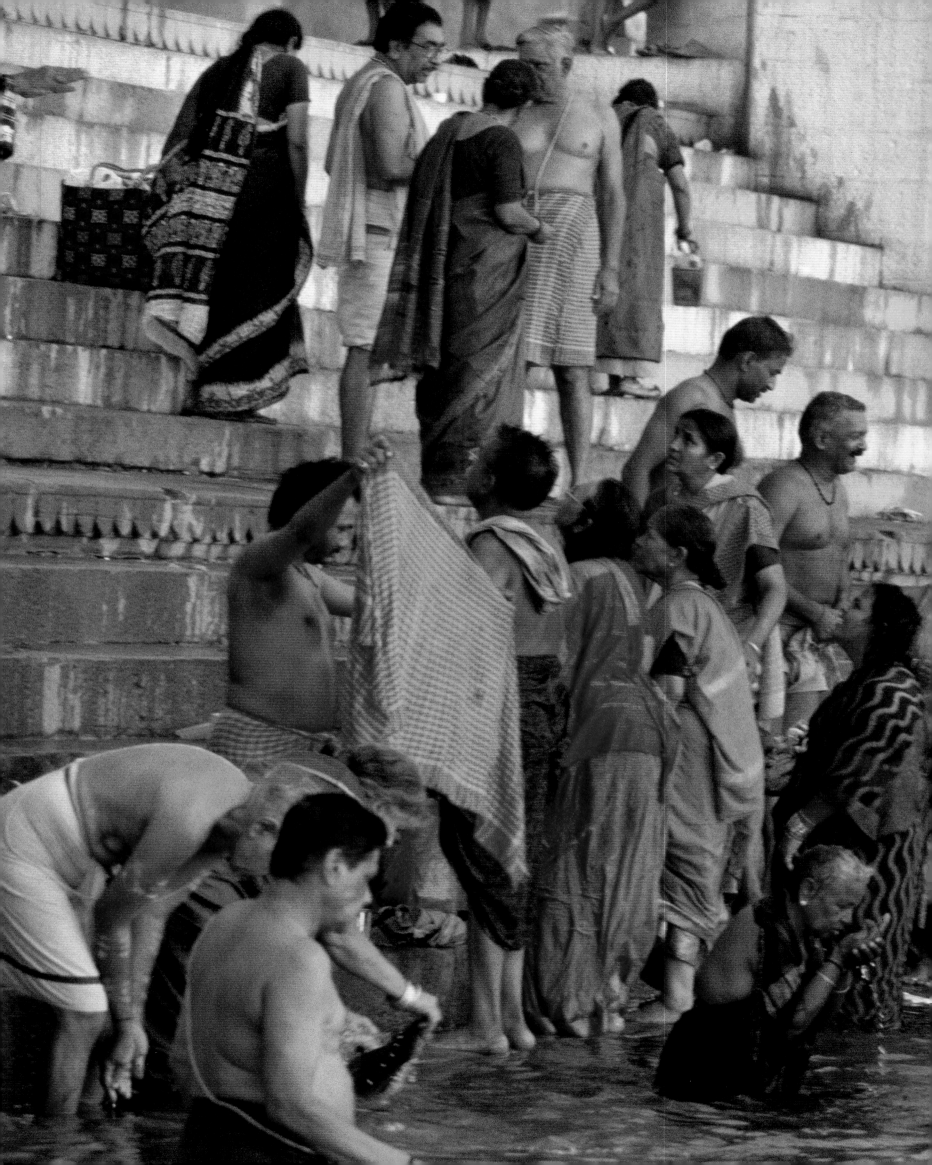

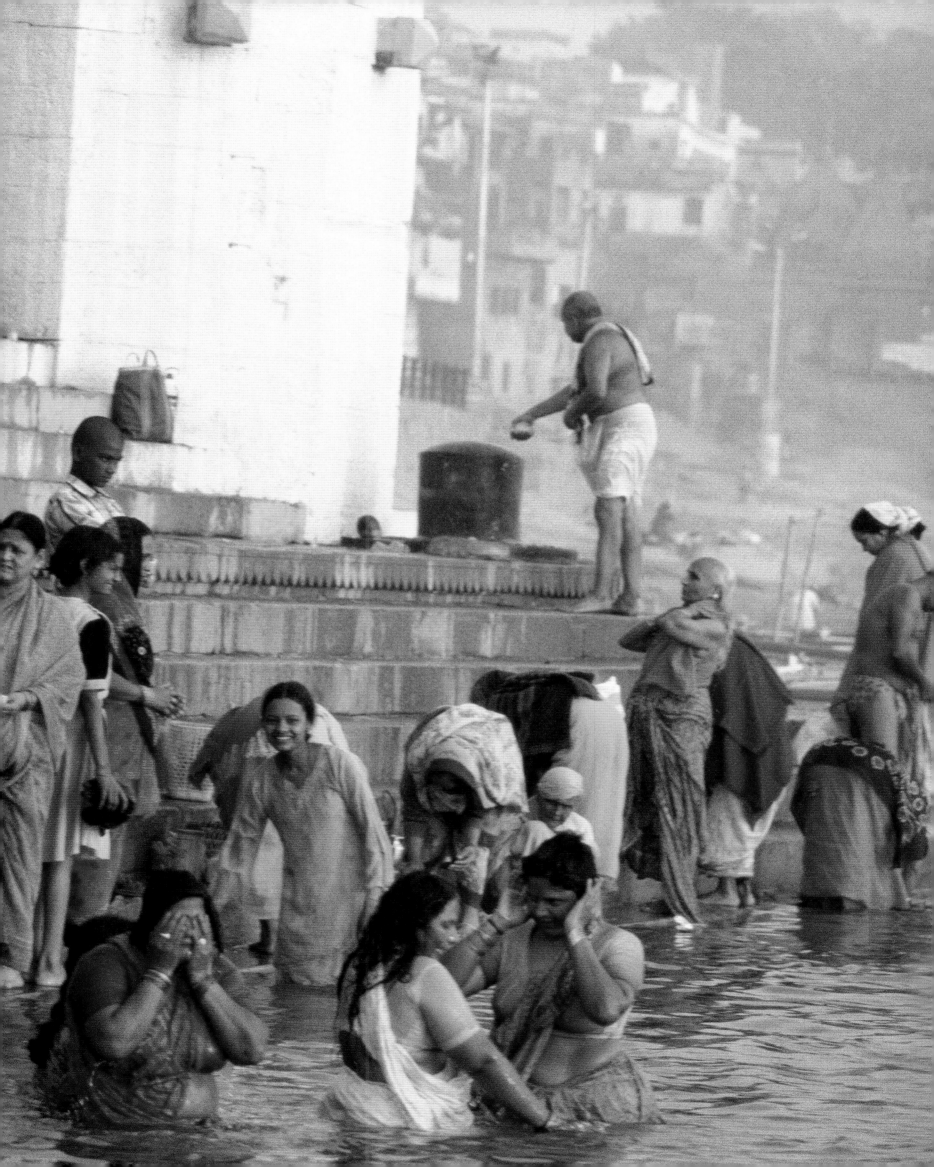

Acknowledgements

I consider it a great honor and a privilege to have had extraordinary people write for *India In My Eyes*. The foreword is written by Pritish Nandy, the great Indian poet, writer, statesman, TV producer and movie director. *A Culture Revealed,* is by International Head of Art and Design and Photography for Christie's, Philippe Garner. Philippe is also an author, with whom I have shared a lifetime of mutual interests in art and antiques. And, Eleanor Heartney the celebrated fine arts writer and critic has written *Barbara Macklowe's India*. My deepest thanks to each of them.

I wish to thank my publisher Alexandra Papadakis for having faith in me and my work. I thank Aldo Sampieri for the genius of his book design.

The images in this book were all photographed on Kodak slide film using Canon cameras and lenses. The slides were digitally scanned and prepared by Sofie Barfoed for the printing of this book. I am gratefully indebted to her and to Claudia Sohrens for guiding me in understanding the myriad possibilities of production. Thanks to Baboo Kumar who gently encouraged me to visit India. Also, thank you to John Brancati for his wisdom and guidance.

My gratitude to all the people who welcomed me in India and to all the color photographers who came before me, especially to Jim Zuckerman my guide and mentor. My debt to Rabindranath Tagore the Nobel Prize winning Indian poet, 1861-1941. I saw India through his eyes before I saw India through my own. All quotes in this book are from his poem, *Stray Birds*.

To my husband Lloyd, and all my friends and family, thank you for your support and love throughout.